THE

NASA IMAGES FROM SPACE

BETH ALESSE
AMHERST MEDIA, INC. ■ BUFFALO, NY

 ${f B}^{}$ eth Alesse is a graphic artist, editor, and author. She curates image collections to present in books, some of which she has written, and media. She is well suited for this with degrees in both art and education and backgrounds in graphic arts, linguistics, and visual and audio digital media.

Copyright © 2019 by Amherst Media, Inc.

All rights reserved.

All photographs by NASA unless otherwise noted.

Published by:

Amherst Media, Inc., P.O. Box 538, Buffalo, N.Y. 14213

www.AmherstMedia.com

Publisher: Craig Alesse

Associate Publisher: Katie Kiss

Senior Editor/Production Manager: Michelle Perkins

Editors: Barbara A. Lynch-Johnt, Beth Alesse

Acquisitions Editor: Harvey Goldstein

Editorial Assistance from: Ray Bakos, Carey Miller, Rebecca Rudell, Jen Sexton-Riley

Business Manager: Sarah Loder

Marketing Associate: Tonya Flickinger

ISBN-13: 978-1-68203-340-1

Library of Congress Control Number: 2017963171

Printed in The United States of America.

10987654321

No part of this publication may be reproduced, stored, or transmitted in any form or by any means, electronic, mechanical, photocopied, recorded or otherwise, without prior written consent from the publisher.

Notice of Disclaimer: The information contained in this book is based on the author's experience and opinions. The author and publisher will not be held liable for the use or misuse of the information in this book.

www.facebook.com/AmherstMediaInc www.youtube.com/AmherstMedia www.twitter.com/AmherstMedia www.instagram.com/amherstmediaphotobooks

AUTHOR A BOOK WITH AMHERST MEDIA

Are you an accomplished photographer with devoted fans? Consider authoring a book with us and share your quality images and wisdom with your fans. It's a great way to build your business and brand through a high-quality, full-color printed book sold worldwide. Our experienced team makes it easy and rewarding for each book sold—no cost to you. E-mail submissions@amherstmedia.com today.

Contents

Introduction5	Solar Orbiter (SolO)	37
	Distinct Instruments	
The Facts About the Sun6	One Star, One Day, Many Faces	41
Location and Neighbor		
One of Many Stars	Sunspots and Solar Cycles	42
Heavy-Metal Stars9	First Recordings	43
The Sun's Age and Birth10	Early Observations	44
Recycled Star Material	Christopher Scheiner	45
The Sun's Elements11	Galileo Galilei Sun Spot Observations	
The Size of the Sun	Camera Obscura	
The Habitable Zone12	Pairing	
A System for Life	The Size of a Sunspot	
Plasma: A State of Matter	The Umbra and Penumbra	
The Sun's Plasma	As the Sun Rotates	
	The Solar Cycle	
The Layers of the Sun		
The Core	Coronal Holes	56
Radiative Zone	Apparent Unipolar Magnetic Fields	
Convective Zone	Massive Coronal Hole	
Tachocline	Faster Solar Wind	
Photosphere20	The Same Moment In Time	
Chromosphere	More Coronal Holes	
Transition Region	Lower Density Areas	
Corona	201101 20110119 / 1104001 1 1 1 1 1 1 1 1 1 1 1 1 1 1 1 1	
The Sun's Planets	Prominences and Filaments	66
The Heliosphere's Tail	Solar Prominences	
The Heliosphere o ruli	Unstable Features	
Instruments and Missions	Coronagraph	
NASA Missions	Fifty Earths Long	
Ulysses	Suspended Above	
Solar and Heliospheric Observatory (SOHO) 35	The Forces on a Filament	
Interstellar Boundary Explorer (IBEX)	The Forces on a Financial	/ 0
Voyager 1 and 2	The Magnetic Sun	76
Geotail	Solar Dynamo	
Magnetospheric Multiscale (MMS)	Magnetic Current Sheet	
Transition Region and Coronal Explorer (TRACE) .35	Created and Reorganizing	
Solar Terrestrial Relations Observatory (STEREO) 35	Magnetic Reconnection	
Living With A Star	The Sun's Polarity	
Solar Dynamics Observatory (SDO)	Magnetic Field Lines	
Van Allen Probes	Plasma	
Balloon Array for Radiation-belt	Magnetic Field Strength	
Relativistic ElectronLosses (BARREL)	Magnetic Hela Strength	
Parker Solar Probe		
Turker solur mobe		

Solar Flares86Solar Flare Facts88Cause of Flares89	Space Weather Effects110NASA and Space Weather112What Is Affected by Space Weather?112Energetic Particles from Solar Plasma115
Coronal Mass Ejections90	Earth's Magnetosphere
Eclipses and Transits	Van Allen Belts
Eclipse Viewed From the SDO	The Reaching Sun
Double Eclipse: Moon and Earth99	Cosmic Bow Shock
Soft Edge of Earth's Shadow 100	The Extent of the Sun's Influence120
A First for SDO	A Grand Distance121
Transit of Venus	Interstellar Medium
Lunar Transit	Our Shielding Sun122
A Comet's Transit	The Outer Limits of the Solar System
Comets and Tails	Heliosphere
Comet's Death	Parker Solar Probe
Space Weather	Index126
Causes of Space Weather	Image andita NACA/CDO

Image credits: NASA/SDO

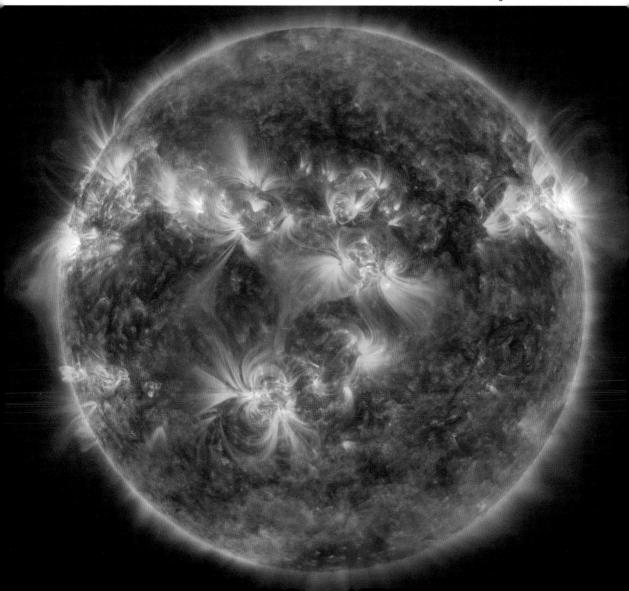

Introduction

The Sun is part of the book trilogy: The Earth, The Sun, and The Moon, and features beautiful and aweinspiring images. Some of the images are historic, technologically unrefined by today's standards; other images are made from state-of-the-art earthbound and spacefaring instruments. The early images illustrate humanity's early understanding that the Sun has nursed life on the planet Earth is evident from ancient Chinese recordings of sunspotsthe first recorded observations of the Sun. Knowing the Sun's rhythms and patterns meant seasons, weather, and climate could be understood, anticipated, and successfully predicted. Our recording of observable features continues today with sophisticated instruments that are on and orbiting Earth, and orbiting the Sun. This data will help us to understand the Sun, the solar system's dynamic environment, cope with the dangers of space weather, and make space

Parker IS⊙IS/EPI-Lo First Light

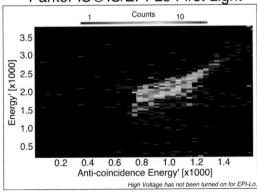

travel safer, increasing the likelihood of exploration.

Many of the images in this book are made by National Aeronautics and Space Administration (NASA) and their astronauts, and some originate from the surface of Earth such as those by the U.S. Forest Service and the U.S. Department of Agriculture. Most are made from instruments on satellites and earthbound telescopes that are part of NASA research projects and their many associates throughout the world. Data is often combined with information from different instruments. Often, what is recorded is not visible to the human eye or safe for the eye to directly observe. Data collected and often visually presented as shown here (below) from the Parker Solar Probe launched in 2018, is not photographic, but allows scientists to make great strides in what we know about the Sun.

I have tried to give image credits as requested by the websites (most often NASA) where each image was acquired. Similar images were available from different websites with variations in credits provided. If I have left anyone out, please contact me and corrections will be made in future editions. Also, if you would like to explain your imaging process, feel free to reach out. For those whose images were not included, I would like to hear from you too.

Beth Alesse
BAlesse@AmherstMedia.com

Facts About the Sun

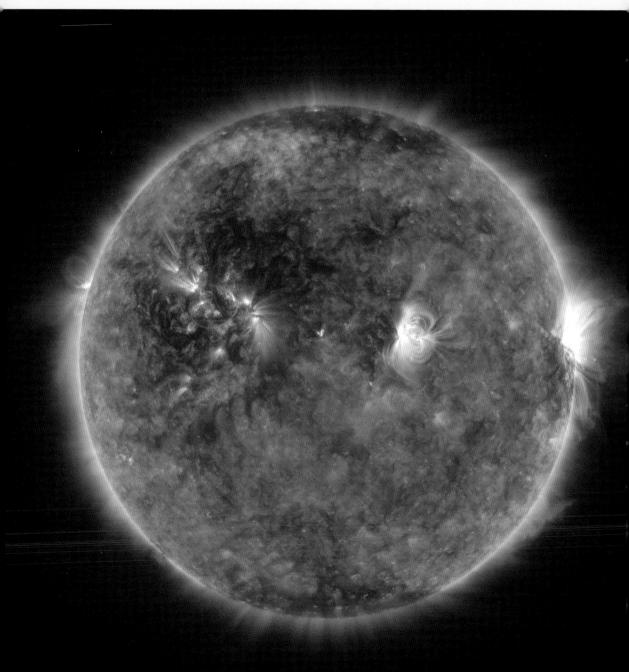

Location and Neighbor

Our star, the Sun, is located in the Milky Way galaxy. The Milky Way is a barred spiral galaxy with two major arms that curl off the center bar of stars in its middle. This image (below) illustrates the two arm model of our galaxy, which was previously thought to have four arms. The two arms are called Scutum-Centaurus and Per-

seus. The two other previous arms, Norma and Sagittarius, still exist as minor arms. The blue areas in the image are star-forming regions.

The Sun is located in a minor arm of the Milky Way called Orion, or the Orion Spur. The closest star system—4.37 light-years away—is Alpha Centauri, which has a binary star Alpha Centauri AB with a third loosely gravitationally bound smaller star, Alpha Centauri C.

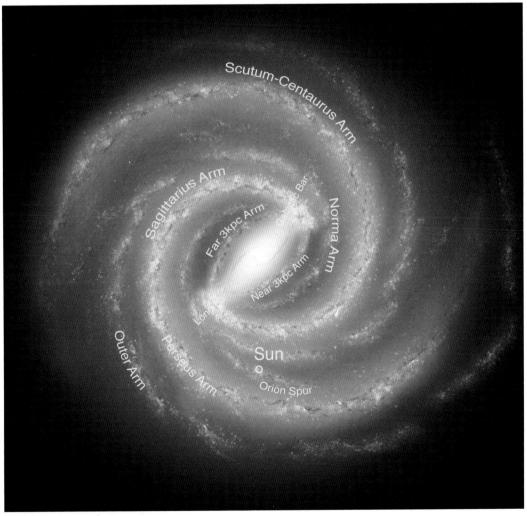

Image credits: NASA/JPL-Caltech Image credits (facing page): NASA/SDO/AIA

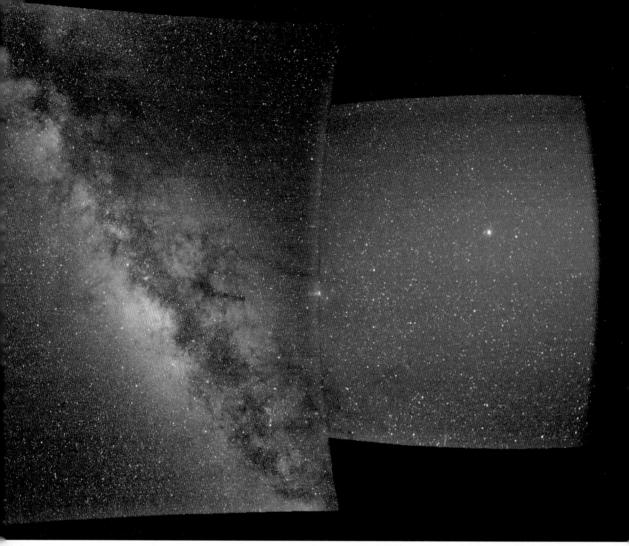

Image credits: NASA/Naval Research Laboratory/Parker Solar Probe

One of Many Stars

The Sun is one of at least 100 billion stars in our Milky Way galaxy (*left side of above image*). Some scientists estimate that the galaxy may hold as many as 400 billion stars.

The data for this image is compiled from two instruments on the Parker Solar Probe, called WISPR (Wide-field Imager for Solar Probe) instrument suite. It was one of the first images taken by the probe. The left side of the image used the probe's outer telescope. The right side used the inner telescope. The main purpose of the probe is to study the Sun. However when it was first launched in 2018, this image of the Milky Way was taken to help test the new probe's instruments. What appears to be a bright star on the right is really the planet Jupiter.

Heavy-Metal Stars

The Sun is a heavy-metal star. This image of globular cluster NGC 6496 was acquired with the Hubble telescope. It shows a higher proportion of stars with elements heavier than hydrogen and helium. In astronomy, these heavier elements are known as heavy metals.

Image credits: NASA/ESA

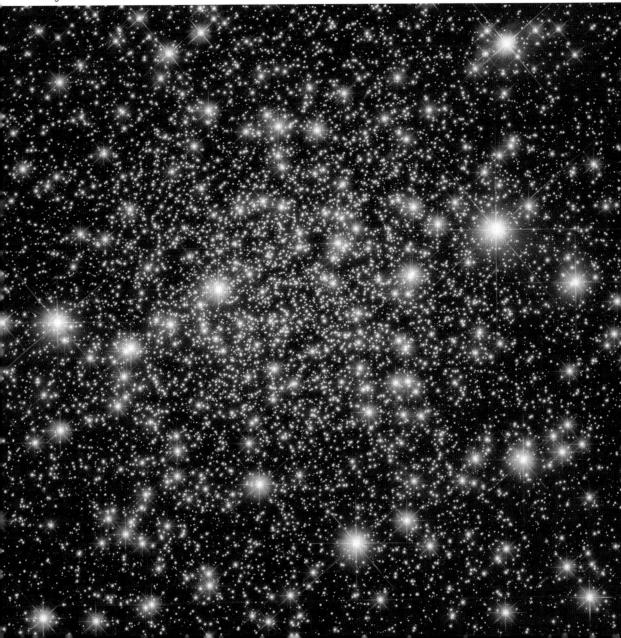

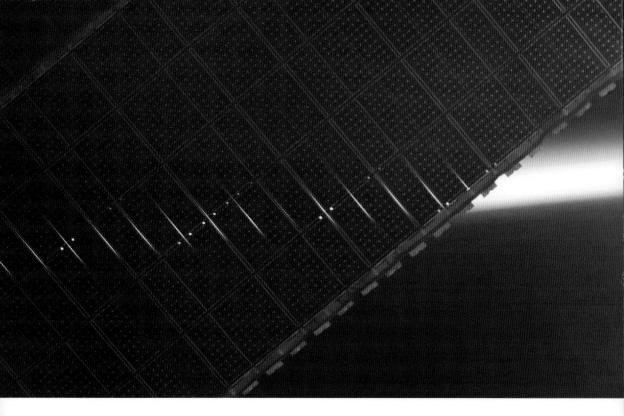

This image shows one of the sixteen daily sunrises on the International Space Station. Solar panels that provide power to the station are in the foreground on the left.

The Sun's Age and Birth

The Sun and the solar system were formed approximately 4.6 billion years ago. This was determined from models and studies of ancient meteorites formed at the same time as our solar system.

The Sun was formed from matter in a large molecular cloud. It likely became compressed from a shock wave from a supernova. The material then became gravitationally bound. Most of the matter collapsed in the center to form a dense core. Its extreme mass and density eventually caused nuclear fusion to begin in its center. The disk of the orbiting material became the planets. Scientists estimate that the Sun is at the halfway point in its life. It will continue for about 5 billion more years.

Recycled Star Material

The Sun is not a first generation star, or even a second generation star. These are called Population III stars and Population II stars, respectively. Scientists believe our Sun is a third generation star, also called a Population I star. Population III

Image credits: NASA, ISS Expedition 52 Crew

stars (first generation stars) are theoretically the first stars to form after The Big Bang, and they are made mostly of hydrogen and helium. As these first generation stars ended their life cycle, their remnants of gas and other material amassed through gravitational attraction and became Population II stars (second generation of stars). Population II stars are the oldest observable stars. These stars are thought to have created all the other elements in the periodic table after hydrogen and helium. Our Sun, being a young star, is rich in elements that are heavier than these two elements. Most of the heavier elements (those with higher atomic numbers above six, *i.e.*, carbon) in our universe have been created through the stellar evolution of pre-

vious stars. Astrophysicists refer to these elements as heavy metals, and they are synthesized from hydrogen and helium in nuclear fusion reactions inside stars. Metals are most abundant in younger stars formed from the material of stars from previous generations.

The Sun's Elements

The sun is mostly hydrogen (73.46%) and helium (24.85%). Other elements include: oxygen (0.77%), carbon (0.29%), iron (0.16%), neon (0.12%), nitrogen (0.09%), silicon (0.07), magnesium (0.05%), and sulfur (0.04%).

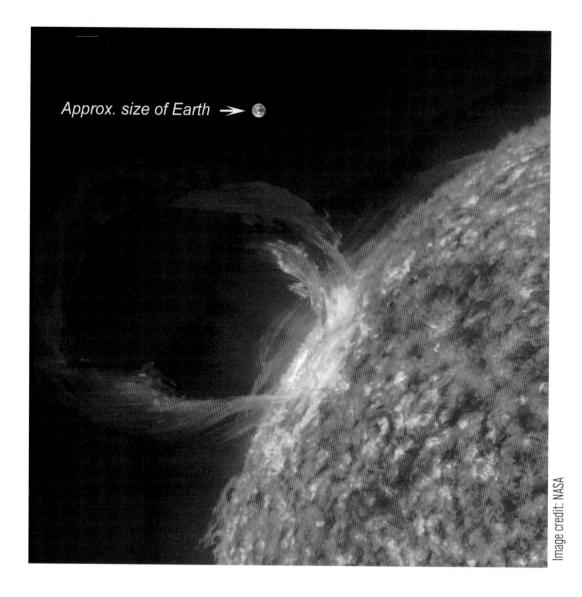

The Size of the Sun

The diameter of the Sun is about 863,706 miles, which is 109 times the diameter of Earth. Its mass is about 330,000 times the mass of the Earth, illustrating that the Sun is extremely dense compared to rocky planets. Even one of the prominences would dwarf the Earth (above).

The Habitable Zone

The Sun is about 93 million miles (150 million kilometers) from Earth. This distance has become the basis for the astronomical unit (AU). The Earth is in a sweet spot called the habitable zone. It is also referred to as the Goldilocks zone. Like in the children's story "Goldilocks and

the Three Bears", Goldilocks needs something that is not too hot and not too cold, something that is just right. If a planet is too close to the Sun, the water that is necessary for life will boil off. Molecules required by life are altered. Venus, Mars, and Earth are planets in our solar system that are in this zone. The moons of planets may also be in a habitable zone if their gravitational pull creates enough energy. Scientists are gaining an understanding of the habitable zones that may exist around other stars such as in the Kepler-186 system (below). Other variables for the habitable zone around a star include the star's size, density, age, and more.

A System for Life

All life on Earth depends on the Sun to sustain it. The Sun is the source of radiation that is beneficial to life. but can also be dangerous to life. The Earth has a magnetosphere that protects its life by preventing too much of the Sun's radiation from reaching into the atmosphere. Earth's magnetosphere along with the Sun's radiation make the Earth habitable. The Sun's heliosphere extends out to the point where the solar winds have a significant influence, protecting the solar system from interstellar medium—radiation and matter that is in the space between star systems. The heliosphere is like a protective bubble that surrounds the Sun and the planets.

Image credit: NASA

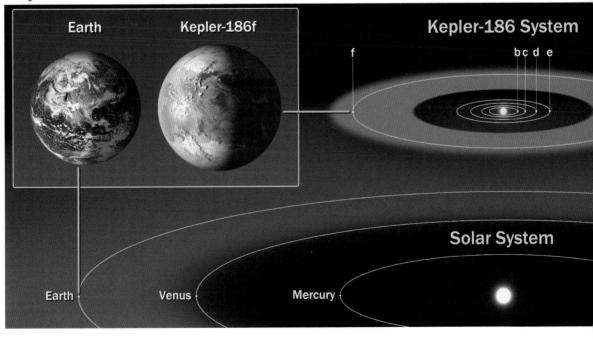

Plasma: A State of Matter

Matter can exist in four states, as far as we understand: solid, liquid, gas, and plasma. Different elements can change from one state to another most often with a change in temperature. We have less personal knowledge of plasma because it is

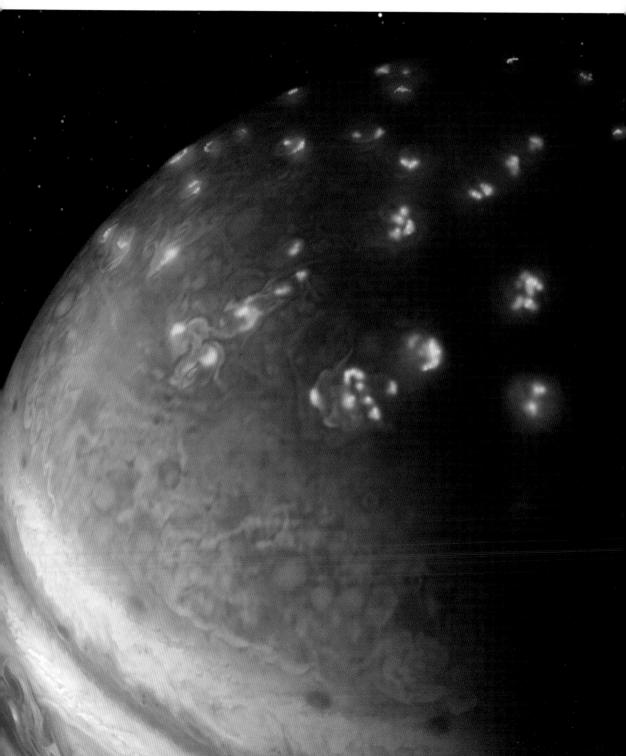

rarely seen up close. Lightning is an example that occurs in nature. Neon lightning is a manufactured example of plasma.

Plasma is a gaseous state of matter that is also ionized. This means that it's made of positive and negative particles that are unbound. So they are electrically conductive. Electric and magnetic fields govern plasma behavior. An example of this is when lightning seeks to ground itself. The regions in the atmosphere when charged, equalize themselves through the flash.

A fire in this forest (top) is not plasma unless enough of the particles in its gas become ionized. Ionization occurs when an atom or molecule becomes charged by either losing or gaining electrons. Other examples of plasma are the heat produced by a Soyuz descent module as it re-enters Earth's atmosphere (right), lightning on Jupiter (facing page), and neon signs.

The Sun's Plasma

Plasma in the Sun is created from gas under extremely high pressure. The helium/hydrogen plasma in the Sun's core is fully ionized. Ionization happens with heat, electromagnetic radiation, and an electrical charge supplying the energy to ionize atoms into plasma.

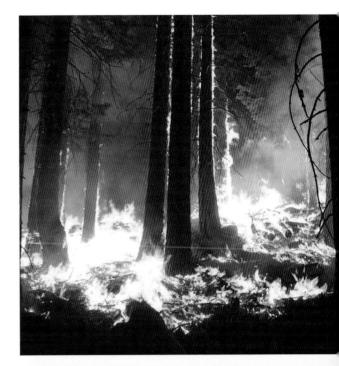

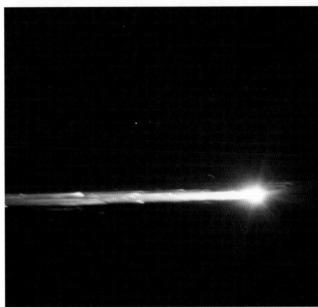

Image credits *(top)*: Mike McMillan – U.S. Forest Service/U.S. Department of Agriculture

Image credit (bottom): NASA

Image credits (facing page): NASA/JPL- Caltech/SwRI/JunoCam

The Layers of the Sun

We can not see the inside of the Sun. However, the Sun is a G-type main-sequence star classified on its spectral class. Therefore, what we know about distant G-type main-sequence stars is relevant to the Sun, and what we learn about the Sun can help us understand more about these faraway stars. With data, calculations, and theory, we can speculate and conjecture about the Sun's interior.

The Core

The core's size is 25 percent of the Sun's radius. The core generates the Sun's energy by consuming hydrogen to form helium. The center of the core is 27,000,000 degrees F (15,000,000 degrees C). It is also very dense, ten times denser than gold. At the edge of the core, the temperature has dropped to half, and it is seven times less dense. The nuclear burning process is almost entirely shut off. It is completely made of plasma.

Radiative Zone

The energy created in the core is carried through the radiative zone with photons (light). Photons travel at the speed of light, but since this part of the sun is still very dense, it may take a million years for a photon to reach the interface between the radiative zone and the convective zone (also called convection zone). This interface between the two zones is called the tachocline. From the bottom to the top of the radiative zone, the temperature falls from 12,600,000 degrees F to about 3,6000,000 F (7,000,000 degrees C to about 2,000,000 degrees C). The density is reduced from the density of gold to the density of water.

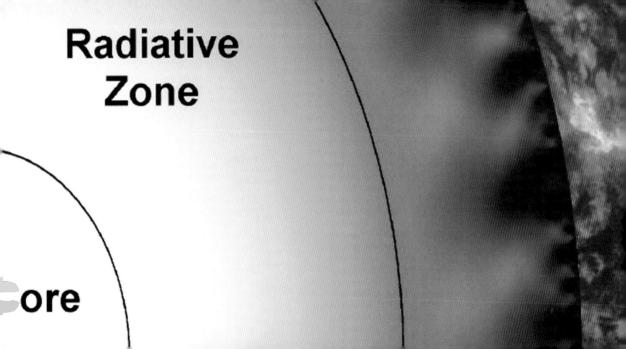

Convective Zone

The convective zone is named for the process of convection, which is movement caused within a fluid or gas by the tendency of hotter and less dense material to rise, and colder, denser material to sink as a result of the forces of gravity. As the material rises, it cools, and at one point will sink

until there is a transfer of heat where it will again rise.

The convective zone (sometimes referred to as the convection zone or convective region) is below the visible surface of the Sun. The currents in the convective zone carry hotter material outward, cooling as it rises. These convective motions are seen on the surface as granules and super-

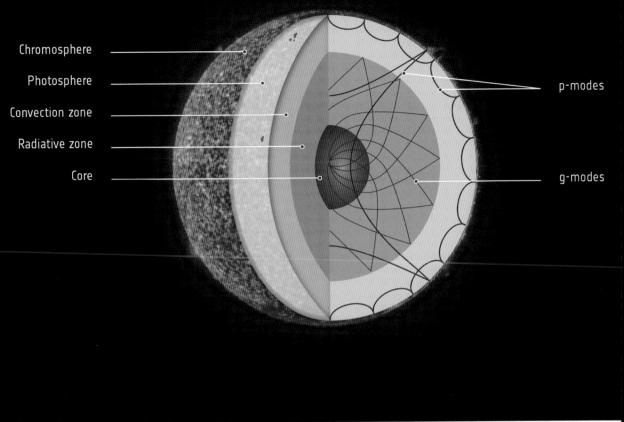

granules (above). Data collected with NASA's Solar Dynamic Observatory (SDO) show huge areas with convective motion (facing page, bottom) As hot material rises and then cools, it will drop down below the surface again. These areas reflect pressure differences as well.

Tachocline

The tachocline is also referred to as the interface layer. It is believed that the Sun's magnetic field is generated in this layer that lies between the radiative zone and the convective zone. Image credit (top): NASA
Image credits (bottom): NASA/MSFC/David Hathaway
Image credit (facing page): NASA

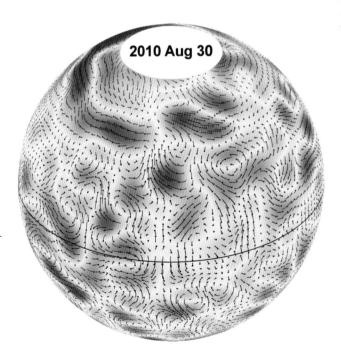

Photosphere

The photosphere is the deepest level of the Sun that is visually observ-

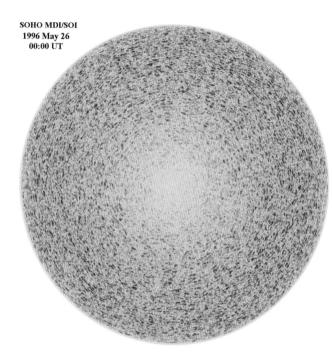

able. It is often referred to as the Sun's surface, but is also considered a layer of its atmosphere. It is about 250 miles deep. The temperature is about 6400 K (11,00 F, 6200 C) at

the bottom and 4000 K (6700F, 337 C) at the top.

In the many images of the Sun, the photosphere can be identified by granulation. In the image below, grains of orange and yellow appear on the Sun's surface. Granules can be seen with earthbound telescopes (top). Another image (bottom) shows this granularity in extreme ultraviolet light using two different wavelengths to record the surface.

The granules vary in size, and are up to several

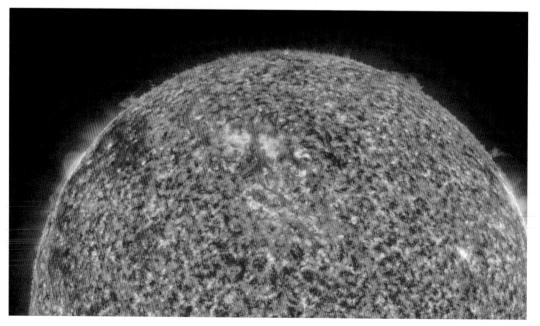

thousand miles/km. Individual granules are short-lived, usually less than an hour. At any time, the Sun is covered with millions of granules. The dark areas that surround each granule are cooler than the lighter centers.

Beneath the granular surface, reaching down into the convective zone, is a layer of supergranules that have a longer life of up to 24 hours.

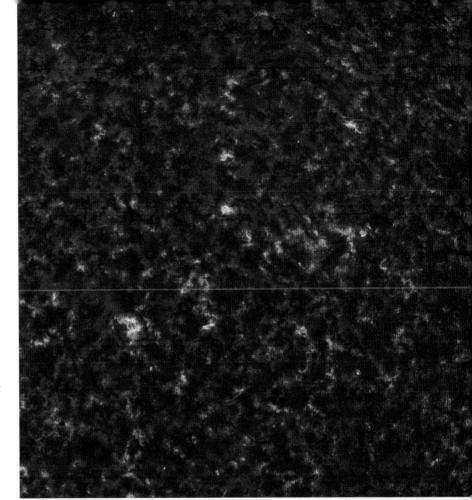

Image credits (facing page, top): NASA/MSFC/David
Hathaway
Image credit (facing page, bottom): NASA
Image credits (top):
G. Scharmer, Swedish Vacuum
Solar Telescope
Image credit (bottom): NASA

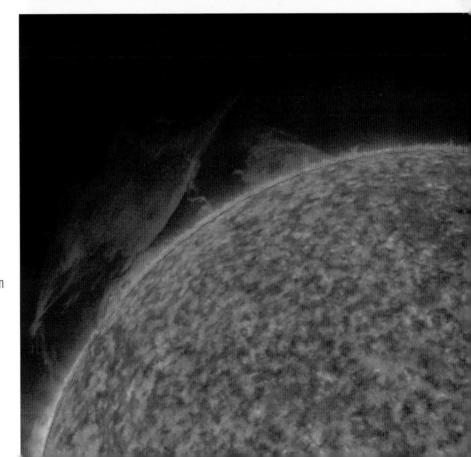

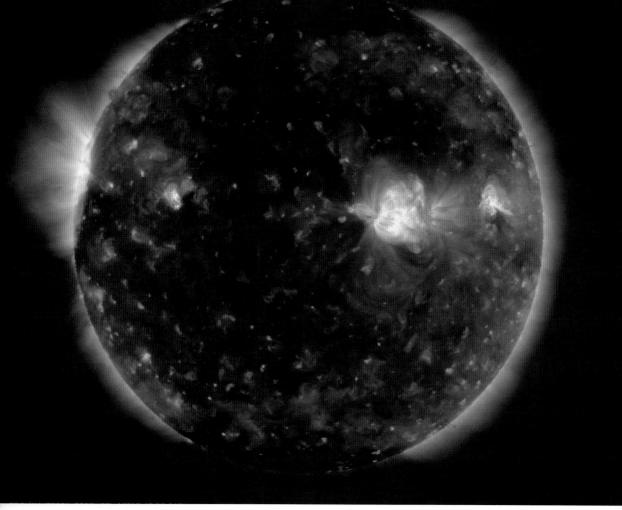

Image credits: NASA/SDO

Similar to a planet, the sun is enveloped in gases that are its atmosphere. There are two main layers in the Sun's atmosphere: the chromosphere and the corona. There is a demarcation between the atmospheric layers called the transition region. The Sun's atmosphere is extremely variable, as can be seen in differences between these two images (above and facing page) acquired only three days apart.

Chromosphere

The chromosphere starts at about 250 miles (400 km) and extends to about 1300 miles (2100 km). Temperatures normally decrease farther from the core. However, the chromosphere is an exception. Here temperatures begin at about 4000 K at the bottom and increase to about 8000 K (14,000 F/7700 C) at the top.

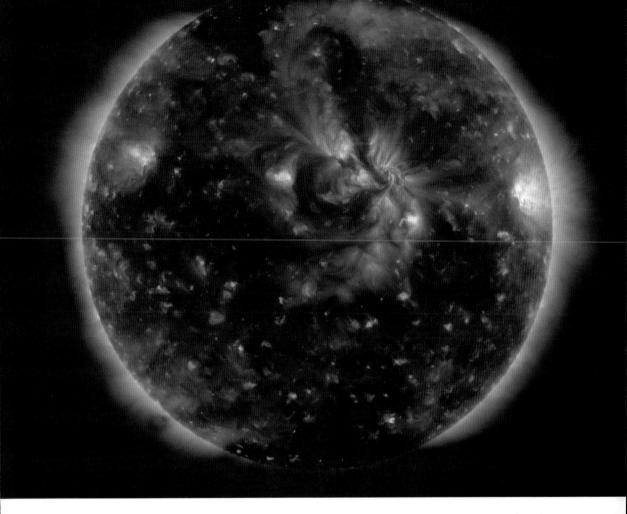

Transition Region

In the narrow (60 miles/100 km) transition region, the temperatures rise from about 8000 K near its bottom to about 500,000 K (900,000 F/500,000 C) at its top.

Corona

The corona is about 1300 (2100 km) above the sun's surface. It's tempera-

ture is 899540 degrees F (500,000 K and 499726.85 C) and possibly up to a few million degrees K. The corona's temperature and depth varies greatly depending on the location and the Sun's activity. Note the variation of depth in the corona on the outer part of each image of the Sun.

We can not look directly into the corona because it would damage our eyes. The corona can be seen during a total eclipse, by using special filters, or by using a coronagraph.

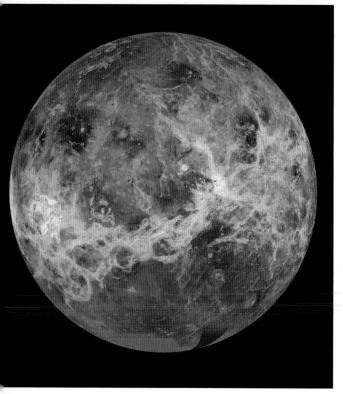

The Sun's Planets

Our solar system has eight planets, five dwarf planets, and numerous natural satellites or moons. The Sun's four closest planets are Mercury, Venus, Earth, and Mars. They are terrestrial (or rocky) planets. They have a metallic core, which is mostly iron, and a mantle of silicate that surrounds it, giving them a mostly solid surface. These four terrestrial planets are presented in order of their proximity to the Sun. These images have been taken with a variety of instruments. Furthermore, they do not reflect the proportionate sizes of the planets.

Mercury (top left), the closest planet to the Sun, has a weak magnetosphere and an extremely thin atmosphere. It is strong enough to trap solar wind, channelling it down to the surface. Surface temperatures are between 840 degrees F (450 C) in the daytime, and minus 275 degrees F (minus 170 C) at night.

Venus is the second closest planet to the Sun and the hottest in the solar system at 863 degrees F (462 C). Venus does not have a magnetosphere, although is does have an atmosphere of sulfuric acid and in its images it usually appears fully cov-

Image credit (left and facing page): NASA

ered in clouds. This image (facing page, bottom left) has been treated to view the surface of Venus through its obscuring clouds. It is speculated that any free hydrogen is carried off the planet into space by solar wind.

Earth is the third planet from the Sun (top right). It has a magnetosphere that prevents ions and electrons that are in the solar wind from entering the atmosphere. A planetary magnetic field is generated by the motion of the planet's metallic core. Convection in the mantle creates a magnetic field much like the convection of plasma inside the Sun creates the solar magnetosphere. It is also referred to as a internal dynamo effect. As a result of the magnetosphere's ability to diminish the effects of solar and cosmic radiation, living organisms are protected from the harmful effects of the Sun while using its energy to grow and thrive.

Mars (bottom right) is the fourth planet from the Sun. It usually appears reddish, possibly due to iron oxide particles in its atmosphere. It had a magnetosphere 4 billion years ago. Today, Mars has only a thin atmosphere which, makes the planet susceptible to the effects of solar wind.

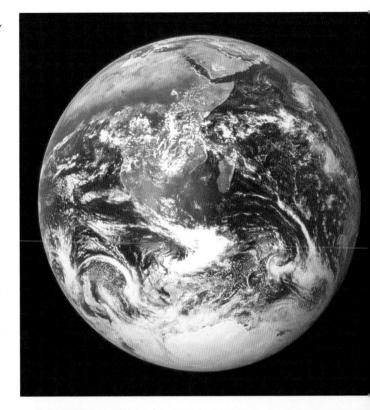

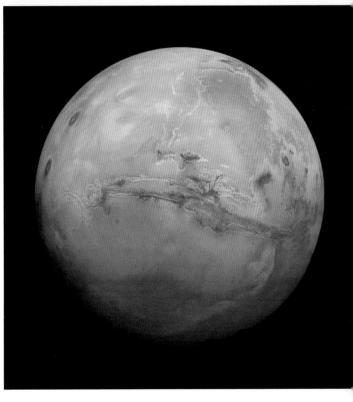

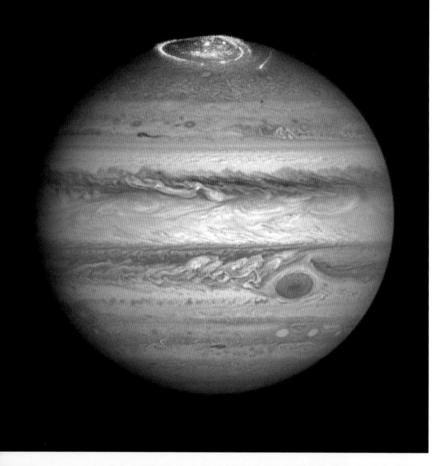

Jupiter (top left) is about 483 million miles (778.57 million km). That is about 5.2 (5.2044 AU) times the distance that the Earth is from the Sun. An AU of one is based on the distance the Earth is from the Sun. Jupiter receives less heat from the Sun than the planet itself radiates, through a process of contraction.

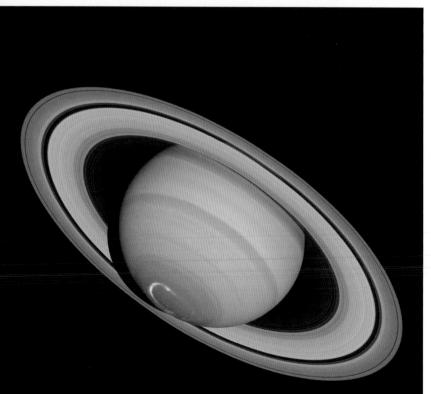

Saturn (bottom left) is about 869,919,669 miles (1.4 billion kilometers) or 9 times (9 AU) the distance that Earth is from the Sun. It takes about 29 ½ years for Saturn to circle the Sun.

Image credit (left and facing page): NASA

Uranus is the seventh planet from the Sun. It is about 19 times the distance from the Sun (19.2184 AU) than Earth is. In other terms, 1,786,461,886 miles or 2,875,031,717 kilometers from the Sun.

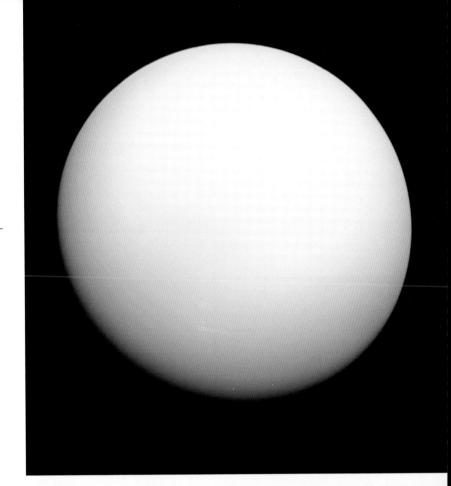

Neptune is the eighth planet from the Sun. It orbits the Sun once every 164.8 years at an average distance of about 30 times the Earth's distance from the Sun (30.1 AU, or 278.7 million miles, or 4.5 billion km).

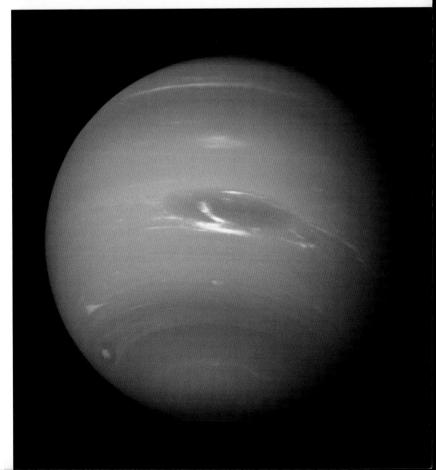

The Heliosphere's Tail

The Sun has a tail similarly to a comet. The tail projects out beyond the heliosphere (below) in the direction of the pressure of the interstellar matter's pressure on the Sun. The plasma that reaches this far is more influ-

enced by the pressures in the interstellar cloud than the Sun, although it appears to be swept away from the Sun as a tail is formed.

The perspective of this illustration (facing page, top) is looking at the Sun straight on. It shows what the tail would look like. The red is a hotter region with plasma originating from the poles.

Instruments and Missions

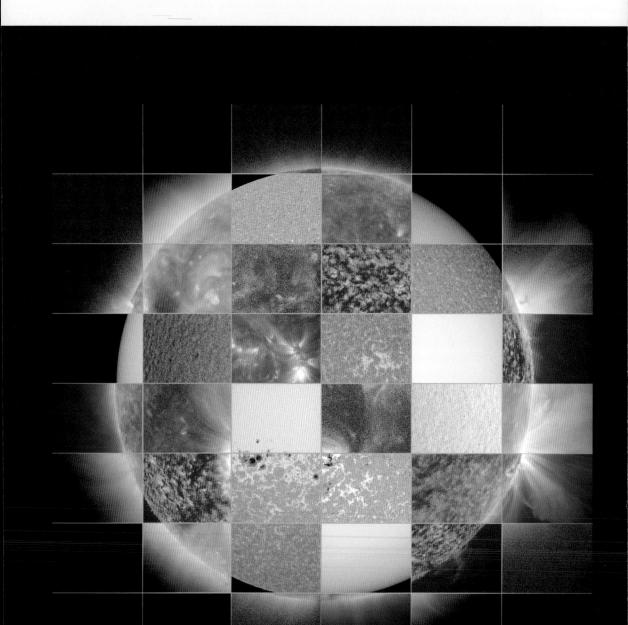

NASA Missions

NASA has had many missions that increased our understanding of the Earth's relationship with the Sun. The instruments of these crafts collect data that scientists use to understand how the Sun works on, near, and around our planet, throughout the solar system.

The first U.S. mission to carry scientific instruments to space was the Explorer 1 satellite (top right), launched on January 1958. This was before computers, so human mathematicians and scientists (middle right) performed the complex computations necessary for missions. This spacecraft was the first to detect and collect data on the Van Allen radiation belt. The belt contains charged particles from solar wind that are trapped by the Earth's magnetic field.

In October of that same year the National Aeronautics and Space Administration (NASA) became operational. Since this beginning, NASA's many missions have

Image credits (facing page and below): NASA/SDO

accumulated an immense amount of data that adds to our current understanding of the Sun. As our instruments for data collection have become more refined and complex, images of the sun have improved. The graphic below compares images from SOHO, STEREO, and SDO, showing the ever-increasing image resolution and data quality.

Image credits (above): NASA

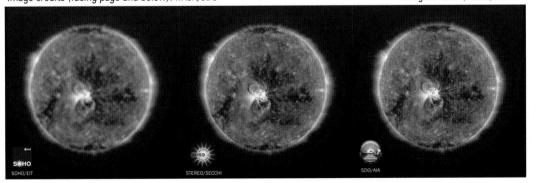

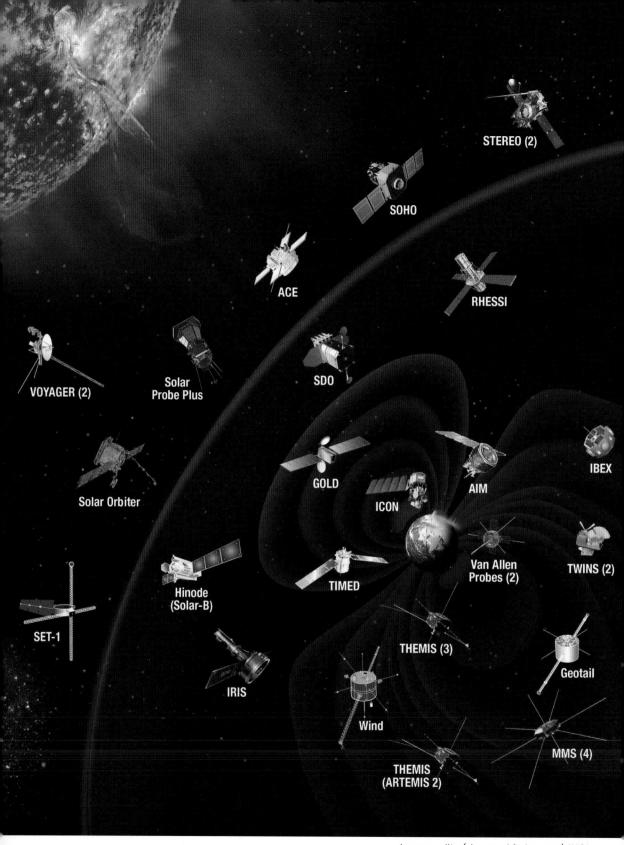

Image credits (above and facing page): NASA

These are NASA's missions that have added to our understanding of the Sun. Here are brief descriptions of some.

Ulysses (top) was a joint venture of NASA and the European Space Agency (ESA) between 1990 and 2009 to study the Sun at all latitudes. Some of the findings are that the Sun's magnetic field interaction with the solar system is more complex than once thought, the Sun's poles are much weaker, the solar winds have grown weaker, and the dust from deep space is 30 times more plentiful than previously thought.

High-energy X-rays are recorded with NASA's **Nuclear Spectroscopic Telescope Array**—referred to as the **NuSTAR** (*upper middle*), which is most often focused on distant stars. Images of the Sun are combined with images taken by NASA's Solar Dynamics Observatory (SDO). The data from NuSTAR come from high-energy x-rays from gas that is above 3 million degrees. The data from SDO indicates lower-temperature material at 1 million degrees. Composite images help us to see where different materials and temperatures are located and help us to understand the solar processes better.

Hinode (lower middle) was a joint mission by the Japan Aerospace Exploration Agency (JAXA), NASA, the United Kingdom and Europe. Its mission was to measure small changes in the Sun's magnetic field.

RHESSI (bottom) Hinode Space-craft was the first satellite to image solar flare gamma rays. One of its purposes was to understand the magnetized plasmas of the Sun.

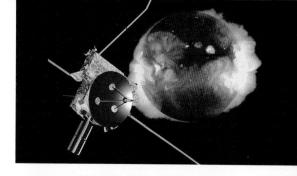

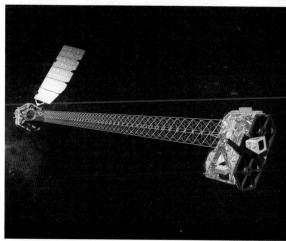

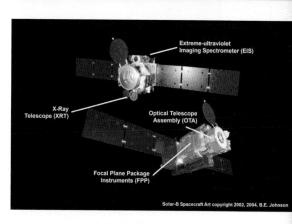

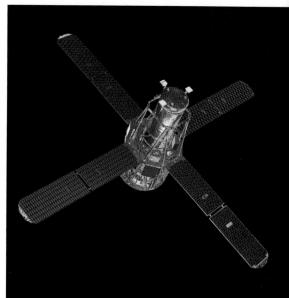

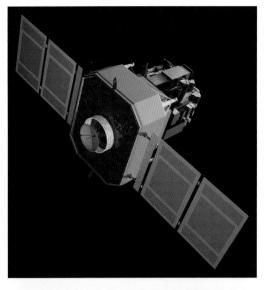

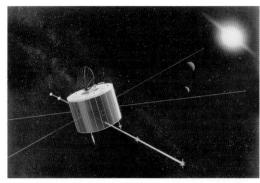

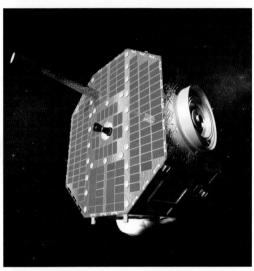

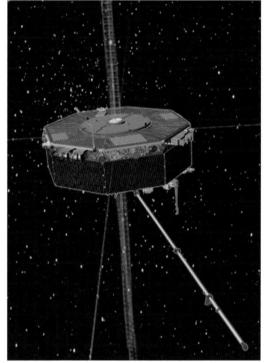

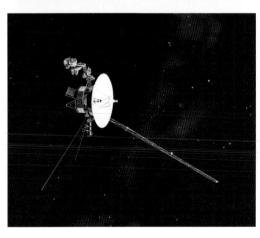

Image credits: NASA

Solar and Heliospheric Observatory (SOHO) (facing page, top left) was launched in 1995, a joint project between the European Space Agency (ESA) and NASA. Its operation continues today (2018). The SOHO goals are: record the chromosphere, transition region, and the corona; observe the solar wind; and probe the interior of the Sun.

The Interstellar Boundary Explorer (IBEX) (facing page, middle left) was launched in 2003 and at present (2018) is still sending data. Some of its initial findings are: detection of neutral atoms from outside the Solar System; the heliosphere has no bow shock where the Sun's stellar winds meet the interstellar medium; a 4-lobed tail on the Solar System's heliosphere; and stellar-wind bubbles, called astrospheres, on other stars.

Voyager 1 and 2 (facing page, bottom left) were launched in 1977 to study the outer planets and farther reaches of the Solar system. Now that they have traveled farther than the known planets and dwarf planets, the satellites are adding to our understanding of the outer boundary of the heliosphere and interstellar space.

Geotail (facing page, top right) is a satellite, developed by Japan's ISAS and NASA. Geotail observes the Earth's magnetosphere. It has shown flux transfer events to be more dynamic previously thought—moving faster than the ambient medium through the Magnetosphere.

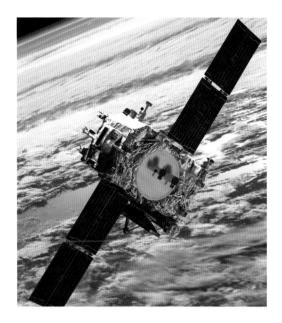

NASA's Magnetospheric Multiscale (MMS) (facing page, middle right) mission uses four spacecraft with an identical set of instruments. The spacecrafts fly in a pyramid formation that allow 3-dimensional observation of magnetic reconnection that occurs around the Sun and the Earth.

Transition Region and Coronal Explorer (TRACE) (facing page, bottom right) launched in 1998 and worked until 2010. Its purpose was to investigate the fine-scale magnetic fields and their relationship to the associated plasma structures on the Sun.

Solar Terrestrial Relations Observatory (STEREO) (top) are spacecrafts launched in 2006. Their orbits are one slightly ahead of the other creating a stereoscopic image of solar phenomena, such as flares and coronal mass ejections.

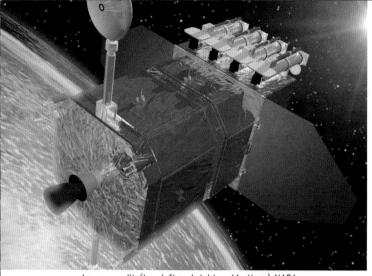

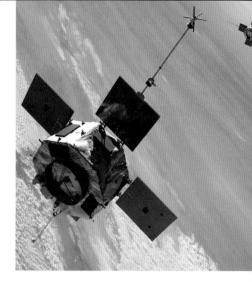

Image credit (top, left and right and bottom): NASA

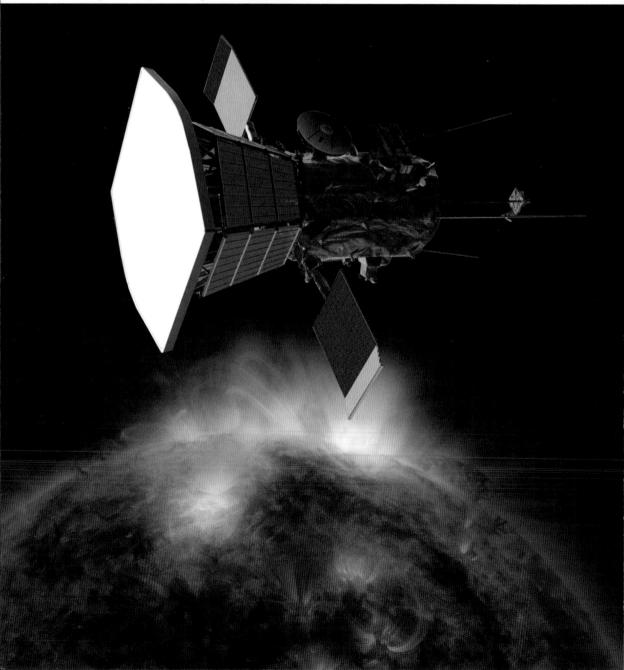

Living With A Star

Living With a Star (LWS) is a NASA scientific program. It studies aspects of the connected Sun and Earth systems that directly affect life and society. Below are some of its associated missions.

The Solar Dynamics Observatory (SDO) (facing page, top left) has been in operation and part of the LWS program since 2010. A goal of the SDO is to understand the effect of the Sun on the Earth, including near-Earth space. SDO studies the solar atmosphere using many wavelengths simultaneously. SDO has been investigating how the Sun's magnetic field is generated and structured, how this stored magnetic energy is converted and released into the heliosphere and geospace in the form of solar wind, energetic particles, and variations in the solar irradiance.

The Van Allen Probes (facing page, top right) were launched in 2012 and are used to study the Earth's Van Allen radiation belt. As part of the Living With A Star program, its aim to understanding how the radiation belt environment works is important for spacecraft design and operation, mission planning, and human safety.

The Balloon Array for Radiation-belt Relativistic Electron Losses (BARREL) (not pictured) was carried out in 2012 and 2013 to

find out why the Van Allen belts have variability—the increasing and decreasing of energetic charged particles caught in the Earth's magnetic field. These particles originate mostly from the solar wind.

The Parker Solar Probe (facing page, bottom) began its mission in 2018. Its principal goals are to discover more about the Sun's energy flow, the heating in the Sun's corona, and to investigate the processes that accelerate the solar wind. It is hoped to help us better understand the structures and dynamics of the plasma and the magnetic fields, as well as their relationship with the solar wind and its composite particles.

The Parker Solar Probe will fly closer to the Sun than any previous craft, a distance of nine times the radius of the sun or about 3.83 million miles (6.16 million kilometers). Its shields will reach temperatures close to 2552 degrees Fahrenheit (1,400 degrees Celsius). The probe used the planet Venus for a gravity assist to get ever closer to the Sun. Its first Venus flyby was in late September 2018. The planned duration of the complete missions is 6 years and 11 months.

The **Solar Orbiter (SolO)** is a Sun-observing satellite, developed by the European Space Agency (ESA) with a planned launch date of 2020. Some of its observations will be coordinated with the Parker Solar Probe.

HMI Dopplergram Surface movement Photosphere

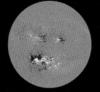

HMI Magnetogram Magnetic field polarity Photosphere

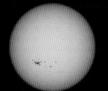

HMI Continuum Matches visible light Photosphere

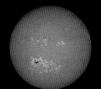

AIA 1700 Å 4500 Kelvin Photosphere

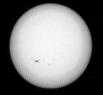

AIA 4500 Å 6000 Kelvin Photosphere

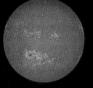

AIA 1600 Å 10,000 Kelvin Upper photosphere/ Transition region

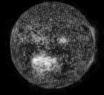

AIA 304 Å
50,000 Kelvin
Transition region/
Chromosphere

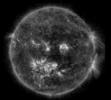

AIA 171 Å
600.000 Kelvin
Upper transition
Region/quiet corona

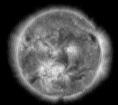

AIA 193 Å
1 million Kelvin
Corona/flare plasmo

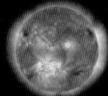

AIA 211 Å 2 million Kelvin Active regions

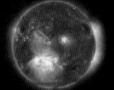

AIA 335 Å 2.5 million Kelvin Active regions

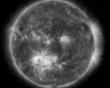

AIA 094 Å 6 million Kelvin Flaring regions

AIA 131 Å 10 million Kelvin Flaring regions

Image credits: NASA/SDO

Top Row

HMI Dopplergram, Surface movement, photosphere

HMI Magnetogram, Magnetic field polarity, Photosphere

HMI Continuum, Matches visible light, Photosphere

AIA 1700 A, 4500 Kelvin, Photosphere

Middle Row

AIA 4500 A, 6000 Kelvin, Photosphere
AIA 1600 A, 10,000 Kelvin,
Transition region
AIA 304 A, 50,000 Kelvin, Chromosphere

AIA 171 A, 600,000 Kelvin, Upper Transition region, quiet corona AIA 193 A, 1 million Kelvin, Corona/ flare plasma

Bottom Row

AIA 211 A, 2 million Kelvin, Active regions AIA335 A, 2.5 million Kelvin, Active regions AIA 093 A, 6 million Kelvin, Flaring regions AIA 131 A, 10 million Kelvin, Flaring regions

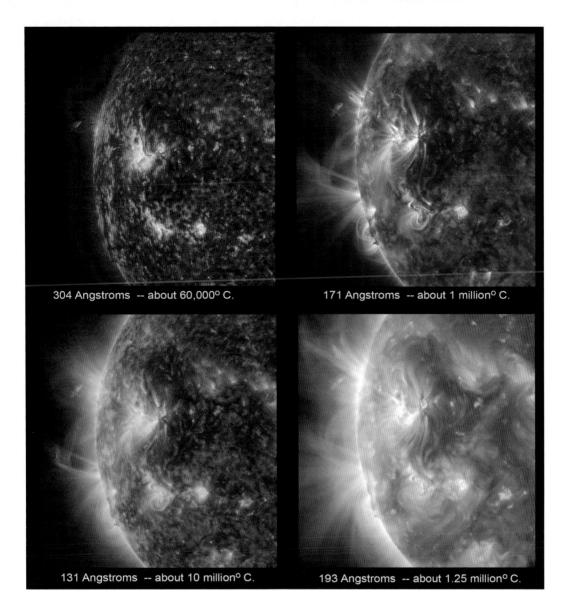

Distinct Instruments

Each of the above images was taken at approximately the same time on July 24, 2014 with instruments on the Solar Dynamics Observatory satellite. Starting with the upper left, the instruments recorded the activity closest to the Sun's surface, and it's

the coolest level imaged, at 60,000 degrees C. Proceeding clockwise, the upper right image shows an increase to 1 million degrees C, the lower right shows 1.25 million degrees C, and the lower left image at 10 million degrees C images the Sun at its highest atmospheric altitudes. Notice how the features change with difference in temperature and distance from the surface.

40 THE SUN

Image credits: NASA/SDO

One Star, One Day, Many Faces

All these images were taken of the Sun on the same day. What solar phenomena can't be seen in one spectrum of light can be seen in another. Using different lenses, filters, and instruments, we are able to track the sun's activity—including temperature variations, altitude, polarity, and more.

Sunspots and Solar Cycles

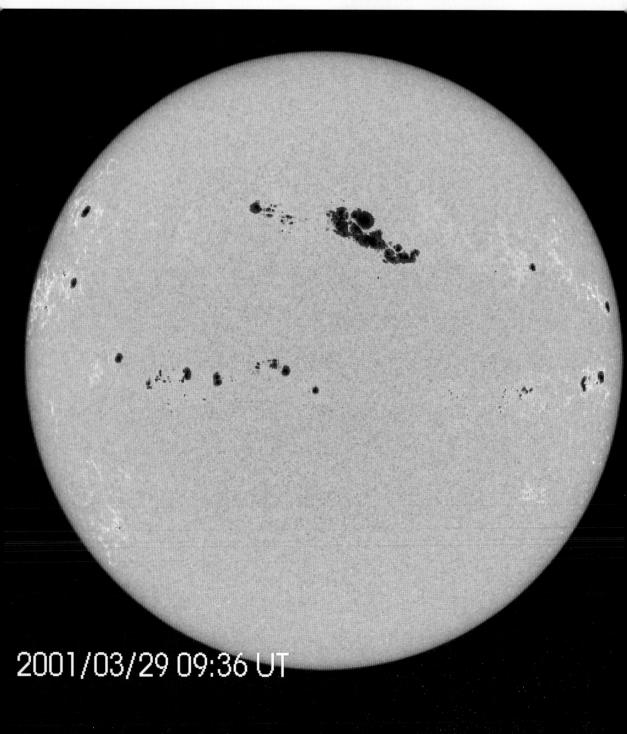

First Recordings

Sunspots are dark spots that appear on the Sun's surface. They are a temporary feature that last from a few days to a few months.

Sunspots can be seen without a telescope. The first observations were over 2000 years ago in China, centuries before the telescope was invented in 1608 at around 364 BC. They are referred to in the *I Ching* (also called *The Book of Changes*). There were also reports of Islamic and European astronomers noting sunspots in the ninth century AD.

The Sun should not be looked at directly with the naked eye, telescope, or binoculars. Precautions need to be taken not to injure the eyes. Telescopes and binoculars can be fitted properly with filters for solar observation. They can also be used to project the Sun onto a surface for indirect viewing.

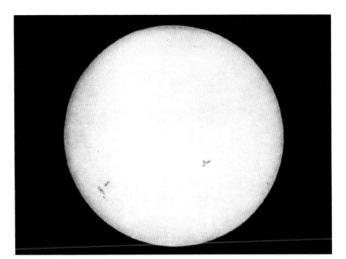

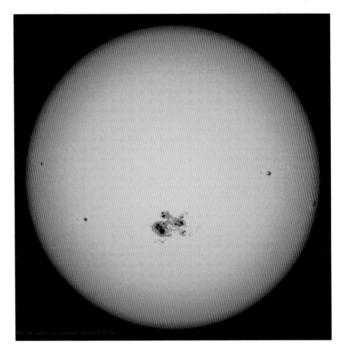

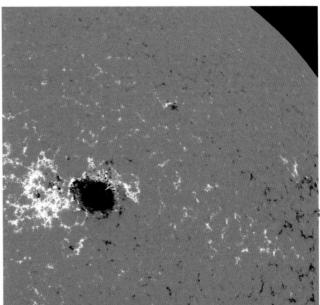

Image credits (top, middle, bottom, and facing page): NASA/SD0

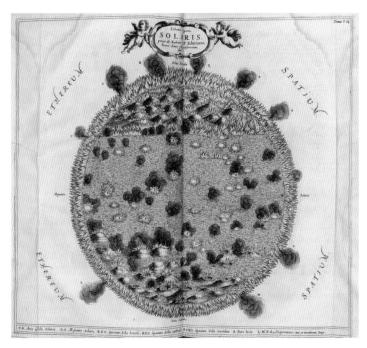

Illustration of the Sun from Athanasius Kircher's Mundus Subterraneus, 1664

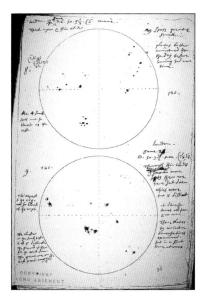

Verum lacer bee certific mount dierre einemalighe für intereser eine machan capper dat condemposite Affecte interessionif pietre gesten. Diant ein eil oculul unde rapea feine omia sie bene feur rumifit drud mehrituide interesse ein eil oculul unde rapea feine omia desponate. Dealt mediciam certific ist drightum masse maritur anno regni. 117 Lockegarii ei angleaum benurea. Ar vitanno, ii fudditume. Ar vitanno quafi due obitam vina infuge.

Anno, ii fudditume. Ar vitanno, ii fudditume vita infuge. Anno ii fudditume. Ar vitanno migre pie infin folis ii ei patre. I ei fudditume. Ar vitanno quafi due fudditume. Ar vitanno quafi due fudditume. Ar vitanno fudicioni ii fudditume. Ar vitanno quafi due fudditume. Ar vitanno fudicioni ii fudicioni iii fudicioni i

Early Observations with Telescopes

These images are some of the earliest drawings of the sunspot feature of the Sun. This detailed image (top left)

is by Athanasius Kircher in 1664. However, this eatlier drawing by an English monk and chronicler (bottom left) is from The Chronicle of John of Worcester, 1118–1140, and is thought to be the earliest of the drawings. John of Worcester's method of observation is described as an unaided eye method.

Thomas Harriot 1560–1621) was the first to draw an astronomical object—the

Moon—after viewing it through a telescope. His drawings of sunspots (top right), although unpublished, were made in 1610. His work in England was contemporaneous with Christopher Scheiner and Galileo, although he was unaware of their observations.

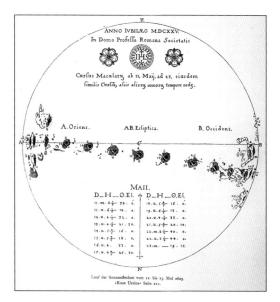

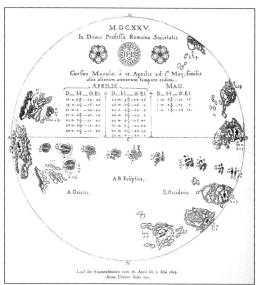

Christopher Scheiner

Christopher Scheiner (1573–1650) established a solar observatory, and was the first astronomer to do so. He was a Jesuit who used the pseudonym "Apelles" for his letters and published work. Much of his work is lost, but some of his drawings were published in *Rosa Ursina sive Sol*, 1630 (*right*). These three drawings are his recordings of sunspots. It was a point of discussion in his letters with Galileo as to whether these were features on the Sun or a planetary transit.

Scheiner also invented the helioscope, which combined the telescope with the camera obscura. This allowed study of the Sun without harming the eyes. Father and son astronomers David and Johannes

Fabricius invented a camera obscura telescopy in 1611 barely predating Scheiner's invention.

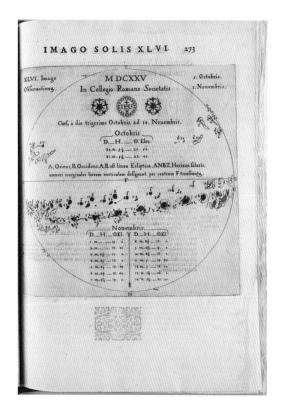

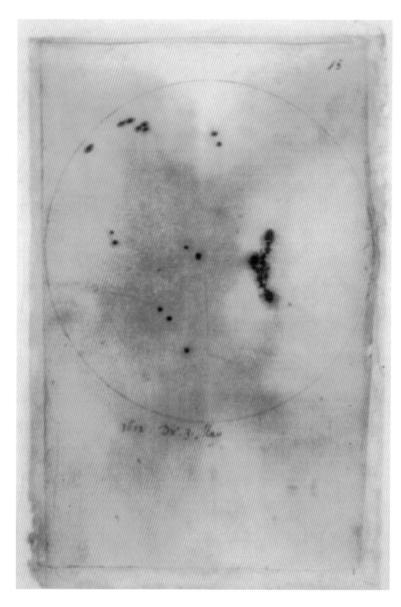

Galileo Galilei Sun Spot Observations

This is a drawing of sunspots by Galileo (above). Galileo wrote a pamphlet in 1612 called *Letters on Sunspots*. Included were his drawings

(facing page, top left). It was a discussion with several other scholars of the day who were interested in the sky and making observations of their own. Because Galileo observed that the sunspots traveled more quickly in the middle of the Sun, he concluded they were in fact features on the sun because this would be consistent with a rotating sphere.

Pierre Gassendi

Pierre Gassendi made drawings of his sunspot

observations (facing page, bottom left) in 1618 and 1638. He agreed with Galileo: sunspots are features on the Sun's surface that appear to move because of its rotation. He used these observation to calculate the speed of the Sun's rotation at 25–26 days.

onde este done più, e done meno oscure apparirebbono: Vedrebbonsene hora molte, hor poche, hor allargars, hora ristringers; e se la Terra in se stefs si si ruolgesse, quelle ancora il suo moto seguirebbono, e per esser di non molta prosondita rispetto all'impiezza, secondo la quale communemente elle si distendono, quelle, che nel mezzo dell'Emissero Veduto apparirebbono molto larghe Venendo Verso l'estremità parrebbono restringers, es in somma accidente alcuno non credo che si scorgesse, che simile non suegga nelle macchie solari; mà perche la terrà è oscura, e l'illumination

Il giorno 26. dell'istesso mese ne tramontar del Sole cominciò ad apparir nella parte suprema della sua cin conferenza na macchia simile alla Bla quale il giorno 28. era come la E. 129. come la F. il 30. come la G. il primo di Maggio come la H. il 3. come la Le fuori le mutationi delle macchie I G. H. L. fatte assail lontane dalla cin conferenza del Sole; sì che l'esse diue; samente vedute il che appresso alla cin conferenza, mediante lo singgiment

della superficie globosa sà gran diuerstà) non potena caggionar tanta m tatione d'aspetto. Da queste ossermations, e da altre satse, e da quelle, ch

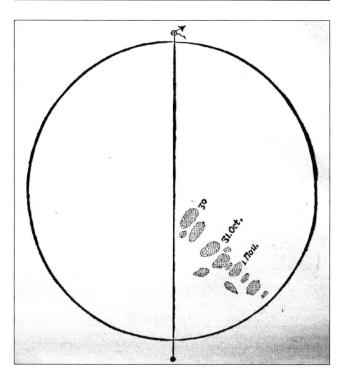

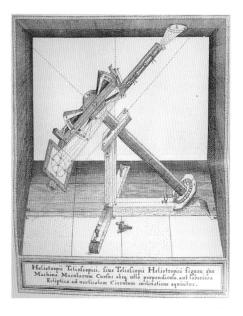

Camera Obscura

Camera obscura (top right), used before telescopes were invented, allowed astronomers to view the Sun as it was projected rather than viewed directly. The premise on which camera obscura is based was probably understood in China BCE. The early users of telescopes were quick to incorporate camera obscura into a scope's designs to avoid the Sun's harmful effects on the eye.

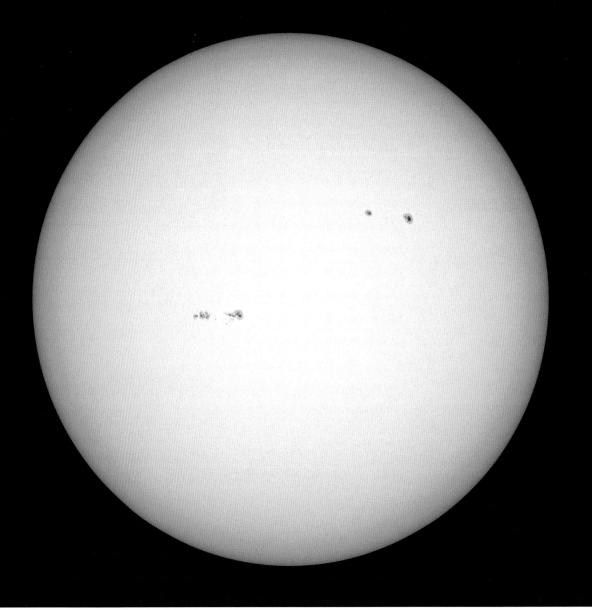

Image credits: NASA/SDO

Pairing

Sunspots appear in pairs, although the pairings are not always visually distinct. Because these features change, pairs can be observed at different stages of their development, but not at every stage. This also depends on their size and which instruments are being used to record or observe them.

The Sun has a tug of war between the complex processes of magnetism and convection within it. The sunspot pairs have opposite charges. They are cooler surface areas, which are caused

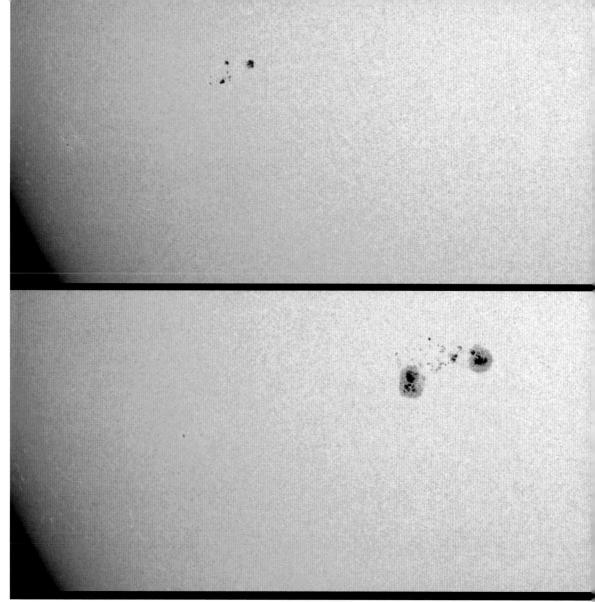

Image credits (top and bottom right): NASA/SOHO

by the magnetic field hindering the convection process on and beneath the Sun's surface. The cooler area of the sunspot is indicative of the downdraft vortex beneath its surface. Other features such as solar flares and coronal mass ejections (CME) start in areas where sunspots are visible.

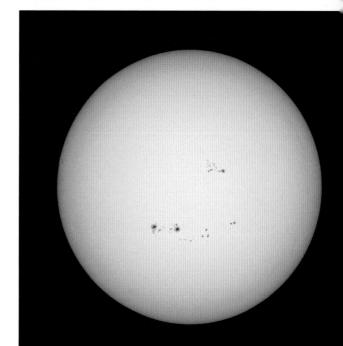

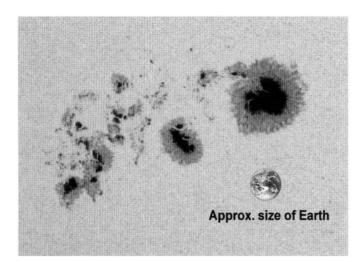

The Size of a Sunspot

Sunspots change as they move across the Sun. The diameter can range from 10 miles (16 km) to as many as 100,000 miles (160,000 km).

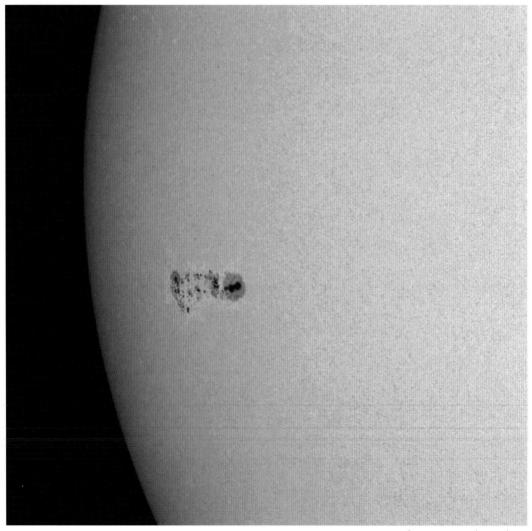

Image credits (top and bottom): NASA/SDO

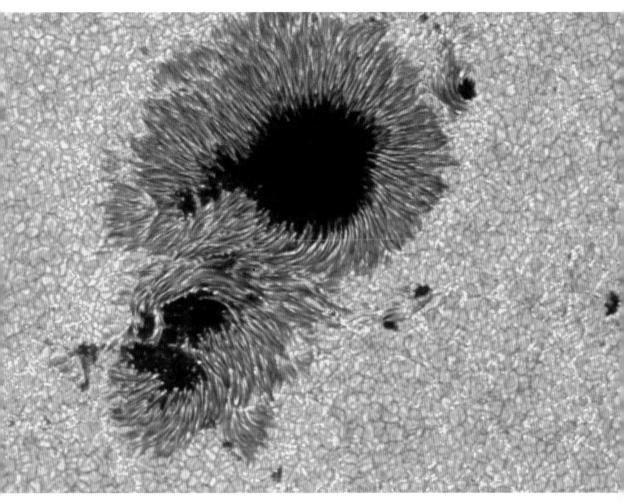

Image credits: Hinode JAXA/NASA

That is much larger than the Earth, which has a diameter of 3,963 miles (6,378 kilometers).

The Umbra and Penumbra

The dark center of the sunspot is called the umbra. The circle around the umbra is penumbra. It appears darker in the center because it is relatively cooler. The material is sinking because of its lower temperature. The direction of the magnetic field lines are more perpendicular to the Sun's surface reaching upward into the atmosphere. The penumbra's magnetic lines of each sunspot are more curved, as they reach for its oppositely charged pair somewhere on the Sun's surface.

Image credits (above and facing page): NASA/SDO

As the Sun Rotates

The world keeps an eye on the Sun and its sunspots as they rotate. They appear to move across the surface. In actuality, the rotating Sun is responsible for this apparent movement.

08/10/2010 23:00 UT

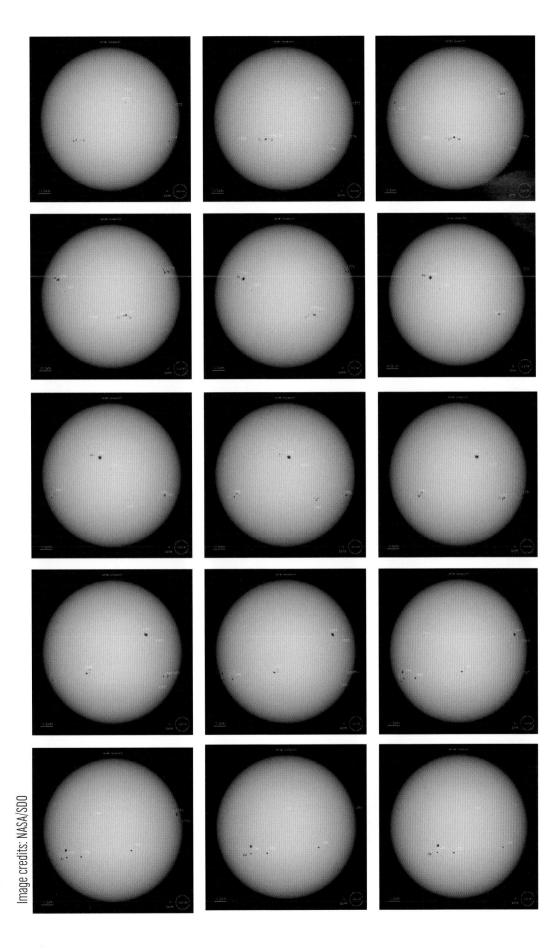

The Solar Cycle

Solar cycles have been recorded since 1755. The solar cycle is approximately eleven years long. The Sun's magnetic poles reverse, making a completed change back again in about 22 years. Although the pattern of the 11-year cycle is distinctive, there is variation between cycles. There are possibly wider arcing cycles and patterns that are yet undetected by our ability to observe and measure.

Image credits: Steele Hill, SOHO, NASA/ESA

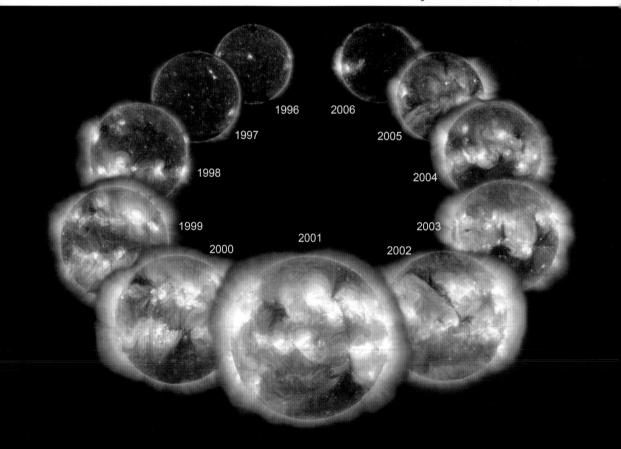

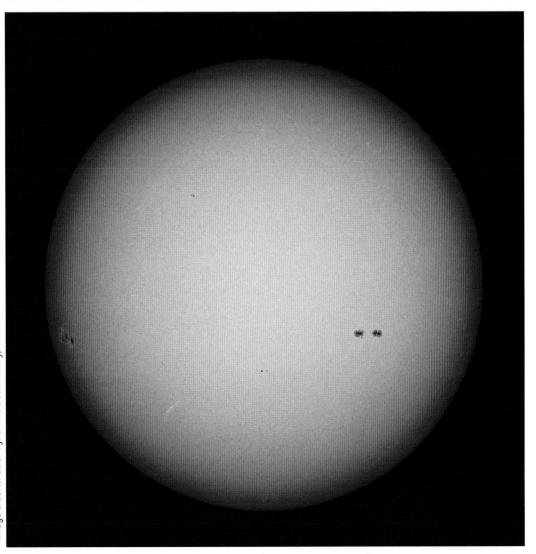

Coronal Holes

Coronal holes are dark irregularly shaped holes on the Sun's surface. A coronal hole is a variable solar feature and can last weeks and

sometimes months. Coronal holes are more plentiful in the years after solar maximum or what can be described as the declining phase of the solar cycle.

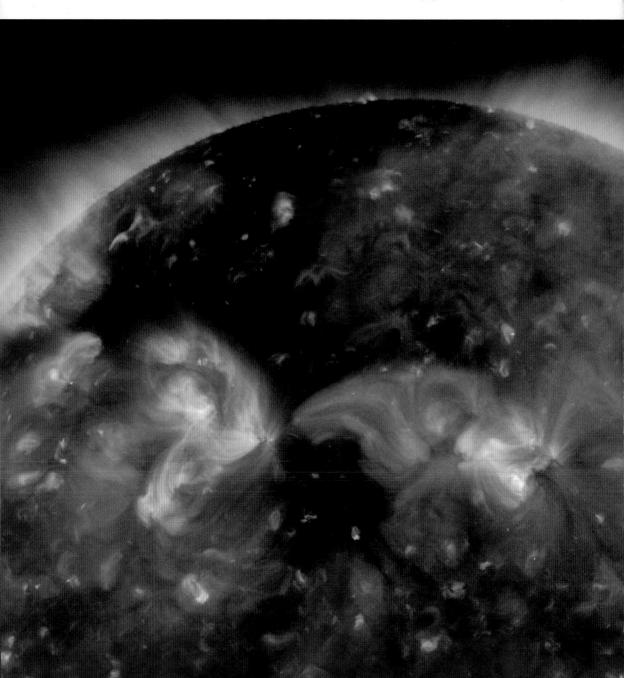

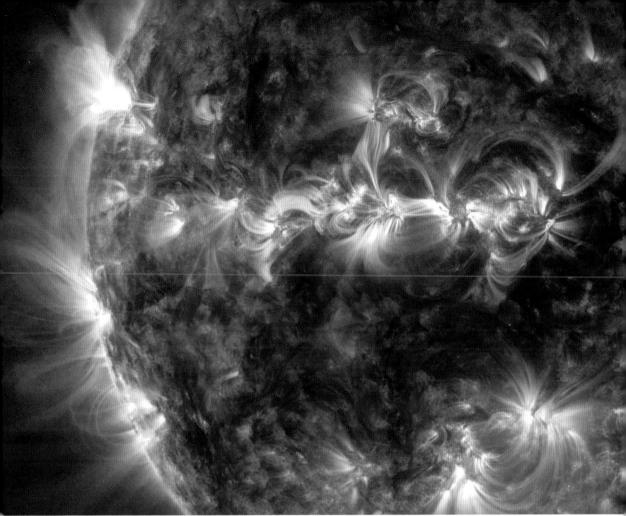

Image credits (facing page and above): NASA/SDO

Apparent Unipolar Magnetic Fields

Apparent unipolar magnetic fields are characteristic of coronal holes. While solar prominences show looping filaments that have a stretch that is characteristic of dipolar magnetic fields, coronal holes do not. Their magnetic lines do not loop back to the surface, but extend outward into the solar system. These extended,

open, magnetic-field lines are responsible for solar winds that shoot from the sun toward the planets and beyond at speeds up to 500 miles (800 kilometers) per second. These extending magnetic lines may be an indication of the far reach of the Sun's magnetic influence and of its impact at the boundaries of the solar system.

Massive Coronal Hole

Captured by NASA's SDO on June 18, 2013, this extremely large coronal hole (dark blue area on the top left) is almost as big as fifty Earths spread out in a line.

Image credits: NASA/SDO

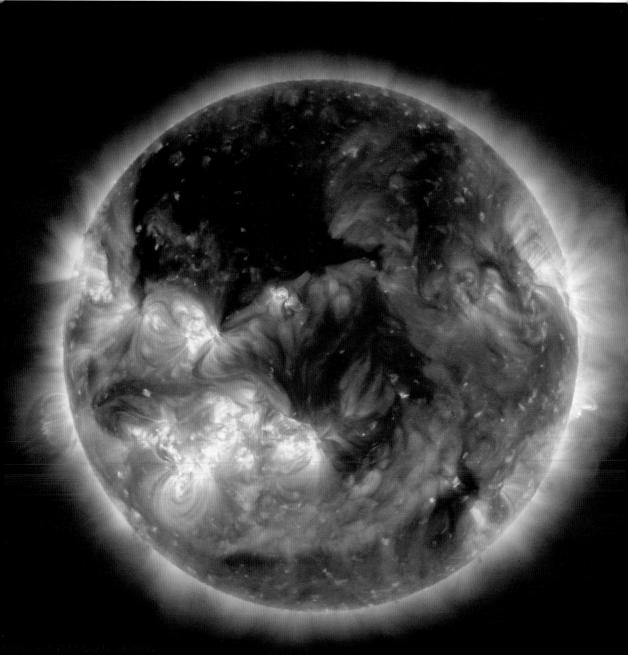

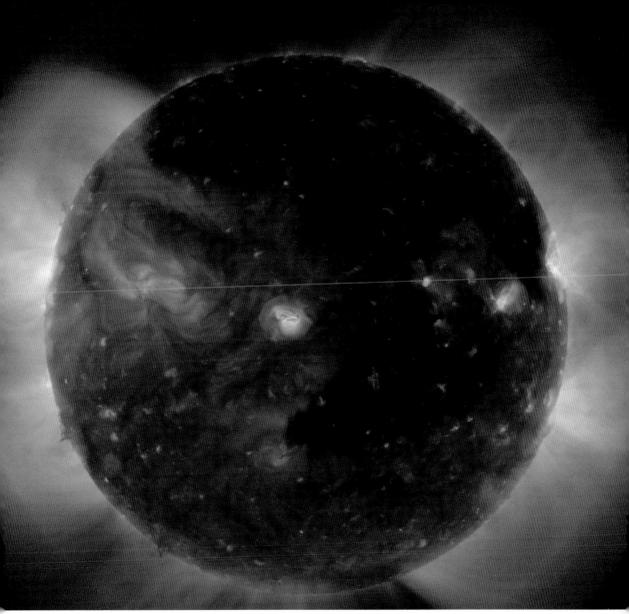

Image credits: NASA/SDO

Faster Solar Wind

Solar wind is the continuous flow of charged particles from the Sun that spreads out in every direction through the solar system. The solar wind that pours out of coronal holes travels about 400 to 500 miles per second.

The Same Moment In Time

Both of these images (above and facing page) of the Sun were taken on

the same day. The image above uses an Atmospheric Imaging Assembly (AIA) wavelength channel of AIA 304 from the SDO satellite to record light emitted from the chromosphere

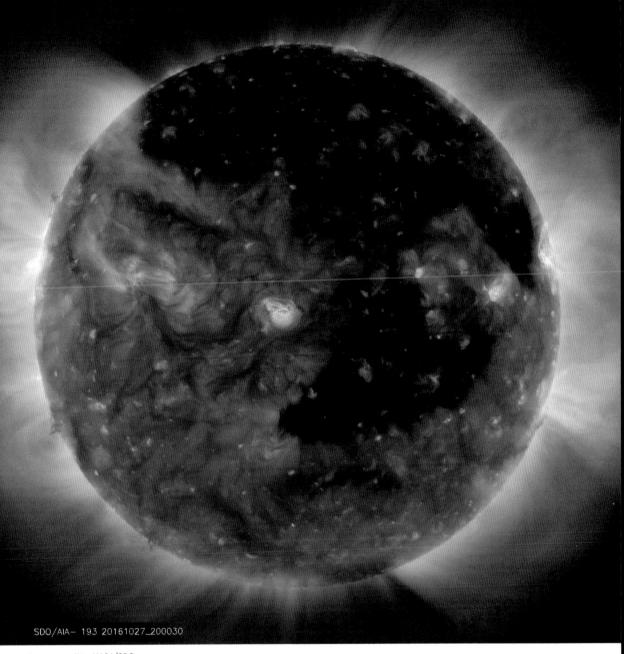

Image credits: NASA/SDO

and transition region. Images of this wavelength are most often colorized in red.

This image uses the AIA 193 channel and is typically colorized in an orange-brown. It registers hotter regions of the corona and hot

flare plasma. The temperature differences between the hotter and cooler material is distinct when recorded with this filter, making coronal holes very evident.

More Coronal Holes

Scientists have found that there are more coronal holes in the years after solar maximum. This follows the time when there are the greatest number of sunspots in the solar cycle.

Image credits: NASA/SDO

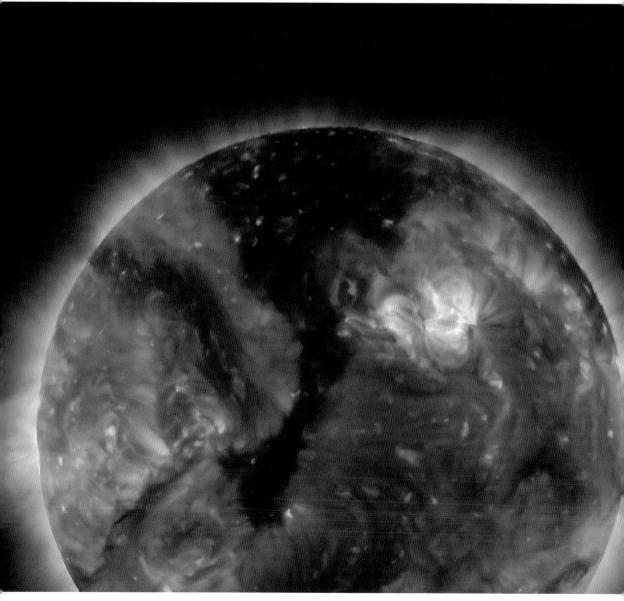

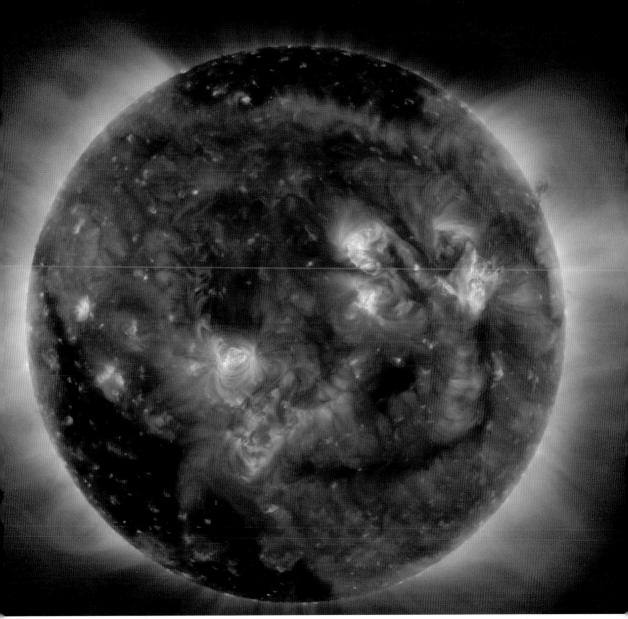

Image credits: NASA/SDO

Lower Density Areas

Areas with coronal holes have a lower density than other parts of the Sun. In the area above the coronal holes, the magnetic field extends upward into space and further out into the solar system.

This image was taken December 2, 2016. It would take several days for the spewed particles to reach Earth. As solar wind reaches our atmosphere, these particles can interact with the Earth's magnetosphere, creating auroras.

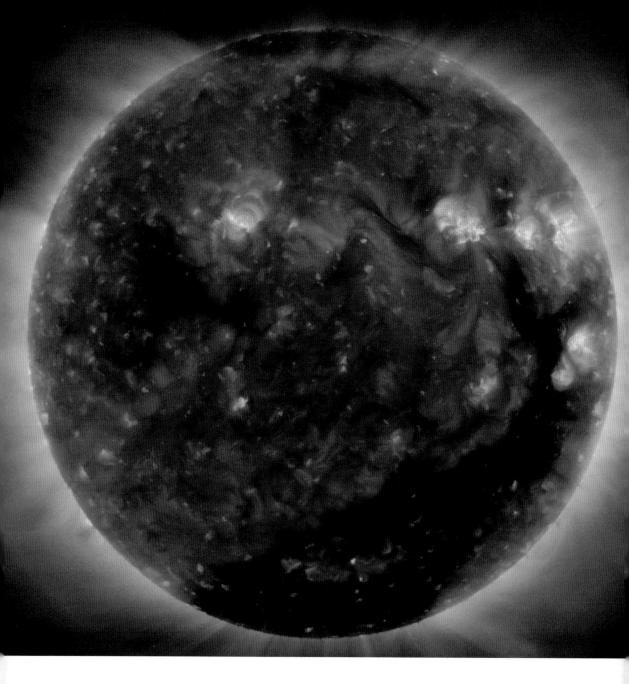

This image (above) was taken February 2017. These cooler, lower density areas appear dark. When viewed in extreme ultraviolet (EUV) or x-ray imaging, large coronal holes can appear to be as big as one quarter of the Sun's face.

These two images (facing page) illustrate that coronal holes form more often at the Sun's poles, although portions of the holes may reach toward the Sun's middle

Image credits: NASA/SDO

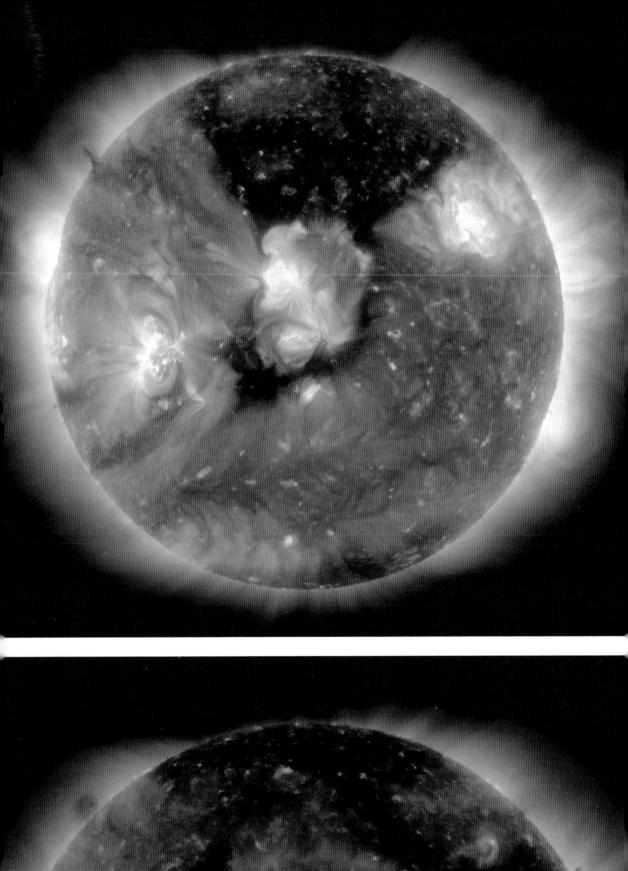

Prominences and Filaments

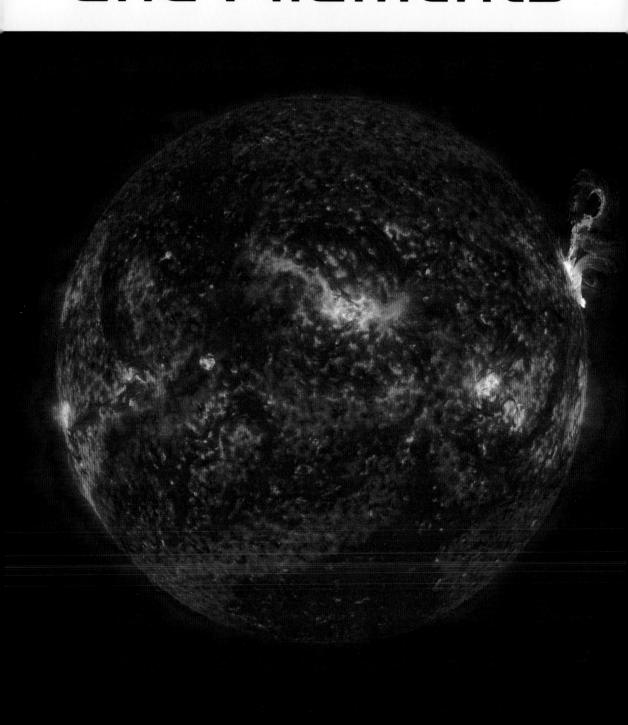

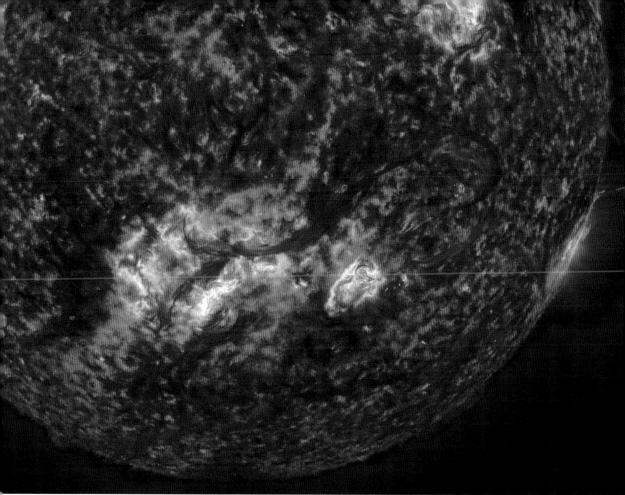

Image credits (facing page and above): NASA/SDO

Solar Prominances

A solar prominence extends outward from the Sun's surface. Anchored in the photosphere, prominences reach far into the corona where the plasma is made of extremely hot ionized gases. They can extend out many times farther than the diameter of the Earth. A particularly large prominence was estimated to be nearly the radius of the sun—500,000 miles (800,000 kilometers) long.

These swirling masses of plasma are similar to the photosphere in tem-

perature. They are hot gases made of electrically charged hydrogen and helium.

In this image (facing page), from this vantage point, we have a view of the prominences positioned on the outer edge of the Sun against the blackness of space. Viewed from a different vantage point, in the middle of the sun's spherical shape (above), they are often called filaments because they appear to be long strands. They are darker than the surrounding areas.

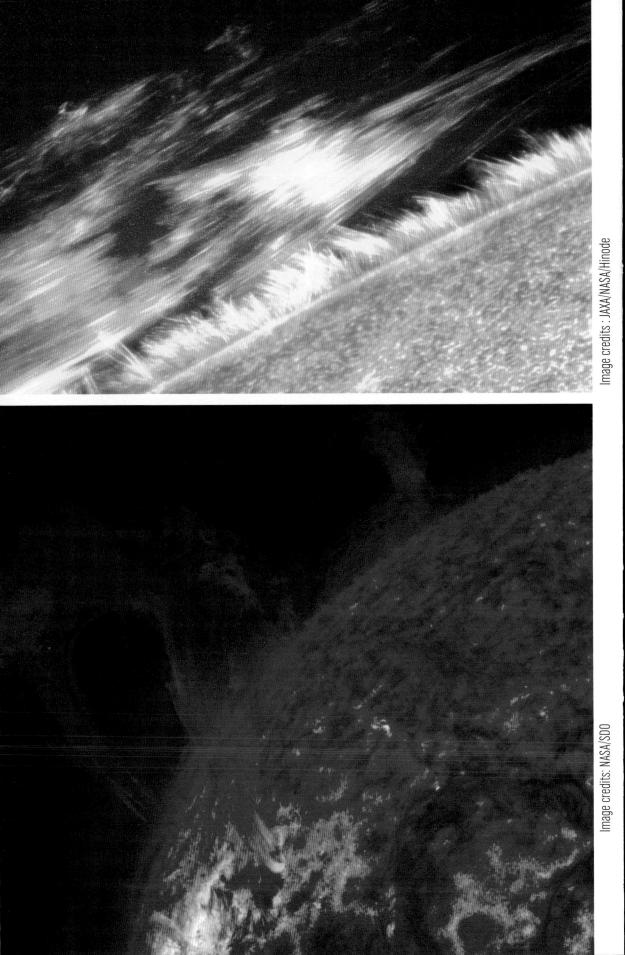

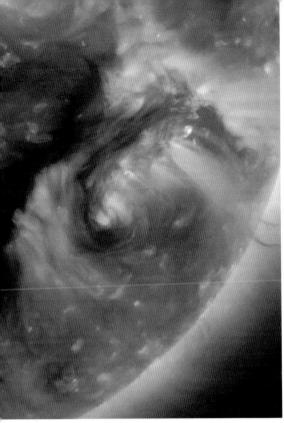

Image credits: NASA/GSFC/SDO

Filament Closeup

This close-up image of a giant filament (facing page, top) was taken in October 2013. The individual threads of particles that are suspended above the Sun by magnetic forces are distinguishable.

Unstable Features

This twisted solar filament (facing page, bottom) erupted and then within hours fell back into the Sun. The speed of the material being projected out from the prominences

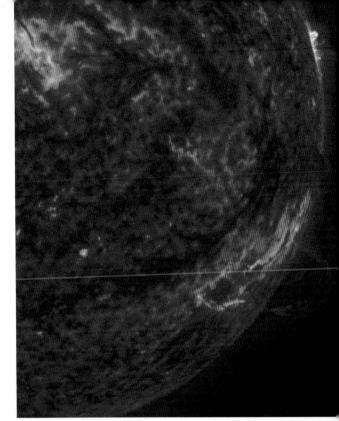

Image credits (bottom): ESA&NASA/SOHO

can be from 372 miles per second (600 km/s) to more than 620 miles per second (1000 km/s). Many of the images of prominences show immense arches or loops. Prominences last from several days to a few months.

This image (top left) shows a rare occurrence of a circular filament (to the right of the coronal holes). Filaments (top right), which originate in the lower atmosphere, are relatively cool. Then they are pulled by fluctuating magnetic forces into the much hotter corona.

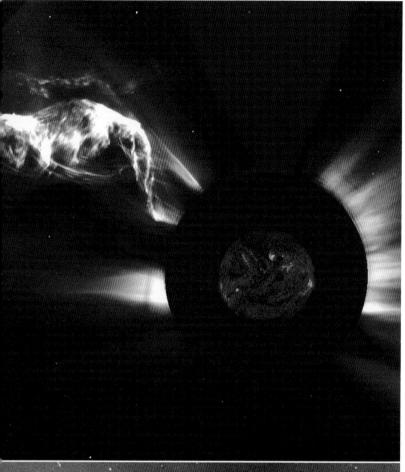

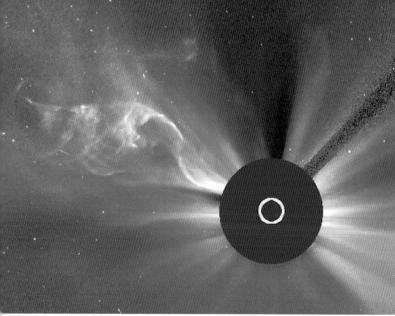

Coronagraph

Historically, a coronagraph is an attachment for an earth-based telescope that blocks the impeding light of the Sun so that it's corona can be seen. Viewing the corona is an important way to study the Sun's atmosphere.

The Large Angle Spectrometric Coronagraph (LASCO) is one of the instruments on the SOHO satellite. It blocks the bright solar light emitted by the Sun's surface that travels in the direction of the Earth. It creates an artificial eclipse that allows us to see the activity of the corona once the blinding surface light has been impeded from reaching the image sensor.

These images of an unusually large filament were captured in April 2015. The top image combines images from LASCO used to record the perimeter of the Sun, and SOHO used to record the Sun's center.

Image credits: ESA/NASA/SOHO

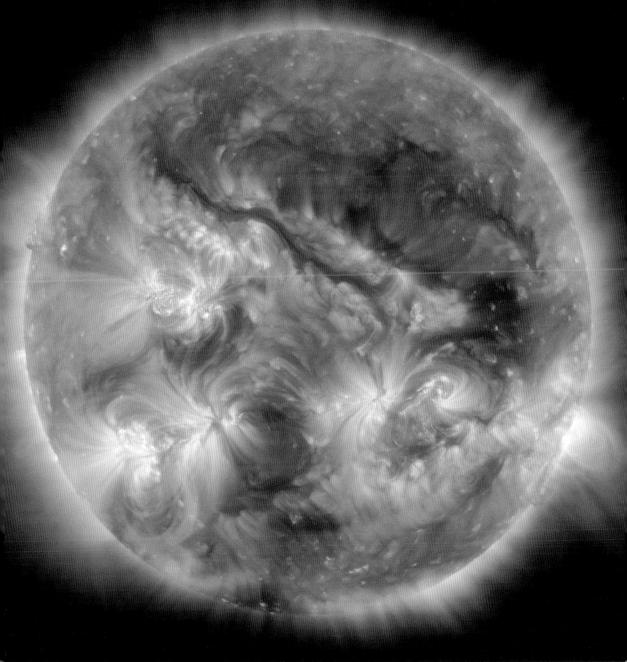

Image credits: NASA/SOHO

Fifty Earths Long

This filament captured in October 2015 is about the length of fifty Earths. Filaments are normally not visible to our eyes. The images were

recorded with an instrument sensitive to extreme ultraviolet wavelengths and colorized.

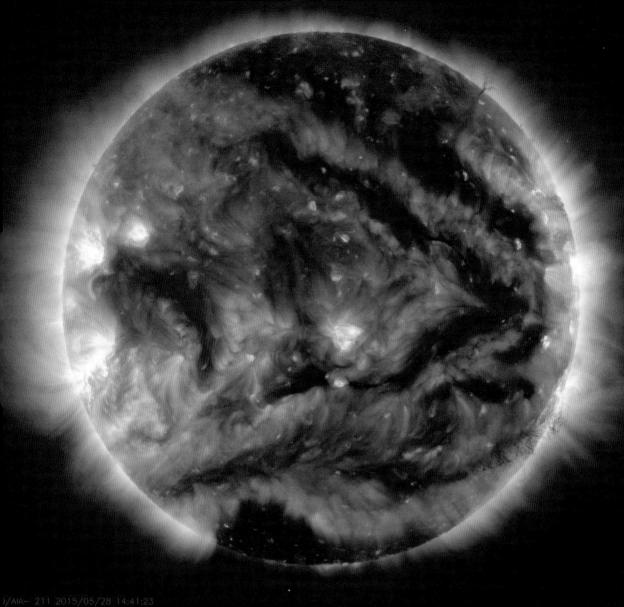

)/AIA-- 211 2015/05/28 14:41:23)/AIA- 193 2015/05/28 14:41:06

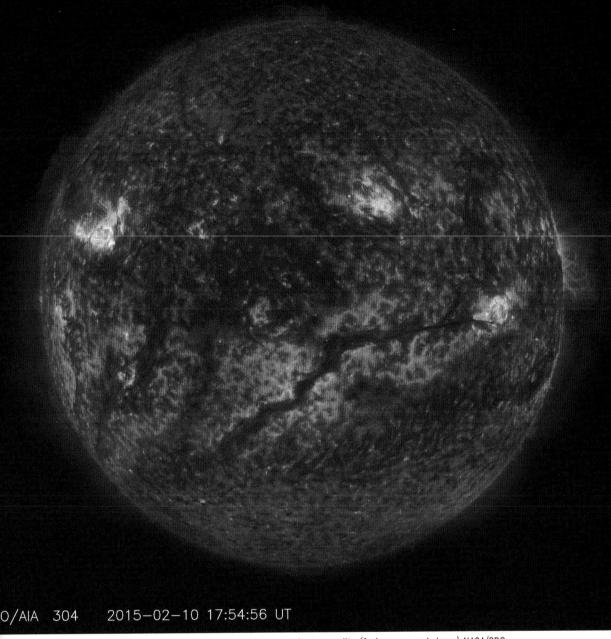

Suspended Above

Filaments are suspended above the Sun surface for days by the Sun's magnetic forces. The images on the facing page were captured with Image credits (facing page and above): NASA/SDO

instruments that are sensitive to different wavelengths.

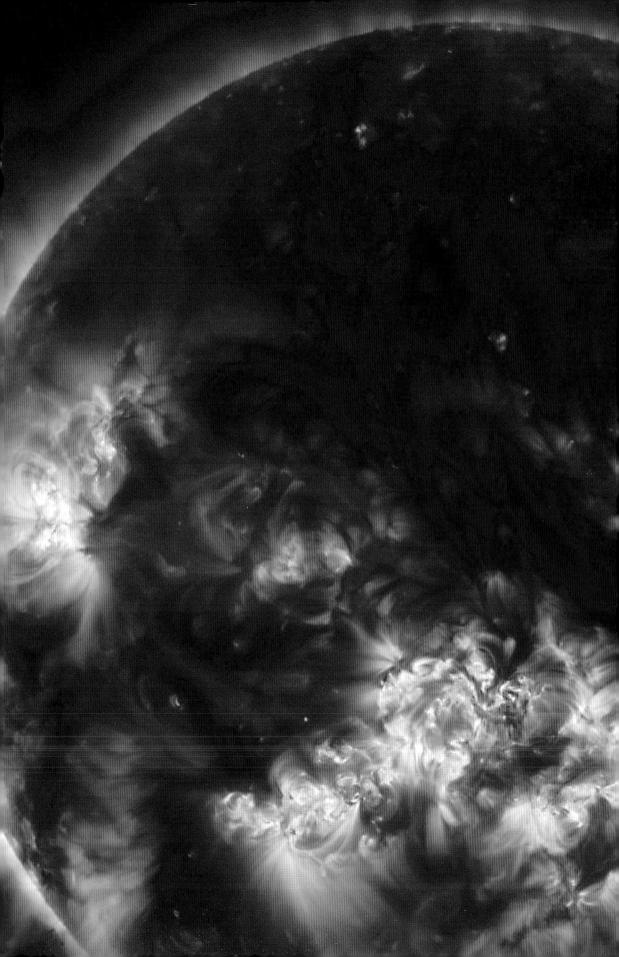

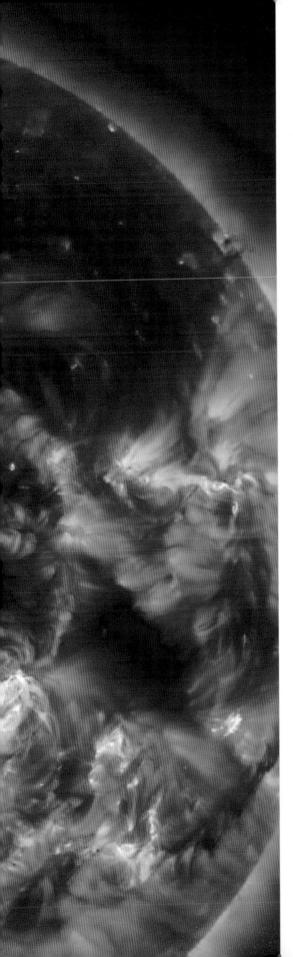

The Forces on a Filament

Filaments succumb to whichever force is more powerful: the upward pull of magnetic forces or the downward pull of gravity and convective forces. The filament's material returns back down into the Sun, or it can be released into space as a coronal mass ejection (CME).

This very long filament illustrated in this image from August 2014 lasted for over a week. It is over thirty times the diameter of the Earth.

Image credits: NASA/SDO

The Magnetic Sun

The Sun's magnetic field is variable, although there are consistencies too, such as sunspot activity and the solar cycles. Solar activity is a display of the Sun's dynamic magnetic field. The Sun is like a generator—a dynamo—that creates electri-

cal energy and a magnetic field from mechanical energy that is derived in part from the convective properties within it.

Image credits: NASA/ISS

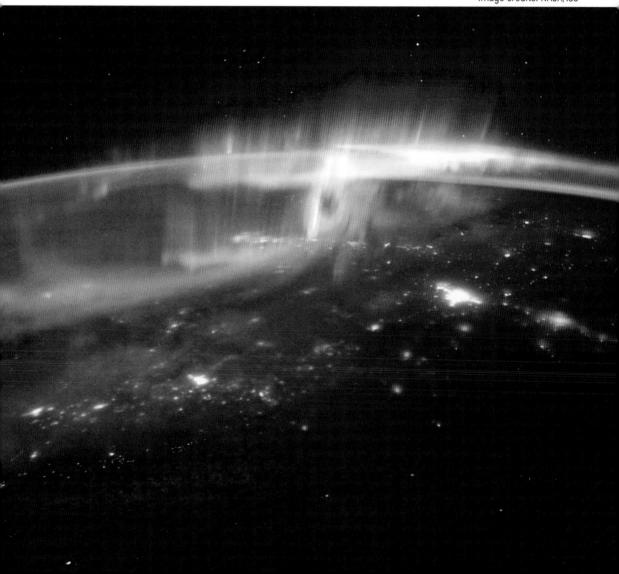

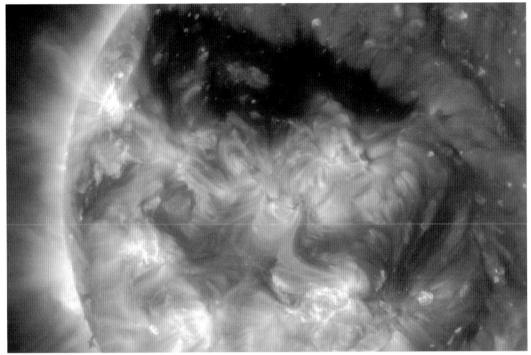

Image credits (top and bottom): NASA/SDO

Solar Dynamo

The solar dynamo is the process by which the Sun's magnetic field is generated. An electric generator of sorts is inside the Sun, which makes electric currents and a magnetic field. Scientists believe the magnetic field is generated in the relatively thin interface between the radiative zone and the convective zone called the tachocline.

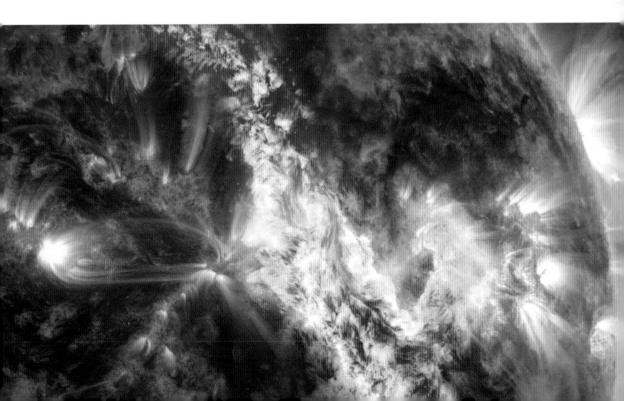

Magnetic Current Sheet

The heliospheric current sheet can be visualized as a flat plane that dissects the Sun's equator and extends into the heliosphere beyond Pluto. Like the Earth's poles, one is positive and the other is negative. The current sheet originates in the Sun's equatorial region where the polarity changes from north to south. The sheet extends outward from the Sun. The solar magnetic field is not limited to

the Sun and its atmosphere. It reaches out far beyond the planets and protects the Earth from cosmic rays. This part of the Sun's magnetic field is called the interplanetary magnetic field or the heliospheric magnetic field. Solar wind from the corona extends the magnetic field into the solar system beyond the planets. Because of the outward motion of the winds and the Sun's rotation, the magnetic field is actually a spiral pattern. This illustration (bottom) shows how the heliospheric current sheet is shaped by the Sun's forces.

Image credit: NASA

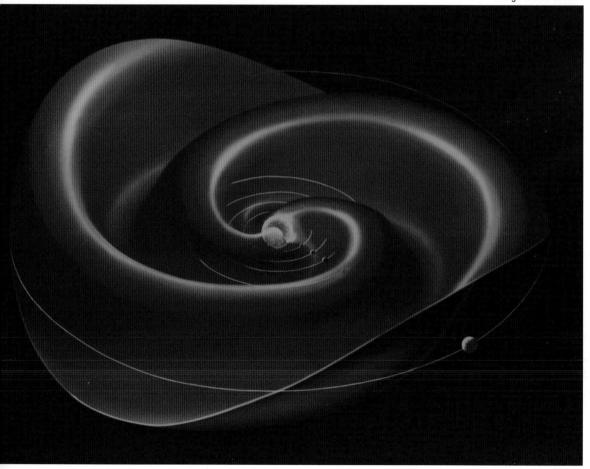

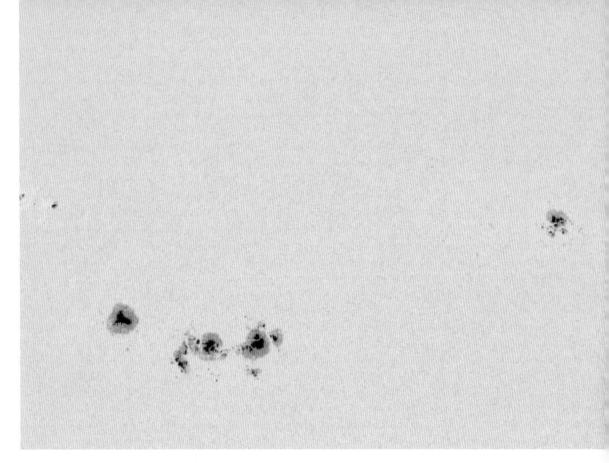

Created and Reorganizing

The Sun's magnetic field is not fully understood. We do know that the field is dynamic, and it is continually being created and reorganized. Sunspots (top) are most often seen in pairs which reflect the negative and positive polar aspects of magnetism. We also know that the solar poles' magnetic field flips every eleven year cycle, returning again after twenty-two years.

We can also see this activity in the magnetic field lines seen in these coronal loops (bottom right).

Image credits (top and bottom): NASA/SDO

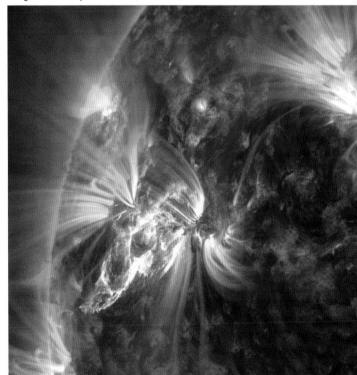

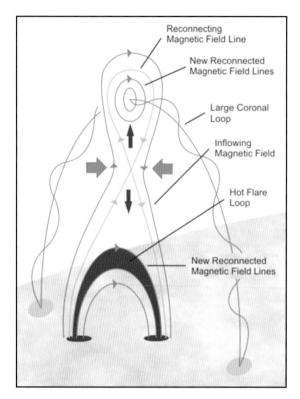

Magnetic Reconnection

Filaments of solar material rise from the surface. These become rising loops that follow magnetic lines projecting from the Sun, some of which erupt from the surface and are ejected out into space. These are coronal mass ejections (CME). More often than not, the magnetic lines reconnect allowing the solar materials to fall back to the Sun's surface.

Image credit (top and bottom): NASA

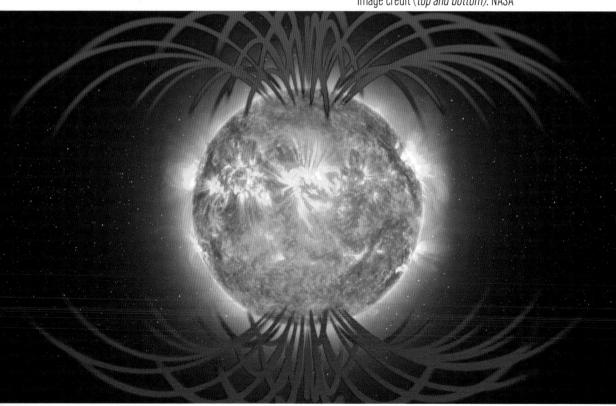

The Sun's Polarity

The Sun's polarity changes every eleven years at the peak of the solar cycle. It is a normal part of the solar cycle. The Sun's polar field progressively weakens, and then surfaces again with the opposite polarity. During reversals, the magnetic sheet that extends to the outer reaches of the solar system becomes even more wavy. A full twenty-two year cycle sees the polarity return to what it was at the beginning of the cycle, encompassing two eleven-year sunspot cycles.

The upper solar pole is negatively charged as indicated by the blue lines (facing page, bottom) and the bottom pole is positively charged as indicated by red lines. After approximately eleven years, the poles reverse. The positively charged pole is now on top (below) and the negatively charged pole is on the bottom.

Image credit: NASA

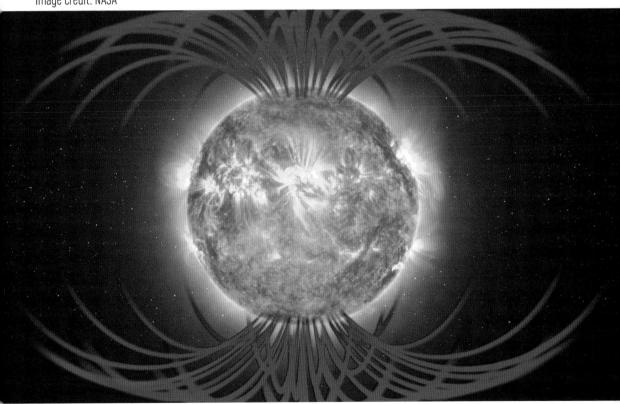

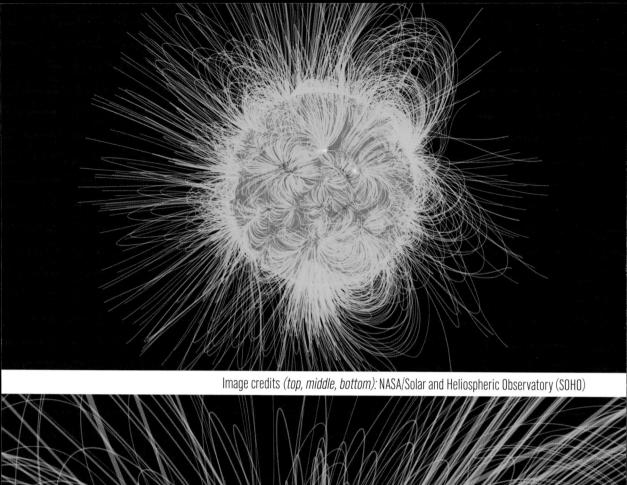

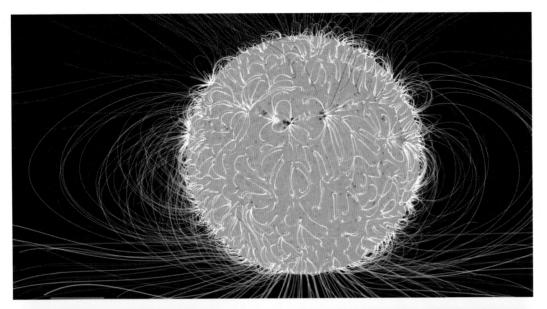

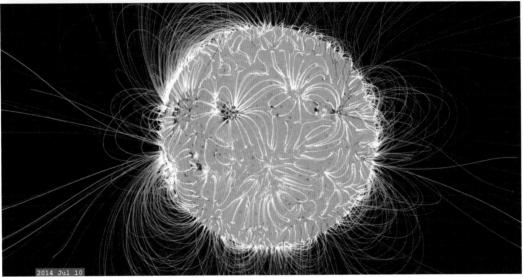

Magnetic Field Lines

Magnetic field lines are called coronal loops. These illustrations of modeled computer simulations show the

Image credits: NASA's Goddard Space Flight Center/Duberstein

dynamic lines. The actual lines of the coronal loops can also be seen when solar material flows along these lines. Through modeling, scientists hope to understand how energy and plasma move and transform around the Sun.

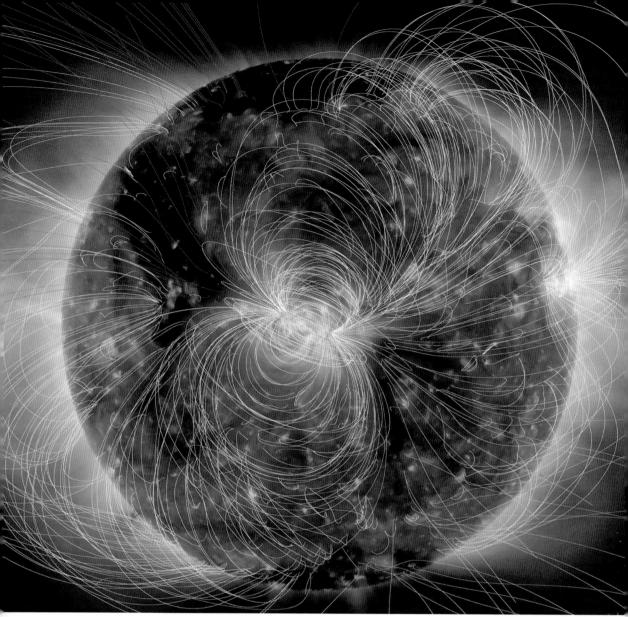

Image credits: NASA/SDO

Plasma

The Sun's material—plasma—is made up of charged particles. They stream along the magnetic field lines that arch between two oppositely charged areas.

Magnetic Field Strength

These images from the Solar Dynamics Observatory were taken over a month's time show the sun as it revolves, moving from left to right. The red areas are 2 million degrees, green areas are 1.3 million degrees, and the coolest areas are blue at about 600,00 degrees. They were recorded at extreme ultraviolet wavelengths. The most active regions are brighter (lighter). These areas have a stronger magnetic field. The differences between active and quiet areas is dramatic. These dramatic and continual changes are remarkable.

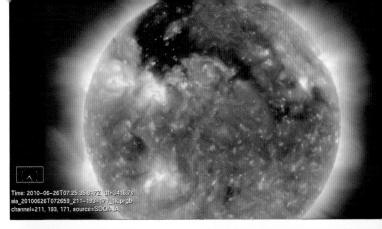

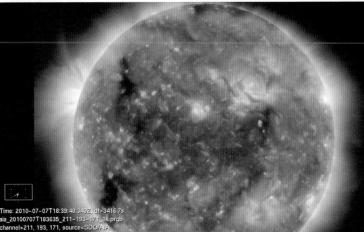

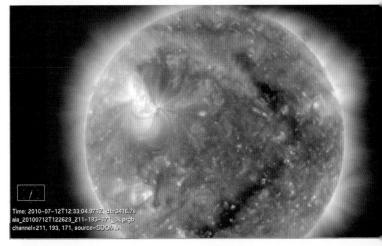

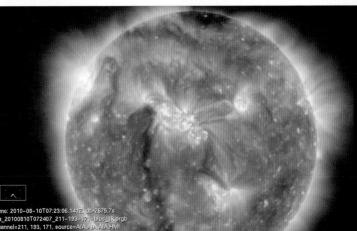

Image credits: NASA/SDO

Solar Flares

A solar flare is a flash of intense brightness that appears to be on or near the Sun's surface. During this burst of radiation, the plasma is

heated to tens of millions of degrees Kelvin. Most flares are not visible to the naked eye because the energy is outside of the visible range.

Image credits (below and facing page): NASA/SDO

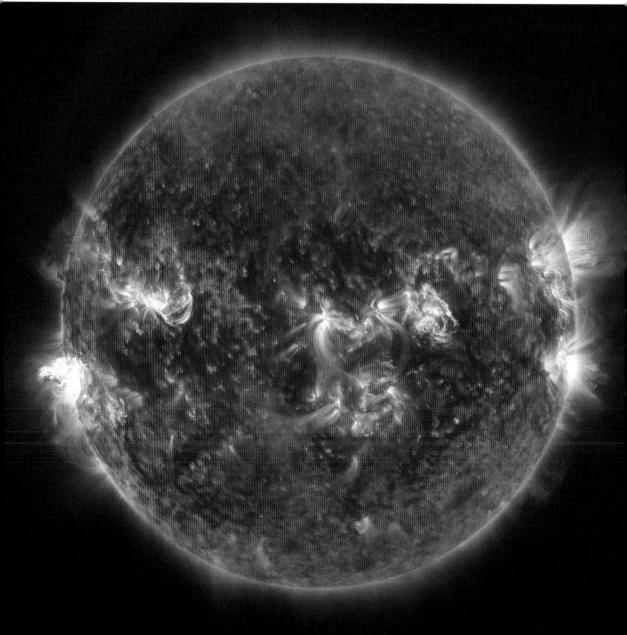

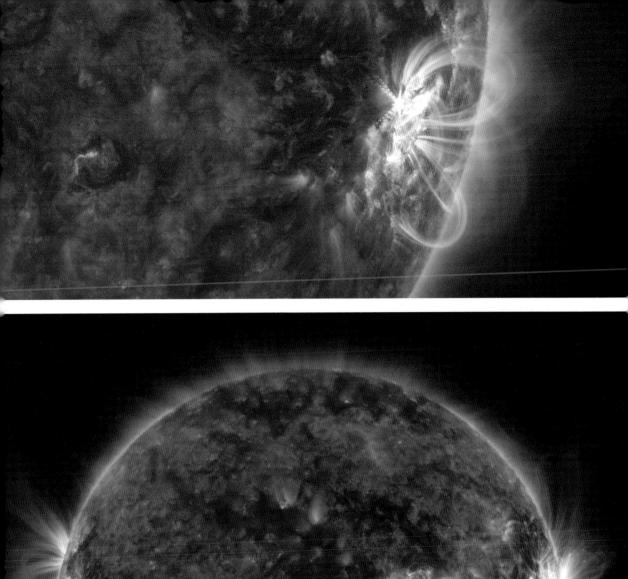

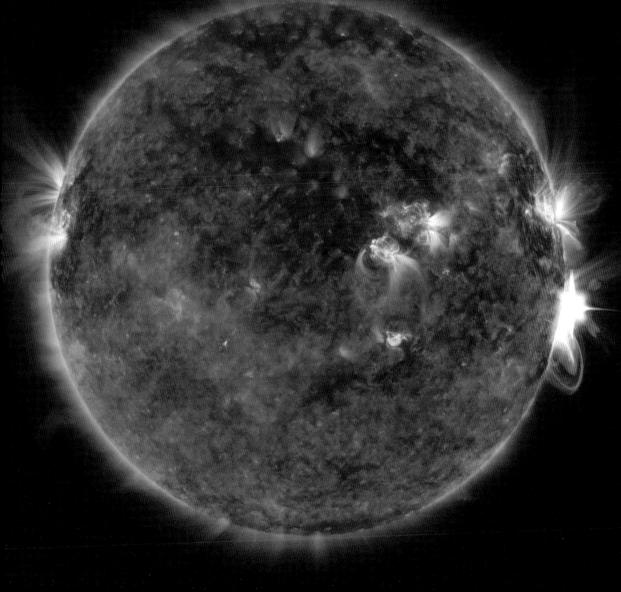

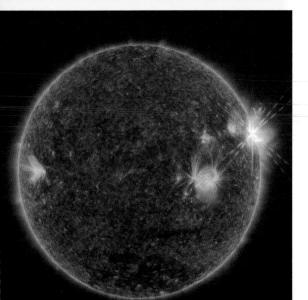

Solar Flare Facts

Knowledge of solar flares is limited. What we know is from observations of the Sun from Earth and from our instruments in space. Here are some facts about solar flares:

- A flare ejects clouds of electrons, ions, atoms, and radio waves through the Sun's atmosphere into outer space.
- When flares eject in the direction of the Earth, the particles striking the atmosphere can cause auroras.
- Our atmosphere stops any harmful radiation from flares. However, flares can have an impact on space weather by disrupting long range radio communication.
- The particles from a flare take one to two days to reach Earth.
- Flares have been observed on distant stars and are called stellar flares.

The three images on this page show three solar flares over a two day period, April 2–3, 2017.

Image credits: NASA/SDO

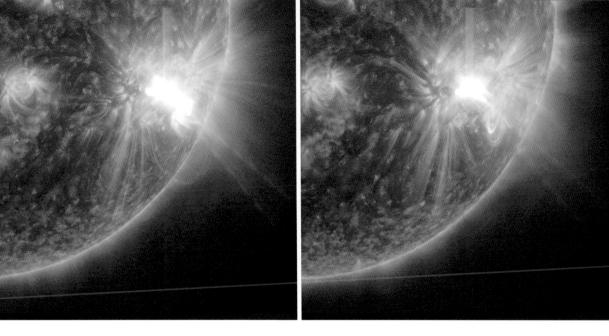

Cause of Flares

The cause of solar flares is not well understood. The phenomenon of magnetic reconnection may lead to the acceleration of charged particles. Flares occur when these particles interact with the plasma medium. Magnetic reconnection happens on cascades of magnetic loops pos-

sibly causing the flare. As the loops twist in the reconnection process, an unconnected upper portion of the curl may come loose in a coronal mass ejection.

A set of images (top) that show the progression of a flare is revealing. Another set of images (bottom) shows the same flare imaged at different wavelengths.

Image credits (top and bottom): NASA/SDO

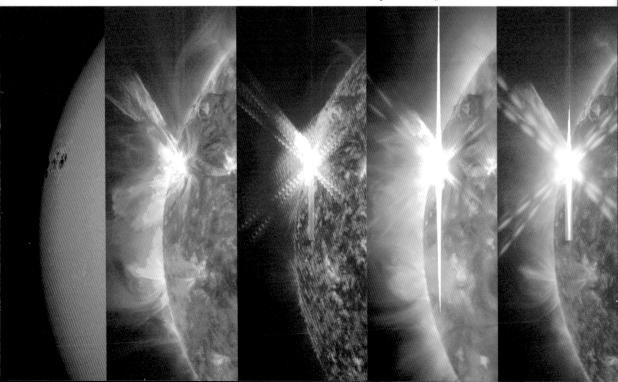

Coronal Mass Ejections

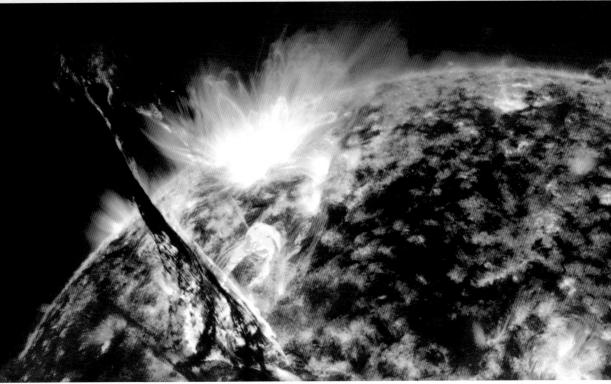

Image credits: NASA/SDO

Coronal mass ejection (CME) is the release of magnetized plasma from the Sun's corona. About three CMEs happen every day near solar maxima, and near solar minima they happen at a rate of about one CME every five days. CMEs are the source of most of the space weather experienced on Earth. A solar flare can be compared to the flash that can be seen from a distance when a canon is fired. The CME would be the actual canon ball. The flare is like light—it travels fast, taking one or two days to get to Earth. The plasma from a CME takes on average 3.5 days to reach Earth.

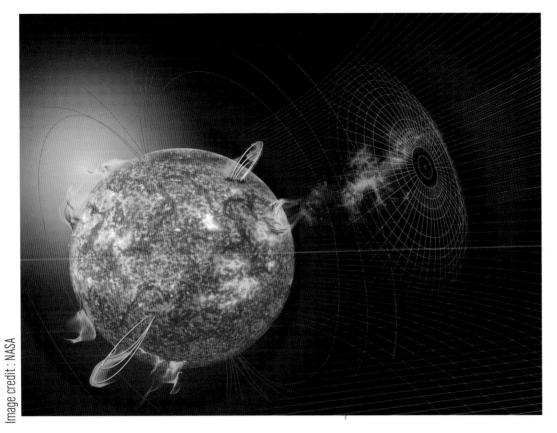

This artistic rendering of a CME (above) shows the plasma spewing from the Sun into space. The plasma of the CME is directional, so it does not always endanger the Earth. The

images below show the Sun's corona during a CME. Its ejection reaches much farther into space than a solar flare.

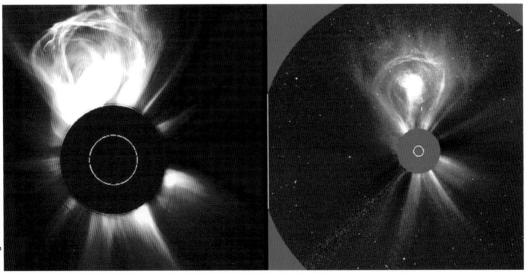

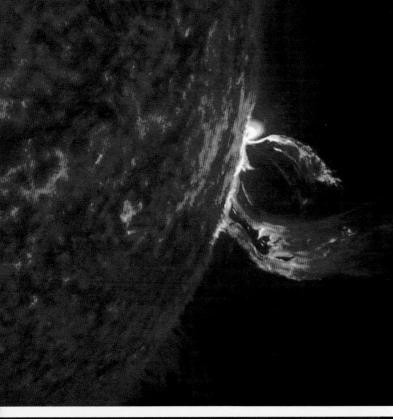

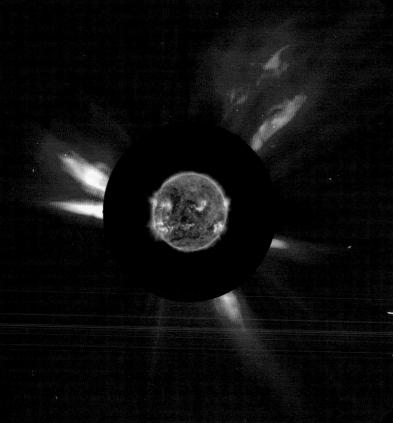

This plasma with magnetic field (*left*) is comprised predominantly of electrons and protons.

This image (bottom left) is a combination of an SDO image and a SOHO image, which helps scientists make a connection between what is happening close in and further from the Sun.

During this CME (facing page, top) the plasma escaping the Sun's atmosphere is on the upper right. The image above (facing page, bottom) shows the Sun on the same day with lines indicating the magnetic connections between areas. Where the connections are weak, the plasma escapes and is flung outward into space. These areas have sometimes been described as monopolar because they appear not to loop back to the Sun's surface, keeping the plasma bound. Instead, these lines extend out and allow the plasma to be released into space. This may be part of the magnetic reconnection process.

Image credits (top): NASA/SDO Image credits (bottom): ESA/NASA

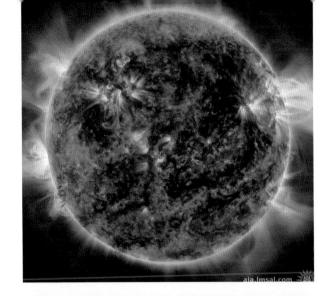

Image credits *(top):* NASA/SDO/ESA/SOHO/Nune Image credits *(bottom):* NASA/SDO

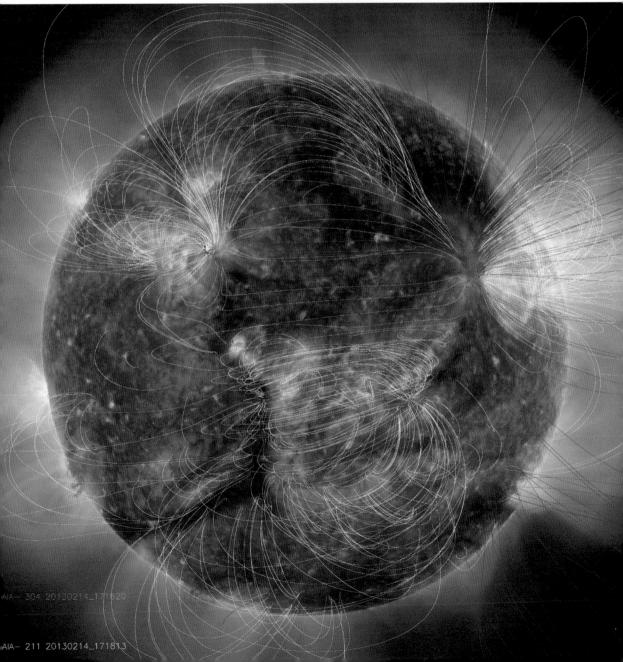

Eclipses and Transits

Image credit: NASA

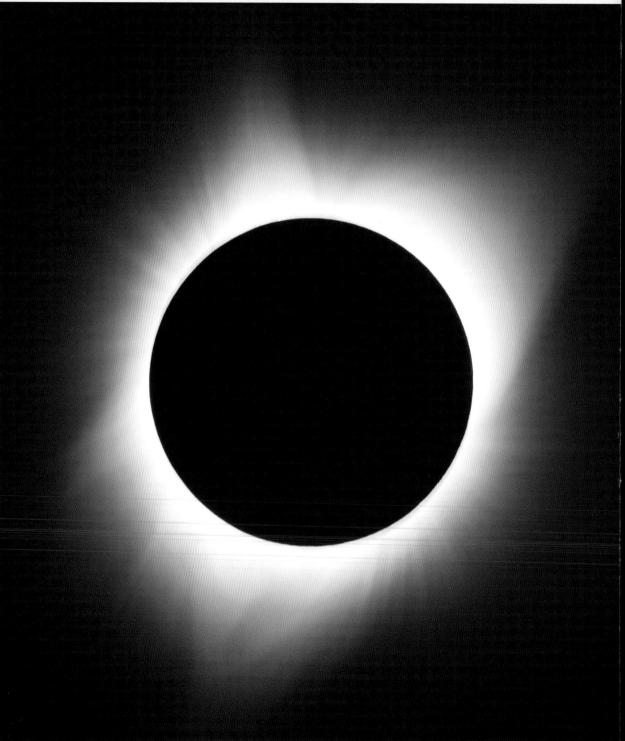

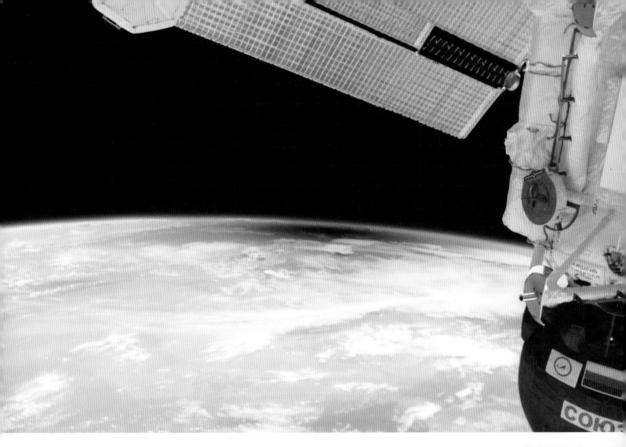

Transits and eclipses are visible from Earth's surface. A solar eclipse happens when the Moon moves between the Sun and Earth. They can be partial or total. As the Sun's light is blocked, the Moon casts shadows on the Earth (top). The umbra is the darker and smaller shadow. People in this shadow will see a total eclipse (facing page). People in the second larger shadow called the penumbra should see a partial eclipse (right).

Image credits (top): NASA/ISS/ESA Image credit (bottom): NASA

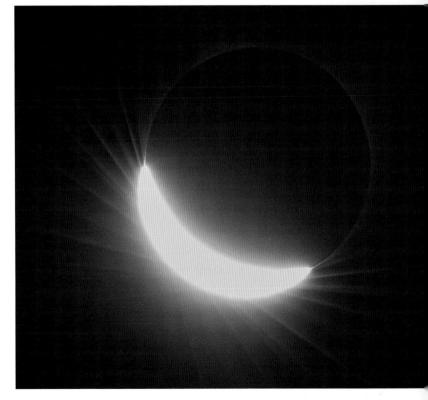

THE SUN 95

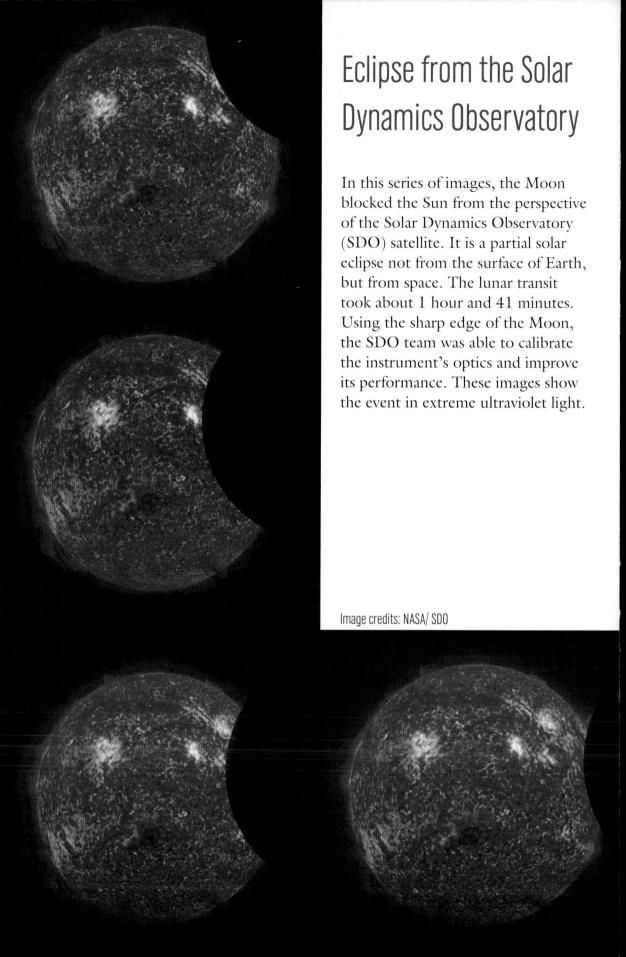

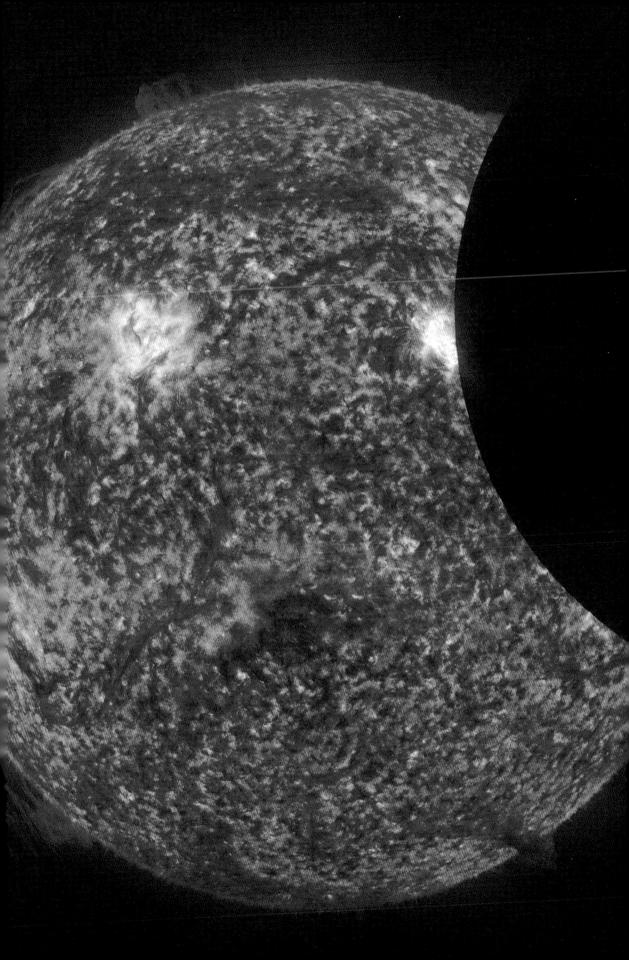

Eclipse Viewed From the SDO

Image credits: NASA/SDO

Sun from the vantage point of the Solar Dynamics Observatory (SDO) on February 11, 2018.

From Earth, the Moon blocks the Sun from view during an lanar eclipse. In this image, Earth is eclipsing the

Soft Edge of Earth's Shadow

As the Earth blocks the Sun, its edge is soft, not sharp. This is because of the diffusing effect of the Earth's atmosphere.

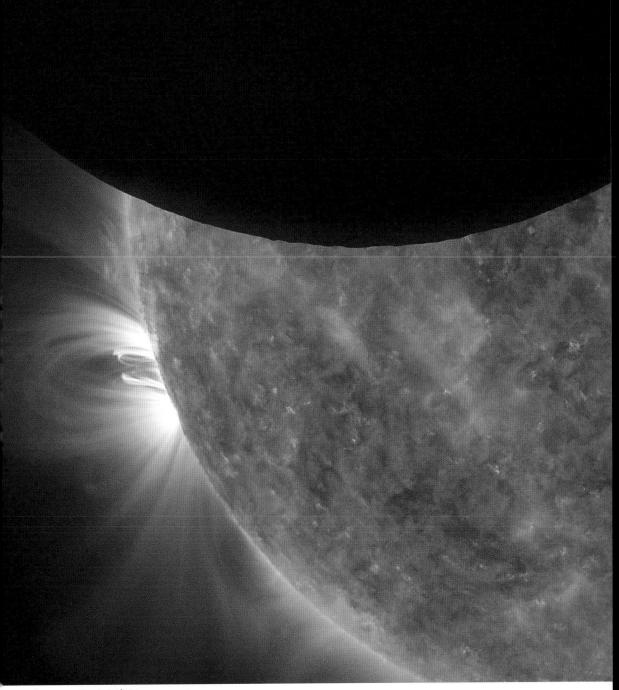

Image credits: NASA/SDO

A First for SDO

This image of the Moon and Sun is the first partial eclipse of the Sun viewed by the SDO on October 7, 2010.

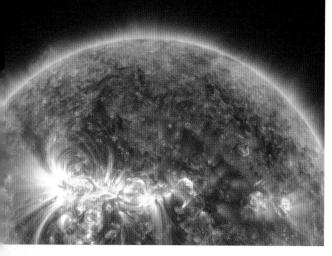

Transit of Venus

A transit is an eclipse where a body between the viewer and the farthest body does not largely cover the farther body. This sequence of images from the Solar Dynamic Observatory (SDO) shows the Venus 2012 transit. The path *(facing page, top)* shows the merged images of Venus and the Sun.

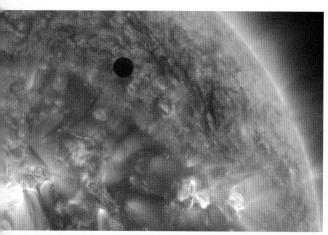

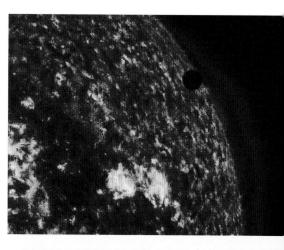

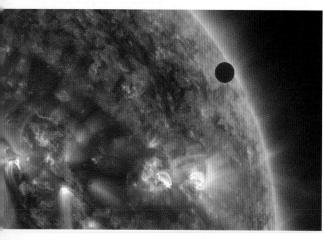

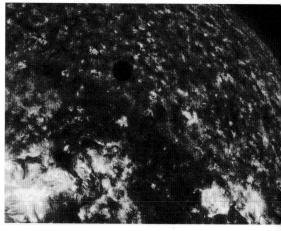

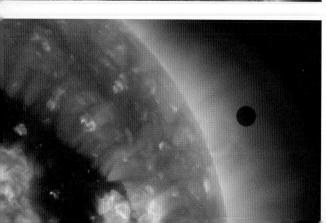

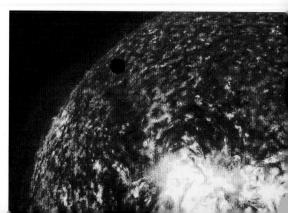

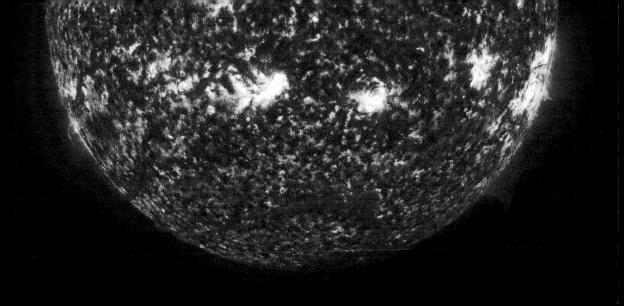

Lunar Transit

This lunar transit was not seen from Earth, but recorded from NASA's STEREO-B in February 2007. The Moon's coverage of the Sun is not nearly as much as seen from

an earthly lunar eclipse because the recording instrument was 4.4 times farther from the Moon than the Earth. The Moon's coverage in this synergy makes the image unique.

A Comet's Transit

On November 27, 2013, Comet ISON was imaged by the European Space Agency/NASA Solar and Heliospheric Observatory (SHO). It is a coronagraph that blocks all the light

of the Sun except for the outer edge of the corona. It allows us to see what is around the Sun. The effect is much like a lunar eclipse. Coronal mass ejections (CME) can be seen. The comet can be seen in the lower right.

Image credits: ESA/NASA/SOHO

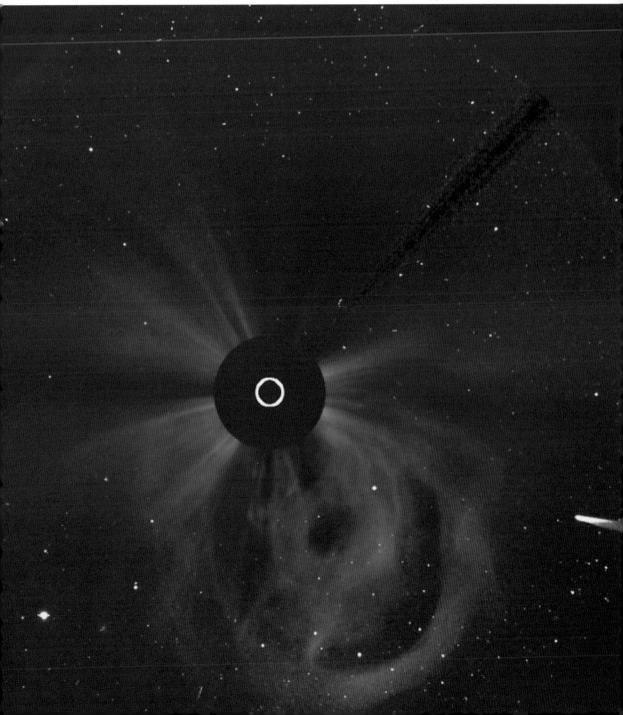

Comets and Tails

Comets have an elliptical orbit around the Sun, with one end of their ellipse passing very close to the star. As a comet approaches, it warms and begins to outgas. The outgassing

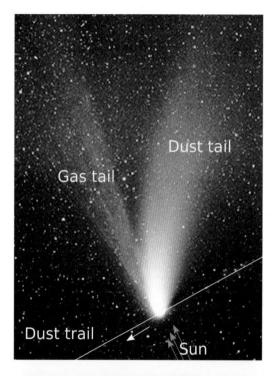

creates a temporary atmosphere and often a tail. Solar radiation and solar wind act on the outgassed material making a tail.

Comets can have two kinds of tails: dust and gas. The dust tail often follows the orbit trailing, behind the comet. The gas tail is lighter, so it is pushed away from the Sun by solar wind. As the comet leaves the proximity of the Sun, its gas tail can precede it.

NASA's EPOXI mission captured this image of Comet Hardey 2 (bottom) in 2010. Note the outgassing.

Comet's Death

Sun-grazer comets (facing page) come very close to the Sun at their perihelion (closest point to the sun). They can survive many passages, but may eventually break apart from the strong forces.

Image credit: NASA

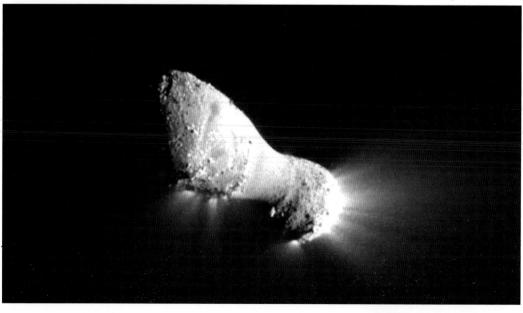

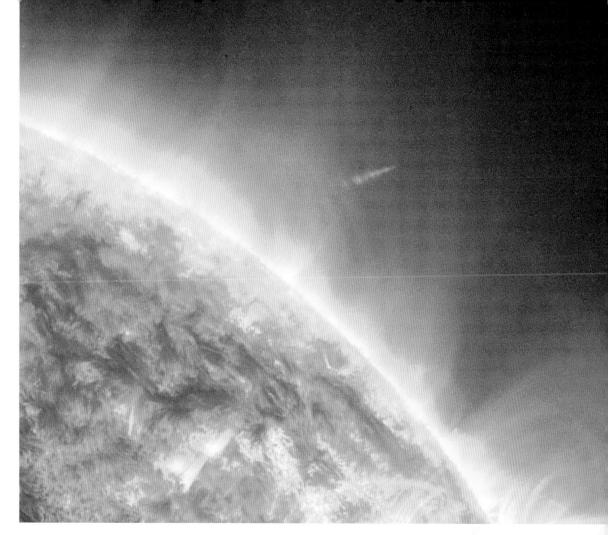

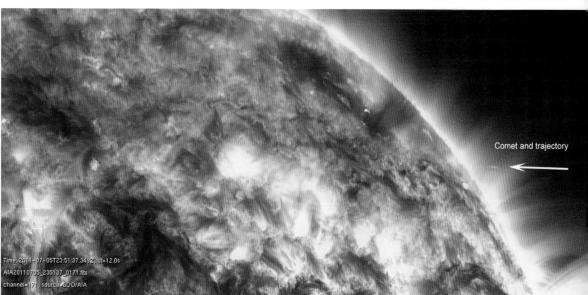

Image credits (top and bottom): NASA/SDO

Space Weather

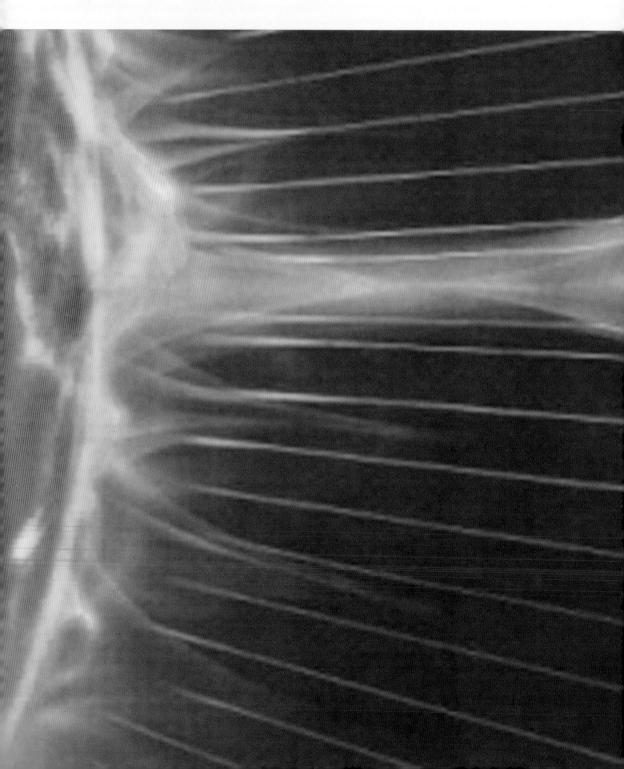

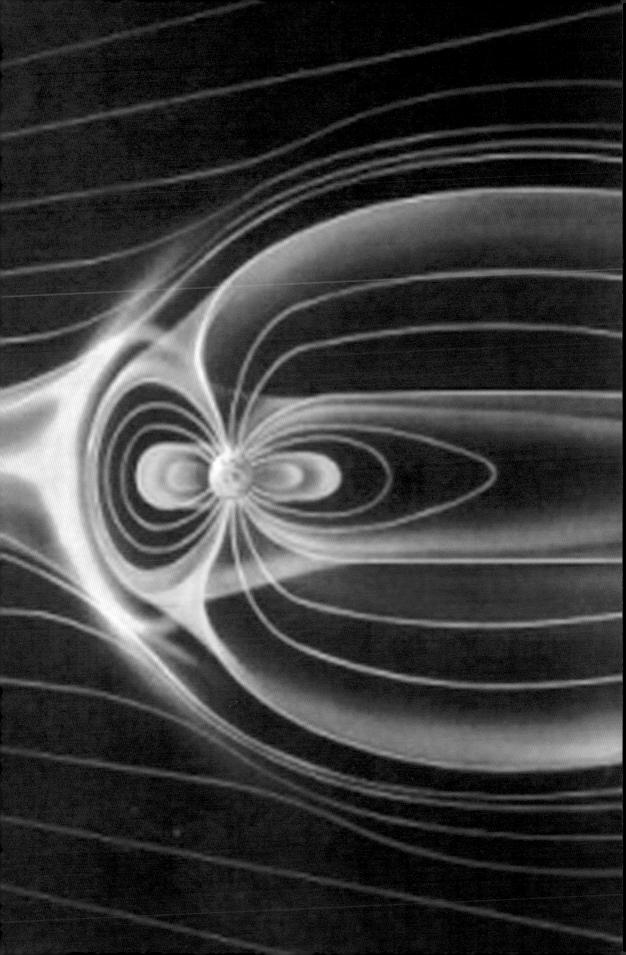

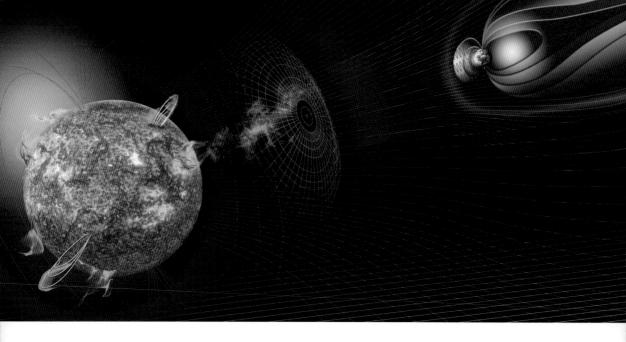

The Sun emits energy that can affect the Earth and humankind's technology. Forecasting space weather, like Earth's atmospheric weather, can allow us to make preparations and avert dangerous or costly situations.

Causes of Space Weather

Solar flares and coronal mass ejections are huge explosions on the Sun. Both occur as the magnetic field snaps and realigns in the process of magnetic reconnection. However, while they can happen at the same time, their emissions, travel, and effects are different.

The light from flares reach Earth in a matter of eight minutes, because they go at the speed of light. Some high energy particles that are acceler-

ated by the flare also reach Earth not long after the light.

The coronal mass ejection (CME) explosions spews out solar matter in a particular direction. The particles in this matter are magnetized. They can take up to three days to arrive at the Earth.

Space Weather Effects

The energy from flares can disrupt the Earth's atmosphere where radio waves travel. This can cause temporary blackouts in communication and navigation signals.

The energy from CMEs collide with the Earth's magnetic field, pushing particles to the poles. This results in spectacular auroras in the north and south—see here (facing page) from the International Space Station.

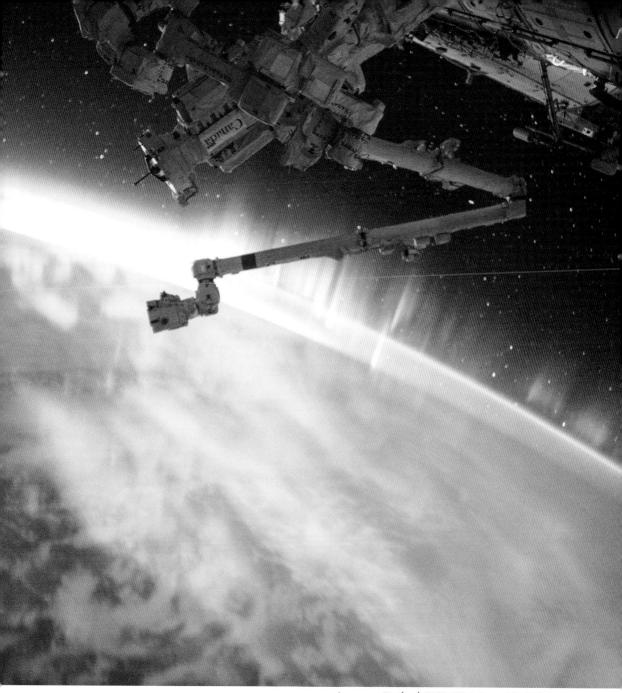

A more detrimental and damaging effect of CMEs is their impact on radio transmission, GPS coordinates, and the possibility of overloading and damaging electrical systems.

Image credits *(top):* NASA, ISS, Astronaut Scott Kelly Image credit *(facing page):* NASA Image credit *(page 108-9):* NASA

NASA and Space Weather

NASA explains that space weather is the result of light and electrically charged particles and magnetic fields that impact us. The following is how United Space in Europe (ESA) describes space weather: "Space weather refers to the environmental conditions in Earth's magnetosphere, ionosphere and thermosphere due to the Sun and the solar wind that can influence the functioning and reliability of spaceborn and ground-based systems and services or endanger property or human health."

Space weather deals with phenomena involving ambient plasma, magnetic fields, radiation, particle flows in space, and how these phenomena

may influence man-made systems. In addition to the Sun, non-solar sources such as galactic cosmic rays can be considered a factor of space weather since they alter space environment conditions near Earth."

NASA's Solar Dynamics Observatory takes one image of the Sun every second, recording space weather data. Based on this, alerts can be made about possible upcoming space weather issues.

What Is Affected by Space Weather?

Space weather affects power systems, satellites, GPS positioning, can reduce the lifetime of pipelines, communication cables, and HF radio. As early as 1847, it was noted that telegraph in-

struments malfunctioned at the same time as significant auroras were witnessed. This continued to be observed throughout the late 19th and the early 20th centuries. Notably, a powerful geomagnetic solar storm known as the Carrington Event in 1859, if occuring today would cause

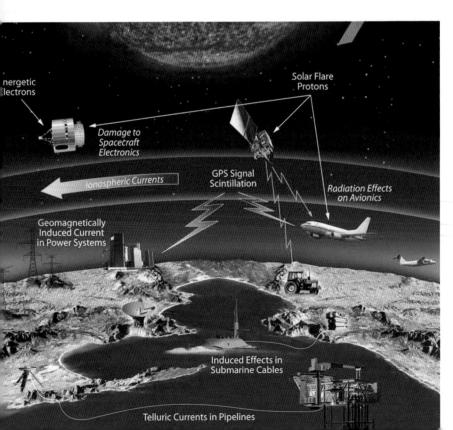

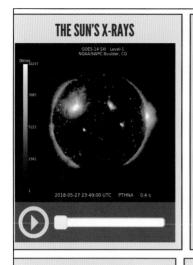

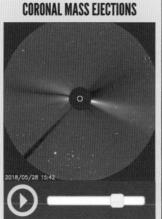

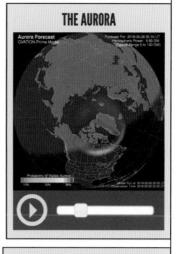

GOES X-RAY FLUX

GOES PROTON FLUX

ESTIMATED PLANETARY K-INDEX

widespread damage. In the mid-20th century, power grids and the transatlantic submarine cables were affected. Affected power system issues manifest as transformer trips, variations in voltage and power-frequency control, reduced power, blackouts, transformer damage, abnormalities in railroad circuits (e.g. signals tripped to red), and vulnerabilities to nuclear power plants. This is not a complete list.

The country of Canada occupies a sizable landmass near or in the arctic. They are a good example for space weather preparation. They divide their country into three zones for short and long-term forecast: subauroral, auroral, and polar cap. The range of activity for each zone can be classified as quiet, unsettled, active, or storm. Regional forecasts are for the upcoming three hours and are updated every fifteen minutes. They issue regional storm watches.

Once space weather is forecasted, disruptions can be minimized with safeguards. Pipeline, power, and communications companies can prepare their systems for impact.

Image credit (top, bottom, and facing page): NASA

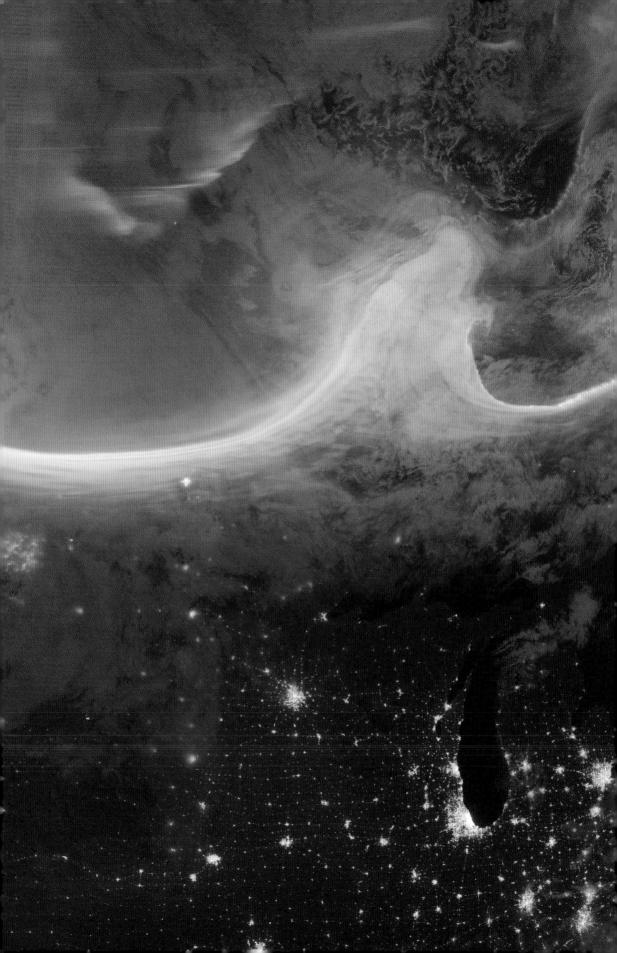

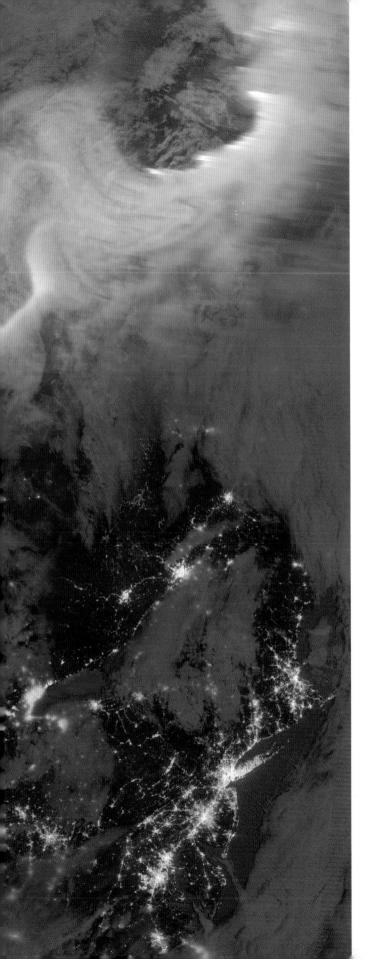

Energetic Particles from Solar Plasma

This storm over the Great Lakes in North America on October 4–5, 2012, was caused by a coronal mass ejection on the Sun three days earlier. It produced displays of northern lights that could be seen with the naked eye.

The instrument used to collect this image is Suomi NPP - VIIRS weather satellite

Image credits: NASA Earth Observatory image by Jesse Allen and Robert Simmon, using VIIRS Day-Night Band data from the Suomi National Polar-orbiting Partnership (Suomi NPP) and the University of Wisconsin's Community Satellite Processing Package. Suomi NPP is the result of a partnership between NASA, the National Oceanic and Atmospheric Administration, and the Department of Defense.

Earth's magnetic field is called a magnetosphere. It is a region in space that surrounds the planet and, because of its field, can affect charged particles that come within their influence. In the near space close to Earth, the magnetic field is a magnetic dipole. This means that it registers as a closed loop, as illustrated in these artistic conceptions. The lines reach between the north and south, creating a closed loop. Farther out in space, these lines become more distorted by the solar plasma, which is electrically conductive.

Other astronomical objects have magnetospheres of varying strength. Planets that have a more powerful magnetosphere have a greater ability to protect their atmosphere from the star they orbit.

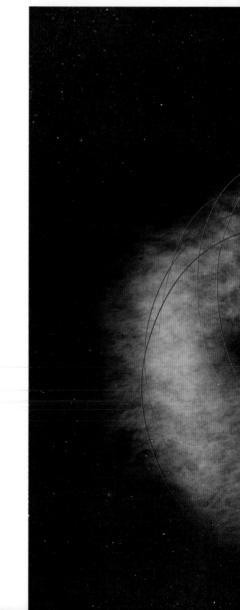

Van Allen Belts

The Van Allen radiation belt is an area around the Earth that has energetic charged particles. Most of the particles come from solar wind and some are by cosmic rays from beyond our solar system.

The particles are captured and become trapped in the magnetic field. The belts protect the atmosphere and surface from harmful cosmic rays and solar particles.

Image credits *(facing page):* Visualization built by Greg Shirah and Tom Bridgman, NASA/Goddard Space Flight Center Scientific Visualization Studio

Image credits (bottom): T. Benesch and J. Carns for the NASA Science Mission Directorate

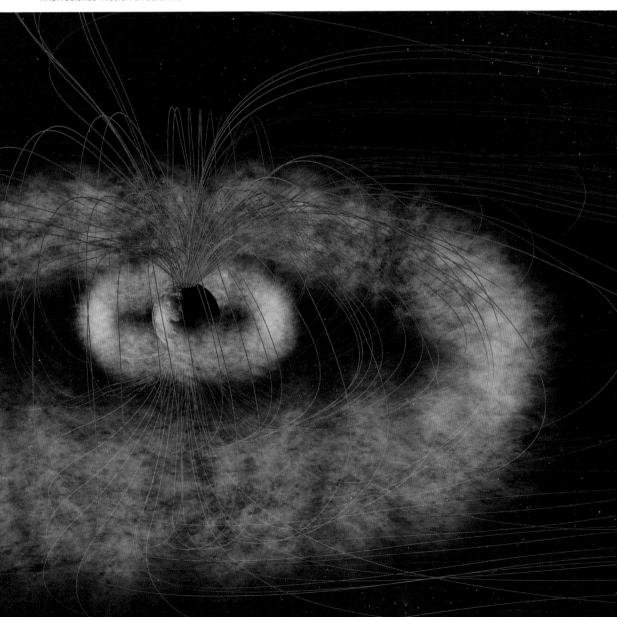

The Sun's Reach

Our family of planets is part of the Sun's system, along with their satellites, comets, and meteors. We question and seek to understand how far is the Sun's reach, and where is the end of its influence? Where does interstellar space actually begin? These are questions that scientists have asked for a long time. Our instruments are increasingly sensitive and far reaching. Much of what we know about the Sun has been acquired from information gathered about similar stars that are

light years away. We can see from our distant vantage point what can only be imagined about the Sun from inside our solar system. These stars (facing page) are similar to the Sun and show the boundaries between their local region and their interface with the interstellar medium in which they are located.

Image credit: NASA

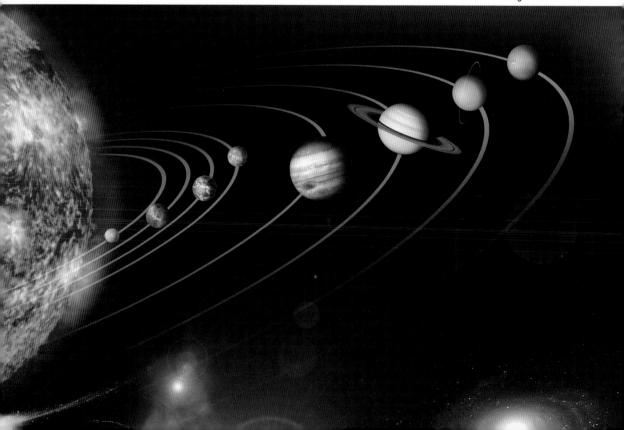

Cosmic Bow Shock

These images of stars LLOrionis (top) and WR 31a (right) show bow shocks. They form as the stars' fast moving stellar winds make contact with slow moving interstellar medium. Our Sun also has a bow shock.

Image credits (top and bottom): NASA, ESA, and The Hubble Heritage Team

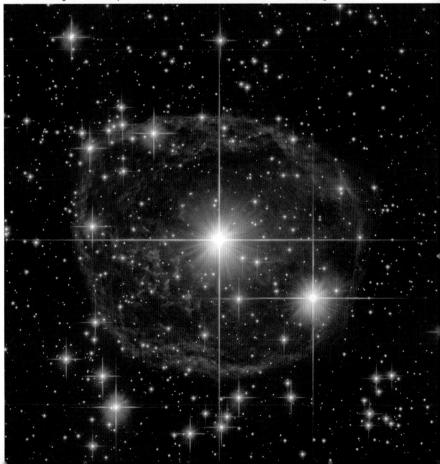

The Extent of the Sun's Influence

The edge of the solar system and the Sun's influence goes beyond our last planet Neptune. It is believed to extend to the inner Oort Cloud, which

we believe is the source of comets that occasionally have a closer visit to the Sun. In the outer Oort Cloud, the Sun's gravitational influence declines to the point that it is replaced by the gravitational pull of other stars. New data is telling us more about the Sun and its more distant reach.

Image credit: NASA

Termination Shock 100 leliosphere

A Grand Distance

The distance shown in the image below is in astronomical units (AU), which is the distance from the Earth to the center of the Sun. On the scale bar, each set distance beyond 1 AU represents ten times the previous distance.

Interstellar Medium

Voyager 1, humankind's most farreaching spacecraft, arrived at interstellar medium in 2012. It is accompanied into the interstellar medium by Voyager 2. These are the first crafts to make this distant journey beyond our solar system.

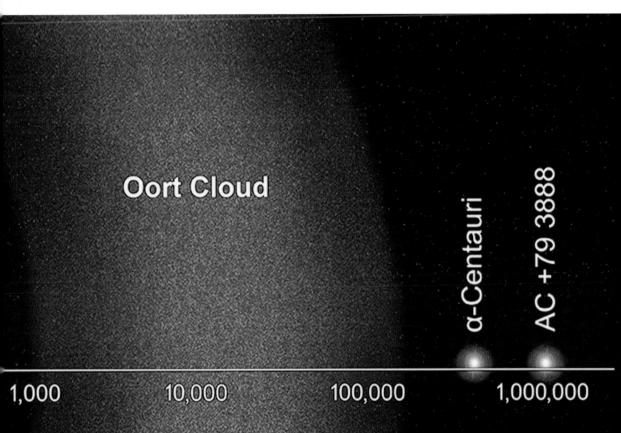

Space

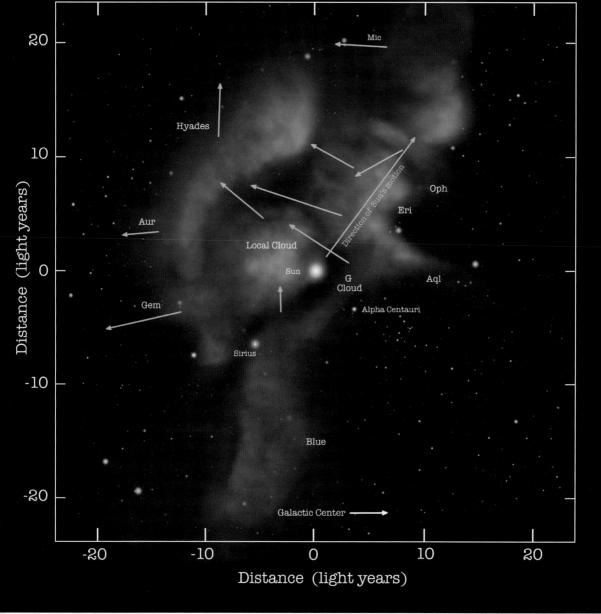

Image credit: NASA

Our Shielding Sun

The Milky Way galaxy is spinning. However, within the Sun's small part on a minor arm of the galaxy, there is localized movement. The Sun is moving through the Local Interstellar Cloud at this time, and will do so for 10,000 to 20,000 more years. The solar winds and the Sun's heliosphere create a boundary that protects Earth and the rest of the solar system from the interstellar medium in the cloud.

The Outer Limits of the Solar System

There is a boundary between the solar winds and the interstellar medium. The interstellar medium is composed of clouds that have different densities, temperatures, and magnetic fields. The flow of this material also differs in its speed and density.

The solar winds flow outward and form a bubble as they push into the interstellar medium. The boundary between the two is called the heliopause.

The plasma in the two winds, interstellar and solar, are charged particles that are restricted to their respective magnetic fields. However, there are neutral particles that do cross the region and enter the solar system.

Image credit: NASA

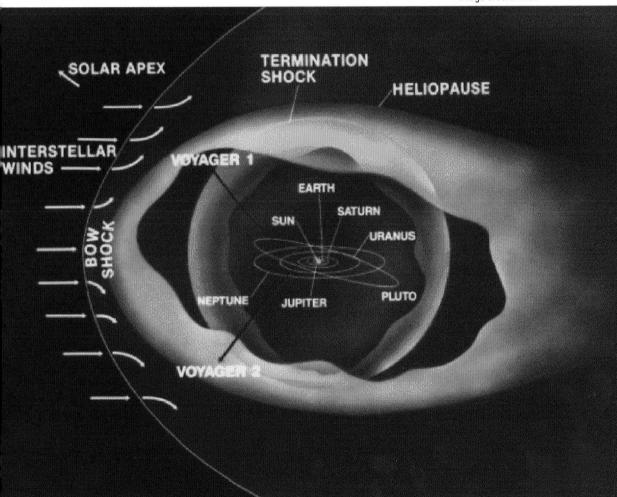

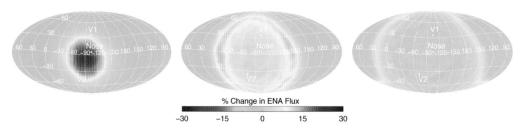

Image credits: Eric Zirnstein and colleagues

Heliosphere

The Voyager 1 and Voyager 2 spacecrafts, along with the Interstellar Boundary Explorer (IBEX) are primarily responsible for our understanding of the Sun and heliosphere.

This image (top) simulates the progress of the Sun's heliosphere following an increase in solar wind in 2014. Data from these instruments was used by Eric Zirnstein and colleagues to help gain an understanding of the dynamics of the outer boundaries of our solar system.

Parker Solar Probe

The Parker Solar Probe (launched in 2018) is designed to withstand extreme heat and radiation, allowing it to get close enough to sample the low solar corona. The probe will help us understand more about the Sun's coronal magnetic field, how the solar corona and wind are heated and accelerated, and the processes involved in accelerating high-energy particles The mysteries of the Sun are many. Humankind is slowly revealing their powerful star's secrets.

Image credit (bottom and facing page): NASA

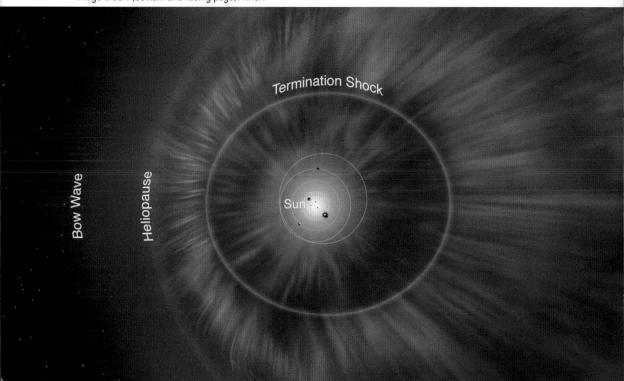

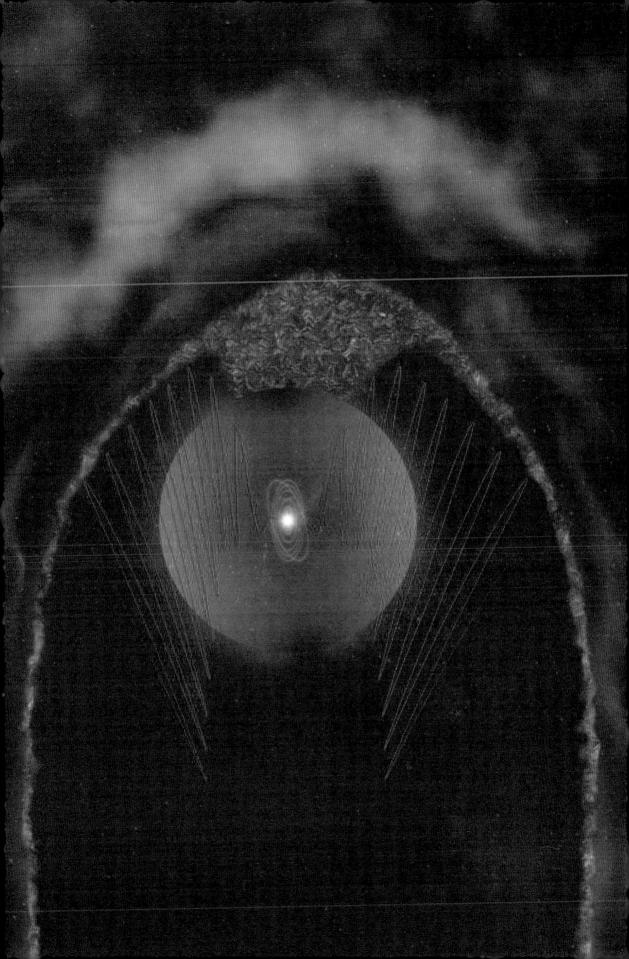

Index

A Alpha Centauri, 7 astronomical unit (AU), 12,

astronomical tilit (AC), 12, 26, 27, 121 astronomers, 43, 45, 47 astrophysicists, 11, 124 atmosphere, solar, 20, 22, 37, 51, 69, 70, 78, 88, atmosphere, planetary, 13, 15, 24, 25, 100, 106, 110, 116, 117 atmospheric altitudes,

Atmospheric Imaging Assembly (AIA), auroras, 63, 88, 110, 112, 113

20-23, 39,

В

Balloon Array for Radiation-belt Relativistic Electron Losses (BARREL), 37 bow shock, 35, 119

C

camera obscura, 45, 47
carbon, 11
charge, 15, 31, 37, 48, 51,
59, 67, 81, 84, 89, 112,
116, 117, 123
chromosphere, 22, 35, 38, 60
clouds (interstellar,molecular,
planetary, and stellar), 10, 25,
28, 88, 122, 123
comets, 105, 106, 118, 120
convection zone (see convective zone)
convective zone, 16, 18,
19, 21, 77

core, 10, 15, 16, 22, 24, 25

corona, 22, 23, 35, 37, 38, 61, 67, 69, 70, 78, 90, 91, 105, 124 coronagraph, 23, 70, 105 coronal holes, 56–63, 64, 69 coronal mass ejections (CME), 35, 49, 75, 80, 90, 91, 92, 105, 110

D density, 10, 12, 13, 16, 18,

63, 64, 123

E

Earth, 5, 12, 13, 15, 24, 25, 26, 27, 31, 35, 37, 51, 58, 63, 67, 70, 71, 75, 78, 88, 90, 91, 95, 96, 98, 99, 100, 104, 108–118, 121, 122 eclipse, 23, 70, 94–101, 102, 104, 105 electromagnetic radiation, 15 elements, 9, 11, 14 European Space Agency (ESA), 33, 35, 37, 105 extreme ultraviolet (EUV), 21, 64, 71, 96

F

Fabricius, David and Johannes, 45 filaments, 66–75, 80 filters, 23, 41, 43, 61

G

Galilei, Galileo, 44, 45, 46 Gassendi, Pierre, 46 globular cluster, 9 Goldilocks zone, 12, 13 granules, 18, 19, 20, 21 geotail, 35 gravitationally bound, 7, 10 gravity, 18, 37, 75

Н

habitable zone, 12, 13 heavy-metal star, 9, 11 heliosphere, 13, 28, 35, 37, 78, 122, 124 helium, 11, 15, 16, 67 Hinode, 33, 51, 68 Hubble telescope, 9, 119 hydrogen, 9, 11, 15, 25, 67

I

International Space Station (ISS), 10, 110 Interstellar Boundary Explorer (IBEX), 35, 124 interstellar medium, 13, 35, 118, 119, 121, 122, 123 ionization, 15, 67

T

Japan Aerospace Exploration Agency (JAXA), 33, 51, 68 John of Worcester, 44 Jupiter, 8, 15, 26

K

Kepler-186 system, 13 Kircher, Athanasius, 44

Τ.

Large Angle Spectrometric Coronagraph (LASCO), 70 lenses, 41 lightning, 15 Living With a Star (LWS), 37 LLOrionis, 119 Local Interstellar Cloud, 122

M

magnetic current sheet, 78 magnetic fields, 15, 19, 25, 31, 33, 35, 37, 38, 49, 51, 57, 63, 76, 77, 78, 79, 81, 83, 84, 85, 92, 110, 112, 116, 117, 123, 124 magnetic field lines, 51, 57, 79, 80, 81-92, 116 magnetic reconnection, 80, 89 magnetospheres, 13, 25, 35, 63, 112, 116 Magnetospheric Multiscale (MMS), 35 Mars, 13, 24, 25 Mercury, 24 Milky Way galaxy, 13, 25, 35, 63, 112, 113 Moon, 5, 13, 24, 44, 95, 96, 98, 99, 101, 104 moons (natural satellites), 13, 24

N

NASA missions, 30–41 Neptune, 27, 120 Nuclear Spectroscopic Telescope Array (NuSTAR), 33

O

obscura telescopy, 45, 47 Oort Cloud, 120 optics, 96 Orion Spur, 7

P

Parker Solar Probe, 4, 5, 8, 38, 124 particles, 4, 16, 25, 31, 37, 59, 63, 69, 84, 88, 89, 110, 112, 115, 116, 117, 123, 124 penumbra, 51, 95 Perseus arm, 7 photosphere, 20, 38, 67
planets, 8, 10, 12, 13, 22,
24–27, 31, 35, 45, 57,
116, 118, 120
planets, rocky, 24–2v5
plasma, 14, 15, 16, 25, 26,
33, 35, 37, 38, 61, 67, 83,
84, 86, 89, 90, 91, 92, 112,
115, 116, 123
polarity, 36, 41, 78, 81
poles, 28, 333, 54, 64, 79,
81, 110, 116
Population II, 10–11
Population III, 10–11
prominences, 12, 57, 67, 69

R

radiation, 13, 15, 31, 37, 86, 88, 106, 112, 117, 124 radiative zone, 16, 77 RHESSI, 33

S

Saturn, 26 scientific instruments, 5, 8, 24, 30, 31, 39, 41, 48, 70, 73, 88, 118, 124 Scheiner, Christopher, 44, 45 Scutum-Centaurus arm, 7 Solar and Heliospheric Observatory (SOHO), 31, 35, 49, 54, 69, 70, 71, 82, 91, 92, 93, 105 solar cycle, 42-55, 56, 62, 81 Solar Dynamic Observatory (SDO), 19, 33, 39, 50, 52, 53, 55, 85, 96, 98, 102 solar dynamo, 25, 76, 77 solar flare, 33, 35, 49, 86, 88, 89, 90, 91, 110 Solar Orbiter (SolO), 37 Solar Terrestrial Relations Observatory (STEREO), 31, 35, 104

solar maxima and minima, 90

solar wind, 24, 25, 31, 37, 59, 63, 78, 106, 112, 117, 124 space weather, 5, 88, 90–117 stars, 7, 8, 9, 10, 11, 13, 16, 33, 35, 40–41, 88, 118, 119, 120 sunspots, 5, 42–55, 62, 76, 79 Suomi NPP-VIIRS, 115 supergranules, 21 supernova, 10

T

tachocline, 16, 19, 77
telescopes, 5, 8, 20, 21, 33, 43, 44, 47, 70
The Big Bang, 11
transits, 22, 23, 35, 45, 94, 96, 102, 104, 105
transition region, 22, 23, 35, 38, 61
Transition Region and Coronal Explorer (TRACE), 35

U

Ulysses, 33 ultraviolet (UV), 20, 64, 71, 96 umbra, 51, 95 Uranus, 27

V

Van Allen radiation belt, 31, 37, 117 Van Allen Probes, 37 Venus, 13, 24, 25, 37, 102 Voyager 1 and 2, 35, 1121, 124

W

wavelength, 20, 60, 61, 71, 85, 89 Wide-field Imager for Solar Probe (WISPR), 8

\mathbf{Z}

Zirnstein, Eric, 124

AmherstMedia.com

- New books every month
- Books on all photography subjects and specialties
- Learn from leading experts in every field
- Buy with Amazon (amazon.com), Barnes & Noble (barnesandnoble.com), and Indiebound (indiebound.com)
- Follow us on social media at: facebook.com/AmherstMediaInc, twitter.com/AmherstMedia, or www.instagram.com/amherstmediaphotobooks

Other Books in This Series

The Earth

Take an amazing trek around the planet to examine its surface details, vast oceans, and atmospheric phenomena. Images from satellites, space stations, and historic NASA missions reveal incredible new stories and inspire a deeper understanding of the place we call home. \$24.95 list, 7x10, 128p, 180 color images, index, ISBN 978-1-68203-316-6.

Hubble in Space

Images from NASA's Hubble Space Telescope show the solar system, Milky Way, galaxies, and the far reaches of the universe up close like never before. See amazing details and explore the immense content of the universe. \$24.95 list, 7x10, 128p, 180 color images, index, ISBN 978-1-68203-300-5.

The Moon

Go on a virtual expedition to the moon to explore its mysterious beauty, compelling terrain, and scientific significance. Images taken from satellites, space stations, massive telescopes, and NASA missions reveal incredible new stories to inspire deeper understanding. \$24.95 list, 7x10, 128p, 180 color images, index, ISBN 978-1-68203-368-5.

Samsung Galaxy S21

asiminub

Samsung Galaxy' S21

by Bill Hughes

Samsung Galaxy® S21 For Dummies®

Published by: John Wiley & Sons, Inc., 111 River Street, Hoboken, NJ 07030-5774, www.wiley.com

Copyright © 2021 by John Wiley & Sons, Inc., Hoboken, New Jersey

Published simultaneously in Canada

No part of this publication may be reproduced, stored in a retrieval system or transmitted in any form or by any means, electronic, mechanical, photocopying, recording, scanning or otherwise, except as permitted under Sections 107 or 108 of the 1976 United States Copyright Act, without the prior written permission of the Publisher. Requests to the Publisher for permission should be addressed to the Permissions Department, John Wiley & Sons, Inc., 111 River Street, Hoboken, NJ 07030, (201) 748-6011, fax (201) 748-6008, or online at http://www.wiley.com/go/permissions.

Trademarks: Wiley, For Dummies, the Dummies Man logo, Dummies.com, Making Everything Easier, and related trade dress are trademarks or registered trademarks of John Wiley & Sons, Inc. and may not be used without written permission. Samsung Galaxy is a registered trademark of Samsung Electronics Company, Ltd. All other trademarks are the property of their respective owners. John Wiley & Sons, Inc. is not associated with any product or vendor mentioned in this book.

LIMIT OF LIABILITY/DISCLAIMER OF WARRANTY: THE PUBLISHER AND THE AUTHOR MAKE NO REPRESENTATIONS OR WARRANTIES WITH RESPECT TO THE ACCURACY OR COMPLETENESS OF THE CONTENTS OF THIS WORK AND SPECIFICALLY DISCLAIM ALL WARRANTIES, INCLUDING WITHOUT LIMITATION WARRANTIES OF FITNESS FOR A PARTICULAR PURPOSE. NO WARRANTY MAY BE CREATED OR EXTENDED BY SALES OR PROMOTIONAL MATERIALS. THE ADVICE AND STRATEGIES CONTAINED HEREIN MAY NOT BE SUITABLE FOR EVERY SITUATION. THIS WORK IS SOLD WITH THE UNDERSTANDING THAT THE PUBLISHER IS NOT ENGAGED IN RENDERING LEGAL, ACCOUNTING, OR OTHER PROFESSIONAL SERVICES. IF PROFESSIONAL ASSISTANCE IS REQUIRED, THE SERVICES OF A COMPETENT PROFESSIONAL PERSON SHOULD BE SOUGHT. NEITHER THE PUBLISHER NOR THE AUTHOR SHALL BE LIABLE FOR DAMAGES ARISING HEREFROM. THE FACT THAT AN ORGANIZATION OR WEBSITE IS REFERRED TO IN THIS WORK AS A CITATION AND/OR A POTENTIAL SOURCE OF FURTHER INFORMATION DOES NOT MEAN THAT THE AUTHOR OR THE PUBLISHER ENDORSES THE INFORMATION THE ORGANIZATION OR WEBSITE MAY PROVIDE OR RECOMMENDATIONS IT MAY MAKE. FURTHER, READERS SHOULD BE AWARE THAT INTERNET WEBSITES LISTED IN THIS WORK MAY HAVE CHANGED OR DISAPPEARED BETWEEN WHEN THIS WORK WAS WRITTEN AND WHEN IT IS READ.

For general information on our other products and services, please contact our Customer Care Department within the U.S. at 877-762-2974, outside the U.S. at 317-572-3993, or fax 317-572-4002. For technical support, please visit https://hub.wiley.com/community/support/dummies.

Wiley publishes in a variety of print and electronic formats and by print-on-demand. Some material included with standard print versions of this book may not be included in e-books or in print-on-demand. If this book refers to media such as a CD or DVD that is not included in the version you purchased, you may download this material at http://booksupport.wiley.com. For more information about Wiley products, visit www.wiley.com.

Library of Congress Control Number: 2021934056

ISBN 978-1-119-81435-1 (pbk); ISBN 978-1-119-81436-8 (ebk); ISBN 978-1-119-81437-5 (ebk)

Manufactured in the United States of America

SKY10028674_080221

Contents at a Glance

Introduction	1
Part 1: Getting Started with the Samsung Galaxy S21 CHAPTER 1: Exploring What You Can Do with Your Phone	9
Part 2: Communicating with Other People CHAPTER 3: Calling People CHAPTER 4: Discovering the Joy of Text CHAPTER 5: Sending and Receiving Email CHAPTER 6: Managing Your Contacts	47 61 71
Part 3: Living on the Internet CHAPTER 7: You've Got the Whole (Web) World in Your Hands CHAPTER 8: Playing in Google's Play Store	107
Part 4: Having Fun with Your Phone CHAPTER 9: Sharing Pictures CHAPTER 10: Creating Videos CHAPTER 11: Playing Games CHAPTER 12: Playing Music and Videos	133
Part 5: Getting Down to Business CHAPTER 13: Using the Calendar CHAPTER 14: Mapping Out Where You Want to Be CHAPTER 15: Paying with Samsung Pay	201
Part 6: The Part of Tens CHAPTER 16: Ten Ways to Make Your Phone Totally Yours CHAPTER 17: Ten (Or So) Ways to Make Your Phone Secure CHAPTER 18: Ten Features to Look for Down the Road.	247
Index	. 291

contents at a Glance

	noir subastini
	Fact it getting started with the Samsung Gelaxy S2
	course. Explaine When you han Lo with your Phone
	and the second section of the second
Part Same	Part 2: Communicating with Other Replace
14	Programme College Propose section (College Propose section)
	and the second of the second o
1 X	2
26	TOTAL CONTROL OF THE
	Fig. 3: Liwing on the facement
	SELECT BUT I SICY OF LITTLE SAME HOW OF THE PROPERTY OF THE PR
e etr.	elumente (de la comitación Georgies Play Store que la Comitación de securidad de la Comitación de la Comitac
	Port of Having Fundam Your Phone
	The second of th
Trace.	
	southly promited that the same of the second
VB	Part is Getting Down to Eustness
	en na actività de la como de la c
3.5	of search as the policy of the Whole Property of Configuration
2850.	Part 6: Pho Part of Tens
	commission Lea Waysate Make Your Phone Littally Yourse Lamber and Lamber
(B);	Ten (C. 1.0) Way to Miller Your Prince Struck
C25	CHAPPER BY THE BUTTER TO LOOK FOR TOWARD THE PROOF THE WARD
fe1,	nation in the second second

Table of Contents

INTRO	DUCTION	1
	About This Book. Foolish Assumptions. Icons Used in This Book Beyond the Book Where to Go from Here	.3
	GETTING STARTED WITH THE NG GALAXY S21	7
	Exploring What You Can Do with Your Phone Discovering the Basics of Your Phone Taking Your Phone to the Next Level: The Smartphone Features Internet access Photos Wireless email Multimedia Customizing Your Phone with Games and Applications Downloading games Downloading applications What's cool about the Android platform 1	910112131313131414
	Surviving Unboxing Day	
	Beginning at the Beginning	19 21 26 26 29 34 38 39 41 42 43
PART 2	COMMUNICATING WITH OTHER PEOPLE4	15
	Calling People 4 Making Calls 4 Answering Calls 5	17
	Keeping Track of Your Calls: The Recents5	

	Making an Emergency Call: The 411 on 911
CHAPTER 4:	Discovering the Joy of Text.61Sending the First Text Message.61Carrying on a Conversation via Texting.66Sending an Attachment with a Text.68Receiving Text Messages.69Managing Your Text History.69
CHAPTER 5:	Sending and Receiving Email71Setting Up Your Email71Getting ready72Setting up your existing Gmail account73Setting up a new Gmail account75Working with non-Gmail email accounts76Setting up a corporate email account82Reading Email on Your Phone84Writing and Sending Email85Replying to and Forwarding Email87
CHAPTER 6:	Managing Your Contacts89Using the Galaxy S21 Contacts App90Learning the Contacts App on your phone90Deciding where to store your contacts92Linking Contacts on your phone96Creating Contacts within Your Database99Adding contacts as you dial99Adding contacts manually101How Contacts Make Life Easy102Playing Favorites104
PART 3	B: LIVING ON THE INTERNET105
CHAPTER 7:	You've Got the Whole (Web) World in Your Hands

CHAPTER 8: Playing in Google's Play Store115
Exploring the Play Store: The Mall for Your Phone
PART 4: HAVING FUN WITH YOUR PHONE
CHAPTER 9: Sharing Pictures
Say Cheese! Taking a Picture with Your Phone
CHAPTER 10: Creating Videos
CHAPTER 11: Playing Games
The Play Store Games Category 164 The Games Home screen 165 The Games Categories tab 166 Leaving Feedback on Games 169
CHAPTER 12: Playing Music and Videos
Getting Ready to Be Entertained
Licensing Your Multimedia Files

Using the Full Capacity of the Memory in Your Phone	182 182 187 190
PART 5: GETTING DOWN TO BUSINESS	199
CHAPTER 13: Using the Calendar Syncing Calendars Setting Calendar Display Preferences Setting Other Display Options Creating an Event on the Right Calendar Creating, editing, and deleting an event Keeping events separate and private	201 203 206 208 208
CHAPTER 14: Mapping Out Where You Want to Be GPS 101: First Things First	216 217 218 221 224
CHAPTER 15: Paying with Samsung Pay How Mobile Payment Works Getting Started with Samsung Pay Setting Up Samsung Pay Using Samsung Pay Managing Samsung Pay Adding Loyalty Cards	230 232 234 238 240
PART 6: THE PART OF TENS.	245
CHAPTER 16: Ten Ways to Make Your Phone Totally Yours. 2 Using a Bluetooth Speaker. 2 Cruising in the Car. 2 Considering Wireless Charging Mats 2 Making a Statement with Wraps 2 You Look Wonderful: Custom Screen Images. 2 Empowering Power Savings. 2 Controlling Your Home Electronics. 2 Wearing Wearables 2 Using Your Phone as a PC 2	248 249 251 252 253 255 256 257 259
Creating Your Own AR Emoii in the AR Zone	59

CHAPTER 17	r: Ten (Or So) Ways to Make Your Phone Secure	263
	Using a Good Case	
	Putting It on Lockdown	
	Preparing for your Screen Lock option	
	Selecting among the Screen Lock options	
	Entering your face	271
	Entering your fingerprints	273
	Creating a Secure Folder	
	Using Knox to Make Your Phone as Secure as Fort Knox	
	Being Careful with Bluetooth	
	Protecting against Malware	
	Downloading Apps Only from Reputable Sources	
	Rescuing Your Phone When It Gets Lost	
	Wiping Your Device Clean	282
CHAPTER 18	E: Ten Features to Look for Down the Road	283
	Your Medical Information Hub	283
	Better 911 Services	
	Home Internet of Things Services to Differentiate Real Estate	
	New Delivery Concepts	
	Smarter Customer Care for Your Phone	286
	Smartphone as Entertainment Hub	
	Driving in Your Car	
	Serving You Better	
	Placing You Indoors	
	Reducing Your Carbon Footprint	290
INDEX	(. 291

FAT IS STUDBLESS	Ten (Or So) Ways to Make Your Rho	O CETTORIE
400		
	r, and the second of the second secon	
	noing Value Mena 2 proyect garagers	
	Selecting among the Society pour pytions	
488.00	Eugenag your face	
prompt La Void Contract of the	Spreading you in genganits as a second	
	Gestion a Secure volder	
TYLE TO YOUR P	stissing Peroxic Make Your Phonicist Berne as feet	
	nower of the second second	
	Reserved Server Phangasys ones Geschenker	
	riviging Your Bevice clean Courses.	
	Ten Features to Look for Davin that	
	and graphical during factorism technical arox	
NO.		
2005 g		
	Search Consumptification of the control of the	
	the state of the s	
	Reducing Yapi Carbon Policy in a Secretary	

Introduction

he Samsung Galaxy S21 5G, S21+ 5G, and S21 Ultra 5G are powerful smartphones, among the most powerful mobile phones ever sold. As of the publication of this book, the Galaxy S21s are the standard against which all other Android-based phones are measured.

Each cellular carrier offers a slightly customized version of the Galaxy S21 lineup. Some phones from cellular carriers come out of the box with preloaded applications, games, or files. This book doesn't dwell on these kinds of differences.

The name for each network is different, these phones are largely the same. (At least one marketing person at each cellular carrier is cringing as you read this.) This similarity allows me to write this book in a way that covers the common capabilities.

At a more core level, these phones are built for high-speed wireless communications, in particular the 5G networks you're seeing in ads. The cellular carriers have spent kajillions upgrading their networks to offer more coverage and better data speeds than their competition. Again, this book doesn't dwell on these differences in network technology because they don't really make much difference in ways that you can see in a book. (Again, at least one engineering person at each cellular carrier is cringing as you read this.)

Similarly, most of the capabilities among the different Galaxy S21 models are similar. The S21+ has a bigger screen and a bigger battery than the S21. Similarly, the S21 Ultra has a bigger screen with higher resolution, a bigger battery, and more camera capabilities than its little brothers. Actually, that's putting it mildly. The S21 Ultra has oh-my-goodness-you-cannot-be-serious kind of camera capabilities compared to every other mobile phone in the known universe. Otherwise, the three versions of the Galaxy S21 are practically identical. When there is an important distinction between the S21 5G, the S21+ 5G, and the S21 Ultra 5G, I mention it. Otherwise, I just call the phone the Galaxy S21 or just S21.

I assume that you already have a Galaxy S21, and I just hope that you have good coverage where you spend more of your time with your phone. If so, you'll be fine. If not, you need to switch to another network; otherwise, the experience

with your phone will be frustrating. I would advise you to return your phone to that carrier and buy your Galaxy S21 at another cellular carrier. As long as you have good cellular data coverage, owning a Samsung Galaxy S21 will be an exciting experience!

First, in much the same way that different brands of PCs are all based on the Microsoft Windows operating system, all Galaxy S phones use the Google Android platform. The good news is that the Android platform has proven to be widely popular, even more successful than Google originally expected when it first announced Android in November 2007. More people are using Android-based phones, and more third parties are writing applications. This is good news because it offers you more options for applications (more on this in Chapter 8 on the Play Store, where you buy applications).

In addition, all Galaxy S21 phones use a powerful graphics processor, employ Samsung's Super AMOLED touchscreen, and are covered in Corning's Gorilla Glass. The superior screen differentiates this product line from other Android phones. Because of these enhanced capabilities, you can navigate around the screen with multi-touch screen gestures with ease. Plus, the videos look stunning from many angles.

Smartphones are getting smarter all the time, and the Galaxy S21 is one of the smartest. However, just because you've used a smartphone in the past doesn't mean you should expect to use your new Galaxy S21 without a bit of guidance.

You may not be familiar with using a multi-touch screen, and your new phone offers a lot of capabilities that you may or may not be familiar with. There used to be a physical button on the front to bring you back to the Home screen. It's no longer a physical button; instead, it's now software based. It would be unfortunate to find out from a kid in the neighborhood that the phone you've been carrying around for several months could solve a problem you've been having because you were never told that the solution was in your pocket the whole time.

In fact, Samsung is proud of the usability of its entire Galaxy lineup — and proud that the user's manual is really just a quick start guide. You can find lots of instructions on the web. However, you have to know what you don't know to get what you want unless you plan to view every tutorial.

That's where this book comes in. This book is a hands-on guide to getting the most out of your Galaxy S21.

About This Book

This book is a reference — you don't have to read it from beginning to end to get all you need out of it. The information is clearly organized and easy to access. You don't need thick glasses to understand this book. This book helps you figure out what you want to do — and then tells you how to do it in plain English.

Within this book, you may note that some web addresses break across two lines of text. If you're reading this book in print and want to visit one of these web pages, simply key in the web address exactly as it's noted in the text, pretending as though the line break doesn't exist. If you're reading this as an e-book, you've got it easy — just click the web address to be taken directly to the web page.

Foolish Assumptions

You know what they say about assuming, so I don't do much of it in this book. But I do make a few assumptions about you:

- >> You have a Galaxy S21 phone. You may be thinking about buying a Galaxy S21 phone, but my money's on your already owning one. After all, getting your hands on the phone is the best part!
- >> You're not totally new to mobile phones. You know that your Galaxy S21 phone is capable of doing more than the average phone, and you're eager to find out what your phone can do.
- >> You've used a computer. You don't have to be a computer expert, but you at least know how to check your email and surf the web.

Icons Used in This Book

Throughout this book, I used *icons* (little pictures in the margin) to draw your attention to various types of information. Here's a key to what those icons mean:

This whole book is like one big series of tips. When I share especially useful tips and tricks, I mark them with the Tip icon.

TIP

REMEMBER

This book is a reference, which means you don't have to commit it to memory—there is no test at the end. But once in a while, I do tell you things that are so important that I think you should remember them, and when I do, I mark them with the Remember icon.

,

Whenever you may do something that could cause a major headache, I warn you with the, er, Warning icon.

TECHNICA

These sections provide a little more information than is necessary to use your phone. The hope is that these sections convey extra knowledge to help you understand what is going on when things go wrong, or at least differently than you might have expected.

Beyond the Book

In addition to what you're reading right now, this product also comes with a free access-anywhere Cheat Sheet. To get to this Cheat Sheet, simply go to www.dummies.com and type Samsung Galaxy S21 For Dummies Cheat Sheet in the Search box.

Where to Go from Here

You don't have to read this book from cover to cover. You can skip around as you like. For example, if you need the basics on calling, texting, and emailing, turn to Part 2. To discover more about photos, games, and apps, go to Part 4.

Many readers are already somewhat familiar with smartphones and won't need the basic information found in Parts 1 and 2. A reasonably astute mobile phone user can figure out how to use the phone, text, and data capabilities. Parts 1, 2, and 3 are not for those readers. For them, I recommend skipping ahead to the chapters in Parts 4 through 6.

Former iPhone users, on the other hand, are a special case. (First, welcome to the world of Android!) The reality is that the iPhone and Galaxy S series have very similar capabilities, but these functions are just done in slightly different ways and emphasize different approaches to the similar problems. iPhone users, don't

worry if you find that this book spends a fair amount of time explaining capabilities with which you're familiar. You can read through those chapters quickly, focus on the *how* instead of the description of *what*, and bypass potential frustration.

Current Samsung Galaxy S9, S10, and S20 users are also a special case. The Samsung Galaxy S21 is very similar to the earlier Galaxy S phones in many ways. Galaxy S21 operates mostly like these earlier models, but has improvements in usability, power consumption, and performance. Plus, the camera has even more capabilities (if you can believe it!). If you're comfortable with the earlier Galaxy models and now have a Galaxy S21, Chapters 15 and beyond will be of interest to you.

The majority of readers of this book are actually very astute and get the fact that this book covers the basics of using the Samsung Galaxy S21. A subset of readers complain in Internet reviews that a *For Dummies* book is too basic. If you do this, people will know that you did not read the title. Be sure to read the title and avoid public embarrassment.

Venty if you imposhed this bookspreads a felr amount of three exoluting expendit tigs with which you're landing. You can read according these enapters questly, for a go, the sex series of the designifies of sales, and bugsas. The charten

Contract Someting Calasty Str. Str., and see hear are plso a second base, the Summing Calasty Summing Calasty and the carbon Galasty of process manage wave. Calasty Str. , contract monethy like those carbon sunded but has are proveduntally assume a contract and preferred to the carbon source a base even more capabilities (if you can the calasty in the carbon as allowed models and managed and managed the calasty and the calasty and the calasty of the calasty and calasty.

The midpatter of take actificities be all are actively only licitive and get also that the constant of the beautiful of the constant of the co

Getting Started with the Samsung Galaxy S21

IN THIS PART . . .

Review the capabilities of cellphones and what sets smartphones apart.

Turn off your phone and manage sleep mode.

- » Understanding what sets smartphones apart
- » Mapping out what makes Samsung Galaxy S21 phones so cool
- » Getting you prepared to enjoy your phone

Chapter **1**

Exploring What You Can Do with Your Phone

hether you want just the basics from a mobile phone (make and take phone calls, customize your ringtone, take some pictures, maybe use a Bluetooth headset) or you want your phone to be always by your side (a tool for multiple uses throughout your day), you can make that happen. In this chapter, I outline all the things your Samsung Galaxy S21 can do — from the basics to what makes Galaxy S21 phones different from the rest.

Discovering the Basics of Your Phone

All mobile phones on the market today include basic functions, and even some entry-level phones are a little more sophisticated. Of course, Samsung includes all basic functions on the Galaxy S21 model. In addition to making and taking calls (see Chapter 3) and sending and receiving texts (see Chapter 4), the Galaxy S21 sports the following basic features:

>> 64MP digital camera: This resolution is for the S21 and S21+. The S21 Ultra has a mind-boggling 108MP. The mere 64MP is far more than is needed for

posting good-quality images on the Internet. It is about right for making 24-x-36 posters that are photo quality. There is also a front-facing camera with 10MP that is useful for videoconference calls and selfies along with some combination of specialty lenses, depending upon the model. Your phone has some amazing capabilities (see Chapter 9 for more information on cameras and photographs and Chapter 10 on videos).

- >>> Ringtones: You can replace the standard ringtone with custom ringtones that you download to your phone. You also can specify different rings for different numbers.
- >> Bluetooth: The Galaxy S21 phone supports stereo and standard Bluetooth devices. (See Chapter 3 for more on Bluetooth.)
- High-resolution screen: The Galaxy S21 and the S21+ have screen resolutions of 2,400 x 1,080 pixels. The S21 Ultra offers the highest-resolution touchscreen on the market (3,200 x 1,440 pixels).
- Capacitive touchscreen: The Galaxy S21 phone offers a very slick touchscreen that's sensitive enough to allow you to interact with the screen accurately, but not so sensitive that it's hard to manage. In addition, it has an optional setting that adjusts the sensitivity for special circumstances, like when you want to use one hand or add a screen protector!

Taking Your Phone to the Next Level: The Smartphone Features

In addition to the basic capabilities of any entry-level phone, the Galaxy S21, which is based on the popular Android platform for mobile devices, has capabilities associated with other smartphones, such as the Apple iPhone:

- >> Internet access: Access websites through a web browser on your phone.
- >> Wireless email: Send and receive email from your phone.
- >> Multimedia: Play music and videos on your phone.
- >>> Contact Manager: The Galaxy S21 lets you take shortcuts that save you from having to enter someone's ten-digit number each time you want to call or text a friend. In fact, the Contact Manager can track all the numbers that an individual might have, store an email address and photo for the person, and synchronize with the program you use for managing contacts on both your personal and work PCs!

- >> Digital camcorder: The Galaxy S21 comes with a built-in digital camcorder that records live video at a resolution that you can set, including 4K/UHD (ultra-high definition, which is the resolution that is available on the newest televisions). If you want to future-proof your videos, you can even select 8K for when you obtain a TV that operates at this resolution.
- >> Mapping and directions: The Galaxy S21 uses GPS (Global Positioning System) along with other complementary positioning systems to tell you where you are, find local services that you need, and give you directions to where you want to go.
- >> Fitness information: The Galaxy S21 automatically tracks important health information within the phone and with external sensors.
- **>> Business applications:** The Galaxy S21 can keep you productive while you're away from the office.

I go into each of these capabilities in greater detail in the following sections.

Internet access

Until a few years ago, the only way to access the Internet when you were away from a desk was with a laptop. Smartphones are a great alternative to laptops because they're small, convenient, and ready to launch their web browsers right away. Even more important, when you have a smartphone, you can access the Internet wherever you are — whether Wi-Fi is available or not.

The drawback to smartphones, however, is that their screen size is smaller than that of even the most basic laptop. On the Galaxy S21 phone, you can use the standard version of a website if you want. You can pinch and stretch your way to get the information you want. (See Chapter 2 for more information on pinching and stretching. For more information on accessing the Internet from your Galaxy S21 phone, turn to Chapter 7.)

To make things a bit easier, most popular websites offer an easier-to-use app that you can download and install on your phone. This is discussed in detail in Chapter 8. Essentially, the website reformats the information from the site so that it's easier to read and navigate in the mobile environment. Figure 1-1 compares a regular website with the app version of that website.

Full Web Page

Mobile App Home Page

FIGURE 1-1:
A website and the app version of the main site.

Photos

The image application on your phone helps you use the digital camera on your Galaxy S21 phone to its full potential. It would almost make sense to call the Samsung Galaxy S21 a smart camera with a built-in phone! There are all kinds of smarts in these applications that automatically figure out what you're trying to do and make it so that you're suddenly the next Ansel Adams.

Studies have found that cellphone users tend to snap a bunch of pictures within the first month of phone usage. After that, the photos sit on the phone (instead of being downloaded to a computer), and the picture-taking rate drops dramatically.

The Galaxy S21 image management application is different. You can integrate your camera images into your home photo library, as well as photo-sharing sites such as Google Photos and Instagram, with minimal effort.

For more on how to use the Photo applications, turn to Chapter 9.

Wireless email

On your Galaxy S21 smartphone, you can access your business and personal email accounts, reading and sending email messages on the go. Depending on your email system, you might be able to sync so that when you delete an email on your phone, the email is deleted on your computer at the same time so that you don't have to read the same messages on your phone and your computer.

Chapter 5 covers setting up your business and personal email accounts.

Multimedia

Some smartphones allow you to play music and videos on your phone. On the Galaxy S21, you can use the applications that come with the phone, or you can download applications that offer these capabilities from the Play Store.

Chapter 12 covers how to use the multimedia services with your Galaxy S21 phone.

Customizing Your Phone with Games and Applications

Application developers — large and small — are working on the Android platform to offer a variety of applications and games for the Galaxy S21 phone. Compared to the other smartphone platform, Google imposes fewer restrictions on application developers regarding what's allowable. This freedom to develop resonates with many developers — resulting in a bonanza of application development on this platform.

As of this writing, more than three million applications are available from Google's Play Store. For more information about downloading games and applications, turn to Chapter 8.

Downloading games

Chapter 11 of this book is for gamers. Although your phone comes with a few general-interest games, you can find a whole wide world of games for every skill and taste. In Chapter 11, I give you all the information you need to set up different gaming experiences. Whether you prefer stand-alone games or multiplayer games, you can set up your Galaxy S21 phone to get what you need.

Downloading applications

Your phone comes with some very nice applications, but these might not take you as far as you want to go. You might also have some special interests, such as philately or stargazing, that neither Samsung nor your carrier felt would be of sufficient general interest to include on the phone. (Can you imagine?)

Your phone also comes with preloaded *widgets*, which are smaller applications that serve particular purposes, such as retrieving particular stock quotes or telling you how your phone's battery is feeling today. Widgets reside on the extended Home screen and are instantly available.

Buying applications allows you to get additional capabilities quickly, easily, and inexpensively. Ultimately, these make your phone, which is already a reflection of who you are, even more personal as you add more capabilities.

What's cool about the Android platform

The Samsung Galaxy S21 is a top-of-the-line Android phone. That means you can run any application developed for an Android phone to its full capability. This is significant because one of the founding principles behind the Android platform is to create an environment where application developers can be as creative as possible without an oppressive organization dictating what can and cannot be sold (as long as it's within the law, of course). This creative elbow room has inspired many of the best application developers to go with Android first.

TAKE A DEEP BREATH

You don't have to rush to implement every feature of your Galaxy S21 phone the very first day you get it. Instead, pick one capability at a time. Digest it, enjoy it, and then tackle the next one.

I recommend starting with setting up your email and social accounts, but that's just me.

No matter how you tackle the process of setting up your Galaxy S21 phone, it'll take some time. If you try to cram it all in on the first day, you'll turn what should be fun into drudgery.

The good news is that you own the book that takes you through the process. You can do a chapter or two at a time.

WHAT IF I DIDN'T GET MY PHONE FROM A CELLULAR COMPANY?

With a few exceptions, such as an "unlocked" phone, each phone is associated with a particular cellular company. (In this context, a *locked* phone can work only on its original carrier.) Maybe you bought a secondhand phone on eBay, or you got a phone from a friend who didn't want his anymore. If you didn't get your phone directly from a cellular provider, you will need to figure out which provider the phone is associated with and get a service plan from that company.

If there's no logo on the front, you'll have to figure out which cellular carrier it can work with. The quickest way is to take the phone to any cellular store; the folks there know how to figure it out.

In addition, Android is designed to run multiple applications at once. Other smartphone platforms have added this capability, but Android is designed to let you to jump quickly among the multiple apps that you're running — which makes your smartphone experience that much smoother.

Surviving Unboxing Day

When you turn on your phone the first time, it will ask you a series of ten questions and preferences to configure it. Frankly, they are trying to make this book unnecessary and put me out of business. The nerve!

The good folks at Samsung are well-intentioned, but not every customer who owns a Samsung Galaxy S21 knows, from day one, whether he or she wants a Samsung account, what's a good name for the phone, or what the purpose of a cloud service, such as Dropbox, is and how it would be used.

You can relax. I help you answer these questions — or, when appropriate, refer you to the chapter in this book that helps you come up with your answer.

On the other hand, if your phone is already set up, you probably took a guess or skipped some questions. Maybe now you're rethinking some of your choices. No problem. You can go back and change any answer you gave and get your phone to behave the way you want.

The following are the kinds of questions you may be asked. These questions may come in this order, but they may not. They typically include the following:

- >> Language/Accessibility: This option lets you select your language. The default is English for phones sold within the United States. Also, the phone has some special capabilities for individuals with disabilities. If you have a disability and think you might benefit, take a look at these options. They have really tried to make this phone as usable as possible for as many folks as possible.
- >> Wi-Fi: Your phone automatically starts scanning for a Wi-Fi connection. You can always use the cellular connection when you are in cellular coverage, but if there is a Wi-Fi connection available, your phone will try to use this first. It is probably cheaper and may be faster than the cellular.
 - At the same time, you may not want your phone to connect to the Wi-Fi access point with the best signal. It could be that the strongest signal is a fee-based service, whereas the next best signal is free. In any case, this page scans the available options and presents them to you.
- >> Date and Time: This is easy. The default setting is to use the time and date that comes from the cellular network and the date and time format is the U.S. style. Just tap on the next button and move on. This date and time from the cellular network is the most accurate information you'll get, and you don't need to do anything other than be within cellular coverage now and again. If you prefer non-U.S. formatting, such as a 24-hour clock or day/month/year formatting, you can change your phone any way you want.
- Sign Up for a Samsung Account: Go ahead and sign up for an account. The Samsung account offers you some nice things to help you get your phone back should you lose it. All you need is an account name, such as an email account, and a password.

TIP

When you buy a Galaxy S21 smartphone, you are now a customer of multiple companies! These include Samsung for the phone hardware, Google for the phone operating system (Android), and the wireless carrier that provides the cellular service. Plus, if you bought the phone through a phone retailer, such as Best Buy, it is in the mix as well. All of them want to make you happy, which is a good thing for the most part. The only downside is that they want to know who you are so that they can provide you with more services. Don't worry. You control how much they offer you.

>> Google Account Sign-up: Google account can means an email account where the address ends in @gmail.com. If you already have an account on Gmail, enter your user ID and password on your phone. If you don't have a Gmail account, I suggest waiting until you read Chapter 5. The good news is that you

can use your existing email account. I highly recommend that you create a Google account, but it can wait until you read Chapter 5.

>> Location Options: Your phone knowing your location and providing it to an application can be sensitive issue.

If you're really worried about privacy and security, tap the green check marks on the screen and then tap the button that says Next. Selecting these options prevents applications from knowing where you are. (This choice also prevents you from getting directions and a large number of cool capabilities that are built into applications.) The only folks who'll know your location will be the 911 dispatchers if you dial them.

If you're worried about your security but want to take advantage of some of the cool capabilities built into your phone, tap the right arrow key to move forward. Remember, you can choose on a case-by-case basis whether to share your location. (I cover this issue in Chapter 17.)

- >> Phone Ownership: This screen asks you to enter your first and last name. Go ahead and put in your real name. If you want to know more, read Chapter 5.
- >> Setting Up Voicemail: Your cellular carrier manages the voicemail service that comes with your phone. If you're simply upgrading your phone but staying with the same carrier, you don't need to change your voicemail. If you're new to this carrier, you'll probably want to set up a new voicemail message. If you want to know more, read Chapter 3.
- Solution Services: The chances are that you will be offered the option to sign up for a cloud service where you can back up your phone and get access to a gazillion MB of free storage. This can be a tricky decision. You could sign up for every cloud service that comes along. Then you need to remember where you stored that critical file. You could sign up for one, and you may miss a nice capability that is available on another. You could have one cloud service for work and another for personal. Here is what I recommend: Sign up for whatever is the cloud service your phone offers during this initial setup process if you do not already have one. You will see what it is later. If you are happy with a cloud service you already have, such as Dropbox or OneDrive, chances are, they will have all the services you need for you and your phone. You can link your Galaxy S21 to this service by downloading the necessary app (which I cover how to do in Chapter 8).
- >> Learn about Key Features: If you think you don't need this book, go ahead and take this tour of all the new things you can do. If you think you might need this book in any way, shape, or form, tap the Next button. This screen is for setting up the coolest and the most sophisticated capabilities of the phone. I cover many of them in this book.

>> Device Name: When this screen comes up, you'll see a text box that has the model name. You can keep this name for your phone, or you can choose to personalize it a bit. For example, you can change it to "Bill's Galaxy S21" or "Indy at 425-555-1234." The purpose of this name is for connecting to a local data network, as when you're pairing to a Bluetooth device. If this last sentence made no sense to you, don't worry about it. (I go over all of this in Chapter 3.) Tap Finish. In a moment, you see the Home screen, as shown in

FIGURE 1-2: The Home screen for the Samsung Galaxy S21.

- » Turning on your phone
- Charging the phone and managing battery life
- » Navigating your phone
- Turning off your phone and using sleep mode

Chapter 2

Beginning at the Beginning

n this chapter, I fill you in on the basics of using your new Samsung Galaxy S21. You start by turning on your phone. (I told you I was covering the basics!) I guide you through charging your phone and getting the most out of your phone's battery. Stick with me for a basic tour of your phone's buttons and other features. Then I end by telling you how to turn off your phone or put it in "sleep" mode.

TIP

Unless you're new to mobile phones in general — and smartphones in particular — you might want to skip this chapter. If the term "smartphone" is foreign to you, you probably haven't used one before, and reading this chapter won't hurt. And, just so you know, a *smartphone* is just a mobile phone on which you can download and run applications that are better than what comes preloaded on a phone right out of the box.

First Things First: Turning On Your Phone

When you open the box of your new phone, the packaging will present you with your phone, wrapped in plastic, readily accessible. If you haven't already, take the phone out of the box and remove any protective covering material on the screen. (There is no need to keep the plastic. It is not an effective screen protector!)

First things first. The Power button is on the right side of the phone. You can see where in Figure 2-1. Press the Power button for a second and see whether it vibrates and the screen lights up. Hopefully, your phone arrived with enough electrical charge that you won't have to plug it into an outlet right away. You can enjoy your new phone for the first day without having to charge it.

FIGURE 2-1: The Power button on the Galaxy S21.

The phones that you get at the stores of most cellular carriers usually come with the battery partially charged and registered with the network.

If the screen does light up, don't hold the Power button too long, or the phone might turn off.

If the phone screen doesn't light up (rats!), you need to charge the battery. That means that you have to wait to use your beautiful new phone. Sorry.

THE NITTY-GRITTY OF HOW YOUR PHONE WORKS

As soon as you turn on your phone, several things happen. As the phone is powering up, it begins transmitting information to (and receiving information from) nearby cellular towers. The first information exchanged includes your phone's electronic serial number. Every cellphone has its own unique serial number built into the hardware of the phone; the serial number in current-generation cellphones can't be duplicated or used by any other phone.

This electronic serial number is long. Cellular equipment is fine with long numbers. We mere mortals have enough trouble remembering 10-digit numbers, even with the hack of having only a limited number of area codes. To help us out, you and I get to use the shorter number and the cellular equipment happily keeps track of the 10-digit and the long device serial numbers and shows us only what we can handle.

It doesn't matter to the phone or the cellular tower if you're near your home when you turn on your phone — and that's the joy of mobile phones. All cellular networks have agreements that allow you to use cellular networks in other parts of the country and, sometimes, around the world.

That said, a call outside your cellular provider's own network may be expensive. Within the United States, many service plans allow you to pay the same rate if you use your phone anywhere in the United States to call anywhere in the United States. If you travel outside the United States, even to Canada, you might end up paying through the nose. *Remember:* Before you leave on a trip, check with your cellular carrier about your rates. Even if you travel internationally only a few times yearly, a different service plan may work better for you. Your cellular carrier can fill you in on your options.

Charging Your Phone and Managing Battery Life

To charge your phone, you need a battery charger. The most basic kind is a two-piece battery charger (cable and the transformer), as shown in Figure 2-2. (These used to come with the phone, but that's no longer the case.) Battery chargers are readily available at the store where you bought your phone.

The cable has two ends: one end that plugs into the phone, and the other that's a standard rectangular USB connector. The phone end is a small connector called a *USB-C* that is used on many Samsung devices and is the standard for charging cellphones and other small electronics — and for connecting them to computers.

FIGURE 2-2: The transformer and USB cable for charging your phone.

suradech123yim/Shutterstock

TIP

One cool thing you will notice about the USB-C connector is that you can insert it either side up. The older, rectangular USB-A connector probably drove you crazy because it wouldn't go in if you had the plug upside down. You still have that problem with the wall charger and cable, but you won't have the problem with the cable and phone!

To charge the phone, you have two choices:

- >> Plug the transformer into a wall socket and then plug the cable's USB plug into the USB receptacle in the transformer. This is the option I recommend.
- >> Plug the USB on the cable into a USB port on your PC.

Then you plug the small end of the cable into the phone. The port is on the bottom of the phone. Make sure that you push the little metal plug all the way in.

.......

TIP

It doesn't really matter in what order you plug in things. However, if you use the USB port on a PC, the PC needs to be powered on for the phone to charge.

Your phone will charge faster with a Samsung wall charger that has Adaptive Fast Charging on it. When the wall charger or car charger has Adaptive Fast Charging, it knows if the phone is getting too warm and slows down the speed of charging. Because the charging speed can slow down, it can go faster the rest of the time.

If your phone is off when you're charging the battery, an image of a battery appears onscreen for a moment. The green portion of the battery indicates the amount of charge within the battery. You can get the image to reappear with a

quick press of the Power button. This image tells you the status of the battery without your having to turn on the phone.

If your phone is on, you see a small battery icon at the top of the screen showing how much charge is in the phone's battery. When the battery in the phone is fully charged, it vibrates to let you know that it's done charging.

Depending upon the circumstances, it can take less than an hour to go from a dead battery to a fully charged battery. You don't need to wait for the battery to be fully charged. You can partially recharge and run if you want.

You'll hear all kinds of "battery lore" left over from earlier battery technologies. For example, Lithium-polymer (LiPo) batteries in your S21 don't have a "memory" (a bad thing for a battery) as nickel-cadmium (NiCad) batteries did. That means that you don't have to make sure that the battery fully discharges before you recharge it. In fact, you want to avoid fully discharging the battery if you can avoid it.

In addition to the transformer and USB cable that come with the phone, you have other optional charging tools:

- >> USB travel charger: If you already have a USB travel charger, you can leave the transformer at home. This accessory will run you about \$15. You still need your cable, although any USB-to-USB-C cable should work.
- Car charger: You can buy a charger with a USB port that plugs into the power socket/cigarette lighter in a car. This is convenient if you spend a lot of time in your car. The list price is \$30, but you can get the real Samsung car charger for less at some online stores.
- >> Portable external charger: You can buy a portable external charger that you can use to recharge your phone without having to plug into the power socket or cigarette lighter in a car. You charge this gizmo before your travel and connect it only when the charge in your phone starts to get low. These usually involve rechargeable batteries, but some of these products use photovoltaic cells to transform light into power. As long as there is a USB port (the female part of the USB), all you need is your cable. These chargers can cost from \$30 to \$100 on up. See some options in Figure 2-3.
- >> Wireless charger: This option is slick. You simply put your phone on a charging mat or in a cradle, and the phone battery will start charging! Your Galaxy S21 uses the widely adopted Qi standard (pronounced *chee*). This option saves you from having to plug and unplug your phone.

FIGURE 2-3: Some portable external charging options.

Left: Stas Malyarevsky/Shutterstock, Right: GO DESIGN/Shutterstock

Ideally, use Samsung chargers or chargers from reputable manufacturers or retailers. The power specifications for USB ports are standardized. Reputable manufacturers comply with these standards, but less reputable manufacturers might not. Cheap USB chargers physically fit the USB end of the cable that goes to your phone. However, LiPo batteries are sensitive to voltage. There are many, many creative options available outside the store where you bought your phone, but avoid the allure of low price.

Be aware that the conditions that make for a good charge with a photocell also tend to make for high heat. It will do you little good to have a beautifully functioning charger and a dead phone.

It is best to get a charger with a USB-C Connector. All the cool kids have a device with a USB-C connector so there are many options in stores, but some of the chargers still out there are either for the Apple iPhone and have an Apple Lightning connector or have a micro-USB connector. A micro USB will not work with a USB-C connector. You either need to get a cable that has a USB-C connector or use an adapter that will allow you to connect micro USB to a USB-C connector. Figure 2-4 shows the micro USB to USB-C adapter.

FIGURE 2-4: The micro USB to USB-C adapter.

Yoyochow23/Shutterstock

ONLY YOU CAN PREVENT PHONE FIRES

The Galaxy S21 uses lithium-polymer (LiPo) batteries. This is related to, but different from, Lithium-ion batteries. As the name implies, these batteries are based upon the element lithium (Li). Lithium works really well for cellphone batteries because it's very light.

The problem is that if lithium gets too hot, it burns. Lithium can catch fire at a relatively modest 180°F, and then burn like crazy at 1,100°F. By comparison, dry firewood won't ignite until 451°F, and will then burn at 1,100°F. In other words, lithium burns just as hot as a campfire, but it ignites at a much lower temperature.

To make things safe, battery makers and cellphone manufacturers implement all kinds of sneaky and imaginative methods of removing the heat from around the lithium battery. In addition, your phone invisibly monitors temperatures and takes steps to ensure that it doesn't get too hot. This all works so well and seamlessly that you probably didn't even notice this was happening in your earlier phones and other gizmos that use Lithium technology.

So, here's the big problem: If things start going wrong with Lithium-based batteries, many of the sneaky and imaginative methods used to remove the heat begin to fail. The fancy term for what happens next is *thermal runaway*. When thermal runaway happens in a device with a Lithium battery, one of two things happens:

- The guts of the phone will bubble and melt.
- The battery will burst into flames, throwing sparks for several feet in all directions.

LiPo is supposed to be safer than Li-ion, but a bunch of YouTube videos can show you what can happen when you create the wrong situation. So, what should you do and, perhaps more important, what should you *not* do? If your phone has started to melt, the best possible solution is to dunk it in a glass, bucket, or toilet full of water. If you can't find something to dunk it in, you can throw water on the phone to stop the fire. Water both cools the lithium and prevents oxygen from getting to the flame. I know: Getting your phone wet goes against all your instincts, but once a phone has started bubbling, all your texts and photos have already been lost. Prevent further damage and use water to put out the fire.

If you don't have water handy, and you're somewhere outside, in a parking lot or on a sidewalk away from people, you can set the phone on the ground, get far away from it, and call 911. Stand far back from the phone. It could explode. For obvious reasons, putting out the fire by dunking the phone in water or dousing it with water is best.

(continued)

(continued)

Smothering the phone with a blanket or dirt won't work. Even if you get the fire stopped momentarily with these methods, the battery is likely to start burning again because it's still too hot. A fire extinguisher with anything other than water or a liquid will also not work well. As with a blanket or dirt, the battery stays hot, and when oxygen reaches it, the lithium will simply reignite.

SHARING IS CARING: WIRELESS PowerShare

A great deal of attention is paid to keeping your phone charged. Sometimes your phone has plenty of power, but another device is running low. Your S21 has a cool new feature called Wireless PowerShare. You go into Settings, turn this capability on, and the back of your S21 becomes a wireless charger! You can charge the Galaxy S20 of your best friend and be a hero for the day.

Navigating the Galaxy S21

Galaxy S21 phone devices differ from many other mobile phones in design: They have significantly fewer hardware buttons (physical buttons on the phone). They rely much more heavily on software buttons that appear onscreen.

In this section, I guide you through your phone's buttons.

The phone's hardware buttons

Samsung has reduced the number of hardware buttons on the Galaxy S21. There are only three: the Power button, the Volume Down button, and the Volume Up button. Before you get too far into using your phone, orient yourself to be sure that you're looking at the correct side of the phone. When I refer to the *left* or *right* of the phone, I'm assuming a vertical orientation (meaning you're not holding the phone sideways) and that you're looking at the phone's screen.

The Power button

The Power button (refer to Figure 2-1) is on right side of the phone, toward the middle when you hold it in vertical orientation.

In addition to powering up the phone, pressing the Power button puts the device into sleep mode if you press it for a moment while the phone is On. *Sleep mode* shuts off the screen and suspends most running applications.

The phone automatically goes into sleep mode after about 30 seconds of inactivity to save power, but you might want to do this manually when you put away your phone. The Super AMOLED (Active-Matrix Organic Light-Emitting Diode) screen on your Samsung Galaxy S21 is cool, but it also uses a lot of power.

Don't confuse sleep mode with powering off. Because the screen is the biggest user of power on your phone, having the screen go blank saves battery life. The phone is still alert to any incoming calls; when someone calls, the screen automatically lights up.

The Volume button(s)

Technically, there are two Volume buttons: one to increase the volume, and the other to lower it. Their locations are shown in Figure 2-5.

FIGURE 2-5: The Galaxy S21 Volume buttons on the upper right.

The Volume buttons control the volume of all the audio sources on the phone, including:

- >> The phone ringer for when a call comes in (ringtone)
- >> The notifications that occur only when you're not talking on the phone, such as the optional ping that lets you know you've received a text or email
- >> The phone headset when you're talking on the phone
- >> The volume from the digital music and video player (media)

The volume controls are aware of the context; they can tell which volume you're changing. For example, if you're listening to music, adjusting volume raises or lowers the music volume, but leaves the ringer and phone-earpiece volumes unchanged.

The Volume buttons are complementary to software settings you can make within the applications. For example, you can open the music-player software and turn up the volume on the appropriate screen. Then you can use the hardware buttons to turn down the volume, and you'll see the volume setting on the screen go down.

Another option is to go to a settings screen and set the volume levels for each scenario. Here's how to do that:

1. From the Home screen, press either Volume button.

You can press it either up or down. Doing so brings up the screen shown in Figure 2-6.

FIGURE 2-6: The ringer volume pop-up.

If you press the Volume Up or Volume Down button, the ring tone gets louder or softer. Hold off on this tweak for now and go to the next step.

2. From this screen, tap the arrow down in the upper-right corner.

Tapping it brings up the screen shown in Figure 2-7.

FIGURE 2-7: The All Volume Settings pop-up.

> From the screen shown in Figure 2-7, set the volume at the desired setting.

You can adjust the volume of any setting by placing your finger on the dot on the slider image. The dot will get bigger; you can slide it to the left to lower this particular volume setting or to the right to raise it.

The touchscreen

To cram all the information that you need onto one screen, Samsung takes the modern approach to screen layout. You'll want to become familiar with several finger-navigation motions used to work with your screen.

Before diving in, though, here's a small list of terms you need to know:

- >> Icon: An *icon* is a little image. Tapping an icon launches an application or performs some function, such as making a telephone call.
- **Button:** A *button* on a touchscreen is meant to look like a three-dimensional button that you would push on, say, a telephone. Buttons are typically labeled to tell you what they do when you tap them. For example, you'll see buttons labeled Save or Send.

- >> Hyperlink: Sometimes called a *link* for short, a *hyperlink* is text that performs some function when you tap it. Usually text is lifeless. If you tap a word and it does nothing, then it's just text. If you tap a word and it launches a website or causes a screen to pop up, it's a hyperlink.
- >> Thumbnail: A thumbnail is a small, low-resolution version of a larger, high-resolution picture stored somewhere else.

With this background, it's time to discuss the motions you'll be using on the touchscreen.

You need to clean the touchscreen glass from time to time. The glass on your phone is Gorilla Glass (made by Corning) — the toughest stuff available to protect against breakage. Use a soft cloth or microfiber to get fingerprints off. You can even wipe the touchscreen on your clothes. However, never use a paper towel! Over time, glass is no match for the fibers in the humble paper towel.

Tap

Often, you just tap the screen to make things happen (as when you launch an app) or select options. Think of a *tap* as a single mouse click on a computer screen. A tap is simply a touch on the screen, much like using a touchscreen at a retail kiosk. Figure 2–8 shows what the tap motion should look like.

FIGURE 2-8: The tap motion.

One difference between a mouse click on a computer and a tap on a Galaxy S21 phone is that a single tap launches applications on the phone in the same way that a double-click of the mouse launches an application on a computer.

TIP

A tap is different from press and hold (see the next section). If you leave your finger on the screen for more than an instant, the phone thinks you want to do something other than launch an application.

Press and hold

Press and hold, as the name implies, involves putting your finger on an icon on the screen and leaving it there for more than a second. What happens when you leave your finger on an icon depends upon the situation.

For example, when you press and hold on an application on the Home screen (the screen that comes up after you turn on the phone), a garbage-can icon appears onscreen. This is to remove that icon from that screen. And when you press and hold an application icon from the list of applications, the phone assumes that you want to copy that application to your Home screen. Don't worry if these distinctions might not make sense yet. The point is that you should be familiar with holding and pressing — and that it's different from tapping.

TIP

You don't need to tap or press and hold very hard for the phone to know that you want it to do something. Neither do you need to worry about breaking the glass, even by pressing on it very hard. If you hold the phone in one hand and tap with the other, you'll be fine. I suppose you might break the glass on the phone if you put it on the floor and press up into a one-fingered handstand. I don't recommend that, but if you do try it, please post the video on YouTube.

WARNING

On average, a person calls 911 about once every year. Usually, you call 911 because of a stressful situation. Like every phone, the Samsung Galaxy S21 has a special stress sensor that causes it to lock up when you need it most. Okay, not really, but it seems that way. When you're stressed, it's easy to think that you're tapping when you're actually pressing and holding. Be aware of this tendency and remember to tap.

Moving around the screen or to the next screen

Additional finger motions help you move around the screens and to adjust the scaling for images that you want on the screen. Mastering these motions is important to getting the most from your phone.

The first step is navigating the screen to access what's not visible onscreen. Think of this as navigating a regular computer screen, where you use a horizontal scroll bar to access information to the right or left of what's visible on your monitor, or a vertical scroll bar to move you up and down on a screen.

The same concept works on your phone. To overcome the practical realities of screen size on a phone that will fit into your pocket, the Galaxy S21 phone uses a panorama screen layout, meaning that you keep scrolling left or right (or maybe up and down) to access different screens.

In a nutshell, although the full width of a screen is accessible, only the part bounded by the physical screen of the Galaxy S21 phone is visible on the display. Depending upon the circumstances, you have several ways to get to information not visible on the active screen. These actions include drag, flicks, pinch and stretch, and double taps. I cover all these gestures in the following sections.

Drag

The simplest finger motion on the phone is the *drag*. You place your finger on a point on the screen and then drag the image with your finger. Then you lift your finger. Figure 2-9 shows what the motion looks like.

FIGURE 2-9: The drag motion for controlled movement.

Dragging allows you to move slowly around the panorama. This motion is like clicking a scroll bar and moving it slowly.

Flick

To move quickly around the panorama, you can *flick* the screen to move in the direction of your flick (see Figure 2-10).

FIGURE 2-10: Use a flick motion for faster movement.

Better control of this motion comes with practice. In general, the faster the flick, the more the panorama moves. However, some screens (such as the extended Home screen) move only one screen to the right or left, no matter how fast you flick.

Pinch and stretch

Some screens allow you to change the scale of images you view on your screen. When this feature is active, the Zoom options change the magnification of the area on the screen. You can zoom out to see more features at a smaller size or zoom in to see more detail at a larger size.

To zoom out, you put two fingers (apart) on the screen and pull them together to pinch the image. Make sure you're centered on the spot that you want to see in more detail. The pinch motion is shows in Figure 2-11.

The opposite motion is to zoom in. This involves the stretch motion, as shown in Figure 2–12. You place two fingers (close together) and stretch them apart.

FIGURE 2-12: Use the stretch motion to zoom in.

Double tap

The double tap (shown in Figure 2-13) just means tapping the same button area on the screen twice in rapid succession. You use the double tap to jump between a zoomed-in and a zoomed-out image to get you back to the previous resolution. This option saves you frustration in getting back to a familiar perspective.

When you double tap, time the taps so that the phone doesn't interpret them as two separate taps. With a little practice, you'll master the timing of the second tap.

FIGURE 2-13: The double-tap motion.

The extended Home screen

The Home screen is the first screen you see when the phone is done with setting up. Additional screens off to the right and left make up the extended Home screen. They can be seen as a panorama in Figure 2–14.

Home Screen

FIGURE 2-14: The Galaxy S21 phone panorama display of the extended Home screen.

At any given moment, you see only one screen at a time. You navigate among the screen by flicking to the right and left. The Home button, which I describe in more detail in the next section, will always bring you back to the Home screen.

The extended Home screen is where you can organize icons and other functions to best make the phone convenient for you. Out of the box, Samsung and your cellular carrier have worked together to create a starting point for you. Beyond that, though, you have lots of ways you can customize your Home screens for easy access to the things that are most important to you. Much of the book covers all the things that the phone can do, but a recurring theme is how to put your favorite capabilities on your Home screen, if you want.

To start, check out the layout of the Home screen and how it relates to other areas of the phone. Knowing these areas is important for basic navigation.

Figure 2–15 shows a typical Home screen and highlights three important areas on the phone:

- >> The notification area: This part of the screen presents you with small icons that let you know if something important is up, like battery life or a coupon from McDonald's.
- The primary shortcuts: These four icons remain stationary as you move across the Home screen. If you notice in Figure 2-15, these have been determined by Samsung and your cellular carrier to be the four most important applications on your phone and are on all the screens.
- >> The Function keys: These three keys control essential phone functions, regardless of what else is going on at the moment with the phone.

TIP

There are a series of dots just above the primary shortcuts on the extended Home screen. You may also notice that one of the dots isn't just a dot — it's a little house. That is the "home" Home screen. The brightest dot indicates where you are among the screens. You can navigate among screens by dragging the screen to the left or right. This moves you one screen at a time. You can also jump multiple screens by tapping on the dot that corresponds to the screen number you want to see or by dragging the dots to the screen you want to see. The following sections give you more detail on each area.

Using the Home button

One of the important design features Samsung has implemented with the Galaxy phone is the "invisible" Home button. Some other smartphones have a physical button on the bottom of the front screen. To offer more screen real estate, the S21 makes it a software-based button on the bottom in the center of the function keys.

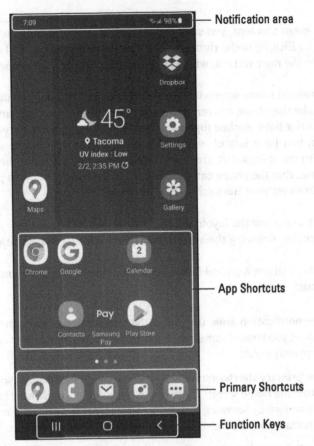

FIGURE 2-15: Important areas on the Galaxy S21 phone and Home screen.

The Home button (see Figure 2–16) may not look like much, but it is very important because it brings you back to the Home screen from wherever you are in an application. If you're working on applications and feel like you're helplessly lost, don't worry. Press the Home button, close your eyes, click your heels together three times, and think to yourself, "There's no place like home," and you will be brought back to the Home screen.

FIGURE 2-16: The Galaxy S21 Home button on the front.

TIP

You don't really need to do all that other stuff after pressing the Home button. Just pressing the Home button does the trick.

Adding shortcuts to the Home screen

You have a lot of screen real estate where you can put icons of your favorite applications and widgets (refer to Figure 2-14). (*Widgets* are small apps that take care of simple functions, like displaying time or the status of your battery.) You can add shortcuts to the apps and to these widgets to your Home screen by following these steps:

1. From the extended Home screen page where there is some space for the icon of an app, swipe your finger upward on the screen.

This brings up a directory of all the apps you currently have on the phone. The number of apps and pages for their icons is practically unlimited. (I cover how to add new apps in Chapter 8.)

2. Press and hold the icon of the app you want to add.

The icon under your finger will get a pop-up like the one shown in Figure 2-17.

FIGURE 2-17: An Apps page.

3. Tap the Add to Home option.

The icon now appears in a random spot on one of your home pages. If you like where the icon is, you're all set. If you want to move it to another spot on your Home page, continue on to the next step.

4. Press and hold the icon you want to move.

Two things happen with the icon. First you get a pop-up that asks you if you want to uninstall the app and some other options. To move the icon, slide your finger on the screen to where you want it to live. When you're happy with its location, lift your finger and it now has a new home.

Done.

Taking away shortcuts

Say that you find that you really don't use that app as much as you thought you would, and you want to have less clutter on your Home page. No problem. Press and hold the icon. A pop-up like the one shown in Figure 2-18 appears.

FIGURE 2-18: The shortcut pop-up on the Home page.

Simply tap the garbage can, and off it goes to its maker.

It's gone from your Home page, but if you made a mistake, you can get it back easily enough. To re-create it, simply go back to the App Menu key and follow the process again. It's still on your phone.

The notification area and screen

The notification area is located at the top of the phone (refer to Figure 2-15). Here, you see little status icons. Maybe you received a text or an email, or you'll see an application needs some tending to.

Think of the notification area as a special email inbox where your carrier (or even the phone itself) can give you important information about what's happening with your phone. These little icons at the top tell you the condition of the different radio systems on your phone: The number of bars shown gives you an indication of signal strength, and usually the phone will also tell you what kind of mobile data speed you're getting — such as 3G, 4G, or 5G.

You could take the time to learn the meanings of all the little icons that might come up, but that would take you a while. A more convenient option is to touch the notification area and pull it down, as shown in Figure 2–19.

This brings up the most commonly used notifications. In this case, it's the cellular signal strength indicator, sound, Bluetooth, auto-rotate, flashlight, and airplane mode. This information is written so that you can understand what's going on and what, if anything, you're expected to do — for example, if you see that you have connected to the Wi-Fi access point you intended.

FIGURE 2-19: Notification area initial pull-down.

If this screen gets too full, you can clear it by tapping the Clear button. You can also clear notifications one at a time by touching each one and swiping it to the side. If you want a shortcut to control some key phone capabilities, you can tap one of these icons. For example, if you want to turn off Wi-Fi, you can just tap the Wi-Fi icon. This saves you from having to go to Settings to do the same thing.

There are more handy capabilities at your disposal. When you're finished reading these notifications, slide your finger from top to bottom.

This brings up many more options that you would otherwise need to find with the Settings icon (see Figure 2–20). If the icon is blue, it means that the capability is enabled. If the icon is gray, it is not enabled.

The Device Function keys

At the bottom of the screen are three important buttons: the Device Function keys. They're always ready for you to navigate your phone even though they might switch off to hide their presence and give you more screen. Whatever else you're doing on the phone, these buttons can take over. I talk about the Home button earlier in this chapter. The other buttons are equally cool.

Recent Apps button

The button to the left of the Home button, the three vertical lines, is the Recent Apps button. Tapping the button brings up a list of the open apps. This is handy to navigate between running apps. Figure 2–21 shows a typical screen of recent apps.

Notification area second pull-down.

FIGURE 2-21: Recent Apps screen.

You can scroll among the open apps by flicking left or right. You can jump to one of these apps by tapping somewhere on the image. You can also shut down one of the apps by flicking upward. You can shut them all down by tapping the link at the bottom that says Close All.

The Device Function keys are cool because they light up when you're touching them or the screen, but fade away the rest of the time.

TIP

The Back button

The Back button on your phone is similar to the Back button in a web browser: It takes you back one screen.

As you start navigating through the screens on your phone, tapping the Back button takes you back to the previous screen. If you keep tapping the Back button, you'll eventually return to the Home screen.

The keyboard

The screen of the Galaxy S21 phone is important, but you'll still probably spend more time on the keyboard entering data on the QWERTY keyboard.

Using the software keyboard

The software keyboard automatically pops up when the application detects a need for user text input. The keyboard, shown in Figure 2-22, appears at the bottom of the screen.

FIGURE 2-22: Use the software keyboard to enter data.

Using voice recognition

The third option for a keyboard is . . . no keyboard at all! Galaxy S21 phones come with voice recognition as an option. It's very easy and works surprisingly well. In most spots where you have an option to enter text, you see a small version of the microphone icon shown in Figure 2-23.

The voice recognition icon.

Just tap this icon and say what you would have typed. You see the phone thinking for a second, and then a screen tells you that it is listening. Go ahead and start talking. When you're done, you can tap the Done button or just be quiet and wait. Within a few seconds, you'll read what you just said!

The orientation of the phone

Earlier in this chapter where I discuss the Power button, I refer to the phone being in vertical orientation (so that the phone is tall and narrow). It can also be used in the *landscape* orientation (sideways, or so that the phone is short and wide). The phone senses in which direction you're holding it and orients the screen to make it easier for you to view.

REMEMBE

The phone makes its orientation known to the application, but not all applications are designed to change their inherent display. That nuance is left to the writers of the application. For example, your phone can play videos. However, the video player application that comes with your phone shows video in landscape mode only.

In addition, the phone can sense when you're holding it to your ear. When it senses that it's held in this position, it shuts off the screen. You need not be concerned that you'll accidentally "chin-dial" a number in Botswana.

Going to Sleep Mode/Turning Off the Phone

You can leave your phone on every minute until you're ready to upgrade to the newest Galaxy phone in a few years, but that would use up your battery in no time. Instead, put your idle phone in sleep mode to save battery power. *Note:* Your phone goes into sleep mode automatically after 30 seconds of inactivity on the screen.

You can manually put the phone in sleep mode by pressing the Power button for just a moment.

TIP

Sometimes it's best to simply shut down the phone if you aren't going to use it for several days or more. To shut down the phone completely, pull down the initial notifications screen, swipe down again for the second notifications screen (refer to Figure 2-20), and press the Power Off button. The following options appear (see Figure 2-24):

- >> Power Off: Shut down the phone completely.
- >> Restart: The Android operating system is stable. Well, mostly stable.

 Sometimes you may want to reboot it because it starts acting quirky. Tap the restart option and see whether that solves the problem.
- >>> Emergency Mode: After you have agreed to some terms and conditions, your phone will go into semi-hibernation and take actions that limit battery use very severely. It can come back to life quickly if you feel you need to dial 911. Before you can use this option, you need to agree to some of the limitations. You can disable the mode by returning to the Power Off icon on the second notifications screen.

Good night!

FIGURE 2-24: Options when you tap the Power Off button.

Going to Sleep Wode/Turning Off the Phone

We acan bear your plane ones or monto host for a cody to upgrade to the pewer to large plane to a key your fact would as a provent calcomplane to a key yours, but the two up to a fact of put your labeled made to save carrier power. With Your phone goes into sleep made your plane goes into sleep made automatically aired or seconder of matterial on the creen.

of the Arman manually put the printer in view sneed by press as the Put Tourison for the contract of the contr

Sometimes if a destrocking that down the phone it you are discring to use a trior several tays at come. To shut down the phone completely pad down the anithm thought at messages away again for the message and heat one server a construction of the bigure x - u0), and press the form the law on the law of the following optimal appear to the destruction.

- 32 Power Office Lucy of the chicken a completely.
- 45. Resisert The Offered Operating system is stante. Well growy stable:
 § Somethies you may want to reapent because it that samps quirky. The case reserved action and see whather this sulves the places.
- The representative median from you have detected once length and conditions, your property of your first with Battery OS, paying a several median countries to the first several median of the first several median several median produced to several median median several median several median several median several median median median contribution of the first median media

- highlic aco.

Communicating with Other People

IN THIS PART . . .

Dial and answer phone calls.

Send and receive text messages.

Set up email accounts on your phone.

Get all your contacts in one location.

- » Using your call list
- » Making emergency calls
- » Connecting to a Bluetooth headset

Chapter **3**

Calling People

t its essence, any cellphone — no matter how fancy or smart — exists to make phone calls. The good news is that making and receiving phone calls on your Galaxy S21 is easy.

In this chapter, I show you not only how to make a call, but also how to use your call list to keep track of your calls. And don't skip the section on using your phone for emergencies.

Finally, if you're like many people, you're never doing just one thing at a time, and a Bluetooth headset can make it easier for you to talk on the phone while driving and getting directions, checking email, wrangling kids and dogs, or just plain living life. In this chapter, I show you how to hook up your phone to a Bluetooth headset so that you can make and receive phone calls hands-free.

Making Calls

After your phone is on and you're connected to your cellular carrier (see Chapters 1 and 2), you can make a phone call. It all starts from the Home screen. Along the bottom of the screen, above the Device Function keys, are either four or

five icons, which are the *primary shortcuts* (see Figure 3-1). The primary shortcuts on your phone may differ slightly, but in this case, from left to right, they are

- >> Phone
- >> Camera
- >> Email
- >> Messages

FIGURE 3-1: The primary shortcuts on the Home screen.

To make a call, follow these steps:

1. From the Home screen, tap the Phone icon.

You will see a screen like the one shown in Figure 3-2. This screen, called Recents, shows any calls you have made or received, such as the one from your carrier to confirm that you phone has been set up correctly.

2. Tap the Keypad link at the bottom left of your screen.

This icon is a green circle with little white dots that symbolize the touch pad on a regular landline phone.

3. Tap the telephone number you want to call.

The Keypad screen (see Figure 3-3) appears. This looks like a full-sized version of a touch pad on a regular landline phone.

TIP

For long distance calls while in the United States, you don't need to dial 1 before the area code — just dial the area code and then the seven-digit phone number. Similarly, you can include the 1 and the area code for local calls. On the other hand, if you're traveling internationally, you need to include the 1 — and be prepared for international roaming charges!

In Chapter 6, you can read about how to make a phone call through your contacts.

4. Tap the green phone button at the bottom of the screen to place the call.

The screen changes to the screen shown in Figure 3-4. You have a chance to verify you dialed the person you intended.

Within a few seconds, you should hear the phone ringing at the other end or a busy signal. From then on, it is like a regular phone call.

When you're done with your call, tap the red phone button at the bottom of the screen.

The call is disconnected.

FIGURE 3-2: The Main screen for the phone.

Keypad Link

If the other party answers the phone, you have a few options available to you by tapping on the correct icon/hyperlink on the screen, including:

- >> Put the call on hold.
- >> Add another call to have a three-way conversation.
- >> Increase the volume.

Without Telephone Number

With	Tele	phone	Num	be
		911 (914 /1 fe	1	

Phone 1 (425) 555-1234 4 9 # * 111 0

FIGURE 3-3: Dial the number from the Keypad screen.

- >> Switch on a Bluetooth device (see the section "Syncing a Bluetooth Headset," later in this chapter).
- >> Turn on the phone's speaker.
- >> Bring up the keypad to enter numbers.
- >> Mute the microphone on the phone.

You can do any or all of these, or you can just enjoy talking on the phone.

If the call doesn't go through, either the cellular coverage where you are is insufficient, or your phone got switched to Airplane mode, which shuts off all the radios in the phone. (It's possible, of course, that your cellular carrier let you out the door without having set you up for service, but that's pretty unlikely!)

FIGURE 3-4: Dialing screen.

> Check the notification section at the top of the screen. If there are no connectionstrength bars, try moving to another location. If you see a small airplane silhouette, bring down the notification screen (see how in Chapter 2) and tap the plane icon to turn off Airplane mode.

If you pull down the notification screen and you don't see the silhouette of an airplane, scroll the green or gray icons downward a second time. This icon may be off the page.

Answering Calls

Receiving a call is even easier than making a call. When someone calls you, caller ID information appears in a pop-up screen. Figure 3-5 shows some screen options for an incoming call.

Full Screen Incoming call

Partial Screen Incoming call

FIGURE 3-5: Possible screens when you're receiving a call.

If you aren't doing anything with the phone at that moment, it will present you with the full screen. If you're using an app, it will give you a pop-up screen, as shown in the image on the right. To answer the call, tap or slide the green phone button. To not answer a call, you can simply ignore the ringing, or you can tap or slide the red phone button. The ringing stops immediately, and in either case, the call goes to voicemail.

710

In Part 4, I fill you in on some exciting options that you can enable (or not) when you get a call. For example, you can specify a unique ringtone for a particular number, or have an image of the caller pop up (if you save your contacts to your phone).

Regardless of what you were doing on the phone at that moment — such as listening to music or playing a game — the answer pop-up screen can appear. Any active application, including music or video, is suspended until the call is over.

For callers to leave you messages, you must set up your voicemail. If you haven't yet set up your voicemail, the caller will hear a recorded message saying that your voicemail account isn't yet set up. Some cellular carriers can set up voicemail for you when you activate the account and get the phone; others require you to set up

voicemail on your own. Ask how voicemail works at your carrier store or look for instructions in the manual included with your phone.

Most cellular carriers give you a special seven-digit telephone number for your voicemail that should be in your contacts with the name Voicemail (Chapter 6 explains more about contacts). For now, the thing to remember is that you can call this number to record the message if you're unable to answer the call and to retrieve messages.

Don't give your voicemail number to anyone. If you do share it so that person can just call directly to your voicemail, you'll want to increase security and require a four-digit PIN before anyone can retrieve your messages.

The answer and reject icons are pretty standard on any cellular phone. However, your Galaxy S21 is no standard phone. There is a third option, and what happens depends on your individual phone. In addition to the standard options of answer or reject, you have one more option — to reject and send the caller a text message. As your caller is sent to your voicemail, you also can immediately send the caller a text message that acknowledges the call.

Some of the typical canned messages that you can send are:

- >> Sorry, I'm busy. Call back later.
- >> I'm in a meeting.
- >> I'll call you back.
- >> I'm at the movie theater.
- >> I'm in class.

You tap the message that applies. The message is sent as a text right away, which alerts the caller that you're not ignoring him — it's just that you can't talk right now. Nice touch.

You can also create and store your own message, like "Go away and leave me alone," or "Whatever I am doing is more important than talking to you." You could also be polite. To create your own canned message, tap Compose new message and type away. It's then stored on your phone for when you need it.

The caller has to be able to receive text messages on the phone used to make the call. This feature doesn't work if your caller is calling from a landline or a cell-phone that can't receive texts.

Keeping Track of Your Calls: The Recents

One of the nice features of cellular phones is that the phone keeps a record of the calls that you've made and received. Sure, you might have caller ID on your landline at home or work, but most landline phones don't keep track of whom you called. Cellphones, on the other hand, keep track of all the numbers you called. This information can be quite convenient, like when you want to return a call and you don't have that number handy. In addition, you can easily add a number to the contact list on your phone.

By tapping the Recents link on the phone screen, you get a list of all incoming and outgoing calls. (This hyperlink is located at the bottom of the screen shown on the left side in Figure 3-2.)

Adjacent to the number for each call is an icon meaning the following:

- >> Outgoing call you made: An orange arrow points to the number.
- >> Incoming call you received: A green arrow points away from the number.
- >> Incoming call you missed: A red phone silhouette with a broken arrow.
- >> Incoming call you ignored: A blue slash sign is next to the phone number.

The log is a list of all the calls you made or were made to you. This is handy so that you can easily call someone again or call her back. By tapping any number in your call list, you see a screen like the one shown in Figure 3-6. From this screen, you can do several things:

- >> Call the number by tapping the green call button.
- >> Send a text to that number by tapping the blue talk bubble icon. (More on this in Chapter 4.)
- >> Make a video call if you're set up to do that.
- >> Tap the details icon to add the number to your contacts list. I cover contacts in more detail in Chapter 6.

If you tap the image in Figure 3-6, you can see the recent history of all the communication you've had with this person as shown in Figure 3-7. This includes calls, texts, and videocalls.

FIGURE 3-6: An entry on the call log.

FIGURE 3-7: Call Log detail.

Making an Emergency Call: The 411 on 911

Cellphones are wonderful tools for calling for help in an emergency. The Samsung Galaxy S21, like all phones in the United States and Canada, can make emergency calls to 911.

Just tap the Phone icon on the Home screen, tap 911, and then tap Send. You'll be routed to the 911 call center nearest to your location. This works wherever you're at within the United States. So, say you live in Chicago but have a car accident in Charlotte; just tap 911 to be connected to the 911 call center in Charlotte, not Chicago.

Even if your phone isn't registered on a network, you don't have a problem as long as you have a charge in the battery. You phone lets you know that the only number you can dial is a 911 call center, even if the Home screen is locked.

WHEN YOU ACCIDENTALLY DIAL 911

If you accidentally dial 911 from your phone, don't hang up. Just tell the operator that it was an accidental call. She might ask some questions to verify that you are indeed safe and not being forced to say that your call was an accident.

If you panic and hang up after accidentally dialing 911, you'll get a call from the nearest 911 call center. Always answer the call, even if you feel foolish. If you don't answer the call, the 911 call centers will assume that you're in trouble and can't respond. They'll track you down from the GPS in your phone to verify that you're safe. If you thought you'd feel foolish explaining your mistake to a 911 operator, imagine how foolish you'd feel explaining it to the police officer who tracks you down and is upset with you for wasting the department's time.

TIP

When you call 911 from a landline, the address you're calling from is usually displayed for the operator. When you're calling from a cellphone, though, the operator doesn't have that specific information. So, when you call 911, the operator might say, "911. Where is your emergency?" Don't let this question throw you; after all, you're probably focused on what is happening and not on where. Take a moment and come up with a good description of where you are — the street you're on, the nearest cross street (if you know it), any businesses or other landmarks nearby. An operator who knows where you are is in a better position to help you with your emergency. Your phone does have a GPS receiver in it that 911 centers can access. However, it's not always accurate; it may not be receiving location information at that moment, as is the case when you're indoors.

When traveling outside the United States or Canada, 911 might not be the number you call in an emergency. Mexico uses 066, 060, or 080, but most tourist areas also accept 911. And most — but not all — of Europe uses 112. Knowing the local emergency number is as important as knowing enough of the language to say you need help.

Syncing a Bluetooth Headset

With a Bluetooth headset device, you can talk on your phone without having to hold the phone to your ear — and without any cords running from the phone to your earpiece. You've probably come across plenty of people talking on Bluetooth headsets. You might even have wondered whether they were a little crazy talking to themselves. Well, call yourself crazy now, because when you start using a Bluetooth headset, you might never want to go back.

Not surprisingly, Galaxy S21 phones can connect to Bluetooth devices. The first step to using a Bluetooth headset with your phone is to sync the two devices. Here's how:

1. From the Home screen on your phone, slide up to get to the Apps screen.

This gets you to the list of all the applications on your phone.

2. Flick or pan to the Settings icon and tap it.

The Settings icon is shown here. This screen holds most of the settings that you can adjust on your phone. If you prefer, you can also bring down the notification screen and tap the gear icon or tap the menu button on the Home screen. All these actions will get you to the same place.

Tapping on the Settings icon brings up the screen shown in Figure 3-8.

The Settings

3. Tap the Connections icon.

All the options for connectivity on your phone appear.

4. Tap the Bluetooth icon.

This will bring up one of the two screens shown in Figure 3-9. If Bluetooth is off, it will looks like the screen to the left. If it is on, it will look like the screen on the right.

Bluetooth in "Off" Mode

Bluetooth in "On" Mode

FIGURE 3-9: The Bluetooth Settings screens.

5. Put the phone in Pairing mode by turning on Bluetooth and tapping Scan.

This step enables your phone to be visible to other Bluetooth devices. This state will last for about 60 seconds — enough time for you to get your Bluetooth device into pairing mode so that both devices can negotiate the proper security settings and pair up every time they "see" each other from now on.

6. Next, put your headset into sync mode.

Follow the instructions that came with your headset.

After a moment, the phone "sees" the headset. When it does, you're prompted to enter the security code, and the software keyboard pops up.

7. Enter the security code for your headset and then tap the Enter button.

The security code on most headsets is 0000, but check the instructions that came with your headset if that number doesn't work.

Your phone might see other devices in the immediate area. If so, it asks you which device you want to pair with. Tap the name of your headset.

Your headset is now synced to your phone. If you turn one on when the other is already on, they recognize each other and automatically pair up.

TIP

Some manufacturers make it easier to link via Bluetooth. For example, you may have received a pair of Samsung Galaxy Buds. With these ear buds, you simply open the case where you store the buds with your phone in scan mode. You're asked to connect, and it's all done. Don't be surprised when it's even easier than the steps listed in this section!

Options Other than Headsets

Headsets are not the only option anymore. Although many people walk around with the ubiquitous Bluetooth headset dangling from an ear, many other choices are out there. You can sync to all kinds of Bluetooth devices, including external keyboards, laptops, tablets, external speakers, and even your car.

There are also external sensors for measuring blood pressure, heart rate, and a lot of other physical information. Some of these are built into wearable devices, like a fitness bracelet. Manufacturers are now embedding computers into home appliances that can also connect to your smartphone through Bluetooth!

The good news is that regardless of the technology, you can connect all these devices to your phone simply by using the steps described in the preceding section. I talk more about these possibilities in later chapters.

Options Other than Headsets

Recuests are not the only option anymost. A botten many people was around with the objects of Rine with fielded congling from an edit ment other above. The remains out there was ten same to all locals of factorial bottes, including external keyboalds tashed and remain car.

Ungre are also extensed sensors for overanting blood pressure, he are une artis and of or other physical informations forme or these are unit und scalar jestentees. The a areas that can also compete to your stantishes entitle particular.

The good naws is that recordless of the teshi dogs, you can order all these devices to your phone simply by distinguish as applied that in the proceeding services to your phone these possibilities in laster thanks.

- » Sending a text message with an attachment
- » Receiving a text message

Chapter 4

Discovering the Joy of Text

ure, cellphones are made for talking. But these days, many people use their cellphones even more for texting.

Even the most basic phones support texting these days, but your Galaxy S21 phone makes sending and receiving text messages more convenient, no matter whether you're an occasional or pathological texter. In this chapter, I fill you in on how to send a text message (with or without an attachment), how to receive a text message, and how to read your old text messages.

TIP

This chapter uses images from the Samsung Messaging application. It is possible that your phone may have as its default another texting application. If so, you can easily switch to the Messaging app. You can also use the default app, but the images will be somewhat different. Your choice.

Sending the First Text Message

Text messages (which are short messages, usually 160 characters or less, sent by cellphone) are particularly convenient when you can't talk at the moment (maybe you're in a meeting or class) or when you just have a small bit of information to share ("Running late — see you soon!").

Many cellphone users — particularly younger ones — prefer sending texts to making a phone call. They find texting a faster and more convenient way to communicate, and they often use texting shorthand to fit more content in a short message.

There are two scenarios for texting. The first is when you send someone a text for the first time. The second is when you have a text conversation with a person.

When you first get your phone and are ready to brag about your new Galaxy S21 and want to send a text to your best friend, here's how easy it is:

1. On the Home screen, tap the Messages icon.

The Messages icon looks like a squared-off voice bubble from a comic strip within a blue circle. When you tap it, you will get a mostly blank Home screen for texting. This is shown in Figure 4-1.

When you have some conversations going, it begins to fill up.

The initial Messaging Home

2. Tap the New Message icon.

Tapping the New Message icon brings up the screen shown in Figure 4-2.

FIGURE 4-2: A blank texting screen.

3. Tap to enter the recipient's ten-digit mobile telephone number.

A text box appears at the top of the screen with the familiar To field at the top. The keyboard appears at the bottom of the screen.

As shown in Figure 4-3, the top field is where you type the telephone number. The numerals are along the top of the keyboard.

Be sure to include the area code, even if the person you're texting is local. There's no need to include a 1 before the number.

If this is your first text, you haven't had a chance to build up a history of texts. After you've been using your messaging application for a while, you will have entered contact information, and your phone will start trying to anticipate your intended recipient. You can take one of its suggestions or you can just keep on typing.

Partially typed number with guesses

Fully typed number

FIGURE 4-3: Type the recipient's number in the upper text box.

4. To type your text message, tap the text box that says Enter Message. Figure 4-4 shows you where to enter your text.

In the Android Messaging app, your text message can be up to 160 characters, including spaces and punctuation. The application counts down the number of characters you have left.

5. Send the text by tapping the Send button to the right of your message.

The Send button is not present before you start typing. After you type something, a blue-green circle with the silhouette of a paper airplane turns blue-green. Once you tap the blue-green button, the phone takes it from here. Within a few seconds, the message is sent to your friend's cellphone.

FIGURE 4-4: Type your text.

TIP

After you build your contact list (read about this in Chapter 6), you can tap a name from the contact list or start typing a name in the recipient text box. If there's only one number for that contact, your phone assumes that's the receiving phone you want to send a text to. If that contact has multiple numbers, it asks you which phone number you want to send your text to.

REMEMBER

In most cases, the default for your texting app is for your phone to automatically correct what it thinks is a misspelled word. You can see it guess on the darker gray area under the text message. This capability is called *autocorrect*. You may find it very handy, or you may find it annoying. If you like it, you should still verify that it corrected the word in the right way. If you want evidence as to why this is a good idea, search "funny autocorrect examples" in your favorite search engine (although some can be very racy).

WARNING

You've probably heard a thousand times about how it's a very bad idea to text while you're driving. Here comes one-thousand-and-one. It's a very bad idea to text while you're driving — and illegal in many places. There are Dummies who read this book, who are actually very smart, and then there are DUMMIES who text and drive. I want you to be the former and not the latter.

Carrying on a Conversation via Texting

In the bad ol' pre-Galaxy S days, most cellular phones would keep a log of your texts. The phone kept the texts that you sent or received in sequential order, regardless of who sent or received them.

Texts stored sequentially are old-school. Your Galaxy S21 keeps track of the contact with whom you've been texting and stores each set of back-and-forth messages as a *conversation*.

In Figure 4-5, you can see that the first page for messaging holds *conversations*. After you start texting someone, those texts are stored in one conversation.

FIGURE 4-5: A messaging conversation. As Figure 4-5 shows, each text message is presented in sequence, with the author of the text indicated by the direction of the text balloon.

Note the Enter Message text box at the bottom of the screen. With this convenient feature, you can send whatever you type to the person with whom you're having a conversation.

In the bad old days, it was sometimes hard to keep straight the different texting conversations you were having. When you start a texting conversation with someone else, there is a second conversation.

Before too long, you'll have multiple conversations going on. Don't worry. They aren't the kind of conversations you need to keep going constantly. No one thinks twice if you don't text for a while. The image in Figure 4–6 shows how the text page from Figure 4–1 can look before too long.

FIGURE 4-6: The Text screen showing multiple conversations.

It is easy to change the font size of conversations. To make the fonts larger and easier to read, use the stretch motion. Use the pinch motion to make the fonts smaller so that you can see more of the conversation.

Sending an Attachment with a Text

What if you want to send something in addition to or instead of text? Say you want to send a picture, some music, or a Word document along with your text. Easy as pie, as long as the phone on the receiving end can recognize the attachment. Here is the recipe:

- 1. From the Home screen, tap the Messages icon.
- 2. Either tap the New Message icon and enter the number of the intended recipient or pick up on an existing conversation.

You'll see the Enter Message bubble from Figure 4-1. Enter the information you want like a normal text.

To add an attachment, tap the arrow sign to the left of where you enter text.

The arrow sign brings up three icons: a silhouette of mountains, a silhouette of a camera, and a plus sign. If you want to attach a photo, tap the silhouette of the mountains. If you want to take a new picture or video, tap the camera icon. Otherwise, tap the plus sign. You see the options shown in Figure 4-7, which asks what kind of file you want to attach. Your choices include information on your location, audio files, and some others I describe in Chapters 9, 10, 12, 13, and 14 when you have some good files to share. For now, it's just good that you know you have options.

Figure 4-7: File types you can attach to a text. 4. Tap your choice of file type, and your phone presents you with the options that fall into that category.

Get ready to be amazed. Underneath the text box, you have five choices. These include the Gallery for photos, a shot you can take now with the camera, a doodle, a map with your location, or other categories. Figure 4-7 shows the Other category. This is for any file you want to attach that is already on your phone. It can be your electronic business card. It could be a video.

The Quick response opens up canned responses, such as "What's up?" or "Where's the meeting?" How cool is that?!

- 5. Continue typing your text message, if needed.
- 6. When you're done with the text portion of the message, tap the Send button (the one that looks like a line drawing of a paper airplane), and off it all goes.

A simple text message is an SMS (short message service) message. When you add an attachment, you're sending an MMS (multimedia messaging service) message. Back in the day, MMS messages cost more to send and receive than SMS messages did. These days, that isn't the case in the United States.

Receiving Text Messages

Receiving a text is even easier than sending one.

When you're having a text conversation and you get a new text from the person you're texting with, your phone beeps and/or vibrates. Also, the notification area of the screen (the very top) shows a very small version of the Messages icon.

You can either pull down the notification area from the very top of the screen or start the messaging application. Your choice.

If an attachment comes along, it's included in the conversation screen.

Managing Your Text History

The Messaging Conversations screen stores and organizes all your texts until you delete them. You should clean up this screen every now and then.

The simplest option for managing your messages is to tap the Menu icon and then tap Delete. You can then select and unselect all the conversations that you want deleted. Tap the icon that looks like a garbage can at the bottom of the screen, and they disappear.

Another deletion option is to open the conversation. You can delete each text by pressing and holding on the balloon. After a moment, a menu appears from which you can delete that message. This method is a lot slower if you have lots of texts, though.

I recommend that you be vicious in deleting the older texts and conversations. Trust me; deleting all your old messages can be cathartic!

- » Reading email on your phone
- » Managing your email folder
- » Sending email from your phone

Chapter 5

Sending and Receiving Email

f you've had email on your phone for a while, you know how convenient it is. If your Galaxy S21 phone is your first cellphone with the capability to send and receive email, prepare to be hooked.

I start this chapter by showing you how to set up your email, regardless of whether your email program is supported. Then I show you how to read and manage your email. Finally, I tell you how to write and send email in the last section in this chapter.

Setting Up Your Email

These days, many people have multiple personal email addresses for many reasons. Your phone's Email app can manage up to ten email accounts. With a Galaxy S21 phone, you'll want to create Google account if you don't already have one. If you don't have a Google account, you'll miss out on so many exciting capabilities that it's almost worth settling for a lesser phone.

If you have an email account that ends in <code>@gmail.com</code>, by default you have a Google account. If you do not have an account that ends in <code>@gmail.com</code>, you can either create a Google account with your existing email or create a separate email account on Google's Gmail just for your phone. Setting up a new Gmail account if you don't have one already (see the upcoming section "Setting up a new Gmail account") is easy, but it isn't too hard to use an existing email for a Google account.

The Email app on your phone routinely "polls" all the email systems for which you identify an email account and password. It then presents you with copies of your email.

Your phone mainly interacts with your inbox on your email account. It isn't really set up to work like the full-featured email application on your computer, though. For example, many email packages integrate with a sophisticated word processor, have sophisticated filing systems for your saved messages, and offer lots of fonts. As long as you don't mind working without these capabilities, you might never need to get on your computer to access your email again, and you could store email in folders on your phone.

Setup is easy, and having access to all your email makes you so productive that I advise you to consider adding all your email accounts to your phone.

Getting ready

In general, connecting to a personal email account simply involves entering the name of your email account(s) and its password(s) in your phone. Have these handy when you're ready to set up your phone.

As mentioned, you can have up to ten email accounts on your phone; however, you do need to pick one account as your favorite. You can send an email using any of the accounts, but your phone wants to know the email account that you want it to use as a default.

Next, you may want to have access to your work account. This is relatively common these days, but some companies see this as a security problem. You should consult with your IT department for some extra information. Technologically, it's not hard to make this kind of thing happen as long as your business email is reasonably modern.

Finally, if you don't already have a Gmail account, I strongly encourage you to get one. Read the nearby sidebar, "The advantages of setting up a Google account" to find out why.

THE ADVANTAGES OF SETTING UP A GOOGLE ACCOUNT

Several important functions on your phone require a Google account:

- The ability to buy applications from the Google Play Store. (This is big!) I go over the Play Store in Chapter 8.
- The ability to use the Google Drive for storage. (This is pretty important and almost huge!)
- Free access to the photo site Google Photos (although other sites have many of the same features).
- Automatic backup of your contacts and calendar. That's explained in more detail in Chapters 6 and 13.

To make a long story short, it's worth the trouble to get a Google account, even if you already have a personal email account.

Setting up your existing Gmail account

If you already have a Gmail account, setting it up on your phone is easy as can be. Follow these steps from the Apps menu:

1. Find the Gmail icon in the Apps list.

Here is a confusing part. The icon on the left in Figure 5-1 is the Gmail app. The icon on the right is for the general email app. The general email app is for your combined email accounts. The general email account is the app that you will use to access any and all of your email accounts.

2. Tap the Gmail icon.

Because your phone does not know if you have a Gmail account yet, it offers you the option of entering your Gmail account or whether you want to create a new account. This page is shown in Figure 5-2.

Enter your Gmail account email address and tap Next.

Be sure to include the @gmail.com suffix.

Enter your existing Gmail password and tap Next.

Go ahead and type your password. When you're ready, tap Next on the keyboard.

Google	
Sign in with your Google Account	Contraction of the world
	100
profit interviews and any date that the order profits and the state and appearing on the second	
Email or phone	
Next	
Find my account	
Create account	A STATE OF THE STA
One Google Account for everything Google	
GMBBC+>6	nice que grante à
o ig non an gir . The residen	tion, seem yours out
	कर्त जानी स्वाप्त हैं हैं है ।
K.	of a managed the rest
III O C	The second second second

FIGURE 5-2: Add your account page.

You may get a pop-up reconfirming that you agree with the terms of use and all that legal stuff. Tap OK. You'll see lots of flashing lights and whirling circles while your phone and your Gmail account get to know each other.

If everything is correct, your phone and your account get acquainted and become best friends. After a few minutes, they are ready to serve your needs. There are even a few screens that tell you all the wonderful things that your Gmail account will do for you. Believe every word!

If you have a problem, you probably mistyped something. Try retyping your information. From this point on, any email you get in your Gmail account will also appear on your phone!

Setting up a new Gmail account

If you need to set up a new Gmail account, you have a few more steps to follow. Before you get into the steps, think up a good user ID and password.

Gmail has been around for a while. That means all the good, simple email addresses are taken. Unless you plan to start using this email account as your main email, which you could do if you wanted, you're probably best off if you pick some unusual combination of letters and numbers that you can remember for now to get through this process.

When you have all of this ready, follow Steps 1 and 2 in the previous section, but tap the Create Account link when you get to the screen shown in Figure 5-2. From there, follow these steps:

1. Enter your first and last names on the screen.

Google asks for your name in the screen shown in Figure 5-3. This is how Google personalizes any communications it has with you.

You may be tempted to use a fake name or some other clever two-word combination in place of a name. Don't do it. You will still be getting email to Rita Book or Warren Peace long after the humor has worn off.

2. Enter the username you want to use with Gmail.

On the screen shown in Figure 5-3, enter the username you want. Hopefully you get this name approved on the first shot.

If your first choice isn't available, try again. There is no easy way to check before you go through these steps. Eventually, you hit on an unused ID, or you will use one of the suggestions in blue font. When you're successful, it will congratulate you.

3. Pick a good password of at least eight characters.

Be sure to pick one that is unique and that you can remember.

4. Enter the other information and an alternate email address and tap Continue.

If you forget your password, Google wants to verify that you're really you and not someone pretending to be you. Google does this check by sending a confirmation email to another account or sending a text to your phone. You can do this now or tap Skip to do it later.

Initial Account Creation Screen

Follow-up Account Creation Screen

FIGURE 5-3: The Create Your Google Account screen.

After you tap Done, light flashes, and you see the screen working away. This process usually takes less than two minutes. While you wait, you'll see all kinds of messages that it's getting ready to sync things. Don't worry. I explain these messages in good time. For now, you can add any other email accounts you want by following the steps in the next section.

Working with non-Gmail email accounts

Your phone is set up to work with up to ten email accounts. If you have more than ten accounts, I'm thinking that you might have too much going on in your life. No phone, not even the Galaxy S21, can help you there!

I now cover the steps to adding your email accounts. Once you tell your phone all your email accounts, the Email screen will let you see the inbox of each account or combine all your email in a single inbox. You can choose which option works best for you.

Adding your first email account

To get started, have your email addresses and passwords ready. When you have them, go to your phone's Home screen. Look for the Mail icon; it is an envelope in silhouette (refer to Figure 5-1). This is probably on your Home screen as one of the four primary shortcuts just above the Device Function keys or in your application list.

1. Tap the Mail icon from the Home screen.

This brings up a screen like the one shown in Figure 5-4. Choose one of the options to get started. In every case, it starts with entering your email address.

Your email address should include the full shebang, including the @ sign and everything that follows it. Make sure to enter your password correctly, being careful with capitalization if your email server is case-sensitive (most are). If in doubt, select the option that lets you see your password.

FIGURE 5-4: The setup screen for the Email app.

2. Tap the box to enter your password.

Don't be surprised if your S21 brings you to a special screen specifically for your email provider for you to enter your password. Figure 5-5 shows the sign-in screen for a generic email account. Figure 5-6 shows the screen for a Microsoft Exchange account. One of these will work.

FIGURE 5-5: The sign-in screen for a generic email account.

FIGURE 5-6: The Enter Account Information screen for a Microsoft Exchange account,

3. Carefully enter your password in the appropriate field and tap Next.

You're asked for permissions. Just go with the default settings for now. This brings up the screen shown in Figure 5-7.

Select your desired Sync Settings and then tap Next.

You can select how often you want your phone and the email service to synchronize. A lot of thought and consideration has been put into the default settings. If you just want to get started, tap Next.

If you want to fine-tune things later, it is not hard to go back and adjust these settings. These settings are intended to be gentle on your data usage.

FIGURE 5-7: The Sync Settings screen.

If you want images in email to download immediately, store older email messages on your phone, or check to see whether you have new email all the time, you can change these settings on this page for this email account. If you know what you want that is different from the default settings, make the changes and then tap Next.

5. Enter a name for the new email account.

The next screen is shown in Figure 5-8. This gives you the option to call your email account something other than its address. You can call it what you like, but I recommend choosing something shorter, like Joe's MSN or My Hotmail. (Do as I say, not as I do.)

6. Tap Done.

Using Figure 5-9 as an example, you can see that my account is now registered on my phone. It worked!

FIGURE 5-8: Naming your email account.

FIGURE 5-9: The Email Home screen.

Adding additional email accounts

Once you have entered your first email account, there are a few different steps to add additional accounts.

1. Tap the Options icon at the top-left part of the screen.

The three horizontal lines bring up the slide-in screen shown in Figure 5-10. This allows you to see other email folders. It also lets you access the setting icon.

The Options slide-in screen.

2. Tap the Settings icon.

Tapping Settings brings up the screen shown in Figure 5-11.

3. Tap Add Account next to the green plus sign.

This brings you back to the email setup screen (refer to Figure 5-5).

FIGURE 5-11: The Email Settings screen.

At this point you can add up to nine more accounts, and remember, you will be asked which email account you want to be your primary account. It is entirely up to you. You can send and receive email from all your accounts by selecting it, but only one can be the primary account used if you send an email from another application, such as the Contacts app.

Setting up a corporate email account

In addition to personal email accounts, you can add your work email account to your phone — if it's based upon a Microsoft Exchange server, that is, and if it's okay with your company's IT department.

Before you get started, you need some information from the IT department of your company:

- >> The domain name of the office email server
- >> Your work email password
- >> The name of your exchange server

If the folks in IT are okay with you using your phone to access its email service, your IT department will have no trouble supplying you with this information.

Before you set up your work email on your phone, make sure that you have permission. If you do this without the green light from your company, and you end up violating your company's rules, you could be in hot water. Increasing your productivity won't be much help if you're standing out in the parking lot holding all the contents of your office in a cardboard box.

Assuming that your company wants you to be more productive with no extra cost to the company, the process for adding your work email starts at your email Home screen shown in Figure 5–5.

1. Enter your email address and password.

The Corporate screen is shown in Figure 5-12.

FIGURE 5-12: The Corporate setup email screen.

2. Tap Manual Setup.

This brings up the screen shown in Figure 5-13.

Chances are that you don't have the foggiest notion what any of this means or what you are to do now.

Verify that your IT department is good with you having email on your own device and have them give you the necessary settings.

The Manual Setup screen for adding corporate email accounts.

Seriously. It is increasingly common that a firm will give you access on your phone. At the same time, companies do not generally circulate documents with how to make this happen. This would be a big security problem if anyone could get access. Save yourself the time and get help from IT.

Reading Email on Your Phone

In Figure 5-9, you can see how the email screen looks for what I have called My Personal Email. You can also set up this screen so that it combines all your email into one inbox. At any given time, you might want to look at the accounts individually or all together.

To look at all your email in one large inbox, tap the downward pointing arrow next to the word Inbox and select Combined Inbox. This lists all your email in chronological order. To open any email message, just tap it.

If, on the other hand, you want to see just email from one account, tap the box at the top that says Combined Inbox. When you tap this icon, your phone will display all the individual email accounts. Tap on the account you want to focus on at the moment, and your phone will bring up your email in chronological order for just that email address.

Writing and Sending Email

After you set up the receiving part of email, the other important side is composing and sending email. At any time when you're in an email screen, simply tap the Menu button to get a pop-up screen. From the pop-up menu, tap the Compose icon to open the email composition screen.

Here's the logic that determines which email account will send this email:

- If you're in the inbox of an email account and you tap the Compose icon after tapping Menu, your phone sends the email to the intended recipient(s) through that account.
- If you're in the combined inbox or some other part of the email app, your phone assumes that you want to send the email from the default email account that you selected when you registered your second (or additional) email account.

When you tap the Compose icon in the Menu pop-up menu, it tells you which account it will use. The Email composition screen shown in Figure 5-14 says this email will be coming from this account: galaxysfordummies@qmail.com.

As shown in this screen, the top has a stalwart To field, where you type the recipient's address. You can also call up your contacts, a group, or your most recent email addresses. (Read all about contacts in Chapter 6.) Tap the address or contact you want, and it populates the To field.

Below that, in the Subject field, is where you enter the email's topic. And below that is the body of the message, with the default signature, *Sent from my Samsung Galaxy S21*, although your cellular carrier might have customized this signature.

At the top of the screen are three links:

- >> Attach: Tap this hyperlink to attach a file of any variety to your email.
- >> Send: Tap this icon that looks like a paper airplane to send the email to the intended recipient(s).

The Email composition screen.

- >> More (three vertical dots): Tap this option, and you get the pop-up shown in Figure 5-15. This may give you some of the following options:
 - Save in Drafts: This allows you to complete the email later without losing your work.
 - Send email to myself: This is an alternative to saving the email in your Sent mail folder.
 - Priority: This option signifies that this is more important that the average email to your recipients.
 - Security options: You have some fancy, 007 options here. You can sign
 the document or encrypt it.
 - Turn on Rich text: To save data usage, email is sent in a default font. If you want to burn at little more data, you can get creative and add more elaborate fonts.
 - **Permission:** This is an advanced setting to have a fancy template for the background in your email.

Save in Drafts

Priority

Security options

Turn on Rich text

FIGURE 5-15: Composition email options.

Permission

If you change your mind about sending an email message, you can just tap the Back key. If you're partially done with the message, you're asked whether you want to save it in your Drafts folder.

The Drafts folder works like the Drafts folder in your computer's email program. When you want to continue working on a saved email, you open the Drafts folder, tap on it, and continue working.

Replying to and Forwarding Email

Replying to or forwarding the email that you get is a common activity. You can do this from your Email app. Figure 5-16 shows a typical open email message.

You can reply by tapping the icon with the return arrow at the bottom of the screen. If other people were copied on the email, you could tap the double return arrow to Reply All.

When you tap either of these options, the Reply screen comes back with the To line populated by the sender's email address (or addresses) and a blank space where you can leave your comments. (In the case of Figure 5-16, you could ask that your dad not send you any more jokes like these.)

To forward the email, tap the arrow pointing to the right above the word Forward and enter the addressee just as you do when sending a new email.

FIGURE 5-16: An opened email.

88

- » Getting all your contacts in one location
- » Keeping up to date with just a few taps

Chapter 6

Managing Your Contacts

ou're probably familiar with using contact databases. Many cellphones automatically create one, or at least prompt you to create one. You also probably have a file of contacts on your work computer, made up of work email addresses and telephone numbers. And if you have a personal email account, you probably have a contact database of email accounts of friends and family members. If you're kickin' it old school, you might even keep a paper address book with names, addresses, and telephone numbers.

The problem with having all these contact databases is that it's rarely ever as neat and tidy as I've just outlined. A friend might email you at work, so you have her in both your contact databases. Then her email address might change, and you update that information in your personal address book but not in your work one. Before long, you have duplicate and out-of-date contacts, and it's hard to tell which is correct. How you include Facebook or LinkedIn messaging in your contact profile is unclear.

In addition to problems keeping all your contact databases current, it can be a hassle to migrate the database from your old phone. Some cellular carriers or firms have offered a service that converts your existing files to your new phone, but it's rarely a truly satisfying experience. You end up spending a lot of time correcting the assumptions it makes.

You now face that dilemma again with your Galaxy S21: deciding how to manage your contacts. This chapter gives you the advantages of each approach so that you can decide which one will work best for you. That way, you won't have the frustration of wishing you had done it another way before you put 500 of your best friends in the wrong filing system.

Using the Galaxy S21 Contacts App

Your phone wants you to be able to communicate with all the people you would ever want to in any way you know how to talk to them. This is a tall order, and your Galaxy S21 makes it as easy as possible. In fact, I wouldn't be surprised if the technology implemented in the Contacts app becomes one of your favorite capabilities of the phone. After all, your phone is there to simplify communication with friends, family, and coworkers, and the Contacts app on your phone makes it as easy as technology allows.

At the same time, this information is only as good as your contact database discipline. The focus of this section is to help you help your phone help you.

Learning the Contacts App on your phone

The fact of the matter is, if you introduced your phone to your email accounts in Chapter 5, the Contacts list on your phone has all the contacts from each of your contact lists.

Take a look at it and see. From your Home screen, tap the Contacts icon.

If you haven't created a Gmail account, synced your personal email, or created a contact when you sent a text or made a call, your Contacts list will be empty. Otherwise, you see a bunch of your contacts now residing on your phone (as shown in Figure 6-1).

The top of the contact list includes the contacts with which you most frequently interact. As you swipe upward, the rest of your contacts are in alphabetical order.

This Contacts database does more than just store names, phone numbers, and email addresses. However, you can have the contact include any or all of the following information:

Top of the Contact List

The "E's" in the Contact List

FIGURE 6-1: The Contacts list.

Menu

- All telephone numbers, includingMobile
 - Home
 - Work
 - Work fax
 - Pager
 - Other
- >> Email addresses
 - Home
 - Work
 - Mobile

- >> Instant Messaging addresses
- >> Company/organization
- >> Job title
- >> Nickname
- >> Mailing address for
 - Home
 - Work
 - Another location
- >> Any notes about this person
 - Web address
 - Birthday (or other significant event)
 - A phonetic spelling of the name

As if all this weren't enough, you can assign a specific ringtone to play when a particular person contacts you. I cover the steps to assign a music file to an individual caller in Chapter 12.

Finally, you can assign a picture for the contact. It can be one out of your Gallery; you can take a new picture; or you can connect to a social network like Facebook and use that person's profile picture.

Fortunately, the only essential information is a name. Every other field is optional and is only displayed if the field contains information to be displayed. Figure 6-2 shows a lightly populated contact.

Deciding where to store your contacts

Before you get too far, it is important for you to decide the default option where you want to store your contacts. Deciding this now with the information this section provides you will make your life much easier as you go forward. It is possible to combine contact databases, but even the best tools are imperfect.

A lightly populated contact.

The first time you try to save a new contact, the Contacts App will offer you a popup screen, as shown in Figure 6-3. This lists the options you have and will take your first entry as the option you want as a default.

Whenever you save a new entry, you can manually switch to another of these databases. Save yourself some time and aggravation and decide now what you want to do. Here are your options on where to save new contacts:

- >> Within the memory of your phone
- >> On the SIM card inserted in your phone
- >> Within your Samsung account
- >> Within your Gmail account
- >> As a contact in one of your other accounts

FIGURE 6-3: Choosing a default for creating new contacts.

Each of these options has advantages and disadvantages. If you simply want my advice, I suggest using your Gmail account to store new contacts. If this satisfies you, skip to the next section on linking contacts from other sources. Read on if you need some context.

Here is the deal: If everything is working properly, all options work equally well. However, if you switch phones regularly, ever lose you phone, need to make significant updates to your contacts, or are frequently out of wireless coverage, such as on an airplane, you should consider the options.

The first option mentioned involves storing your contacts within your phone. This is a great option, as long as you have your phone. However, there will come a day when Samsung (or HTC, or LG, and so on) has something faster and better, and you will want to upgrade. At that point, perhaps next year or in ten years, you will need to move your contacts to another location if you want to keep them. Plus, if you lose your phone, I sure hope that you have recently used one of the backup options I explore in this chapter.

The second option is to store your new contacts on your SIM card. The SIM card is familiar technology if your previous phone worked with AT&T or T-Mobile. Figure 6-4 shows a profile of a typical SIM card, next to a dime for scale, although yours probably has the logo of your cellular carrier nicely printed on the card. To the right of the SIM card is the newer micro SIM card. This is the same idea, but in a smaller package.

FIGURE 6-4: A SIM card and a micro SIM card.

The cool aspect of using your SIM card is that you can pluck it out of your existing phone and pop it in another phone and all your contacts come with you. It works this easily if you stay with an Android smartphone of recent vintage. It almost works this easily if you, say, switch back to a feature phone (as in the kind of phone that merely makes calls and texts and costs \$1). Another advantage is that your SIM card does not rely on having a wireless connection to update changes.

The next option is to store new contacts on your Gmail account. What this means is that your new contacts are automatically copied from your phone to the Gmail account of Google servers. This keeps the records on your phone, but Google maintains a copy of this record in your Gmail account. You can make changes to a contact on your phone or on your PC.

The two reasons I recommend using your Gmail account are:

- >> You can maintain these records with your full-sized keyboard rather than the smaller keyboard on your phone.
- >> It is easy to get back all these contacts on a new Android phone simply by telling the new phone your Gmail account. Because you will probably enter your Gmail account right away when you get a new phone, your contacts reappear quicker than they would with the fourth option.

The fourth option is to store the contacts in one of your existing email accounts. This may be the best option if you already consider your email, either your personal or work account, to be the primary location where you store contacts. If you already have good database discipline with one of your email accounts, by all means, use this email account as the default place to store new contacts.

If this particular account you currently use for keeping your contacts is not set up yet on your phone, you can tap the Add New Account link shown in Figure 6-3 to go through the process described in Chapter 5 to set up a new email account.

Linking Contacts on your phone

The Contacts list is smart. Allow me to explain some of the things that are going on.

Say your best friend is Bill McCarty, affectionately known as "the Kid." You sent Bill a text earlier to let him know about your new phone. You followed the instructions on how to send a text in Chapter 4 and entered his telephone number. You took it to the next step and tapped Add Contact. When you were prompted to add his name, you did. Now your phone has a contact, "Bill McCarty."

Then you linked your email. Of course your buddy Bill is in your email Contacts list. So while you were reading this chapter, several things happened. First, these two contacts automatically synced. Your phone thinks about it and figures this must be the same person. It automatically combines all the information in one entry on your phone!

Then your phone automatically updates your Gmail account. On the left side of Figure 6-5, you see Bill's mobile number. This contact is synced with your Gmail account. You didn't have to do anything to make this happen.

Your phone noticed that Bill's work number was in your email contact information, but the mobile phone number you used to text him was not. No problem! Now the contact on your phone includes both the information you had in your email contact as well as his cellular phone.

Now, as slick as this system is, it isn't perfect. In this scenario, both contacts have the same first and last name. However, if the same person also goes by a different name, you have to link these contacts. For example, if you created a contact for Bill McCarty, but your email refers to him as William H. McCarty, your phone will assume that these are two different people. This is shown in Figure 6-6.

William H. McCarty

William H. McCarty

Home
billy@thekid.com

FIGURE 6-5: Two contacts for the same person.

FIGURE 6-6: The Linking Page for Bill McCarty.

No problem, though. Do you see the three vertical dots in Figure 6-6? Here are the steps to link the two contacts for the same person:

1. From a contact, tap on the three vertical dots.

This brings up the pop-up shown in Figure 6-7.

FIGURE 6-7: The pop-up with the linking suggestions.

2. Tap the Link Another Contact link.

Your phone will try to help you with some suggestions. If it gets it all wrong, you can just find the other contact by searching alphabetically, as shown in Figure 6-8.

The linking suggestions.

3. Tap the contact you want joined.

In this case, the second guess, Bill McCarty, is the one you want. Tap the face (or circle) to the left of his name and then the two contacts are linked.

4. Now tap the link that says Link in the bottom center of the screen.

This combined link will now have all the information on this one person.

Creating Contacts within Your Database

Your phone is out there trying to make itself the ultimate contact database with as little effort on your part as possible. The interesting thing is that the salesperson in the cellular store probably didn't explain this to you in detail. It's a subtle-but-important capability that's hard to communicate on the sales floor. Here's what happens.

Whenever you make or receive a call, send or receive an email, or send or receive a text, your phone looks up the telephone number or email address from which the message originated to check whether it has seen that address before. If it has, it has all the other information on that person ready. If it doesn't recognize the originating telephone number or email, it asks whether you want to make it a new contact or update an existing one. What could be easier?

Adding contacts as you dial

When you get a call, a text, or an email from someone who isn't in your contacts, you're given the option to create a profile for that person. The same is true when you initiate contact with someone who isn't in your Contacts list. Chapter 3 shows you the empty and full dialing screens. The image on the left in Figure 6-9 shows the phone trying its best to anticipate the person you are in the process of calling, and, if it is not saved already, the image on the right shows how it offers you the option to add this number to your contacts.

You're immediately given the option to create a contact or update an existing contact. Your phone doesn't know whether this is a new number for an existing contact or a totally new person. Rather than make an assumption (as lesser phones on the market would do), your phone asks you whether you need to create a new profile or add this contact information to an existing profile.

Dialing in Process with Guesses

		1
400	aron C. Aardvark	14255551617
8 w	illiam H. McCarty	14255554567
A 1	4255551234	Unsaved
	1 425-5	55
1	2 ABC	3 DEF
4	5	6 MNO
7 PQRS	8	9 wxyz
*	0	#
		•
) man	r	**************************************

Dialing of a New Number

The dialing screens in process and when there is a new number.

Keep in mind that if you are calling an existing contact and your phone guesses the right person, you can save yourself time and tap the phone to dial.

Say that you want to enter this number as a new contact. You follow these steps:

1. Tap the Create Contact link.

A new contact page appears. An example is shown in Figure 6-10.

The number is already populated. You just need to fill in the correct name plus any other information that you want associated with this person.

2. When you're done typing in the information for this contact, tap Save at the top of the contact.

Figure 6-10 shows the Save button at the bottom of the screen.

A partially populated contact.

Adding contacts manually

Adding contacts manually involves taking an existing contact database and adding its entries to your phone, one profile at a time. (This option, a last resort, was the only option for phones back in the day.)

1. Tap the Contacts icon.

Doing so brings up the list of existing contacts shown in Figure 6-1.

2. Tap the Add Contacts icon (the + [plus] sign next to a silhouette).

This icon is shown in Figure 6-11. Tapping it will bring up a blank contact page with nothing populated.

- 3. Fill in the information you want to include.
- 4. When you're done entering data, tap Save at the bottom of the screen.

The profile is now saved. Repeat the process for as many profiles as you want to create.

The Add Contacts icon.

How Contacts Make Life Easy

Phew. Heavy lifting over. After you populate the profiles of dozens or hundreds of contacts, you're rewarded with a great deal of convenience.

To contact someone from the Contacts directory, start by tapping the contact icon. Your Contacts list appears (refer to Figure 6-1). Scroll down or search for the contact you want. When you tap that contact name, you're given some choices, as shown in Figure 6-12.

The Contacts database when you tap a profile.

I've tapped on the contact for my friend, Ludwig, and I have choices:

- >> Tap the green telephone next to the number to dial that number.
- >> Tap the blue message icon to send a text.
- >> Tap the green video call icon to have a video chat.
- >> Tap the gray envelope icon to send an email.

About the only thing that tapping on a data field won't do is print an envelope for you if you tap the mailing address! At the bottom of the contact is a button that says History. This is a running log of all your communications with that contact regardless of the media you used. Figure 6-13 shows an example.

It is all there.

FIGURE 6-13: Your history with that person.

Playing Favorites

Over the course of time, you'll probably find yourself calling some people more than others. It would be nice to not have to scroll through your entire Contacts database to find those certain people. Contacts allow you to place some of your contacts into a Favorites list for easy access.

From within the Contacts app, open the profile and notice the star next to that person's name (refer to Figure 6-12). To the right of the contact name is a star. If that star is gold, that contact is a Favorite. If not, then not.

To make a contact into a star, tap the blank outline of the star. To demote a contact from stardom without deleting, tap the gold star.

You won't immediately see a difference in your contacts other than the appearance of the gold star. When you open your phone, however, this contact now appears under your Favorites tab. The Favorites tab is like a mini-contact database. It looks similar in structure to your regular Contacts database, but it includes only your favorites.

Living on the Internet

IN THIS PART . . .

Surf the web from your phone.

Get to know Google's Play Store and add exciting new apps to your phone.

- » Changing the browsing settings
- » Visiting websites
- » Adding and deleting bookmarks

Chapter 7

You've Got the Whole (Web) World in Your Hands

f you're like most people, one of the reasons you got a smartphone is because you want Internet access on the go. You don't want to have to wait until you get back to your laptop or desktop to find the information you need online. You want to be able to access the Internet even when you're away from a Wi-Fi hotspot — and that's exactly what you can do with your Galaxy S21 phone. In this chapter, I show you how.

The browser that comes standard with your Galaxy S21 works almost identically to the browser that's currently on your PC. You see many familiar toolbars, including the Favorites bar and search engine. And the mobile version of the browser includes tabs that allow you to open multiple Internet sessions simultaneously.

This chapter goes into much more detail on using the Internet browser on your Galaxy S21, as well as the websites you can access from your phone, and discusses some of the trade-offs you can make when viewing a web page.

Starting the Browser

You have three options for getting access to information from the Internet via your Galaxy S21 phone. Which one you use is a personal choice. The choices are

- Use the regular web page. This option involves accessing a web page via its regular address (URL) and having the page come up on your screen. The resulting text may be small.
- >> Use the mobile web page. Almost all websites these days offer a mobile version of their regular web page. This is an abbreviated version of the full website that can be more easily read on a mobile device.
- >>> Find out whether a mobile app is associated with the web page. Many websites have found that it is most expedient to write a mobile application to access the information on its website. The app reformats the web page to fit better on a mobile screen a convenient option if you plan to access this website regularly. I cover the trade-offs about this option later in the section "Deciding between Mobile Browsing and Mobile Apps" and explore how to find and install such apps in Chapter 8.

With this background, head to the Internet. On your Galaxy S21 phone, you may have a few choices on how to get there. Figure 7-1 shows three possible icons that can get you there. Tap any of these, and you can start surfing.

Possible paths to the Internet on your Galaxy S21.

If you want a little more understanding as to why there are multiple options, read the nearby sidebar on Internet terminology.

For your purpose, tap either the Chrome icon or the Google icon to get started. These icons will typically be on the Home screen. Alternatively, tap the Application icon and find the Chrome or Google icon.

If you love Bing, you are not out of luck. Bing is either on your phone, or you can get it installed (I cover how to install things like Bing in Chapter 8.) For now, just stay with Chrome and Google. Things on other browsers and search engines are mostly similar, and choosing the Chrome/Google pair simplifies things.

BASIC INTERNET TERMINOLOGY FOR DUMMIES

The term *Internet access* can mean a few different things. In some circumstances, the word Internet can mean a web browser. A *web browser* is an app that will display pages on the Internet. In other circumstances, the word Internet may refer to a search engine. You use a *search engine* to find either information you are seeking or to bring you to a website. Then you use a web browser to look at the information. Chances are the web browser on your phone that you will use is an app from Google called Chrome.

The chances are that the search engine you use on your phone is Google, but it may be the search engine for Microsoft called Bing. The goal with your phone is to get you where you want with minimal fuss. It is easier for the people who are bringing you this phone and service (Samsung, Google, and your wireless carrier) to give you three icons that essentially point to the same thing than to explain the terminology. Tapping the Internet icon, the Chrome icon, or the Google icon will most likely bring up the Chrome web browser.

As long as you're connected to the Internet (that is, you are either near a Wi-Fi hotspot or in an area where you have cellular service), your home page appears. If you tap the Google icon, it will be Google. If you tap Chrome, your default home page could be blank or the Google home page, but many cellular carriers set their phones' home pages to their own websites.

If you're out of coverage range or you turned off the cellular and Wi-Fi radios because you turned on Airplane mode, you get a pop-up screen letting you know that there is no Internet connection. (Read about Airplane mode in Chapter 2.)

If you should be in coverage but are not connected or when you get off the airplane, you can reestablish your connections by pulling down the Notification screen and either tapping the Wi-Fi icon at the top or turning off Airplane mode.

Accessing Mobile (or Not) Websites

The browser on your phone is designed to work like the browser on your PC. At any time, you can enter a web address (URL) by tapping the text box at the top of the screen. You can try this by typing in the address of your favorite website and seeing what happens.

For example, the page shown in Figure 7-2 is the desktop version of the website Refdesk.com.

The desktop version of the website Refdesk.com.

As you can see, the website is all there. Also as you can see, the text is very small. This particular website is designed to take you to a lot of useful links throughout the Internet, so this is an extreme example of a regular website.

While this text is crisp and bright on your beautiful screen, it is still small. You can stretch and pinch to find the information you need. (Stretching and pinching are hand movements you can use to enlarge/shrink what you see onscreen, as covered in Chapter 2.) With a little bit of practice, you can navigate your familiar websites with ease.

The other option is to find the mobile version of a website. As a comparison, Figure 7-3 shows the mobile version of Refdesk.com. It has fewer pictures, the text is larger, and the mobile version loads faster — but it's less flashy.

So how do you get to the mobile websites? If a website has a mobile version, your phone browser will usually bring it up without your having to do anything. Samsung has gone out of its way to make the web experience on the Galaxy S21 phone as familiar as possible to what you experience on your PC.

FIGURE 7-3: The mobile version of Refdesk.com.

Choosing Your Search Engine

If you tapped one of the icons shown in Figure 7-1, you opened up the browser. Now would be a good time to try some of your favorite websites. Go ahead and tap in a few website addresses and see how they look!

One of the early goals for browsers that work on smartphones was to replicate the experience of using the Internet on a PC. For the most part, the browsers on your phone achieve that goal, even if you probably need to practice your zooming and panning.

One of the key decisions for your browser is which search engine you want as the default. You probably want whatever is the search engine that exists on your desktop PC. The leading options are all really good, but you'll probably be happiest with the search engine that you use the most. If you don't care, feel free to skip to the next section on bookmarks.

1. From the browser screen, tap the Settings icon.

Tapping the Settings icon, the icon that looks like a gear, brings up the menu options shown in Figure 7-4.

The Settings Menu options.

2. Tap the Apps link.

Tapping the Apps link brings up the screen shown in Figure 7-5.

3. Choose default apps link.

The screen shown in Figure 7-6 appears.

4. Tap the link for Browser App.

The screen shown in Figure 7-7 appears.

5. Select the search engine you want.

Tapping the toggle switch by the name of the search engine you prefer takes care of it all.

FIGURE 7-5: The Apps screen.

FIGURE 7-6: The Default Apps selections.

FIGURE 7-7: The Search Engine selections.

Deciding between Mobile Browsing and Mobile Apps

When you open the browser, you can use any search engine you want (for example, Bing or Yahoo!). This is a very familiar approach from your experience with PCs. However, you may get very tired of all the pinching and stretching of the screen.

Many companies are aware of this. What they have done is to develop a mobile app that provides you the same information as is available on their website that is formatted for a smartphone screen. Companies in particular will put the information from their website in a mobile app and then add some important mobile features.

For example, it is very convenient to order a custom-made pizza from the website of a national pizza chain. You can order your desired variety of crusts and toppings. The website version also offers directions to the nearest store. The mobile app can take this one step further and give you turn-by-turn directions as you drive to pick up your pizza.

This capability of providing turn-by-turn directions makes no sense for a desktop PC. This capability could make sense for a laptop, but a few laptops have GPS receivers built in. It is also too cumbersome and probably unsafe to rely on turn-by-turn directions from a laptop. It is much easier to get turn-by-turn directions over a smartphone.

This is just one example where downloading a mobile app offers a superior experience. The best part is you get to choose what works for you on your Galaxy S21.

- » Getting to know Play Store
- » Finding Play Store on your phone
- » Seeing what Play Store has to offer
- » Downloading and installing Facebook for Android
- » Rating and uninstalling apps

Chapter 8

Playing in Google's Play Store

ne of the things that makes smartphones (such as the phones based on the Google Android platform) different from regular mobile phones is that you can download better apps than what comes standard on the phone. Most traditional cellphones come with a few simple games and basic apps. Smartphones usually come with better games and apps. For example, on your Galaxy S21 phone, you get a more sophisticated Contact Manager, an app that can play digital music (MP3s), basic maps, and texting tools.

To boot, you can download even better apps and games for phones based on the Google Android platform. Many apps are available for your Galaxy S21 phone, and that number continues to grow over time.

So where do you get all these wonderful apps? The main place to get Android apps is the Google Play Store (sometimes simply called "Google Play"). You might be happy with the apps that came with your phone, but look into the Play Store and you'll find apps you never knew you needed and suddenly won't be able to live without.

In this chapter, I introduce you to the Google Play Store and give you a taste of what you find there.

Exploring the Play Store: The Mall for Your Phone

The Play Store is set up and run by Google, mainly for people with Android phones. Adding an app to your phone is similar to adding software to your PC. In both cases, a new app (or software) makes you more productive, adds to your convenience, and/or entertains you for hours on end — sometimes for free. Not a bad deal.

There are some important differences, however, between installing software on a PC and getting an app on a cellphone:

- >> Smartphone apps need to be more stable than computer software because of their greater potential for harm. If you buy an app for your PC and find that it's unstable (for example, it causes your PC to crash), sure, you'll be upset. If you were to buy an unstable app for your phone, though, you could run up a huge phone bill or even take down the regional cellphone network. Can you hear me now?
- >> There are multiple smartphone configurations. These days, it's pretty safe to assume that your computer has standard capabilities. There are differences in the amount of memory and speed of the processor. Otherwise, most PCs are similar. On the other hand, the various smartphones have significantly different features. There is a great deal of smartphone software built on the Android platform that cannot work with many Android smartphones. The Play Store ensures that the app you're buying will work with your version of phone.

Getting to the Store

You can access the Play Store through your Galaxy S21 phone's Play Store app or through the Internet. The easiest way to access the Play Store is through the Play Store app on your Galaxy S21 phone. The icon is shown in Figure 8-1.

If the Play Store app isn't already on your Home screen, you can find it in your Apps list. To open it, simply tap the icon.

TIP

When you tap the Play Store icon, you're greeted by the screen looking something like what is shown in Figure 8-2.

FIGURE 8-1: The Play Store icon.

FIGURE 8-2: The Play Store home page. As new apps become available, the highlighted apps will change, and the Home page will change from one day to the next.

In addition, the good folks at Google spend a lot of time thinking about what is the best way to help the hundreds of millions of Android users find the best application from the selection of 3.1 million apps.

This is no small task. Some of those users are very experienced and know just what they want. Others are walking in the door for the first time while still others are just coming to browse and see whether anything strikes their fancy.

The goal for Google is to make all users who comes in find what they want. The goal in this book is to give you enough information so that you can be comfortable downloading your first app and then comfortable finding other interesting apps as you become more familiar with the layout.

Seeing What's Available: Shopping for Android Apps

The panorama that exists for the Google Play home page seen in Figure 8-2 is very extensive. You can swipe to the right a long way and you can swipe down dozens of levels. Take a look at the structure of Figure 8-2.

TIP

Do not be surprised if you open up the Play Store home page one day and find that it has a completely different layout. Google tries different formats from time to time to solve one problem or another and keep things fresh. The chances are good that the lower level categories are still there, and you can find what you are looking for, even if the structure described in this chapter is no longer exactly accurate.

The first stab at helping you sort through the millions of things you can download to your S21 is the offering categories. You find these at the bottom of the page.

Sames: Games are apps in which you're are an active participant. See Chapter 11 for much more information on this topic.

- >> Apps: This is a catchall category. It includes the apps for productivity, information, social connection, or enjoyment.
- >> Movies & TV: The Google Play Store is a great source for video entertainment. Chapter 12 has more information on this subject.
- Books: This is the section for audiobooks and e-books. Audiobooks are the smartphone version of books on tape, where a person reads you the book. E-books allow you to use your smartphone as an e-reader.

The Apps option in Figure 8-2 is highlighted at the bottom of the page. If you tap one of the other categories, it will change the layout to show whatever kind of offering you're seeking.

Navigating the Google Play apps offerings

When you've decided that you want to look at apps, you see the following options when you tap the link for one of the top-level categories:

- >> For You: The geniuses at Google have some mathematical wizardry that tries to match you with apps that they think you would like based upon what you're already using. This is mostly a shot in the dark if you're new to the Play Store. As you use your smartphone, these guesses improve over time.
- >> Top Charts: These are the best-selling apps. This is often a good indication that you may want to give it a try.
- >> Categories: This option takes you to a hierarchy of app types that is useful if you already know what you want to add. There is more on these different categories later in this chapter.
- >> Kids: If you're looking for apps suitable for kids, go here.
- >> Editors' Choice: While relying on sales volumes in Top Charts is one way to find apps you may find valuable, this section is curated, hopefully with people who think like you.

Google is doing its best to help you find the app you need among its inventory of millions of choices. Today's version of the Play Store has a link called Categories where you can start digging by app type.

- Art & Design: These apps let you exercise the powerful graphics process to make some cool images, from the abstract to the practical, such as floorplans.
- Augmented Reality: These apps give you the chance to use your camera lens and see things that are not there (in a good way).

- **>> Auto & Vehicles:** We love our cars. These apps help you buy them for less, enjoy them more, and enjoy them for a longer time.
- Beauty: These apps offer tips and techniques on how to look that much better.
- Books & Reference: These apps include a range of reference books, such as dictionaries and translation guides. Think of this section as similar to the reference section of your local library or bookstore.
- **>> Business:** These apps bring you to job search sites, business that will ship your packages, and instant messages with your work cronies.
- >> Comics: These apps are meant to be funny. Hopefully, you find something that tickles your funny bone.
- >> Education: To quote Emil Faber, "Knowledge is good." Senator Blutarsky agrees.
- >> Entertainment: Not games per se, but these apps are still fun: trivia, horoscopes, and frivolous noisemaking apps. (These also include Chuck Norris facts. Did you know that Chuck Norris can divide by 0?)
- >> Events: Who doesn't enjoy the occasional blue-light special for some software you've been considering? This also brings you to sites that sell you theater tickets. New events like these are coming up every day.
- >> Finance: This is the place to find mobile banking apps and tools to make managing your personal finances easier.
- >> Food & Drink: Here is the place to find the best restaurants and obtain the best recipes.
- Health & Fitness: This is a category for all apps related to staying healthy, including calorie counters, and fitness tracking.
- >> House & Home: Most of us like to have a place to call home. These apps help you find a home, furnish it to your liking, and keep it a comfortable temperature while minimizing your carbon footprint.
- >> Kids: Again with the Kids. Just tell them to get off my lawn by learning something interesting on a colorful app.
- >> Libraries & Demo: Computers of all sizes come with software libraries to take care of special functions, such as tools to manage ringtones, track app performance, and protect against malware.
- >> Lifestyle: This category is for apps that involve recreation or special interests, like philately or bird-watching.

- >> Maps & Navigation: Many apps tell you where you are and how to get to where you want to go. Some are updated with current conditions, and others are based on static maps that use typical travel times.
- >> Medical: These are tools to help manage chronic conditions, such as diabetes, and buy your prescriptions at a lower cost.
- >> Music & Audio: The Galaxy S21 comes with music and video services, but nothing says you have to like them. You may prefer offerings that are set up differently or have a selection of music that isn't available elsewhere.
- >> News & Magazines: You'll find a variety of apps that allow you to drill down until you get just the news or weather that's more relevant to you than what's available on your extended Home screen.
- >> Parenting: All those apps for kids must mean that there are lots of parents out there. This category is for the people who created the kids.
- >> Personalization: These tools help you express your individuality just like everyone else.
- >> Photography: In case the camera, photo, and video apps I cover in Chapters 9 and 10 aren't sufficient for you, here are lots more choices and add-ins.
- >> Productivity: These apps are for money management (such as a tip calculator), voice recording (such as a stand-alone voice recorder), and time management (for example, an electronic to-do list).
- >> Shopping: These apps give you rapid access to mobile shopping sites or allow you to do automated comparison shopping.
- >> Social: These are the social networking sites. If you think you know them all, check here just to be sure. Of course, you'll find Facebook, LinkedIn, Twitter, and Pinterest, but you'll also find dozens of other sites that are more narrowly focused and offer apps for the convenience of their users.
- >> Sports: You can find sports sites to tell you the latest scores and analyses in this part of the Play Store.
- >> Tools: Some of these apps are widgets that help you with some fun capabilities. Others are more complicated and help you get more functionality from your phone.
- >> Travel & Local: These apps are useful for traveling, including handy items, such as currency translations and travel guides. The local apps are great for staycations.

- Video Players & Editors: You have the highest resolution camcorder and one of the most powerful graphics cards in your S21. These apps take the standard apps to the next level.
- >> Weather: These are the myriad choices for finding out weather conditions in the way that suits your fancy.

Then there are the curated categories, which change over time. The Google Play Store does its best to keep these categories fresh and customized for your needs and tastes.

The Play Store's algorithms aren't always perfect. For some reason, they keep showing me curated apps related to fashion, personal hygiene, and self-grooming. This has to be a mistake.

Many of your favorite websites are now offering apps that are purpose-built for your phone. Chapter 7 talks about how you can access websites on your phone. You can use the full site with your high-resolution screen or use the mobile version. An alternative is to download the app for that website, and it will present the information you want from that website on your phone in a way that is even easier to access. In fact, when you enter a website, your phone looks to see if you have the corresponding app. If so, your phone automatically opens the app for you. Cool!

Installing and Managing an Android App

To make the process of finding and downloading an app less abstract, I show you how to download and install one in particular as an example: the Facebook for Android app.

Follow these steps to add this app:

- 1. Tap the Play Store icon, and verify that the Offering category is for Apps.
- 2. In the Query box, type Facebook.

Doing so brings up a drop-down screen like the one shown in Figure 8-3.

As you can see in the search results, several options include the word Facebook. The other lines in the Apps section are for apps that include the word Facebook. These are typically for apps that enhance Facebook in their own ways — as of this moment, 112,160 of them. Rather than go through these one by one, stick with the one with the Facebook icon.

FIGURE 8-3: The Facebook Search results.

3. Tap the Facebook logo.

When you tap the box, it brings up the screen shown in Figure 8-4.

- Title Line: The top section has the formal name of the app just above the green Install button. After you click this to download and install the app, you see some other options. I give some examples later in this chapter.
- Description: This tells you what the app does.
- Screen Captures: These representative screens are a little too small to read, but they do add some nice color to the page.
- What's New: This information is important if you have a previous version of this app. Skip this section for now.
- Ratings and Reviews: This particular app has about 4.1 stars out of 5.
 That's not bad at all. The other numbers tell you how many folks have voted, how many have downloaded this app, the date it was released, and the size of the app in MB.
- Similar Apps: Just in case you aren't sure about this particular app, the good folks at Google offer some alternatives.

- More by Facebook: The app developer in this case is Facebook. If you like the style of a particular developer, this section tells you what other apps that developer offers.
- Based on Your Recent Activity: Play Store tells you the names of other apps downloaded by the customers who downloaded this app. It's a good indicator of what else you may like.
- **Google Play Content:** This is how you tell the Play Store whether this app is naughty or nice.

FIGURE 8-4: The Facebook app screen in panorama.

4. Tap the dark green button that says Install.

You see the progress of the app downloading process. When the app is all there, it begins the installation process.

At some point in the process, most apps give you a pop-up to let you know what information from your phone that the app will use. This is to give you an idea on how this particular app may affect your privacy. An example of a permission pop-up is shown in Figure 8-5.

Allow Facebook to access your location?

Facebook uses this to provide more relevant and personalized experiences, like helping you to check-in, find local events and get better ads.

FIGURE 8-5: The Facebook permissions screen.

Deny Allow

Before continuing to the next step, I want to point out some important elements on this page:

Chapter 1 discusses the option to prevent an app from having access to your location information. I mention that you can allow apps to know where you are on a case-by-case basis. Here is where that issue comes up. Each app asks you for permission to access information, such as your location. If you don't want the app to use that information or share it somehow, here's where you find out whether the app uses this information. You may be able to limit the amount of location information. If you're not comfortable with that, you should decline the app in its entirety.

TIP

This is similar to the license agreements you sign when installing software on your PC. Hopefully, you read them all in detail and understand all the implications. In practice, you hope that it's not a problem if lots of other people have accepted these conditions. In the case of a well-known app like Facebook, you're probably safe, but you should be careful with less-popular apps.

After the app downloads and installs, you will come back to a screen like the one in Figure 8-6.

FIGURE 8-6: The Play Store app screen for a successfully downloaded app.

5. Tap the dark green Open button.

This brings up the Home screen for Facebook, as shown in Figure 8-7.

If you have a Facebook account already, go ahead and enter your information. Things will look very familiar. If you don't have a Facebook account, and you want to add one now, go on to the next section.

In any case, the Facebook icon appears on your Apps screen along with some other recently added apps, such as Angry Birds and Solitaire. This is seen in Figure 8-8.

If you want this app to be on your Home screen, press and hold the icon. The Face-book icon appears on your Home screen.

FIGURE 8-7: The Facebook login screen.

FIGURE 8-8: The Facebook icon on the Apps screen.

Rating or Uninstalling Your Apps

Providing feedback to an app is an important part of maintaining the strength of the Android community. It's your responsibility to rate apps honestly. (Or you can blow it off and just take advantage of the work others have put into the rating system. It's your choice.)

If you want to make your voice heard about an app, here are the steps:

1. Open the Play Store.

Refer to Figure 8-2 to see the layout.

2. Tap the Menu button (the three parallel lines in the Google Play banner).

Doing so brings up a drop-down menu like the one shown in Figure 8-9.

FIGURE 8-9: The menu from the Play Store.

3. Tap the link that says My Apps & Games.

This tap brings up the screen shown in Figure 8-10, which lists all the apps on your phone. Keep on scrolling down. You'll eventually see them all.

FIGURE 8-10: The My Apps & Games screen in panorama.

Tapping on one of these apps is how you rate them or uninstall them, as shown in Figure 8-11.

If you love the app, rate it highly on a five star scale. To be clear, to rank it as one star, tap the leftmost star. To rank it highly with five stars, tap the rightmost star.

FIGURE 8-11: The Apps page for Facebook after it is installed. Whatever number of stars you pick will bring up a pop-up with those number of stars, as shown in Figure 8-12. You can then tell all the world just what you think of the app.

The Rating pop-up.

While many app developers read the comments, it takes longer for some. I am still waiting to hear back from my comments. Please note that seeking bribes to provide positive reviews is entirely my idea, and you should probably not copy this approach. I will sue if you do.

On the other hand, if you hate the app, give it one star and blast away. It does not happen often, but there are some major league loser apps out there. In most cases, it occurs when you have an older phone, and the apps you have assume some capabilities that are not there.

This will not happen for a long, long time with the Galaxy S21, but technology does march on. Someday in the future, your wonderful phone will be a relic, and some new apps will assume that your S21 can be operated through thought control/mind reading. Alas, your S21 phone does not have that feature (as far as you know). The new app will not seem to work right.

Go ahead and give that app one star and then tap the Uninstall button. Poof. It is gone.

Having Fun with Your Phone

IN THIS PART . . .

Take pictures on your phone.

Use your phone to record videos.

Peruse the games available on the Play Store and download the best ones to your phone.

Enjoy your favorite music wherever you go.

» Sharing pictures with friends and family

Chapter 9

Sharing Pictures

he Samsung Galaxy S21 should really be called a smartcamera with a phone. If you're like many mobile phone users, you love that you can shoot photographs with your phone.

You probably carry your phone with you practically everywhere you go, so you never again have to miss a great photograph because you left your camera at home.

And don't think that Samsung skimped on the camera on your Galaxy S21. In fact, they poured it on. Frankly, there has never been any smartphone like this on the market. In fact, there is so much power in the Galaxy S21 that many of the capabilities rival that of professional digital cameras. There are three cameras on the back: The first is a 12-megapixel camera with wide-angle lens, the second is a 12-megapixel camera with an ultra-wide-angle lens, and the third is a 64-megapixel camera with a telephoto lens. With the Galaxy S21, you can zoom in by a factor of 30x to make an object that is 100 yards away appear as if you're 10 feet away.

In addition, there is a 10-megapixel camera on the front of the phone. This is sometimes called the "selfie lens," because it's easy to position the camera while looking at the screen. Don't turn up your nose at a mere 10-megapixel camera — it's more than enough for most selfies.

The Galaxy S21+ goes one step further than the S21 with the addition of a DepthVision lens. The objective of this lens is to create 3D images instead of the standard 2D images.

Don't get me started on the capabilities of the S21 Ultra! A 12-megapixel camera is adequate for most people, but the camera with the wide-angle lens in the S21 Ultra boasts 108 megapixels. There are other awe-inspiring camera capabilities in the S21 Ultra. For example, you can zoom in by a factor of 100x and have the ability to take shots in extremely low light.

I could toss around specifications that would impress any scientist or professional photographer. I could explain the calculations needed to pick the better choice about when to use the wide-angle and the ultra-wide-angle lenses to get the optimal field-of-view.

The good news is that the good folks at Samsung get it and have taken steps to take all this raw power and make it easy. And if you want to get fancy, you have that option, although it may take a moment or two.

After you've taken your images, you can view them on that wicked Super AMOLED screen. Samsung also includes a Gallery app for organizing and sharing. As a practical matter, it makes sense to view most of photos on your phone. For most of us, that's more convenient than making prints and putting them in a scrapbook. Your phone is always with you, and if someone wants a copy, you just tap a few icons and it's in that person's photo album.

It's truly amazing to consider the number of options that you have for your photographs. Samsung and a bevy of third-party software developers keep adding new options, filters, and ways to share these files. It would not be surprising if your phone now has more capabilities than your digital camera.

These capabilities actually cause a problem. There are so many options that it can be overwhelming. Research has shown that people fall into one of three categories: The first group tends to use the default settings. If they want to alter the image, they'd prefer to do it on their own PCs. The second group likes to explore some of the capabilities on the phone and will have some fun looking at the scenarios, but keep things within reason. The third group goes nuts with all the capabilities of the phone.

To accommodate everyone, this chapter starts with the basics. I cover how to use the camera on your phone, view your pictures, and share them online. This works for everybody.

I then focus on the most popular settings for the second group. There are some important capabilities. With all these exotic lenses, there is some awesome intelligence embedded in the Camera app. Without your needing to do anything, it takes its cues from what is on the screen and will pick the best lens for what it thinks you're trying to do.

For the third group, the best that can be done is to lead you in the right direction. As much as I would like to, it would be impossible to cover all the options and combinations. In my count, there are 2.43 billion possible combinations of filters, lighting, and modes. If you were to start now and take a picture every 10 seconds, you would not run out of combinations for over 700 years. This would not even include all the options for sharing these images.

Realistically, neither you nor your phone will last that long. To keep things in the realm of reality, I introduce only the most important and valuable options and go from there.

Say Cheese! Taking a Picture with Your Phone

Before you can take a picture, you have to open the Camera app. The traditional way is to simply access the Camera app from the Application list. Just tap the Camera icon to launch the app.

Because the camera is so important, here are a few more ways to get to the Camera app. First, press the Power button twice. Boom. There it is. (If this happens to be turned off on your phone, you can toggle the Quick Launch Camera in the Advanced Features within Settings.)

Next, unless you have turned off the capability for security purposes, there is a camera icon on your lock screen. If you swipe the icon across the screen, the Camera app bypasses the security setting. You can snap away, but you can't access the photo gallery or any other files.

TIP

Here is a suggestion. If you see something suspicious, but are not ready to call 911, go ahead and start taking photos of what concerns you. If you need to, you can go back to the lock screen and slide the phone icon to the right to call 911, again without needing to unlock.

A closely related app on your phone is the Gallery, which is where your phone stores your images. The icons for these two apps are shown in the margin.

With the Camera app open, you're ready to take a picture within a second or two. The screen becomes your viewfinder. You see a screen like the one shown in Figure 9-1.

FIGURE 9-1: The screen is the viewfinder for the Camera app.

And how do you snap the picture? Just tap the big white button on the right, which is the digital shutter button. The image in your viewfinder turns into a digital image.

A SUPER-FAST PRIMER ON SUPER AMOLED

All Samsung Galaxy S21 phones have a Super AMOLED screen. Allow me to take a moment to explain what makes this so good — and what makes you so smart for having bought the Samsung Galaxy S21.

To start, think about a typical LCD screen, like what your TV or PC might have. LCDs are great, but they work best indoors where it's not too bright. LCDs need a backlight (fluorescent, most commonly), and the backlight draws a fair amount of power, although much less power than a CRT. When used on a phone, an LCD screen is the largest single user of battery life, using more power than the radios or the processor. Also, because of the backlight on an LCD screen, these screens display black as kinda washed-out, not a true black.

The next step has been to use light-emitting diodes (LEDs), which convert energy to light more efficiently. Monochrome LEDs have been used for decades. They are also used in the mongo-screens (jumbotrons) in sports arenas. Until recently, getting the colors right was a struggle. (Blue was a big problem.) That problem was solved by using organic materials (organic as in carbon-based, as opposed to being grown with no pesticides) for LEDs.

The first organic LEDs (OLEDs) looked good, drew less power, and offered really dark blacks, but still had two problems. Their imaging really stank in bright light, even worse than did LCD screens. Also, there was a problem with *crosstalk* — individual pixels would get confused, over time about whether they were on or off. You'd see green or red pixels remaining onscreen, even if the area was clearly supposed to be dark. It was very distracting.

The solution to the pixels' confusion is called *Active Matrix*, which tells the pixels more frequently whether they are to be on or off. When you have Active Matrix technology, you have an Active Matrix Organic LED, or AMOLED. The image you get with this technology still stinks in bright light, but at least it's some improvement.

Enter the Super AMOLED technology, made by Samsung. When compared with the first AMOLED screens, Super AMOLED screens are 20 percent brighter, use 20 percent less power, and cut sunlight reflection by 80 percent. This is really super!

This screen still uses a significant share of battery life, but less than with earlier technologies. With Super AMOLED, you even save more power if you use darker backgrounds where possible. A few picture-taking options are right there on the viewfinder. Going from the viewfinder clockwise around the screen, the options include

>> The viewfinder: The viewfinder shows what will be in the picture. Okay, this is obvious, but this is also one way you control the magnification. From within

the viewfinder, you can zoom in and out by pinching or stretching the screen. See Figure 9-2 for an example.

- Stretch the screen to zoom in.
- Pinch the screen to zoom out.

FIGURE 9-2: Flash options.

- >>> Lens Selection: You can zoom in by stretching or zoom out by pinching. Or you can tap one of the lens options. In Figure 9-1, the single tree is a telephoto with 2x magnification, the two trees are normal with 1x magnification, and the three trees are for the macro lens. Here's where there is a difference among the Galaxy S21 models. There are a different number of front and back lenses based upon the model you have and whether you're using the back- or front-facing camera. You'll see a different number of options based upon the lenses you have. This is where the extra cost pays off if you have an S21+ or the S21 Ultra.
- >> Scene Optimizer: This icon is the capability I was telling you about it looks at what is in the viewfinder and uses artificial intelligence to suggest how to get the best shot of what it sees. If it's dark, it'll suggest night mode. If it looks yummy, it'll suggest the best setting for food (yes, there is a setting just for taking pictures of food). Unless you want to be super controlling or creative, my advice is to let the Scene Optimizer do its thing.
- Rear-facing camera to front-facing camera toggle: This icon takes you from the rear-facing camera to the not-too-shabby 10-megapixel front-facing camera. As mentioned, this is a good option for selfies because you can see what the shot will look like before you snap it. If you have the S21 Ultra, the front-facing camera is a staggering 40-megapixel monster.
- >> Shutter button: This icon takes the picture.
- >> Gallery: Tap this icon to see the pictures you've just taken. I discuss the Gallery in the section "Managing Your Photo Images," later in this chapter.

- >> Camera/Camcorder mode: These are important. Figure 9-1 is set for Photo mode, which is probably the best place to start. Your camera is super-smart, and Photo mode does a good job of guessing how to make your image look its best. However, if you want to get a little fancy or really fancy you can change the settings. You can find more on this option later in this chapter. This is also how you switch to recording video. More on this later in Chapter 10.
- Settings: Settings also gives some fancy options that are covered in the next section.
- >> Flash options: Even if you want to keep it simple, you'll want to know how to control your flash. Sometimes you need a flash for your photo. Sometimes you need a flash for your photo, but it's not allowed, as when you're taking images of fish in an aquarium, newborns, or some animals. (Remember what happened to King Kong?) Regardless of the situation, your phone gives you control of the flash. Tap the Settings icon at the top of the viewfinder. The options are Off, On, or Auto Flash, which lets the light meter within the camera decide whether a flash is necessary. The options are shown in Figure 9-2.
- >> Timer: This creates a few seconds lag between the time you press the shutter button and when it takes the image so you have time to get into a group picture.
- >> Aspect Ratio: The standard photo is typically 4 units wide by 3 units high. This means that it has a 4:3 aspect ratio. This is conventional, but why be conventional all the time? You can play with different options.
- >> Motion Photo: I cover this in more detail in the "Using the Photo mode settings" section, later in this chapter.
- >> Photo Effects: I cover this in more detail in the "Using the Photo mode settings" section, later in this chapter.

Also mentioned earlier is the ability to zoom. You accomplish this by using the stretch or pinch motion on the screen. To zoom in, you start with the normal image as shown in the left image of Figure 9-3. Then you put your fingers anywhere on the screen and stretch. That zooms you in, as shown in the right image of Figure 9-3.

The screen shows you the level of zoom and markings to show you how far you can go. There are also shortcuts underneath the image if you want to just jump to higher magnification. This screen show the maximum of 30x magnification. This image shows a modest 1.9x magnification.

No Zoom

FIGURE 9-3: The viewfinder when zooming.

When you jump to 30x, you can see the person admiring the scenery on the observation deck of the Space Needle. If you have the S21 Ultra and take it up to 100x, you can see that he has walked 3,296 steps today on his Fitbit (okay, not really, but 100x is still pretty amazing).

You probably know that it's not a good idea to touch the lens of a camera. At the same time, it's practically impossible to avoid touching the lenses on your Galaxy S21. This can create a problem where there can be a buildup of oil and dirt on your high-resolution lens. You should clean the lens of your camera from time to time with a microfiber cloth to get the most out of your camera. Otherwise, your high-resolution images might look like you live in a perpetual fog bank.

After you take a picture, you have a choice. The image is automatically stored in another app: the Gallery. This allows you to keep on snapping away and come back to the Gallery when you have time. I cover the Gallery app more in the upcoming section "Managing Your Photo Images."

FOR SKEPTICS ONLY

If you've ever used a cameraphone, you might be thinking, "Why make such a big deal about this phone's camera? Cameraphones aren't worth the megapixels they're made of." Granted, in the past, many cameraphones weren't quite as good as a digital camera, but Samsung has not only addressed these issues with the Galaxy S21, you may as well try to sell your digital camera at a garage sale because your S21 takes much better shots:

- Resolution: The resolution on most cameraphones was lower than what you typically get on a dedicated digital camera. The Galaxy S21, however, sports at least a 12-megapixel camera and that's good enough to produce an 8 x 10-inch print that's indistinguishable from what you could produce with a film camera, and 4 x 6-inch photos are plenty large for most uses.
- Low light: Many cameraphones perform badly in low light conditions. The S21 works incredibly well in low light.
- AutoFocus and artificial intelligence: We amateurs like it when a camera will do
 the hard work of focusing. The technology in the S21 takes a big leap by having
 more pixels figuring out where to focus, and then there are the smarts to figure out
 how to get the most out of what you see in the viewfinder.
- Photo transfer: With most cameraphones, the photos are hard to move from the
 camera to a computer. With the Samsung Galaxy S21, however (remember: it uses
 the Android operating system), you can quickly send an image, or a bunch of images,
 anywhere you want, easily and wirelessly.
- Screen resolution: In practice, many cameraphone users just end up showing their
 pictures to friends right on their phones. Many cameraphone screens, however,
 don't have very good resolution, which means your images don't look so hot when
 you want to show them off to your friends. The good news is that the Samsung
 Galaxy S21 has a bright, high-resolution screen. Photos look really good on the
 Super AMOLED screen.
- Organization: Most cameraphones don't offer much in the way of organizational tools. Your images are all just there on your phone, without any structure. But the Samsung Galaxy S21 has the Gallery app that makes organizing your photos easier. It's also set up to share these photos easily.

However, if you want to send that image right away, here's what you do:

1. From the viewfinder screen, tap the Gallery icon.

The viewfinder shows the Gallery icon at the top-right corner of the viewfinder. When you tap it, it brings up the Gallery app, as shown in Figure 9-4.

This brings up the current image, along with the some other recent photos.

FIGURE 9-4: The Gallery app.

2. Tap the thumbnail of the image you want to share.

It also brings up some options, as seen in Figure 9-5. Right now, you're interested in the Share option.

3. Tap the Share button.

This brings up the options you can use to forward the image; see Figure 9-6 (although your phone might not support all the options listed here and may have a few others not in this image). You have the following options (not necessarily in order):

- Nearby Share: You can send the picture to another smartphone that also has Nearby Share enabled. (Having only friends who have a recent Samsung Galaxy phone is your best bet to be able to use this option.)
- People you recently texted: You can send the picture to the last four people with whom you texted.
- Email: You can send the image as an attachment with your primary email
 account.

FIGURE 9-5: Gallery options for the current image.

- Facebook: You can take a picture and post it on your Facebook account with this option.
- Messaging: You can send the picture immediately to someone's phone as a text message.
- Bluetooth: You can send images to devices, such as a laptop or phone, linked with a Bluetooth connection.
- **Gmail:** If your main email is with Gmail, this option and the Email option are the same.
- Your cloud provider: Figure 9-6 shows Google Drive, but if you sign up for any of the cloud storage options, they'll be here.
- Wi-Fi Direct: Talk about slick! This option turns your phone into a Wi-Fi
 access point so that your Wi-Fi-enabled PC or another smartphone can
 establish a connection with you.

FIGURE 9-6: Sharing options for the current image.

The point is that there is an overabundance of options. If an app on your device works with images, this is the place you can upload that image. If one of these options doesn't quite suit your need to share your pictures, perhaps you're being too picky!

Getting a Little Fancier with Your Camera

Using the default Camera setting, Photo, to snap pics is perfectly fine for those candid, casual, on-the-go shots — say, friends in your living room. However, your Samsung Galaxy S21 phone camera can support much more sophisticated shots. Your digital SLR camera may have a bigger lens than your phone, but I can assure you that your phone has a much bigger brain than your camera. I suggest that even the users who want these default settings get familiar with the camera's Mode settings. These are easy to access and will improve the image quality with minimal effort.

Using the Photo mode settings

The mode setting is where you make some basic settings that describe the situation under which you will be taking your shot. The default is a single picture in Photo mode, as shown in Figure 9-1. Sliding this icon to the left brings up the options associated with the MORE link, shown in Figure 9-7.

FIGURE 9-7: The Photo mode options on the camera viewfinder.

The options on the top of the viewfinder bring up a number of choices for photos:

- >> Pro: This mode gets you to all kinds of camera settings that someone who knows what she's doing would want to control rather than let the camera make the choice. This includes setting the exposure, shutter speed, ISO sensitivity, white balance, focal length, and color tone. If you don't know what these terms mean, this is not the mode for you.
- >> Panorama: This mode lets you take a wider shot than you can with a single shot. Press the Camera button while you rotate through your desired field of view. The app then digitally stitches the individual photos into a single wide-angle shot.
- >> Food: This mode takes pictures that emphasize the colors in food to make your friends even more jealous (and/or hungry).
- >> Night: This mode takes pictures when it's dark, and I mean darker than you ever thought possible.
- >> Portrait: This mode offers enhancements that enable you to take the best images of your friends and family members.
- >> Live focus: This mode lets you get within 20 inches of an object, which is too close for the normal autofocus. On top of that, you can change the focus after taking the photo. (You read that right!)

Chapter 10 covers the options for AR Doodle, Portrait Video, Pro Video, Super Slow-mo, Slow Motion, Hyperlapse, and Director's View. Otherwise, choose the option that sounds right by flicking through the options, and snap away.

Settings options on the viewfinder

Tapping the Settings icon on the viewfinder brings up a number of choices, shown in Figure 9-8:

- Scene Optimizer: Once again, I will point out that your phone is super-smart. This setting automatically adjusts setting to take the best possible picture. You can turn off this option, but why would you want to?
- >> Shot Suggestions: This takes the scene optimizer one step further. Your phone will suggest how to set up the shot, and when it's perfect, it will take the picture for you. Try it and see if you like this one.
- >> Scan QR Codes: When the viewfinder sees a QR code, it will try to figure out what it says. If you don't care, switch off the toggle button.
- >> Swipe Shutter Button To: You have two options here. The default when you swipe the shutter button to the side is to take a quick series of pictures. That way, you can go back and pick the best one to keep. You could also set it so that you just take a single picture and store the image as a GIF. If you don't know what a GIF is, you probably don't want to bother with this option.

FIGURE 9-8: The Settings options.

- >>> Format and advanced options: Your average smartphone will save your photo in one of the popular photo formats. But this isn't your average smartphone. You can change the default option to High Efficiency (HEIF) to save some storage. You can select RAW copies if you have super-duper photo-editing software back on your PC. You may want to leave this one alone, though it's complicated.
- >> Use Wide Angle for Group Selfies: If your selfie is more than yourself (in other words, you like to show the world that you have lots of pals), this option will automatically use the wide-angle lens.
- >> Save Selfies as Previewed: If you've ever taken a selfie, you may have noticed that it was a mirror image of what you expected. If that doesn't bother you, toggle this option on. Likewise, if the wording on your shirt says "WOT TOW" or "I bid I" you're all set. Otherwise, let you phone switch your selfie so the words aren't reversed.
- >> Smart Color Tone: You can go natural, or you can have a bright, shiny face.
- >> Auto HDR: The camera can apply this image enhancement when it's needed. You can also just leave it on all the time. Your choice.
- >> Tracking Auto-Focus: The Samsung Galaxy S21 can spot a person's face and assume that you want it to be the place where you focus if you toggle this option to the On position. Otherwise, if you don't use this mode, the camera may assume that you want whatever is in the center of the viewfinder to be in focus.
- >> Grid Lines: Some people like to have a 3 x 3 grid on the viewfinder to help frame the shot. If you are one of these people, toggle on this option.
- Location Tags: The Samsung Galaxy S21 uses its GPS to tell the location of where you took the shot. If this is too intrusive, you can leave out this information on the image description.
- >> Shooting Methods: Do you remember the options you have for taking pictures and videos (refer to Figure 9-7)? Well, you can select them here, too. However, the default is that, when you close the camera, it will default back to Photo mode. If you want it to keep the last mode you used (say, to take videos), you can tell it to keep the last mode.
- Settings to Keep: It can be annoying when you select the camera options you want one day, and then later, you need to remember what you did. Problem solved with this option. You tell the camera to keep your settings and off you go.
- >> Shutter Sound: It can be satisfying to hear the click when you take a picture. If you would rather not, turn that sound off here.

>> Vibration Feedback: In addition to the click, you can have that feeling you remember back in the day when your analog single-lens reflex (SLR) camera would shake when you pressed the button. Your phone can't bring back Pet Rocks or dot matrix printers, but it can bring back that visceral feeling of knowing that you got the shot.

Photo Effects options

When you tap the magic wand on the viewfinder, you get to see a number of effects that you can apply to your image. Some examples are shown in Figure 9-9.

FIGURE 9-9: Some examples of Effects options.

Select the option that looks right for your creative vision by tapping on the thumbnail and snap away.

Visualizing What You Can Do with Bixby Vision

In Figure 9-7, you may have noticed an option called Bixby Vision in the view-finder in the upper-left corner. Bixby is Samsung's version of Apple's Siri or Google's Alexa. This effort ultimately didn't pan out as well as those other

attempts, but that doesn't mean that it isn't as cool as its more successful cousins.

Bixby Vision can tell you information about what the camera is pointed at:

- >> If it's an object, Bixby Vision can tell you what the object is and how much you can buy it for online.
- >> If it's a QR code, Bixby Vision can tell you what the code means.
- If it's text in a foreign language, Bixby Vision can read it and convert it to text. You can then translate that text into any of 108 languages.
- >> If it's a wine label, Bixby Vision can tell you the ranking of the wine.

How Bixby Vision works is simple. You open the camera application, click the MORE option, and tap Bixby Vision. You then get some options that let you tell Bixby what you want to do (see Figure 9-10).

FIGURE 9-10: The options for Bixby Vision in the Viewfinder.

Let's say you want to translate some foreign text into English. You slide the selector over to the T for Translator and center the viewfinder over the text. Figure 9–11 shows the original text and then the translation.

It isn't perfect, but it's not too bad. It'll help you out in a pinch and do a pretty good job of it. Let's see how well Alexa does in translating some text!

Original in French

C'était LE MEILLEUR des temps, c'était le pire des temps, c'était l'âge de la sagesse, c'était l'âge de la folie, c'était l'époque de la croyance, c'était l'époque de l'incrédulité, c'était la saison de la Lumière, c'était la saison des Ténèbres, c'était le printemps de l'espérance, c'était l'hiver du désespoir, nous avions tout devant nous, nous n'avions rien devant nous, nous allions tous directement au Ciel, nous allions tous directement dans l'autre sens — bref, la période était si loin comme la période actuelle, que certaines de ses autorités les plus bruyantes insistaient pour qu'elle soit reçue, pour le bien ou pour le mal, dans le degré de comparaison superlatif seulement.

Bixby Translation to English

FIGURE 9-11: The Bixby Vision translation of a familiar novel from your high school days. It was THE BEST of times, it was the worst of times, it was the age of wisdom, it was the age of madness, it was the age of belief, it was the age of disbelief, it was the season of Light, it was the season of Darkness, it was the spring of despair, had everything before us, we had nothing in front of us, we were all going direct to Heaven, we in short, the period was so distant as the present period, that we could all go directly the other way, some of the loudest authorities insisted that it be received, for the good or for the sake of bad, in the degree of superlative comparison only.

Managing Your Photo Images

After you take some great pictures, you need to figure out what to do with them. Although you can send an image immediately to another site or via email, it will likely be the exception.

In most cases, it's easier to keep on doing what you were doing and go back to the Gallery app when you have some time to look at the images and then decide what to do with them. Your choices include

- Store them on your phone within the Gallery app.
- Transfer them to your PC to your photo album application by sending them with email.
- >> Store them on an Internet site, like Google Photos or Flickr.
- >> Print them from your PC.
- >> Email or text them to your friends and family.
- Any combination of the preceding choices.

Unlike many regular phones with a built-in camera, the Galaxy S21 makes it easy to access these choices. You need to determine the approach you want to take to keep your images when you want them to stick around. The rest of this chapter goes through your options.

Even though the Camera app and the Gallery app are closely related, they are two separate apps. Be sure that you keep straight which app you want to use.

The Gallery Home screen (refer to Figure 9-4) shows how the app first sorts the images on your phone into folders, depending upon when they originated.

All your photos from the Camera app are placed in files sorted by date. The app takes a shot at grouping them when a series of pictures or videos are taken about the same time.

Using Images on Your Phone

In addition to sharing photos from your camera, your Galaxy S21 phone allows you to use a Gallery photo as wallpaper or as a photo for a contact. And if the fancy shooting settings in the Camera app aren't enough, you can wrangle minor edits — as in cropping or rotating — when you have an image in the Gallery app.

The first step is to find the image that you want in Gallery. If you want to do something to this image other than send it, tap the Edit button at the bottom of the screen (refer to Figure 9-5). Some of the options include

- >> Slideshow: This displays each of the images for a few seconds. You can not only set the speed for transition, but also add music and select among several image transitions.
- >> Crop: Cut away unnecessary or distracting parts of the image. The app creates a virtual box around what it considers to be the main object. You can move the box around the image, but you cannot resize it. You then can either save this cropped image or discard.
- >> Set As: Make this image your wallpaper or set it as the image for a contact.
- >> **Print:** This option allows you to print if you have set up a local printer to communicate with your phone either through Wi-Fi or Bluetooth.
- >> Rename: These options allow you to rotate the image right or left. This is useful if you turned the camera sideways to get more height in your shot and now want to turn the image to landscape (or vice versa).
- >> Details: See the information on the image its metadata, which is fixed and cannot change.

Deleting Images on Your Phone

Not all the images on your phone are keepers. In fact, you may get accustomed to deleting far more pictures than you keep. This is hard for some of us who are used to expensive film. However, before too long, you'll have far too many pictures, which defeats the purpose.

When you want to get rid of an image, press and hold the image you want to delete. In a second, a check box with the image selected will appear. Also, the links appear at the top to either Share or Delete. If you want to delete this image, tap Delete. The camera verifies that this is your intent. After you confirm, the image goes away.

If you want to delete more images, you can tap all the images you want to make go away. It is selected if it has a green checkmark on the image. Tap away, then hit Delete. It will confirm with you once. Tap again and these images are gone forever.

When I say that the photos you delete are gone forever, I do mean for-ev-er. Most of us have inadvertently deleted the only copy of an image from a PC or a digital camera. That's not a pleasant feeling, so be careful.

Chapter **10**

Creating Videos

he Samsung Galaxy S21 really poured it on with the still images. Chapter 9 covers all the amazing capabilities that your phone can do with photographs. It's truly amazing. But wait! There's more — much, much more! You can take amazing videos with your phone.

However, before I jump into the capabilities, take a moment and think about what you want to do with videos. A knee-jerk reaction is: "I want the highest resolution and the most frames per second available. After all, memory is cheap."

The issue to consider is that recording videos uses lots of memory and other resources. Plus, videos don't lend themselves to easy modification after you take them. For example, you can take a photo on your phone. You can then make changes, such as adjusting the brightness and cropping it, after the fact.

Making similar adjustments to videos is impractical for most of us. If you take a video in super slo-mo, you can't convert it to normal speed without very costly video-editing software. The point is that video images are fun, but you need to think through in advance what you want to achieve.

You may just want to capture the fun at the beach or a party with your friends and family. That's fairly typical. It can be more fun than still photography. You can also use your phone as a dash-cam with the hope of capturing an accident. That's also fairly typical.

This first part of this chapter presents the basic of taking videos like these. I cover how you set it up, some of the basic options, and how you can view your wonderful creation. Later in the chapter, I discuss some of the more exotic capabilities of the S21.

Ready . . . Action! Taking a Video with Your Phone

To take a video, you start with the Camera app.

With the Camera app open, you're ready to take a picture. But you want to take a video. To start the video, you swipe the Photo link to the left (which is down in the landscape orientation), shown in Figure 10-1.

FIGURE 10-1: The screen is the viewfinder for the Camera app in Video mode.

This is very similar to the screen in Figure 9-1. There are three differences for the icons on the viewfinder:

- >> Record Button: Instead of a shutter button, there is the Record button.
- >> Video Stabilizer: This option does some digital magic and makes it look like you're moving the phone smoothly from place to place. If you shut off this capability, the video will look jerky and will be hard to watch. Under normal

circumstances, it's best to leave the Video Stabilizer on. Your viewing audience will appreciate it.

>> Video Format: This option gives you quick access to numerous options for image resolution and frames per second.

All you need to do to get started is push the Record button. The image in your viewfinder turns into a video, and you see the icon switch from the image on the left in Figure 10-2 to the icon on the right.

FIGURE 10-2: The Record button, Pause button, and Stop button in the viewfinder.

Pausing allow you to temporarily stop recording the video and then restart. Stopping saves the video as it is. It saves the files and reverts to the Record button. If you want to record again, it creates a new file, which is often no big deal.

To get to the video, from the viewfinder screen, you simply tap the Gallery icon. The viewfinder shows the Gallery icon next to the Record button. When you tap it, it brings up the Gallery app, as shown in Figure 10-3.

FIGURE 10-3: The Gallery app with a video.

This brings up the video along with the other recent photos. You can tell the videos from the photos because the videos have the play icon, which is an arrowhead pointing to the right, along with information on the duration of the video. In this case, the video is 7 seconds.

You have a few choices at this point. If you want to view the video, tap the thumbnail. It will expand the thumbnail to the full screen. Tap the link that says Play Video, and off it goes. Just like viewing photos, watching your video on your phone is a pleasant experience.

At the same time, a really good video is really, really worth sharing. To share your video, you press and hold the thumbnail. Every thumbnail suddenly has a white circle in the upper-left corner. Tap the circle with the file you want and a check mark appears (see Figure 10-4).

FIGURE 10-4: Selecting the current video.

You now have two options: You can share it or you can delete it. Since this is really, really worth sharing, you tap the share option. This brings up the sharing screen (see Figure 10-5).

Yes, this is the same screen used as sharing photos, but bear with me. Good videos should be shared on social media without delay. Go ahead and tap the Facebook icon that has the title Your Story. That brings a screen up like seen in Figure 10-6.

When you tap the Share button, it will verify a few things, such as validating your desired level of privacy. Accept it all and this video of a cute kid riding on his trike (or whatever is in your video) will be posted for the world to see.

FIGURE 10-5: Sharing options for the current video.

FIGURE 10-6: The Facebook Share to Story option.

Taking Videography to the Next Level

The default video settings do the job in the vast majority of cases. But that is boring. You have a number of exotic options that you may as well take out for a test drive and see how it goes.

The Video mode settings

Do you remember the part of the viewfinder where you moved from Photo mode to Video mode? If you keep going, you hit the More option. Sliding to this icon brings up the options shown in Figure 10–7.

More Video options on the camera viewfinder.

The options in the viewfinder bring up a number of choices:

- Portrait Video: This setting lets you get very close, within a few feet, of an object. The normal autofocus does not handle it well. If you hear the words, "I'm ready for my closeup, Mr. DeMille," you can be assured that your shot of Norma Desmond, played by Gloria Swanson, will look great and be in focus.
- >> Pro Video: This option opens up all kinds of video options.

- >> Super Slow-Mo: This switches you to video mode to slow down really fast shots. The exceptional thing is that your S21 does this in full 4K resolution, so you're getting both high speed and high resolution with no compromise (other than filling up your memory card)!
- >> Slow Motion: This is plain-old, boring slow motion. It's still cool.
- >> Hyperlapse: You can use this setting to create a time-lapse video. The video camera will adjust the speed of the shots based upon the movement of the phone.
- Director's View: This is a cool option. If you want to be the envy of Cecil B. DeMille, try this option. In addition to the viewfinder view of your video, the other lenses show up as thumbnails. This gives you the creative ability to jump from the wide-angle lens to the telephoto lens while you're shooting.

Go ahead and experiment with these, so when the opportunity presents itself, you know what option to choose.

Settings options on the viewfinder

The Settings icon on the viewfinder brings up choices for the video. Before I get into these, I cover some important considerations.

The first choice you need to make is the aspect ratio. All the cool kids have displays that are 16:9. If you're of a certain age, you remember standard televisions, which were 4:3. Forget about that old technology. Your videos should be 16:9, unless you're getting carried away and are getting artsy.

The next consideration is what resolution you want. The most you can select is 8K. Not even the coolest kids have 8K screens. These are expensive and there is very little content for it . . . yet. Even the mainstream 4K TVs can have images that are a little too sharp for some people. However, 4K TVs have a lot of content these days, so they're selling lots of TVs like this.

Still, the variations of HD are pretty darn good. The starting point on the variations of HD are Standard HD, which is 1280 x 720 pixels. This is sometimes referred to just as 720 HD. Then there is Full HD, which is 1920 x 1080 pixels on a screen. This is sometimes called 1080 HD. Between the 4K TVs and the 1080 HD is Ultra HD (UHD). You access these options (shown in Figure 10–8) by tapping the Video Format icon shown in Figure 10–1.

So, which option is the best? Usually more resolution is good, but at some point, it just takes up a lot more memory. Try them all and see what you like. My guess is that Full HD is probably fine.

FIGURE 10-8: The Video Format options.

Then, the next consideration are the frames per second. You have the option of standard, or you can choose 60 frames per second (fps). But why? Even if you bought the S21 with the extra memory, this option eats it up like crazy. Go ahead and ignore that setting, and you won't regret it . . . probably.

With that background, the video options within the camera settings are shown in Figure 10-9.

FIGURE 10-9: The Settings options for video.

Here's more on what these two options mean:

- Advanced Recording Options: The Samsung Galaxy S21 can let you get really carried away with these options. You can, in spite of having gobs of storage if you upgraded, choose to use the high-efficiency option. You can also use HDR10+, which plays with contrast levels. Unless you know that this option is for you, you probably can skip it. The option you may want is the zoom-in mic. This will guess who is the most important person in the frame that you're following, and will have the microphone pick up his or her voice out of the mix. Pretty cool.
- >> Video Stabilization: This is the same option that is on the viewfinder. Trust me. Leave it on.

Messing with the AR Doodle option

When you tap the squiggly line in the corner of the viewfinder, you can have some fun. This brings up the screen shown in Figure 10-10.

FIGURE 10-10: The start screen for AR Doodle.

Here, you shoot video for about a minute. Then you're offered some writing options. For example, feel free to draw a Snidely Whiplash mustache on your dad. Now that mustache will be flowing him around in the viewfinder.

Silly, but what good is all this elaborate technology if you can't have some fun?!

arija da selesi Selesi da selesi Selesi da da da

Here, you shoot visit to fee, as act, it informed that weake of each capital waiting options. For exemple, feet free bods or a furfely Wingshah me suche on your our Now that nurstache will be flow of him spraid in the specific state.

Translagm, even in les con le codoquines especiales en elle el pougasité, sudiffé le

- » Perusing the games available on the Play Store
- » Downloading games to your phone
- » Keeping track of what you've downloaded
- » Providing feedback

Chapter **11**

Playing Games

ames are the most popular kind of download for smartphones of all kinds. In spite of the focus on business productivity, socializing, and making your life simpler, games outpace all other app downloads. To this point, the electronic gaming industry has larger revenues than the movie industry — and has for several years!

We could have a lively and intellectually stimulating debate on the merits of games versus applications. For the purposes of this book, the differences between games and apps are as follows:

- If a person likes a game, he or she tends to play it for a while, maybe for a few weeks or even months, and then stops using it. A person who likes an app tends to keep on using it.
- Games tend to use more of the graphical capabilities of your phone.
- People who use their phones for games tend to like to try a wide range of games.

The fact of the matter is that your Samsung Galaxy S21, with its large Super AMO-LED screen and beefy graphics processing unit, makes Android-based games more fun. And because you already have one, maybe you should take a break and concentrate on having fun!

The Play Store Games Category

Chapter 8 introduces the Play Store, shown in Figure 11-1. The top level splits offerings into a few categories: Games, Apps, Movies & TV, and Books.

FIGURE 11-1: The Play Store Home screen.

Offering categories

We want games. Games that test our skills; games that are fun; games that are cute; games that immerse us in an alternate universe! To get there, tap on the Games button!

This brings up the Games page as shown in Figure 11-2.

This section of the store has nothing but games. This section includes everything from simple puzzles to simulated violence. All games involve various combinations of intellect, skill (either cognitive or motor), and role-playing. Let's do it.

The Games link on the Google Play Home screen.

Offering Categories

The Games Home screen

If you scroll around this screen, you see many suggested games. This is shown in panorama in Figure 11-3.

If you aren't sure what games you might like to try, don't worry: There are lots of options. As you can see, the Games Home screen makes lots of suggestions. Each row takes a different perspective on helping you find a new game. A few of these are board games, strategy games, and action games. They also include games that allow you to play offline without Wi-Fi.

Another approach is to choose the Categories options, shown partially in the top right in Figure 11-2. This will bring up the game categories shown in Figure 11-4.

FIGURE 11-3: The Games Home screen in Panorama.

FIGURE 11-4: The Games Categories tab.

The Games Categories tab

In the Play Store, games are divided into the following genres:

- Action: Games that involve shooting projectiles that can range from marshmallows to bullets to antiballistic missiles. They also involve fighting games with every level of gore possible.
- Adventure: Games that take you to virtual worlds where you search for treasure and/or fight evil. Zombies and vampires are traditional evildoers.

- >> Arcade: Game room and bar favorites.
- >> Board: Versions of familiar (and some not-so-familiar) board games.
- >> Card: All the standard card games are here.
- >> Casino: Simulations of gambling games; no real money changes hands.
- >> Casual: Games that you can easily pick up and put aside (unless you have an addictive personality).
- Educational: Enjoyable games that also offer users enhanced skills or information.
- Music: Includes a wide range of games that involve music in one way or another. These games may include trivia, educational games involving learning music, or sing-along songs for kids.
- >> Puzzle: Includes games like Sudoku, word search, and Trivial Pursuit.
- Racing: Cars, go-karts, snowboards, jet skis, biplanes, jets, or spacecraft competing with one another.
- >> Role Playing: In a virtual world, become a different version of who you are in real life, be it for better or worse.
- >> Simulation: Rather than live in the virtual world of some game designer, create and manage your own virtual world.
- >> Sports: Electronic interpretations of real-world activities that incorporate some of the skill or strategy elements of the original game; vary based upon the level of detail.
- >> Strategy: Emphasize decision-making skills, like chess; a variety of games with varying levels of complexity and agreement with reality.
- >> Trivia: A variety of games that reward you if you know things like the name of the family dog from the TV show *My Three Sons*. Its name was Tramp, but you knew that already.
- >> Word: Games that are universally popular, such as Scrabble.

Many games appear in more than one category.

TIP

Each game has a Description page. It's similar to the Description page for apps, but it emphasizes different attributes. Figure 11-5 is an example of a typical Description page.

FIGURE 11-5: A Description page for Flow Free.

When you're in a category that looks promising, look for these road signs to help you check out and narrow your choices among similar titles:

- >> Ratings/Comments: Gamers love to exalt good games and bash bad ones. The comments for the game shown in Figure 11-5 are complimentary, and the overall ranking next to the game name at the top suggests that many others are favorable.
- >> About This Game: This tells you the basic idea behind the game.
- >> What's New: This section tells what capabilities have been added since the previous release. This is relevant if you have an earlier version of this game.
- >> Reviews: Here is where existing users get to vent their spleen if they do not like the game or brag about how smart they are for buying it ahead of you. The comments are anonymous, include the date the comment was left, and tell you the kind of device the commenter used. There can be applications that lag on some older devices. However, you have the Galaxy S21, which has the best of everything (for now).

- >> More Games by Developer: If you have a positive experience with a given game, you may want to check that developer's other games. The More By section makes it easier for you to find these other titles.
- >> Users Also Viewed/Users Also Installed: This shows you the other apps that other people who downloaded this app have viewed or downloaded. These are some apps that you may want to check out.
- >> Price: As a tie-breaker among similar titles, a slightly higher price is a final indication of a superior game. And because you're only talking a few pennies, price isn't usually a big deal.

Leaving Feedback on Games

For apps in general, and games in particular, the Play Store is a free market. When you come in to the Play Store, your best path to finding a good purchase is to read the reviews of those who have gone before you. Although more than a million users have commented on Angry Birds, most games do not have that kind of following.

One could argue that your opinion would not move the overall rating for a frequently reviewed game like Angry Birds. The same cannot be said for other games.

One of the new games is Santa City Run from TecApp@2020. The game description is shown in Figure 11-6.

A Description page, before you download it to your phone, will show either the Install button or the price of the game; the feedback areas will be grayed out. The Description page after you download the game to your phone will offer the options to Open or Uninstall, and the feedback areas will be active.

In this case, Santa City Run has not been reviewed at all. Your opinion matters more for this game than for the heavily reviewed games. After you've downloaded and played a game, you can help make the system work by providing your own review. This section reviews the process, starting from the first screen of the Play Store, which was shown in Figure 11-1:

Tap the Menu icon.

This brings up a pop-up menu like the one shown in Figure 11-7.

A game description for Santa City Run.

2. Tap My Apps & Games.

This brings up the apps and games that you've downloaded, as shown in Figure 11-8. The Play Store does not distinguish between games and apps in this menu. They're all in the same list.

3. Tap the game for which you'd like to leave feedback.

Tapping the title of the game normally brings up the game description similar to what is shown in Figures 11-5 and 11-6. After you've downloaded a game, however, a Rate This App section appears that lets you leave feedback. See Figure 11-9 to see this section for Angry Birds 2.

4. Tap the stars on the screen.

This brings up a pop-up screen, as shown on the left of Figure 11-10.

5. Tap the number of stars you believe this game deserves.

The stars are between one and five. You're asked to answer some other questions that are shown in Figure 11-10, including making any comments on the last pop-up.

6. When you're done, tap Submit.

Your comments are sent to the Play Store for everyone to see. For the sake of the system, make sure your comments are accurate!

FIGURE 11-7: The pop-up menu for the Play Store applications.

FIGURE 11-8: Check out your downloads.

TIP

Free apps are great, but don't be afraid to buy any apps that you think you'll use frequently. Games usually cost very little, and the extra features may be worth it. Some people (including me) have an irrational resistance to paying \$1.99 monthly for something they use all the time. Frankly, this is a little silly. Let's all be rational and be willing to pay a little bit for the services we use.

FIGURE 11-9: The Game Description page with space for feedback.

FIGURE 11-10: The ratings stars pop-up screen before and after entering feedback.

- » Viewing videos
- » Knowing your licensing options

Chapter **12**

Playing Music and Videos

martphones have built-in digital music and video players. There was a time not too long ago that having a dedicated music or video player was the way to go. However, having a single device that you can use as a phone and as a source of entertainment is more convenient because then you need only one device rather than two, and you eliminate extra cords for charging and separate headphones for listening. Your Samsung Galaxy S21 is no exception. You can play digital music files and podcasts all day and all night on your phone.

The audio and video technology embedded in your phone is truly among the best there is. This is not just adequate technology; this is state-of-the-art, over-the-top, best-that-money-can-buy technology. You can choose to pursue your level of enjoyment that is convenient, or you can buy complementary equipment that can fully leverage the capabilities within the S21. This is your choice, and no one will judge you (although I may be envious if you buy some of the high-end equipment).

In addition, by virtue of the Super AMOLED screen on your Galaxy S21 smart-phone, your phone makes for an excellent handheld video player. Just listen on the headset and watch on the screen, whether you have a short music video or a full-length movie. You may look at your phone and wonder how good watching a video can be with a relatively small screen, but once you start, the screen is so good, you become immersed in no time.

To boot, your Galaxy S21 comes with applications for downloading and listening to music as well as downloading and watching videos. These apps are very straightforward, especially if you've ever used a CD or a DVD player.

Getting Ready to Be Entertained

Regardless of the model phone you have, the particular app you use for entertainment, and whether you're listening to audio or watching video, here's where I cover some common considerations up front.

The first is the use of headsets. Yeah, you used headphones, but you probably want to use a headset with your phone. The vocabulary is more than just semantics; a headset has headphones plus a microphone on the cable. This makes it easier for when you get a call while listening to music or watching a movie.

Your phone sees an incoming call and will pause the music or movie and show you the caller ID. If you answer it and you have a headset, you can be reasonably assured that the person on the other line will hear you loud and clear. If you have headphones, the phone will use the built-in microphone for your voice while you hear the caller on your headphones. My advice is to test the sound quality using a headphone and judge for yourself whether you want to use a headset or headphones.

Next, I explore speakers. I touch on speakers in Chapter 3 when talking about Bluetooth pairing and in Chapter 16 when I talk about making the phone your own. As you may guess, having a solid strategy for speakers is important to get the most out of your Galaxy S21.

Then you need to know about connecting your Galaxy S21 phone to a television and/or stereo. After I talk about that, I cover the issue of licensing multimedia material.

Finally, I explore storing all these options on your phone for your offline enjoyment. You can have gobs of storage at your disposal if you want. I explore what the term "gobs" really means in terms of audio and video storage.

Choosing your headset

You can use wired or wireless (Bluetooth) headsets with your Samsung Galaxy S21 phone. Wired headsets are less expensive than Bluetooth headsets, and, of course, wired headsets don't need charging, as do the Bluetooth headsets.

On the other hand, you lose freedom of mobility if you're tangled up in wires. In addition, the battery in Bluetooth headsets lasts much longer than the battery in your phone. However, if your headset happens to be running low and it can be charged wirelessly, you can use the PowerShare feature of your S21 to extend the life of your headset until you can recharge everything.

Wired headsets

At the bottom of your Galaxy S21 phone, you won't see a regular headset jack. What you do see is the USB-C port. There are two choices. The first choice is to get headsets that have a USB-C connector. Your phone may come with a wired headset that has a USB-C connector like those shown in Figure 12-1 on the left. In that case, just plug it in to use the device.

Headset with USB-C Connector

3.5 mm to USB-C Connector

FIGURE 12-1: A wired headset with a USB-C connector and a 3.5mm to USB-C connector.

Left: Heng Lim/Shutterstock; Right: vta_photo/Shutterstock

The other option is to get a connector that allows you to plug in your existing headphone/headset. The image on the right in Figure 12-1 is an example of one of these connectors (also called a *dongle*). The retail cost is about \$20, but you can find them online for about \$10.

When you do plug in, you'll hear the audio, but the person on the other end of the call may not hear you as well because the headphones don't come with a microphone. In such a case, your phone tries to use the built-in mic as a speakerphone. Depending upon the ambient noise conditions, it may work fine or sound awful. Of course, you can always ask the person you're talking to whether he or she can hear you.

Some people dislike ear buds. You can obtain other styles at a number of retail franchises that offer options, including:

- Around-the-ear headphones that place the speakers on the ear and are held in place with a clip
- >> A behind-the-neck band that holds around-the-ear headphones in place
- >> An over-the-head band that places the headphones on the ear

The laws in some regions prohibit the use of headphones while driving. Correcting the officer and explaining that these are really "headsets" and not "headphones" won't help your case if you're pulled over. Even if not explicitly illegal in an area, it's still a bad idea to play music in both ears at a volume that inhibits your ability to hear warnings while driving.

Ear buds can have a greater chance of causing ear damage if the volume is too loud than other options. The close proximity to your eardrum is the culprit. There are probably warnings on the ear bud instructions, but I wanted to amplify this information (<harhar>).

In any case, give yourself some time to get used to any new headset. There is often an adjustment period while you get used to having a foreign object in or around your ear.

Stereo Bluetooth headsets

The other option is to use a stereo Bluetooth headset. Figure 12-2 shows a few options.

FIGURE 12-2: Bluetooth stereo headsets.

Left: timquo/Shutterstock; Center: alexanderon/Shutterstock; Right: Photoongraphy/Shutterstock

You need to consider a few important options before you put down your money and buy one. First, you have a choice of the earpieces being "on" the ear, "over" the ear, or "in" the ear.

The over-the-ear option tends to eliminate outside noise a little better because your ears are surrounded by the cushions. This can also get hot if you wear your headset for an extended time. On the other hand, some over-the-ear headsets have noise cancelling, which is nice in noisy areas, like airplanes. The on-the-ear headphone is good for when you have your headphones on for a long time.

The third option for headsets includes those that insert into your ear canal. The ear buds in Figure 12-2 are Samsung Galaxy Buds+. Although they work with any Bluetooth device, they work particularly well with your S21. When you insert them into your ear canal, they just stay there (if they don't, there are a few other silicone ear pieces that you can use to get them to fit). There are no wires or plugs. Having this kind of headset in your ear makes it less likely to shift or fall out than the other options. The in-the-ear headset shown in Figure 12-2 is well-suited for those who want to listen to music and have the ability to take calls as they exercise. How neat is that?

In each of these cases, a stereo Bluetooth headset is paired the same way as any other Bluetooth headset. (Read how to do this in Chapter 3.) When your Galaxy S21 phone and the headset connect, the phone recognizes that the headset operates in stereo when you're listening to music or videos. When you open the case in which you store the ear pieces, not only will the Galaxy Buds pair, but they'll bring up a screen called Galaxy Gear to let you fine-tune the sound quality. It's very slick!

Choosing your Bluetooth speaker

In the last few years, developers released a flurry of products known as *Bluetooth* speakers. These speakers include a range of options, some of which are a very small and convenient. Others are designed to offer excellent audio quality. Some of these speakers look cool or are very small but have poor sound quality. Check them out before your buy.

Although these speakers (which come in a range of sizes) are not as portable as the Bluetooth headset — they're a little difficult to use as you're walking down the street — they're usually pretty easy to take with you and set up when you're at a desk or in someone's living room. They also do not need a cable to make a connection and are always ready to go.

Audio Pro's A36 Bluetooth speaker (see Figure 12-3) is an excellent example of a high-quality Bluetooth speaker. Its list price is about \$950.

FIGURE 12-3: The Audio Pro's A36 Bluetooth speaker.

Photograph courtesy of Audio Pro

If you like high-quality sound, this is the quality of Bluetooth speaker that you'd want to get and your S21 is up to the task. As you may have noticed, it looks very sleek. On the other hand, if you're just looking for background enjoyment, you can get a more modest Bluetooth speaker for a fraction of that price.

Connecting to your stereo

Although being able to listen to your music on the move is convenient, it's also nice to be able to listen to your music collection on your home or car stereo. Your Galaxy S21 phone presents your stereo with a nearly perfect version of what went in. The sound quality that comes out is limited only by the quality of your stereo.

In addition, you can play the music files and playlists stored on your phone, which can be more convenient than playing CDs. If your stereo receiver is older, you have two choices:

- One setup involves plugging a 3.5mm-to-USB-C connector into the 3.5mm jack available on newer stereos. You can also acquire a cable with the male 3.5mm-to-a-male USB-C connector, but these are just becoming available as of this writing. When you play the music as you do through a headset, it will play through your stereo. Although each stereo system is unique, the correct setting for the selector knob is AUX.
- >> The other option is to acquire a Bluetooth receiver and connect that to your stereo (be sure it works at least with Bluetooth version 4.2 for the best sound).

The Bluetooth receiver will connect with a 3.5mm jack or to an unused red and white plug pair, say, for the old cassette tape player you no longer have. This setup lets you walk around with your phone in your house. As long as you don't stray more than 30 feet from your stereo, the connection works great!

Newer stereo receivers recognize that cellular phones are a great place to access music. These receivers support a Bluetooth connection to your phone. If you are in the market for a new receiver, make sure that you get one with Bluetooth capability. In either case, you will be entertained. Enjoy yourself.

Licensing Your Multimedia Files

It's really quite simple: You need to pay the artist if you're going to listen to music or watch video with integrity. Many low-cost options are suitable for any budget. Depending upon how much you plan to listen to music or podcasts, or watch videos, you can figure out what's the best deal.

Stealing music or videos is uncool. Although it might be technically possible to play pirated music and videos on your phone, it's stealing. Don't do it. If your financial circumstances do not allow you to afford to pay for your music, I suggest you listen to Internet Radio. With just a little work on your part, you can get free unlimited music and at least a low monthly fee if you want no advertising.

You can buy or lease music, podcasts, or videos. In most cases, you pay for them with a credit card. And depending upon your cellular carrier, you might be allowed to pay for them on your monthly cellular bill.

Listening up on licensing

Here are the three primary licensing options available for music files and podcasts:

- >> By the track: Pay for each song individually. Buying a typical song costs about 79 cents to \$1.29. Podcasts, which are frequently used for speeches or lectures, can vary dramatically in price.
- >>> By the album: Buying an album isn't a holdover from the days before digital music. Music artists and producers create albums with an organization of songs that offer a consistent feeling or mood. Although many music-playing apps allow you to assemble your own playlist, an album is created by professionals. In addition, buying a full album is often less expensive than on a per-song basis. You can get multiple songs for \$8 to \$12.

>> With a monthly pass: The last option for buying audio files is the monthly pass. For about \$15 per month, you can download as much music as you want from the library of the service provider.

If you let your subscription to your monthly pass provider lapse, you won't be able to listen to the music from this library. This music is *streamed* through the Internet and not stored on your phone.

In addition to full access to the music library, some music library providers offer special services to introduce you to music that's similar to what you've been playing. These services are a very convenient way to learn about new music. If you have even a small interest in expanding your music repertoire, these services are an easy way to do it.

Whether buying or renting is most economical depends on your listening/viewing habits. If you don't plan to buy much, or you know specifically what you want, you may save some money by paying for all your files individually. If you're not really sure what you want, or you like a huge variety of music, paying for monthly access might make better sense for you.

Licensing for videos

The two primary licensing options available for videos are:

- >> Rental: This option is similar to renting a video from a store. You can view the video as many times as you like within 24 hours from the start of the first play. In addition, the first play must begin within a defined period, such as a week, of your downloading it. Most movies are in the \$3 to \$5 range.
- >> Purchase: You have a license to view the file as frequently as you want, for as long as you want. The purchase cost can be as low as \$12, but is more typically in the \$15 range.

At the moment, there are no sources for mainstream Hollywood films that allow you to buy a monthly subscription and give you unlimited access to a film library. This can change at any time, so watch for announcements.

Using the Full Capacity of the Memory in Your Phone

Your Galaxy S21 comes with at least 128GB of storage. Okay. What does that really mean?

TIP

Prior models of the Galaxy offered you the option to supplement the memory installed in your phone with an SD card, but this is no longer an option. For this reason, you need to select a phone with enough memory when you first buy the phone. The least amount of memory you can buy is 128GB. You can buy a model with 256GB. The S21 Ultra offers the option for 512GB. Choose wisely. The Android operating system is stored on some of that storage space. Plus, the apps that you downloaded are stored here. Then, there are the files that you create and use. After it is all said and done, you probably have at least 80GB available for the storage of photos, music, and videos. So how much is that, and do you need more?

The correct answer is, "Who knows?" That is about as worthless of an answer as you will find anywhere in this book. However, I can tell you how to change that response to "It doesn't matter."

The easiest way to describe it is by figuring out how many photos, how many songs, and how many movies fit into 1GB.

- **300 images:** You can take about 300 images from the camera on your phone at resolution at the default settings.
- >> Ten hours of music: If you buy an album, it will take somewhat less than a tenth of a gigabyte. The length of albums was set based upon what could be reliably imprinted on a vinyl record. That works out to be about 45 minutes and maybe a dozen songs.
- About one standard definition (TV-quality) movie: Estimating the size of videos can get really variable. TV quality video is a waste of that beautiful screen. However, an hour of video that uses every pixel of resolution will take about 4GB.

Unfortunately, at this point, you need to do a little bit of math. Say that I want to watch every minute of all 529 episodes of *The Simpsons*. This would take 194 hours or about 8 days. In this case, you would want the 256GB option for about \$50 more. D'oh!

You could binge-watch all the episodes of the series *Breaking Bad* in high definition, but then you would need to delete *The Simpsons*. Sorry.

If you are more into music than videos, you could store over 5,000 hours of music on your phone with 256GB. You could start playing music January 1 at midnight and not repeat a single track until July 27.

Keep in mind that these are rough estimates. These calculations assume there are minor attempts to reduce the size of these files. That can have a huge impact on storage needs. Let's just say that you can put a combination of images, music, and video that will keep you entertained for a very, very long time.

Enjoying Basic Multimedia Capabilities

Regardless of the version of your Galaxy S21, some basic multimedia capabilities are common across the different phones. Figure 12-4 shows the Music and Video applications that come with all Galaxy S21 phones.

The multimedia apps on the Galaxy S21.

YouTube Music

Google TV

Your phone comes with these apps preloaded, and you might have other multimedia apps as well, depending upon your carrier. Also, some sources of music and video, such as Netflix, have their own embedded player.

Grooving with the YouTube Music app

The YouTube Music app allows you to play music and audio files. The first step is to obtain music and audio files for your phone.

Some ways to acquire music and/or recordings for your phone are:

- >> Buy and download tracks from an online music store.
- >> Receive them as attachments via email or text message.
- >> Receive them from another device connected with a Bluetooth link.
- >> Record them on your phone.

Buying from an online music store

The most straightforward method of getting music on your phone is from an online music store. You can download a wide variety of music from dozens of mainstream online music stores when you're a subscriber. The Play Store is an option. In addition to apps, it has music and video. Other well-known sites include Spotify and Amazon Music. In some cases, such as the Google Play Store or Amazon, you may already be a subscriber and not know it. When the music starts

playing, you have your answer. Otherwise, you may need to provide an email address and credit card number to get the ball rolling.

In addition to the mainstream choices, many more specialty or "boutique" stores provide more differentiated offerings than you can get from the mass-market stores. For example, MAQAM offers Middle Eastern music (www.maqammp3.com).

The details for acquiring music among the online stores vary from store to store. Ultimately, there are more similarities than differences. As an example of when you know what you want, what you really, really want, here's how to find the song "Wannabe" by the Spice Girls. I'm using Amazon Music. If you don't have Amazon Music in your Applications list, you would start by loading that app on your phone, as I describe how to do in Chapter 8. After entering your Amazon sign-in information, you see the Amazon Music Home screen, shown on the right in Figure 12-5.

Amazon Music Sign-In Screen

Amazon MP3 Music Store Home Screen

The Amazon Music login and Home screens.

From here, you can search for music by album, song, or music genre.

Many of the music apps try very hard to get you to sign up for their monthly service. This can be annoying if you want to dip your toe in the water before you dive in. As a newcomer, knowing which music service will best serve your needs is difficult, even if they offer you a 30- or 90-day free trial. Be patient and keep your options open until you're comfortable. Or, take them up on their offers, but just remember to cancel a service if you aren't using it. They tend to assume that you want their service even if you've never used it after the first few days, and they'll keep charging you until you cancel.

Now to search for the song you want:

1. Enter the relevant search information in the Amazon Music Find field.

In this case, I'm searching for "Wannabe" by the Spice Girls. The result of the search for songs looks like Figure 12-6.

FIGURE 12-6: Search results for a song at the Amazon Music store. The search results come up with all kinds of options, including: albums, individual tracks, similar songs, karaoke versions, and other songs from the same artist. Be ready for these options.

- 2. To play the track, tap once where it says, "Song."
- 3. To play the song, and then hear similar songs, tap the circle that says, "Spice Girls."

The music store will start playing a list of music that is dominated by Spice Girls songs. They also throw in similar songs. This is called a "Station." In this case, you get the screen shown in Figure 12-7.

FIGURE 12-7: Tap twice to buy.

> 4. To play the album that includes this song, tap the album cover that says, "Spice."

The music store will start playing the songs from the album that includes "Wannabe." Here you get the screen shown in Figure 12-8.

When you open the music player, it's ready for you to play anytime you want to party like it's 1996!

FIGURE 12-8:
The screen
confirming your
purchase from
the Amazon
Music store.

Receiving music as an attachment

As long as you comply with your license agreement, you can email or text a music file as an attachment. Simply send yourself an email from your PC with the desired music file. You then open the email or text on your phone and save the file in the library of your Music app.

Your phone can play music files that come in any of the following formats: FLAC, WAV, Vorbis, MP3, AAC, AAC+, eAAC+, WMA, AMR-NB, AMR-WB, MID, AC3, and XMF.

Recording sounds on your phone

No one else might think your kids' rendition of "Happy Birthday" is anything special, but you probably treasure it. In fact, many sound recording apps are available on your phone.

Some are basic and turn your phone into a basic voice recorder. Others can alter your voice. (I do not want to know why.) Others are meant to allow you to

surreptitiously record voice conversations. Some can specifically record telephone conversations.

Be aware of privacy laws in your area! Some jurisdictions require only one party in a conversation to give permission to record a conversation. Other jurisdictions require positive consent from all parties. While rare, there have been cases where first-time offenders have spent long stints in jail for recording what was perfectly legal in another state!

In general, a simple record button creates a sound file when you stop recording. The sound quality may not be the best, but what you record can be just as important or entertaining as what you buy commercially. Your phone treats all audio files the same and all are playable on your YouTube Music app.

Playing downloaded music

To play your music, tap the YouTube Music app icon shown in Figure 12-4 to open the music playing application.

Okay. Figure 12-9 shows your Home screen after your get through the initial marketing welcome. Sometimes this app can be too enthusiastic in welcoming you.

When you tap the Library icon, you see the screen to the right. It sorts your music files into a number of categories. You can select the category you want to use by tapping on the link.

The categories include

- >> Playlists: Some digital music stores bundle songs into playlists, such as Top Hits from the '50s. You can also create your own playlists for groups of songs that are meaningful to you.
- >> Albums: Tapping this category places all your songs into an album with which the song is associated. When you tap the album, you see all the songs you've purchased, whether one song or all the songs from that album.
- >> Songs: This lists all your song files in alphabetic order.
- >> Artists: This category lists all songs from all the albums from a given artist.
- >> Genres: This category separates music into music genres, such as country and western or heavy metal.

Home Page

Library Page

The Home screen and Library for the YouTube Music app.

TIP

Many music services have an option called *Stations*. These are kind of like radio stations that follow a particular format. You put in a group name, like Genesis or Van Halen, and the app will play songs within that genre that may or may not be currently stored on your phone. Figure 12–10 shows a more recent example when I searched on Bruno Mars.

These categories are useful when you have a large number of files. To play a song, an album, or a genre, open that category and tap the song, playlist, album, artist, or genre, and the song will start playing.

Adding songs as ringtones and alarms

Here's how to add a song as a ringtone or alarm. The first step is to open a contact. A generic contact in Edit mode is seen in Figure 12-11. (Refer to Chapter 6 if you have any questions about contacts.)

FIGURE 12-10: Bruno Mars Radio Station within the YouTube Music app.

Follow these steps:

1. Tap the Default Ringtone link.

This will bring up a list of ringtones (shown in Figure 12-12).

A quick scan finds that *Ode to Joy* is not among the options that come with your phone. To use a music file as a ringtone, find the Add button at the top.

2. Tap Add.

This brings up the option to bring up the Sound Picker App. This app shows all the music files on your phone, as shown in Figure 12-13.

3. Highlight the song you want and tap OK.

From now on, when you hear this song, you know it will be your friend Ludwig. Figure 12-14 shows that this is now Ludwig's ringtone.

FIGURE 12-11: A typical contact for a Baroque composer.

Jamming to Internet Radio

If you have not tried Internet Radio, you should definitely consider it. The basic idea is that you don't need to be near the station to receive its broadcasts. For example, I can be in Seattle and enjoy WXRT, which offers Chicago's Finest Rock.

FIGURE 12-12: Basic ringtones.

The good news is that you can explore your options. Figure 12-15 shows some of the 9,000 Internet Radio apps in the Play Store. Pandora, IHeartRadio, and Slacker Radio are three of the best-known services of this type; one or the other may have been preinstalled on your phone. (Actually, you may find four or more Internet Radio options preinstalled on your phone!)

These apps are a great way to learn about new songs and groups that may appeal to you. The service streams music to your phone for you to enjoy. You can buy the track if you choose.

WARNING

Streaming audio files can use a large amount of data over time. This may be no problem if you have an unlimited (or even large) data-service plan. Otherwise, your "free" Internet Radio service can wind up costing you a lot. You're best off using Wi-Fi.

TIE

If you find yourself bored, do not hesitate to switch Internet Radio providers and use the same band for the radio station. This will almost always bring up new songs.

The track selections.

Looking at your video options

The YouTube Music app allows you to play music files. Similarly, you can use the Google TV app to play video options. Google TV is in your Applications list and might even be on your home page. In most ways, playing videos is the same as playing audio with some exceptions:

- >> Many people prefer to buy music, but renting is more typical for videos.
- >> Video files are usually, but not always, larger.

Otherwise, as with music files, you can acquire videos for your phone from an online video store — and you need to have an account and pay for the use. In addition, you can download video files to your phone, and Google TV will play them like a DVD player.

The ringtone selection.

Suitable ringtone for Ludwig

There is a great selection of videos on the Google Play Store and Amazon Prime Video. Each of these has great video selections that you can rent or buy. Figure 12–16 shows the Home screens for the Google Play Store and Amazon Prime Video.

Using the three screens

If you have a subscription to Amazon Video, I hereby grant you permission to watch any and all of the Amazon Video options on your Galaxy S21 (once you sign in and comply with all the terms and conditions set forth by Amazon). Once you install the Amazon Prime Video app from the Play Store, sign in with the email and password associated with your account, and all the content is there for you to stream. It is that simple. If you don't believe me, give it a try.

FIGURE 12-15: Some Internet Radio options in the Play Store.

If you take a look at the Amazon Prime Video home page on the Internet, seen in Figure 12-17, it shows your options for access to the content to which you subscribe. The original term for this was called serving the *three screens*. Three screens referred to in the strategy included your television at home, your PC or laptop, and your smartphone.

The idea is that you get one subscription and have access to the same content and, importantly, can pick up where you left off. So if you're watching a video on your television, you can pick up where you left off on your smartphone.

Amazon Prime Video is taking this one step further to ensure as many of its subscribers as possible have access. If you have a Smart TV that has an Internet connection, the chances are that Amazon Prime Video will run on the TV. If you have an old and/or a dumb TV, you can get Amazon through streaming media players, game consoles, set-top boxes, or Blu-ray players.

Amazon is not the only organization to do this. Many cable companies offer this kind of solution, as do many of the video subscription services.

Play Store Video Home Page

Amazon Prime Video Home Page

FIGURE 12-16: Home screens for Google Play Store and Amazon Prime Video.

FIGURE 12-17: The Amazon Prime Video home page.

The mainstream video services compete with having a broad range within their libraries that seek to appeal to as many customers as possible. Keep in mind that there are specialty video providers that offer curated videos for their subscribers.

For example, TeacherTube is a site dedicated to K-12 education, as seen in Figure 12-18. If you continue down this path further, there are a great number of options for online education. Many of these sites do not consider themselves to be video aggregators, but that's exactly what happens when they take recorded lectures and provide them to students.

FIGURE 12-18: The TeacherTube app.

The best-known online education service is the University of Phoenix. There are dozens more online universities.

Education is just one curated video service. Others exist for videos of Bollywood movies, British sitcoms, Portuguese game shows, and many other art forms.

Viewing your own videos

In Chapter 10, I cover how to use the digital camcorder on your phone. You can watch any video you've shot on your phone. From the Google Play app, scroll over to the Personal Video section.

Your phone can show the following video formats: MPEG-4, WMV, AVI/DivX, MKV, and FLV.

To play your video, simply tap the name of the file. The app begins showing the video in landscape orientation. The controls that pop up when you tap the screen are similar to the controls of a DVD player.

positiv nwo dov privaly

in Oragner (o, a cover how to due the digital canteeder on year phone You set water that can the law is the set of the form parade. It was the troople Play app, caroll over to the transmit View netten.

i ou grane en show die felloware widen formate: edelle e 1999 - 1999. New Yard lies.

(applied when where straphy applies come of the 1000 means by the Showing feet of the or after the parties of and space the strategy are strategy as a strategy of a st

Getting Down to Business

IN THIS PART . . .

Download your calendars to your phone and upload new events to your electronic calendar.

Use Google Maps and the GPS in your phone to get you there and back.

Pay with Samsung Pay.

- » Downloading your calendars to your phone
- » Uploading events to your PC

Chapter 13

Using the Calendar

ou might fall in love with your Galaxy S21 phone so much that you want to ask it out on a date. And speaking of dates, let's talk about your phone's calendar. The Galaxy S21 phone calendar functions are powerful, and they can make your life easier. With just a few taps, you can bring all your electronic calendars together to keep your life synchronized.

In this chapter, I show you how to set up the calendar that comes with your phone, which might be all you need. The odds are, though, that you have calendars elsewhere, such as on your work computer. So I also show you how to combine all your calendars with your Galaxy S21 phone. After you read this chapter, you'll have no excuse for missing a meeting. (Or, okay, a date.)

Some calendars use the term *appointments* for *events*. They are the same idea. I use the term *events*.

. .

Syncing Calendars

Most likely, you already have at least two electronic calendars scattered in different places: a calendar tied to your work computer and a personal calendar. Now you have a third one — the one on your Samsung phone that is synced to your Gmail account.

Bringing together all your electronic calendars to one place, though, is one of the best things about your phone — as long as you're a faithful user of your electronic calendars, that is. To begin this process, you need to provide authorization to the respective places that your calendars are stored in the same way as you authorized access to your email accounts and contacts in Chapters 5 and 6. This authorization is necessary to respect your privacy.

If your phone doesn't have a Calendar icon on the Home screen, open the Calendar app from your App list. This same app works with the calendar that's stored on your phone and any digital calendars that you add.

When you first open this app, you see a calendar in monthly format, as shown in Figure 13–1. I discuss other calendar views in the next section.

FIGURE 13-1: The monthly calendar display.

YOU MAY ALREADY BE A WINNER!

The calendar on your phone might already be populated with events from your work and personal calendars. Don't be concerned — this is good news!

If you've already set up your phone to *sync* (combine) with your email and your calendar (see Chapter 5), your calendars are already synchronizing with your phone.

When you add an account to your phone, such as your personal or work email account, your Facebook account, or Dropbox, you're asked whether you want to sync your calendar. The default setting for syncing is typically every hour.

Unless you get a warning message that alerts you to a communications problem, your phone now has the latest information on appointments and meeting requests. Your phone continues to sync automatically. It does all this syncing in the background; you may not even notice that changes are going on.

You could encounter scheduling conflicts if others can create events for you on your digital calendar. Be aware of this possibility. It can be annoying (or worse) to think you have free time, offer it, and then find that someone else took it.

Setting Calendar Display Preferences

Before you get too far into playing around with your calendar, you'll want to choose how you view it.

If you don't have a lot of events, using the month calendar shown in Figure 13-1 is probably a fine option. On the other hand, if your day is jam-packed with personal and professional events, the daily or weekly schedules might prove more practical. Switching views is easy. For example, just tap the three lines at the top of the calendar, which in this case displays May 2020, to bring up the options. These are shown in Figure 13-2.

If you tap Week, you see the weekly display, as shown in Figure 13-3.

The Calendar Display Options pop-up menu.

The weekly calendar display.

Or tap the Day button at the top of the calendar to show the daily display, as shown in Figure 13-4.

FIGURE 13-4: The daily calendar display.

To see what events you have upcoming, regardless of the day they're on, you might prefer List view. Tap the List button at the top of the calendar to see a list of your activities.

The weekly and daily calendars show only a portion of the day. You can slide the screen to see the time slots earlier and later. You can also pinch and stretch to see more or less of the time slots.

There is also an annual calendar, as seen in Figure 13-5. This is so busy that it does not allow you to see any appointments. It is primarily useful for setting dates out in the future.

FIGURE 13-5: The annual calendar display.

Setting Other Display Options

In addition to the default display option, you can set other personal preferences for the calendar on your phone. To get to the settings for the calendar, tap the More link on the daily, weekly, or monthly calendars and tap Settings. Doing so brings up the screen shown in Figure 13–6.

You have the following options:

- Manage calendar colors: This is not just aesthetics. Setting different colors offers you control to be sure to keep your calendars organized and put the right event on the right calendar.
- Add a new account: Many people have multiple accounts, including those associated with multiple email accounts. This option makes it convenient to add any other calendars that you haven't already added with your email accounts.

Optional information Alternate calendar Show week numbers Show weather forecast Show completed reminders Hide declined events Alerts Alert style Medium Alert settings More settings Lock time zone Lock the time and date of events to your selected time zone. Customization Service Get personalized content based on how you use your phone Not in use

The Settings options for the calendar app.

- >> First day of week: The standard in the United States is that a week is displayed from Sunday to Saturday. If you prefer the week to start on Saturday or Monday, you can change it here.
- >> Highlight short events: Selecting this option shows color for events that last less than a day, but only when you're in the Month calendar.
- >> Let even titles wrap: This is just aesthetics. Go ahead and make your choice.
- >> Alternate Calendars: The default is the Gregorian Calendar. However, if you're among the more than one billion people who use the Chinese lunar calendar, you're in luck! Tap this option and you'll see the Chinese lunar date on the calendar. The same applies for the Korean lunar calendar, the Vietnamese lunar calendar, and some others.
- >> Show week numbers: Some people prefer to see the week number on the weekly calendar. If you count yourself among those, select this option.
- Show weather forecast: If you want to see the daily forecast for each day, tap the Show Weather Forecast toggle shown in Figure 13-6. You can see an image on some of the days representing the weather forecast. If you like

- seeing this, you can keep this information. If you feel like it takes up too much real estate on your screen, you can delete it.
- Show completed reminders: Some of us want to be reminded that we took care of something. Others of us want to forget about it and move on. Your choice.
- Hide declined events: When some of us decline an event, we don't care to hear about it again. Other people may want to keep a reminder of the declined event in case the situation changes (or in case nothing better comes along). The default setting is to hide declined events; if you want to see them, deselect this box.
- Alert style: When an event is approaching, you can have the phone alert you with a pop-up, signal a notification on the status line, or do nothing. The default is to give you an alert, but you can change that option here.
- Alert settings: It helps some of us to be reminded about an appointment a few minutes before we are to be somewhere. Others of us find this annoying. This setting lets you choose whether you get a reminder or not and how far in advance you will be reminded.
- >> Lock time zone: When you travel to a new time zone, your phone will take on the new time zone. Under most circumstances, this is a nice convenience. However, it may be confusing to some. If you prefer that the calendar remain in your home time zone, select this option.
- >> Customization service: This option lets the apps you choose automatically add events to your calendar.

Creating an Event on the Right Calendar

An important step in using a calendar when mobile is creating an event. It's even more important to make sure that the event ends up on the right calendar. This section covers the steps to make this happen.

Creating, editing, and deleting an event

Here's how to create an event — referred to as (well, yeah) an "event" — on your phone. Start from one of the calendar displays shown in Figures 13-1, 13-3, or 13-4. Tap the bright green circle with the plus (+) sign at the bottom right of the calendar. Doing so brings up the pop-up screen shown in Figure 13-7 (without the keyboard).

FIGURE 13-7: The Create Event screen.

The only required information to get things started is a memorable event name and the Start and End times.

You need the following information at hand when making an event:

- >> Calendar: Decide on which calendar you want to keep this event. Figure 13-7 shows that this event will be stored on the Gmail calendar. This is indicated by showing my Gmail account next to the blue dot in the middle of the screen. When you tap this selection, the phone presents you with the other calendars you've synced to your phone; you can store an event on any of them.
- >> Title: Call the event something descriptive so that you can remember what it is without having to open it up.
- >> Start and End: The two entry fields for the start and end times. Select the All Day toggle if the event is a full-day event.

- >> Notification: This field lets you set how soon before an event your phone will alert you that you have an upcoming event. This makes it less likely that you'll be late to an appointment if you set this alert to accommodate your travel time.
- >> Location: This setting ties in to the Google Maps app, allowing you to enter an address or a landmark. You can also just enter text.

If you want, you can enter more details on the meeting by adding the following:

- >> Repeat: This option is useful for recurring events, such as weekly meetings.
- >> Invitees: This allows you to have a group meeting by entering multiple contacts.
- >> Notes: Add information that you find useful about that meeting.
- >> Privacy: This is the same idea as the Show Me As option, but for non-Outlook-based calendars.
- >> Time zone: If you and everyone who is invited will be in the same time zone, you are set. If you happen to be in another time zone or some of the invitees are in other time zones, you can use this option to ensure that you are not setting a meeting off business hours, or worse, in the middle of the night.

After you fill in the obligatory (and any optional) fields and settings, tap the Save link at the bottom of the page. The event is stored in whichever calendar you selected when you sync.

After you save an event, you can edit it, share it, or delete it by tapping it on any of your calendars. It appears as shown in Figure 13-8. Now you can

- >> Edit: This brings up the information as entered. Make your changes and tap Save.
- >> Share: You can send this event as an attachment to anyone as a text.
- >> Delete: To delete an event, you simply tap the garbage can icon at the bottom of the screen and the event is gone.

ID

You can also create an event by tapping the calendar itself twice. Tapping it twice brings up a pop-up (refer to Figure 13-7) where you can enter the event details.

FIGURE 13-8: The Edit Event screen.

Keeping events separate and private

When you have multiple calendars stored in one place (in this case, your phone), you might get confused when you want to add a new event. It can be even more confusing when you need to add the real event on one calendar and a placeholder on another.

Suppose your boss is a jerk and to retain your sanity, you need to find a new job. You send your resume to the arch-rival firm, Plan B, which has offices across town. Plan B is interested and wants to interview you at 3 p.m. next Tuesday. All good news.

The problem is that your current boss demands that you track your every move on the company calendaring system. His draconian management style is to berate people if they're not at their desks doing work when they're not at a scheduled meeting. (By the way, I am not making up this scenario.)

You follow my drift. You don't want Snidely Whiplash trudging through your calendar, sniffing out your plans to exit stage left, and making life more miserable if Plan B doesn't work out. Instead, you want to put a reasonable-sounding placeholder on your work calendar, while putting the real event on your personal calendar. You can easily do this from your calendar on your Samsung Galaxy S21. When you're making the event, you simply tell the phone where you want the event stored, making sure to keep each event exactly where it belongs.

The process begins with the Create Event screen. You bring this up by tapping the + sign in the green circle seen at the bottom-right corner of any of the calendars seen in Figures 13-1, 13-3, or 13-4. The information for the real event is shown on the left in Figure 13-9. The fake event is shown on the right. This is the one that is saved to your work email. The colored dot by the work address helps you be aware that this is a different calendar.

Real Appointment on Phone

Interview with Plan B

Start Fri, Apr 30 3:00 PM

End 4:00 PM

Time All day

Contain

Fake Appointment on Work Email

FIGURE 13-9: Two scheduled events.

Now, when you look at your calendar on your phone, you see two events at the same time. (Check it out in Figure 13-10.) The Galaxy S21 doesn't mind if you make two simultaneous events.

Under the circumstances, this is what you wanted to create. As long as your boss doesn't see your phone, you're safe — to try to find more fulfilling employment, that is.

FIGURE 13-10: Two events on the same day on your phone calendar.

gam galas, men no 2 galas come no esten menorel scondo com ne metos

- » Using what's already on your phone
- » Using maps safely

Chapter 14

Mapping Out Where You Want to Be

aving a map on your phone is a very handy tool. At the most basic level, you can ask your phone to show you a map for where you plan to go. This is convenient, but only a small part of what you can do.

With the right apps, your Galaxy S21 phone can do the following:

- >> Automatically find your location on a map.
- >> Tell others where you are.
- >> Get directions to where you want to go.
 - As you drive, using historical driving times.
 - As you drive, using real-time road conditions.
 - While you walk, ride a bike, or take public transportation.
- >> Find new places to go.
- >> Use the screen on your phone as a viewfinder to identify landmarks as you pan the area (augmented reality).

There are also some mapping apps for the Galaxy S21 for commercial users, such as TruckMap from TruckMap or SmartTruckRoute2 from Smart-Routing, but I don't cover them in this book.

GPS 101: First Things First

You can't talk smartphone mapping without GPS in the background, which creates a few inherent challenges of which you need to be aware. First off (and obviously), there is a GPS receiver in your phone. That means the following:

- Simme a sec. Like all GPS receivers, your location-detection system takes a little time to determine your location when you first turn on your phone.
- Outdoors is better. Many common places where you use your phone primarily, within buildings have poor GPS coverage.
- >> Nothing is perfect. Even with good GPS coverage, location and mapping aren't perfected yet. Augmented reality, the option that identifies local landmarks on the screen, is even less perfect.
- >> You must be putting me on. Your GPS receiver must be turned on for it to work. Sure, turning it off saves battery life, but doing so precludes mapping applications from working.
- >> Keep it on the down-low. Sharing sensitive location information is of grave concern to privacy advocates. The fear is that a stalker or other villain can access your location information in your phone to track your movements. In practice, there are easier ways to accomplish this goal, but controlling who knows your location is still something you should consider, particularly when you have apps that share your location information.

REMEMBE

Good cellular coverage has nothing to do with GPS coverage. The GPS receiver in your phone is looking for satellites; cellular coverage is based upon antennas mounted on towers or tall buildings.

TIP

Mapping apps are useful, but they also use more battery life and data than many other apps. Be aware of the impact on your data usage and battery life. Leaving mapping apps active is convenient, but it can also be a drain on your battery and your wallet if you don't pay attention to your usage and have the wrong service plan.

Practically Speaking: Using Maps

The kind of mapping app that's easiest to understand is one that presents a local map when you open the app. Depending on the model of your phone, you may have a mapping apps preloaded, such as Google Maps, TeleNay, or VZ Navigator. You can find them on your Home screen and in your Application list.

It's not a large leap for a smartphone to offer directions from your GPS-derived location to somewhere you want to go in the local area. These are standard capabilities found in each of these apps.

This section describes Google Maps, which is free and may come preinstalled on your phone. If not, you can download them from the Google Play Store. Other mapping apps that may come with your phone, such as Bing Maps or Waze, have similar capabilities, but the details will be a bit different. Or you may want to use other mapping apps. That's all fine.

In addition to the general-purpose mapping apps that come on your phone, hundreds of available mapping apps can help you find a favorite store, navigate waterways, or find your car in a crowded parking lot. For more, see the section, "Upgrading Your Navigation," at the end of this chapter.

As nice as mapping devices are, they're too slow to tell you to stop looking at them and avoid an oncoming car. If you can't control yourself in the car and need to watch the arrow on the map screen move, do yourself a favor and let someone else drive. If no one else is available to drive, be safe and don't use the navigation service on your phone in the car.

The most basic way to use a map is to bring up the Google Maps app. The icon for launching this app is shown here.

The first screen that you see when you tap the Google Maps icon is a street map with your location. Figure 14-1 shows an example of a map when the phone user is in the Seattle area.

Your location is the blue dot at the center of the map — unless you're moving, at which point it becomes a blue arrow. The resolution of the map in the figure starts at about one square mile. You can see other parts of the map by placing a finger on the map and dragging away from the part of the map that you want to see. That brings new sections of the map onto the screen.

FIGURE 14-1: You start where you are.

ere you are. Local Services

Turn the phone to change how the map is displayed. Depending on what you're looking for, a different orientation might be easier.

Changing map scale

A resolution of one square mile will work, under some circumstances, to help you get oriented in an unfamiliar place. But sometimes it helps to zoom out to get a broader perspective or zoom in to find familiar landmarks, like a body of water or a major highway.

To get more real estate onto the screen, use the pinch motion I discuss in Chapter 2. This shrinks the size of the map and brings in more of the map around where you're pinching. If you need more real estate on the screen, you can keep pinching until you get more and more map. After you have your bearings, you can return to the original resolution by double-tapping the screen.

On the other hand, a scale of one square mile may not be enough. To see more landmarks, use the stretch motion to zoom in. The stretch motion expands the boundaries of the place where you start the screen. Continue stretching and stretching until you get the detail that you want. Figure 14-2 shows a street map both zoomed in and zoomed out. The map on the left is zoomed in in Satellite view. The map on the right is zoomed out in Terrain view.

Zoomed In Image

Panned Out Image

FIGURE 14-2: A street image zoomed in and zoomed out.

The app gives you the choice of Satellite view or Terrain view by tapping the menu button, the circle with the initial of your first name, on the top-right corner of the map. This brings up a pop-up menu similar to the one shown in Figure 14-3.

To enable the Satellite view, first tap Settings. The Settings options are shows in Figure 14-4.

You enable this view by tapping the Satellite toggle switch. You can select a number of options that are useful to you, including transit routes and bicycling paths. I show you some of the other options in the next section in this chapter.

If you're zooming in and can't find where you are on the map, tap the dot-surrounded-by-a-circle icon (refer to Figure 14-1 for the centering icon). It moves the map so that you're in the center.

219

Distance units Automatic Start maps in satellite view This uses more data Show scale on map When zooming in and out Navigation settings Ride services Manage your preferences Your feedback about places Shake to send feedback About, terms & privacy Sign out of Google Maps

FIGURE 14-4: The Map Settings options.

Finding nearby services

Most searches for services fall into a relatively few categories. Your Maps app is set up to find what you're most likely to seek. By tapping the Local Services icon at the bottom of the page (refer to Figure 14–1), you're offered a quick way to find the services near you, such as restaurants, coffee shops, bars, hotels, attractions, ATMs, and gas stations, as shown in Figure 14–5.

FIGURE 14-5: Tap to find a service on the map.

Not only that, it is aware of the time of day. There are different suggestions during breakfast time than in the evening. Just scroll down and tap one of the topical icons, and your phone performs a search of businesses in your immediate area. The results come back as a regular Google search with names, addresses, and distances from your location. An example is shown in Figure 14-6.

FIGURE 14-6: The results of a service selection.

In addition to the location and reviews, the search results include icons and other relevant information:

- >> Directions: Tap the car icon to get turn-by-turn directions from your location to this business.
- >> Call: Tap this to call the business.
- >> Save: Tap the star to set this place as one of your favorites.
- >> Website: Tap this to be taken to the website for this business.
- Share Place: Tap the Share Place icon, and you're presented with lots of ways to tell your friends, family, co-workers, and the world about this wonderful place.
- >> Order Online: This option is available if the restaurant owners have enabled it.
- >> More options, which include
 - Street View: See the location in Google Street View. As shown at the bottom
 of Figure 14-7, Street View shows a photo of the street address for the
 location you entered.

- Hours: If this establishment has shared its hours of operation, you can find them here.
- Menu: If this establishment has shared its menu, you can find it here.
- Reviews: This includes all kinds of information about what people have experienced at this location.
- More: Run another Google search on this business to get additional information, such as reviews from other parts of the web.

But let's say you show up, and the line is out the door. It happens. All you need to do is tap the street address, and the local map will appear, as shown in Figure 14-7. This map tells you all the locations around you so you can find another option.

FIGURE 14-7: A street map search result.

Getting and Using Directions

You probably want to get directions from your map app. I know I do. You can get directions in a number of ways, including:

- >> Tap the Search text box and enter the name or address of your location for example, Seattle Space Needle or 742 Evergreen Terrace, Springfield, IL.
- >> Tap the Explore icon (refer to Figure 14-1), and select your location.

Any of these methods lead you to the map showing your location.

Sometimes the app gives audio instructions. The Google Maps app has a speaker icon that appears on the map that allows you to turn audio instructions on or off. It might seem intuitive to expect that when you search for a specific attraction (such as the Seattle Space Needle), you get only the Seattle Space Needle. Such a result, however, is sometimes too simple. A given search may have multiple results, such as for chain stores. Google Maps gives you several choices, and you may need to choose your favorite. Typically, the app will give you the closest option.

To get directions, tap the Directions icon. This brings up the pop-up screen shown in Figure 14-8.

Your direction options, from original location to the target.

This gives you the options of

- >> **Driving:** Turn-by-turn directions as you drive from where you are to the destination.
- >> Public Transportation: This option tells you how to get to your destination by taking public transportation using published schedules.
- >> Taxi or Ride Service: This option gives the time if you were to hop a taxi, Uber, or Lyft.
- >> Cycling: This option is for the cyclists among us; it includes bike trails in addition to city streets.
- >> Walking Navigation: Turn-by-turn directions as you walk to your destination.

For each of these options, you can use the options at the bottom of the screen to

- >> Get Directions: Sequential directions, as shown in Figure 14-9, but without telling you when to turn.
- Navigate: Rather than show you a map, this option puts you in a navigation app that monitors where you are as you travel and tells you what to do next.

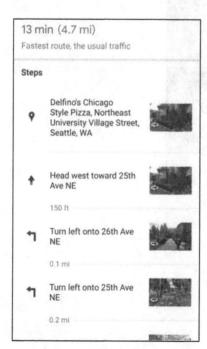

Step-by-step directions to the target.

Upgrading Your Navigation

The good news is that free navigation apps like Google Maps Navigation have real-time updates that avoid taking you on congested routes. This is very handy, particularly in urban areas. Companies that are offering navigation are adding new features all the time.

The next leap you will see has to do with augmented reality.

As you can see in Figure 14-10, the 3D map with a virtual compass gives you context and additional information, which can give you an extra level of confidence. This app, AR GPS Compass Map 3D from CodeKonditor, is a nice example of what you can expect.

FIGURE 14-10: Augmented reality in 3D navigation.

DRIVING SAFELY

Using your phone while driving is a bad idea. Texting while driving is illegal in most states, but studies have shown that laws don't affect behavior that much. It's just so darn tempting to sneak a peek at your phone. The grim reality. According to the National Highway Transportation Administration, texting while driving resulted in just under 600 deaths in the United States in 2016. When you include all the sources of distracted driving (eating, drinking, adjusting the radio, and so on), 3,450 people were killed.

To make matters worse, distracted driving is disproportionately problematic for younger drivers. You can't do much to stop your teen from checking out his hair in the rearview mirror while he's driving, but you can install an app on his phone that will prevent him from texting while the car is in motion. The simplest apps track speed — if the phone is going above some preset limit, it shuts off the phone's communication. More sophisticated apps give you more options, including the ability to place calls to 911 or a list of exceptions, a code that you can enter if you're the passenger and not the driver, and more.

If you have trouble setting down your phone, you may even want to install one of these apps for yourself *and* for your teen.

DAIVING SAFELY.

The state of the s

The matter source source the distance of exceptional area of an exercise to the matter of the source of the source

the angles of the section of each country and by a may be a sent of providence of the each end of the each providence of the each provide

- » Setting up your phone for payments
- » Managing your credit card options
- » Keeping track of your loyalty cards

Chapter 15

Paying with Samsung Pay

omeday in the future, you will be able to leave your wallet at home and just use your smartphone for all the stuff that you carry with you today. We are not there yet, but Samsung has implemented some technology that moves us toward that day.

You may reasonably ask why not carrying your wallet is such a big deal. Fair enough. The two main reasons are that it is more convenient and more secure. Samsung Pay takes us a long way to this ultimate goal. The reality is you will need to continue to carry your wallet with credit cards and cash for now.

For now, you'll need to decide for yourself whether the convenience that Samsung Pay does offer is worth the effort associated with setting it up. Samsung has gone to great lengths to make transactions more secure than simply using a credit card. Like so many of these things, the security is only as good as how the individual implements it.

With that awareness, some things about Samsung Pay are exceptionally cool. If you like to show off new technology to people, this is a good opportunity. In particular, you can one-up your smug friends who use Apple Pay with their iPhones. That capability alone is worth the price of admission for some of us.

How Mobile Payment Works

It helps to explain how mobile payments work to see how Samsung Pay helps you. The idea is that you walk up to the checkout stand at a retailer. You place your finger on the screen, place your phone near the card reader, and instantly your transaction is done. The receipt prints, and you take your purchase and go on your merry way. The charge shows up on your credit card.

Besides a fingerprint, you can enter a four-digit PIN. You choose the security option that is most convenient for you, and Samsung makes sure that everything flows securely. All the authorizations were set up when you set up the credit card with Samsung Pay.

Really. That's all there is.

It sounds so simple. The interesting thing is that this capability has been around in one form or another for close to 30 years. Back in 1997, Mobil gas stations implemented contactless payment with their Speedpass. Users on the system would tap their Speedpass fobs that they would keep on the key ring on the reader installed on the gas pump.

Their credit card would be charged for the gas they pumped. Initially, the tap was all that it took to pay for the gas. Later, users needed to add their ZIP code to enhance security. In spite of Mobil's best efforts, the system had only moderate success. There are a range of reasons, but a major concern was that people were already hesitant to even carry yet another thing. It is the inclusion of some new technology within smartphones that makes it so much more convenient.

Visa and MasterCard also tried contactless systems with limited success. One of their major challenges is that not enough credit card readers support the contactless payment system. After years of trying, fewer than 10 percent of all credit card readers as recently as 2015 have this capability. Those readers that do support contactless payment have the logo shown in Figure 15-1.

The contactless payment logo.

The contactless payment approach got a significant boost when Apple introduced the Apple Pay system on the iPhone in 2014. Like some other technologies that have struggled to find widespread acceptance, the implementation by Apple produced enough momentum to overcome resistance to its widespread use.

Then came Samsung Pay where Samsung leapfrogged Apple. Samsung Pay works similarly to Apple Pay with contactless payment devices. It also works with the vast majority of standard credit card readers. Take that, Apple! Samsung Pay took off.

At about this time, the credit card industry embraced the use of the embedded chip. This meant that most retailers needed to upgrade their readers. In addition to supporting the chip reader, the new readers supported contactless payment. Samsung Pay along with your Galaxy S21 have the electronics built in to work with the contactless system! Using the contactless system lets you avoid the hassle of finding the slot and orienting the card in the right direction.

The chip that is now on most credit card is called an EMV chip. It quickly and securely sends some double-secret codes that verify that this card is the original card sent to the account owner and not created by a thief in his basement. The use of Samsung Pay provides the same level of confidence to the credit card company, so it's just as happy that you use Samsung Pay as the EMV chip. Everyone wins, including the thief who now must go find gainful employment!

Probably the biggest drawback in using this technology these days is that other customers in line freak out the first time they see this slick solution. They will want to ask you more about it, which will end up taking more time than if you were paying by writing a check and having to provide two forms of identification!

Getting Started with Samsung Pay

The first step in the process is to make sure that you have Samsung Pay on your Galaxy S21. As cool as this app is, there are many options to this technology, and your carrier may have preferred to not have it preloaded. No problem. Chapter 8 explains how to download apps from the Play Store. The Samsung Pay logo is seen in Figure 15-2.

Samsung Pay

Google Pay

The Samsung Pay and the Google Pay logos.

It is easy to confuse Samsung Pay and Google Pay. These are two different applications. Google Pay is nice, but it does not have all the cool features of Samsung Pay.

The app page description is shown in Figure 15-3. When you tap Install, you get the image on the right.

Samsung Pay Before Installation

Samsung Pay After Installation

FIGURE 15-3: The Samsung Pay app Play Store images before and after installation. The Samsung Pay app works a little different than most other apps. The first time you open Samsung Pay, you will be given information on how to use it and be asked to put in your credit card information (in a very convenient way, by the way) and asked all kinds of permissions and agreements.

Once you have given all this information, Samsung Pay waits patiently at the bottom of your home pages, ready to meet your payment needs with nothing more than a quick swipe from the bottom of the screen. Most people would simply not use this app if they had to go digging through their screens to find the app. This way, you do not have to search to find the app and wait for it to come up.

Figure 15-4 shows the Home screen with the Samsung Pay launch button sitting at the bottom ready to appear with a quick flick.

The Samsung
Pay quick
launch button.

Samsung Pay Quick Launch button The launch button is also there on the Lock screen, so you don't even need to unlock your phone because you'll be using the exact same security steps before you can use your credit card.

Setting Up Samsung Pay

When you open the Samsung Pay app, you're greeted with a series of pages before you get to the Home screen seen in Figure 15-5. These pages include marketing introductions (which you don't need because you read this chapter), permissions and agreements (which you should give if you want to move forward), and some pages that verify that Samsung Pay can work on your phone.

FIGURE 15-5: The Samsung Pay Home Page. The app wants to make sure that your phone has the right parts (your Galaxy S21 does, but that is not the case for every Android phone) and that you are in one of the 29 countries where Samsung Pay is accepted. You're set if you're in the United States, Canada, China, or Kazakhstan (very nice!). You're out of luck if you're in, say, Yemen. Being in these countries is important for this app because each country has its own set of laws for payments, and Samsung may not have all the arrangements in place if you are not in one of these countries. New countries will be added as quickly as possible.

Read the agreements. In all likelihood, they are the same kind of agreements that exist in the fine print in your existing credit card and every time you sign your name to a credit card charge slip that affirms you won't pull any shenanigans. That said, I am your humble author, not your legal advisor, and you should feel comfortable with these agreements.

The next part of the initial setup process is to step through how you want to set up security. You have two security options when you are making a transaction: using your fingerprint or entering a PIN.

There are a few scenarios where using a Samsung Pay PIN rather than a finger-print might make sense. In most cases, using your fingerprint is exceptionally convenient. If you haven't set these up yet, the Samsung Pay app will walk you through the steps to do so. It's quick and easy.

The next step is to enter your credit card information. When you tap the link that says Cards on the home page or the menu, you're taken to a screen that shows you the images of the credit cards you've added. Initially, the screen will be empty. Figure 15-6 shows what it looks like after you have entered your first card.

To add a new card, tap the blue circle in the lower-right corner with a silhouette of a credit card and a plus sign. You get a pop-up with some choices. Pick the Add Credit/Debit Card option to start this process. The left image in Figure 15-7 is when the screen first comes up and the right image in Figure 15-7 is when you have the desired credit card in the viewfinder.

FIGURE 15-6: The Samsung Pay Card page.

Before taking an image of your card

FIGURE 15-7: The Samsung Pay credit card image processing screen.

After taking an image of your card

Viewfinder

The app then interprets the information on the front of your credit card and populates as many screens as possible with your credit card information. It will ask you to fill out the form seen in Figure 15-8 if it can't figure out the information on your card or the information is on the reverse side of the card.

FIGURE 15-8: The Populated credit card data fields.

TIP

Not every company that offers credit cards is signed up with Samsung Pay. You can check the Samsung website at www.samsung.com/us/samsung-pay/compatible-cards/#bank or tap the link in Figure 15-8 to check before you proceed. Otherwise, just go ahead and see whether things go through.

Tap Next, and Samsung Pay will seek to confirm things with your credit card company. This does not cost you anything. It just wants to make sure that when you do make a charge, everything will flow smoothly. One of the things the company will want to verify is that you are authorized to use that credit card. This means that either you need to be the primary cardholder or you need to coordinate with that person.

Keep in mind that scanning your fingerprint and tapping your phone on a credit card reader has the same legal implications as actually signing a credit slip.

When the credit card company verifies that everything is on the up and up, you get an acknowledgement like the one shown in Figure 15-9.

FIGURE 15-9: Card Added verification screen.

Using Samsung Pay

First, pick something to buy at a store. Have a clerk ring it up and tell him you will pay with a credit card. Swipe the screen upward. You see the screen seen in Figure 15-10.

FIGURE 15-10: Samsung Pay payment screen before reading your fingerprint.

Enter your fingerprint by pressing the icon and you see a screen similar to Figure 15-11.

As seen in Figure 15-11, you should either hold your phone against where the credit card reader would read the magnetic stripe or where there is the contactless payment system logo if it is available.

The semicircle above your signature will start counting down, and your phone will vibrate to let you know that it is transmitting. You will hear a beep if it all goes through. If it fails for some reason, you can try again simply by reentering your security option.

This process works with the vast majority of credit card readers. This does not work well, however, with credit card readers where you insert your card into the machine and pull it out quickly. This type of reader is mostly used on gasoline pumps. Sorry.

FIGURE 15-11: Samsung Pay payment screen after reading fingerprint.

Managing Samsung Pay

As long as you pay your credit card bills and keep your credit card account at the bank, this app is relatively self-sufficient. Still, you will need to access the app settings from time to time. You get there by tapping the Samsung Pay logo on the app screen. This will bring up the screen shown in Figure 15-5.

To add a new credit or debit card, tap the Add link and go through the process described in the section "Setting Up Samsung Pay," earlier in this chapter.

Adding a second card is easy, and the images will stack up when above each other on this page. The quick launch link brings up whatever card is on the top. If you want to change to use a different credit card, you can flip through the options. In addition to credit and debit cards, Samsung Pay is happy to help you with membership cards and loyalty cards. Don't be shy. Give it a try and see if you like the convenience. My bet is that you will.

You tap the three dots to get a pop-up for the settings of Samsung Pay and select Settings. The Settings page is shown in Figure 15-12.

FIGURE 15-12: Samsung Pay Settings screen.

If you want to change the settings for or delete a credit card, all you have to do is tap on the Manage Favorite Cards link. All the information associated with that card will appear in the screen.

Enjoy your spending!

Adding Loyalty Cards

Let's say that you are at Macy's with your child shortly before Christmas. Junior tells Santa that he wants a red fire truck, and Santa assures him that he'll get one. You freak because you know Macy's and every other toy store you know is sold out. It's the hot new toy this season.

"Tut-tut," Santa reassures you — they're available at Shoenfeld's on Lexington Avenue. The first crisis is averted. However, while you brought your membership card for Macy's, you left your membership card for Shoenfeld's at home.

That's when you realize that this is not 1947 and that you scanned your Schoenfeld's membership card into your Galaxy S21. It's available with all your other membership cards. The second crisis is averted.

To add a membership card, start by tapping the Membership link (refer to Figure 15-5). This brings up the screen shown in Figure 15-13.

Listed membership cards Load membership cards Featured SAMSUNG Pay GameStop Rig Lots Buzz Club Rewards PowerUp Rewards Savings Airlines Apparel - Men & We SAMSUNG 24 Hour Fitness TREMARDS 99 Ranch Market Add a card not listed here Unlisted membership cards

FIGURE 15-13: The Samsung Pay Load Membership

Cards screen.

This list of membership cards that the app knows is long. Let's say Crocs are your thing. You're in luck! The Crocs Club is one of the options shown in Figure 15-14.

FIGURE 15-14: The Crocs Club membership card in Samsung Pay.

However, it seems as if Schoenfeld's is not among the list of retailers and other organizations on the list. Adding a card that isn't already on the list does not require a miracle anywhere near 34th Street. Just tap the link that says Add a Card Not Listed Here, and you see the screen in Figure 15-15.

Take photos of the front and back of the card, enter some information (like the name of the card and your membership number), and you'll never again need to worry about carrying that stack of membership cards you only use occasionally.

FIGURE 15-15: Adding an unlisted membership card.

The Part of Tens

IN THIS PART . . .

Get the most out of your phone.

Protect yourself if you lose your phone.

Discover what features will be coming in future versions.

- Checking out the extra cool features that make this phone so good
- » Making a personal statement

Chapter 16

Ten Ways to Make Your Phone Totally Yours

smartphone is a very personal device. From the moment you take it out of the box and strip off the packaging, you begin to make it yours. By the end of the first day, even though millions of your type of phone may have been sold, there's no other phone just like yours.

This is the case because of the phone calls you make and because of all the options you can set on the phone and all the information you can share over the web. Your contacts, music files, downloaded videos, texts, and favorites make your phone a unique representation of who you are and what's important to you.

Even with all this "you" on your phone, this chapter covers ten or so ways to further customize your phone beyond what this book covers. Some of these suggestions involve accessories. Others involve settings and configurations. All are worth considering.

When it comes to accessories, your carrier's retail store has many good options. And oodles, heaps, loads, and tons of options for your phone are available outside the carrier's retail store. There is no need to limit yourself.

Using a Bluetooth Speaker

In just a matter of a couple of years, Bluetooth speakers have gone from an interesting (and expensive) option to mainstream. Prices have come down quickly, and the variety of designs for the speakers has grown dramatically. In all cases, you get the benefit of being able to play your music on your phone without the inconvenience of having headphones. You also get a speakerphone, although the quality of the audio can vary dramatically from Bluetooth speaker to Bluetooth speaker.

This accessory is best purchased in a brick-and-mortar store where you can listen to a variety of choices. Although syncing with a number of speaker choices can be tedious, it's the only way you'll know if a particular Bluetooth speaker meets your needs.

Although sound quality is essential, the folks in the industrial-design department have been having a lot of fun coming up with ways for the Bluetooth speaker to look. Figure 16-1 shows a range of options for the most popular form factors.

Popular Bluetooth speaker form factors.

Left: Passakorn Shinark/Shutterstock; Center: ABC vector/Shutterstock; Right: PROFFIPhoto/Shutterstock

The most popular options are basically a rectangle, the can style, and the sound bar. Each company has its own twist, but these options represent what you can see in the high-volume stores.

Fortunately, you live in a world where designers can get creative. The House of Marley, for example, uses unconventional design and recycled material to stand out in the market. Infinity Orb makes a levitating speaker. More than a few companies make Bluetooth speakers that look like the Death Star from Star Wars.

There is no shortage of imagination when it comes to Bluetooth. Be sure to consider all your options. Before you settle on the mainstream options at the local mall, do some research off the beaten path. You'll be amazed at the range of options.

Cruising in the Car

You may have gotten the idea that I am concerned about your safety when you're using your phone. True, but I'm also concerned with my safety when you're using your phone. I would like you to have a Bluetooth speaker in your car when driving in my neighborhood, if you please.

Most new cars have a built-in Bluetooth system within the car stereo that connects to a microphone somewhere on the dash as well as to your car speakers. It's smart enough to sense an incoming call and mutes your music in response.

If you don't have such a setup, there are lots of good options for car speakers. Figure 16-2 shows an example.

FIGURE 16-2: Bluetooth car speaker.

A closely related accessory is a car mount. A car mount will hold your phone in a place you can easily observe as you drive. The mount attaches to an air vent, the dashboard, or the windshield.

You could always put your phone on the seat next to you, but that's for amateurs. Instead, offer your phone a place of honor with a car docking station. It makes accessing your phone while you drive safer and easier. Some see getting a car mount as a luxury, but my view is that if you need to upgrade your navigation software, you need a vehicle mount.

Be sure to put away the docking station when you park. Even an empty docking station is a lure for a thief.

Figure 16-3 shows a typical vehicle mount. There are a great variety of options. Some mounts grip the phone, while other involve magnets. Some mounts use suction cups to hold onto the inside of your windshield, some clip on air yents, and still others you can screw into your dashboard. Many allow you to plug in a car charger, while others offer wireless charging. They cost \$30 to \$50. You can get these at your carrier's store, at Best Buy, or at Amazon.

A standard vehicle mount.

Roman Arbuzov/Shutterstock

More economical vehicle mounts are available that do not include a wireless charging pad. Figure 16-4 shows an example from SlipGrip that costs closer to \$30.

This version is special because it is specifically designed to work with larger protective cases. It can be a hassle to have to remove the protective case from your phone to insert it in a vehicle mount. In addition to a car mount, SlipGrip also offers a mount for your bicycle.

When shopping for a car mount or a bike mount, be sure to consider the extra girth associated with a case. If you don't use a case (which is a mistake), you just need to be sure that the mount is compatible with a Galaxy S21. If you have a case on your phone (which is anything but a mistake), be sure the mount will work with the Galaxy S21 and the case.

FIGURE 16-4: A SlipGrip vehicle mount.

Photograph courtesy of SlipGrip

Considering Wireless Charging Mats

Those industrial designers have certainly gone crazy with Bluetooth speakers. They have also been having a field day on wireless charging options.

Most wireless charging mats are designed with the idea that you can place your phone on the mat, and technology will do the rest. The wireless charging pads, shown in Figure 16-5, go for between \$35 and \$50. These include Fast Charging capabilities, which will charge your phone from stone-cold dead to 100 percent in just a few hours.

FIGURE 16-5: Wireless charging pads.

Left: suthon thotham/Shutterstock; Right: dmitriynesvit/Shutterstock

If these are too conventional for you, more options are out there as well. Figure 16-6 shows two of the more interesting options: the BOOST^CHARGE Wireless Charging Stand + Speaker from Belkin (left) and a combination wireless charging stand and LED lamp (right).

Look for more options going forward!

BOOST↑CHARGE™ Wireless Charging Stand + Speaker

Combination Wireless Charging Stand and LED Lamp

More exotic wireless charging pads.

Left: Photograph courtesy of Belkin; Right: Jane Khomi/Getty Images

Making a Statement with Wraps

Not the sandwich kind of wraps. I'm talking about the kind of wrap that lets you customize the non-glass portion of the S21.

The Samsung Galaxy S21 is very attractive, but you can spruce it up with an adhesive covering called a wrap from Skinit at www.skinit.com. These designs can express more of what is important to you. As a side benefit, they can protect your phone from minor scratches.

Figure 16-7 shows some design options for a skin. It comes with cut-outs for speakers, plugs, microphones, and cameras specifically for the Galaxy S21. Putting the skin on is similar to putting on a decal, although it has a little give in the material to make positioning easier. The skin material and adhesive are super high-tech and have enough give to allow klutzes like me (who struggle with placing regular decals) to fit the nooks and crannies of the phone like an expert.

If you're not crazy about Skinit's designs, you can make your own with images of your own choosing. Just be sure that you have the rights to use the images!

FIGURE 16-7: Some sample wrap designs from Skinit.

Eat Brains and Zombie On

White Flourish

NYC Sketch Cityscape

Photograph courtesy of Skinit

You Look Wonderful: Custom Screen Images

In addition to the shortcuts on your extended Home screen, you can also customize the images that are behind the screen. You can change the background to one of three options:

- >> Choose a neutral background image (similar to the backgrounds on many PCs) from the Wallpaper Gallery. Figure 16-8 shows a selection of background images that are standard on your phone.
- Any picture from your Gallery can be virtually stretched across the seven screens of your home page. (Read more about the Gallery in Chapter 9.)
- >> Opt for a theme that changes the background and fonts.

The pictures from your Gallery and the Wallpaper Gallery are images that you can set by pressing and holding the Home screen. In a moment, you see icons appear. Select Wallpapers and pick the image you want. Many are free; others you can download for less than a dollar.

The themes take it to a different level. In addition to the background, the phone will change the fonts and many of the basic icons. You can select different themes, as shown in Figure 16-9, that follow different color and font combinations. There are lots of options.

FIGURE 16-8: Standard wallpaper sample images.

FIGURE 16-9: Different theme options.

A few samples also come on your phone. You may be a pink kind of person or a space nut. If these options aren't to your taste, tap the Store link at the top of the page to see a range of options. If you do not see one you like today, be sure to check back as developers are adding new themes all the time. Do yourself a favor, and see if any of these strike a chord with you.

Empowering Power Savings

Imagine that you're flying on a short hop from Smallville to Littleton. You're about to take off when air traffic control tells the pilot that the plane needs to wait on the tarmac. Unfortunately, you're a little low on battery. The pilot says that it is okay to use your mobile phone.

Because you do not know how long this will take, you pull out your phone, go to Settings, tap Battery and Device Care, and tap Battery. From here, you tap the toggle button to put it in Power Savings Mode. This slows down a lot of cool features. For example, it dims the screen, slows the processors and mobile data speeds, and kills the vibration mode. This extends the battery life with minor sacrifices to what you can do with your phone. The apps all run, but perhaps not as fast. If you want to see what you've enabled or you want to disable one of these options, tap the Power Savings Mode link. This brings you to the left screen in Figure 16–10.

From here, you can override one of the three options by tapping the toggle switch. Then you tap the Off toggle switch to On and the phone implements the other power savings options. Hopefully this gets you through the delay. Then the pilot says that your plane has a flat tire, the maintenance crew went home, and you could be sitting there for hours. This time you go back into Settings, tap Battery and Device Care, tap Battery, tap Power Saving Mode, and tap the toggle that says Limit Apps and Home screen. This puts your phone in Super Power Savings mode when you tap Off to make it turn to On.

Your beautiful, powerful smartphone has instantly turned itself into a dumb feature phone. You won't be able to watch a full-length feature film. However, you now have enough battery to make and take phone calls and text messages for hours. This is not an exact science and your mileage may vary, but switching to this mode can multiply the time your smartphone can operate as a phone by eight to ten times. If you aren't ready to return to the 2000s, you can use the regular power savings mode and hope the intelligence of your S21 will be enough to keep your phone alive.

Power Saving Mode Options

Power Savings Mode On

Power Savings mode and the pop-up.

Super Power Savings Mode

Controlling Your Home Electronics

Traditional home appliances are getting smarter, offering more capabilities for better performance. One problem they have is that adding rows of control buttons (so that you can control those new capabilities) complicates manufacture. So, the next generation of appliances has begun to add a small LCD screen to the appliance. This can look slick, but it costs a lot and is prone to breakage. Also, the fancy capabilities involve pushing a confusing combination of buttons with cryptic messages displayed on a tiny screen.

The latest idea is to omit the screen altogether and give you control of the settings through an app on your smartphone. Your appliance retains the very basic buttons but allows you to use the fancy capabilities by setting them through your phone. You just download the free app made by the manufacturer from the Google Play Store, and you have your beautiful and logical user interface to control your new product — no strings attached.

For example, your new oven will allow you to turn it on and set the temperature without using a smartphone. However, if you want it to start preheating at 5:30 p.m. so that you can put the casserole in right when you walk in the door, you can set that up through your phone.

Wearing Wearables

Wearables are a class of mobile accessories that have been getting a lot of attention. For the most part, wearables are connected via Bluetooth and typically worn as a watch, although you can wear some sensors in athletic shoes. Samsung offers its wearables under the brand name Samsung Galaxy Watch (see Figure 16-11).

FIGURE 16-11: Samsung Galaxy Watch wearables.

In addition to telling the time, these wearables give you notifications, weather, and texts and track some relevant information, such as the amount of exercise you've done. These images look like conventional, but stylish analog watches. It shows you texts, a phone dialing pad, your altitude, and the useful information that would otherwise be shown on your phone. How cool is that?!

We can take it one step further. For example, Neuvenalife has a product called Xen (see Figure 16-12) that is designed to offer you relaxation and enhanced sleep with its uniquely designed headphones and mobile app. You use the mobile app to adjust the sensations to meet your preferences for relaxation.

FIGURE 16-12: Neuvana Xen wearable.

Left: Photograph courtesy of Neuvana

This is just another example of how manufacturers are leveraging the capabilities of the smartphone to offer new capabilities far beyond making a call and sending a text.

Using Your Phone as a PC

Your phone has all the computing power of a PC. Wouldn't it be nice if you didn't have to carry a laptop? Enter the Samsung Dex (see Figure 16-13).

Samsung Dex Cable.

The Dex Docking Cable may look like a charging cable, but it's so much more. When you connect the little connector (USB-C) to your phone, you can connect the other end into a PC monitor or a TV. What's on your beautiful small screen now appears on your beautiful big screen! If you connect a Bluetooth keyboard and mouse, it will almost seem like you have a regular PC. This is much smaller and more convenient than lugging around even the lightest laptop.

Creating Your Own AR Emoji in the AR Zone

I've saved the best for last: You can take a self-portrait and make your own emoji that becomes an integral part of your Galaxy S21. You may be used to sending smiley faces, frown faces, and winks. Now you can send you.

Let me show you what I mean. Let's say that you're President Teddy Roosevelt, and you're tired after a successful day of assaulting San Juan Hill, busting trusts, and rescuing orphan bear cubs. You sit down with your new Galaxy S21 smartphone, and decide to send a text to your pal Thomas Jefferson. (They were pals, right? They posed together for Mount Rushmore.) Instead of sending the conventional smiley face, you decide to send an AR Emoji. Figure 16–14 shows what you look like in real life and your smiling emoji.

Portrait of Teddy Roosevelt

Emoji of Teddy Roosevelt

The real image and the emoji image.

When you create an emoji of yourself, this app creates a series of animations, called GIFs, that provide animation of your emoji showing a variety of emotions. These are stored in the Gallery app, and you can send them to anyone you like.

So, let's say you're happy because you just got word that they completed the Panama Canal. You send a happy emoji. You try, but fail, to institute a federal income tax, so you send a sad emoji. When you're campaigning in Milwaukee, saloonkeeper John Schrank shoots you in the chest, but you keep on talking another 90 minutes. When you're done speechifying, you're quite cross with Mr. Shrank, so you send him an angry emoji. These emojis are shown in Figure 16–15.

Happy Emoji

Angry Emoji

FIGURE 16-15: Emoji options.

If you find your emoji to not quite capture you, you do have the ability to modify the image. You can add or take away hair, as well as adjust the color and style. You can also add glasses (although for some reason they don't have the pince-nez glasses Teddy Roosevelt liked to wear). You can also change attire as needed.

When you're an emoji in your phone, you and your phone are in it for the long haul!

If you had some entry to not this capture was verificions in abligation active in the large from the large well as adjustific and the large Yor can also a large from the sone capture well as adjustific and the large from the large

Table sand) of this weeks work that does the of the property of the sand the sand the sand. The sand

- » Avoiding losing your phone in the first place
- » Protecting yourself if you do lose your phone

Chapter 17

Ten (Or So) Ways to Make Your Phone Secure

ack in the "old" days, it sure was frustrating to have your regular-feature phone lost or stolen. You would lose all your contacts, call history, and texts. Even if you backed up all your contacts, you would have to reenter them in your new phone. What a hassle.

The good news is that your smartphone saves all your contacts on your email accounts. The bad news is that, unless you take some steps outlined in this chapter, evildoers could conceivably drain your bank account, get you fired, or even have you arrested.

Do I have your attention? Think of what would happen if someone were to get access to your PC at home or at work. He or she could wreak havoc on your life.

A malevolent prankster could send an email from your work email address under your name. It could be a rude note to the head of your company. It could give phony information about a supposedly imminent financial collapse of your company to the local newspaper. It could be a threat to the U.S. president, generating a visit from the Secret Service.

Here's the deal: If you have done anything with your smartphone as described in this book past Chapter 3, I expect you'll want to take steps to protect your smartphone. This is the burden of having a well-connected device. Fortunately, most of the steps are simple and straightforward.

Using a Good Case

The Samsung Galaxy S21 is sleek and beautiful. The Galaxy S21 has a really cool design that draws attention from people walking by. Plus, the front is made of Gorilla Glass from Corning. This stuff is super-durable and scratch-resistant.

So why am I telling you to cover this all up? It's like buying a fancy dress for a prom or wedding and wearing a coat all night. Yup. It's necessary for safe mobile computing.

Speaking from personal experience, dropping a Galaxy phone on concrete can break the glass and scramble some of the innards. This can happen if you simply keep your phone in a pocket.

There are lots of choices for cases. The most popular are made of silicone, plastic, or leather. There are different styles that meet your needs from many manufacturers.

You can find several good options (see Figure 17-1).

FIGURE 17-1: Cases for the Galaxy S21E, S21, and S21+.

Left: Pavel Kubarkov / Shutterstock.com; Center: doomu / Shutterstock.com; Right: Marko Poplasen / Shutterstock.com

Otterbox is a brand that has been making cases for multiple levels of protection. The Defender Series for the Galaxy S21, its highest level of protection, is on the right in Figure 17-2; the Strada Series is on the left, and the Symmetry Series is in the center.

Otterbox cases for the Samsung Galaxy S21, S21+, and S21 Ultra.

Photograph courtesy of Otter Products, LLC

TIE

I am told by the cooler members of my clan that wearing the belt clip is the modern equivalent of wearing a pocket protector.

You don't just use a good case so that you can hand off a clean used phone to the next lucky owner. A case makes it a little less likely that you will lose your phone. Your Galaxy S21 in its naked form is shiny glass and metal, which are slippery. Cases tend to have a higher coefficient of friction and prevent your phone from slipping out of your pocket when you take a ride in an Uber car.

More significantly, a case protects your phone against damage. If your phone is damaged, you have to mail it or bring it to a repair shop. The problem is that many people who bring their phones in for repair don't wipe the personal information off their devices. You really hope that the repair shop can pop off the broken piece, pop on a new one, and send you on your way. It's rarely that easy. Typically, you need to leave your phone in the hands of strangers for some period of time. For the duration of the repair, said strangers have access to the information on your phone.

The good news is that most workers who repair phones are professional and will probably ignore any information from the phone before they start fixing it.

However, are you sure that you want to trust the professionalism of a stranger? Also, do you really want the hassle of getting a new phone? Probably not, so invest in a good case and screen cover. There are many options for different manufacturers of cases. Be sure to shop around to come up with the ideal combination of protection and style right for you.

Putting It on Lockdown

Let's start with the basics of the Lock Screen. When you leave your phone alone for a while, or when you're doing something and you want to do something else, you can briefly press the power button to turn off the screen. This saves some power. Depending on what you want to do, you can make it easy or hard to return to using your phone by using the Lock Screen. The thinking is that you rarely lose your phone, or have it stolen when you're actively using it. It typically disappears when you leave it alone for a while.

To protect the information you keep on your phone, your S21 has the option of a Lock Screen on which, in most circumstances, you need to prove to the phone that you're you, and not some evildoer or a nosy family member. Figure 17-3 shows you a typical, and stylish, Lock Screen.

TIP

For reasons that sort of make sense, your phone uses some terminology that can be confusing. To clarify, the term *Screen Lock* is an option you can select to prevent unauthorized users from getting into your phone. The term *Lock Screen* is what you see in Figure 17–3 after enabling the Screen Lock option.

The most basic effort you can take to protect your phone is to put some kind of a screen lock on your phone. If you're connected to a corporate network, the company may have a policy that specifies what you must do to access your corporate network. Otherwise, you have seven choices, listed here in increasing degrees of security:

- None (as in your phone will open up to whatever was there before the screen image went dark).
- >> Unlock the Lock Screen with a simple swipe across the screen.
- >> Unlock with a pattern that you swipe on the screen.
- >> Unlock with a PIN.
- >> Unlock with facial recognition.
- >> Unlock with a password.
- >> Unlock with your fingerprint.

FIGURE 17-3: The Lock Screen.

You can select any of these options in the Lock Screen option in Settings. Here's what you do:

1. Tap the Settings icon.

This should be old hat by now.

2. Tap the Lock Screen.

This brings up the options seen in Figure 17-4. You set some of the options mentioned in the preceding list and others when you follow the next instruction. This can be a little confusing, but bear with me while I explain your options and tell you where to go.

3. Tap the Screen Lock Type link.

This brings up the options seen in Figure 17-5. Each option prompts you through what it needs before establishing your security selection.

FIGURE 17-4: The Lock Screen options.

FIGURE 17-5: The Screen Lock options.

TIP

During the initial setup of your phone, you may have been asked to enter a pattern. The person at the store may have walked you through this part. If so, I hope you remember that pattern because you may need it to get to the Screen Lock options.

If you're worried about what will happen if you forget your pattern, pay very, very close attention to the section "Rescuing Your Phone When It Gets Lost," later in this chapter. In addition to helping you find a lost phone, this section covers how to set up your Samsung account from your PC — these steps will not only find your phone but also unlock it. Don't lose the password to your Samsung account — if you do, your beautiful and costly Galaxy S21 will only be useful as a paperweight.

Preparing for your Screen Lock option

Regardless of what Screen Lock you choose, I recommend that you have ready the following choices at hand:

- >> An unlock pattern
- >> A PIN
- >> A password
- >> Your fingerprint
- >> Your face

To clarify definitions, a *PIN* is a series of numbers. In this case, the *PIN* is four digits. A *password* is a series of numbers, upper- and lowercase letters, and sometimes special characters, and is typically longer than four characters. A *PIN* is pretty secure, but a password is usually more secure. Have them both ready, but decide which one you would prefer to use.

Selecting among the Screen Lock options

The first option of skipping the whole lock screen thing altogether is your choice. Good luck with that one <sarcasm alert!>.

The second option, unlocking your phone with a swipe, fools exactly no one and doesn't slow anyone down. Rather than just having the Home screen appear, your phone tells you to swipe your finger on the screen to get to the Home screen. This is about as secure as waving at intruders and tossing them your phone, wallet, and keys. The only reason to choose this over the first option is that you like to see, on occasion, the abstract image shown in Figure 17–3 without the lock icon. Let's keep going.

I recommend drawing out a pattern as the minimum screen-lock option. This is quick and easy. Tap the Pattern option on the screen seen in Figure 17-6 to get started. The phone asks you to enter your pattern and then asks you to enter it again. It then asks you to enter a PIN in case you forget your pattern.

FIGURE 17-6: The unlock patterns: The blank screen and a sample pattern.

> The unlock pattern is a design that you draw with your finger on a nine-dot screen, as shown in Figure 17-6.

> The image on the right in Figure 17-6 happens to include all nine dots. You do not need to use all the dots. The minimum number of dots you must touch is four. The upper limit is nine because you can touch each dot only once. As long as you can remember your pattern, feel free to be creative.

> Be sure to use a PIN you can remember a long time from now. You need this PIN only if you forget your pattern. That is a very rare situation for most people.

Each time you enter a Screen Lock option, two things may happen:

- >> If you've already entered a Screen Lock option, it may ask you to enter it. For example, if you've put in a pattern and you want to add a PIN, it may ask you to enter that pattern. This helps prevent someone from messing with your Screen Lock.
- >> After you enter your PIN, password, or whatever, your phone may ask if you want to save the pattern to your Samsung Account, as shown in Figure 17-7. It can't hurt, so you may as well do it.

Back up your Patterns?

Remote unlock will be turned on in Find My Mobile and your PIN, pattern, or password will be securely stored by Samsung. This allows you to unlock your phone in case you forget your unlock method. It also allows you to control a lost phone remotely, even when it's locked. You'll need to sign in to your Samsung account first.

FIGURE 17-7: The option to back up your patterns.

To continue, read and agree to the Privacy Policy.

Agree

The next two options on the Screen Lock screen, PIN and Password, are more secure, but only as long as you avoid the obvious choices. If you insist upon using the PIN "0000" or "1111" or the word "password" as your password, don't waste your time. It's standard operating procedure within the typical den of thieves to try these sequences first. That's because so many people use these obvious choices.

If, someday, you forget your pattern, your PIN, or your password, the only option is to do a complete reset of your phone back to original factory settings. In such a case, all your texts and stored files will be lost. Try to avoid this fate: Remember your pattern, PIN, or password.

Entering your face

Facial recognition is even easier! From the Settings page, tap the Biometrics and Security link. This brings up the screen shown in Figure 17-8.

Tap the Face Recognition link. You'll be prompted to hold the phone toward your face. The recognition screens are shown in Figure 17-9. They work remarkably fast.

The last screen asks you some questions about whether you want faster facial recognition, whether you want to require that your eyes be open, and whether you want the screen to brighten in case it's dark. Sure. Go ahead and tap Done. Your phone now has your face.

FIGURE 17-8: The Biometrics and Security screen.

Second Face Recognition screen

Third Face Recognition screen

The facial recognition screens for Mona Lisa.

Entering your fingerprints

Using your fingerprint to unlock your phone is very convenient and very effective. There are a few hoops you need to make this happen. You need to give your phone enough views of the finger you will use, which can be whichever finger you like, so that it is sure that it is you. It also wants to make sure that you, and only you, have stored a fingerprint. Your phone can store multiple fingers. Any of your fingers will work, so have at it.

Here's what you do:

- 1. From the Settings screen, tap the Lock screen link.
- Tap the Screen Lock Type link.You're asked to enter your security pattern.
- 3. Enter your security pattern.
- 4. Tap the Fingerprints link.

The leftmost screen in Figure 17-10 appears.

FIGURE 17-10: The Fingerprints registration screen.

5. Press your finger on the fingerprint icon on the screen.

Keep following the directions on the screen for how it wants you to move until you reach 100 percent. The screen in the middle of Figure 17-10 will eventually get tired of telling you to press hard, cover the sensor, and move the position of your finger. Before you know it, you're at 100 percent.

If you ever want to add more of your fingers (up to nine more for most of us, although no judgments here), you can do so any time you want by tapping the Biometrics and Security link within Settings.

Your fingerprints are now in memory and ready to let you get to your home page with a quick press or swipe. Give it a try. It is very slick!

Creating a Secure Folder

Secure Folder is an option to protect data and/or applications on your device. It's an exceptionally secure option: It scrambles every file stored in the Secure Folder into gibberish, which it rapidly descrambles when you need the information. When you lock the folder, it's inaccessible and for all practical purposes invisible. When you enter your security option, like a password, the files are there for you to use like normal. This sounds great, but in practice, there are some important issues to think about.

First, if you put files in the Secure Folder and then forget your password, you can only get it back using your Samsung account. Do try not to lose both or you will never, ever, ever, ever get it back together.

Next, you already have one layer of security to get past your lock screen. If you get lazy and don't bother to lock the folder or use the same PIN or password, it's a waste of time.

If you're sure that using the secure folder is for you, here are the steps:

1. From the Applications screen, tap the Secure Folder link.

Doing so brings up some welcome screens until your get to the Secure Folder home screen, shown in Figure 17-11.

2. Tap the three dots to the right of the plus sign.

The pop-up appears.

The first thing you need to do is figure out what files you want to have protected. Let's say it's a picture of your baby on a bearskin rug. You want to keep it, but you don't want just anyone to see it.

Secure Folder

Secure Folder Actions

FIGURE 17-11: The Secure Folder screen and pop-up.

3. Tap the Add files links.

At this point, you see the options presented in Figure 17-12.

4. Select Images.

You're taken to the Gallery app.

5. Select the image in question and tap Done.

You're asked if you want to copy it or move it. In most cases, you want to move it. If you choose to copy it, a version will remain in the Gallery.

6. Select Move.

The image is now in your Secure Folder and gone from the Gallery.

 When you're ready, tap the three dots on the Secure Folder home page, bring up the pop-up, and tap the Lock and Exit link.

If you don't lock the Secure Folder, it's just as accessible as it was before.

FIGURE 17-12: The Secure Folder Add Files options.

When you want to access the image to chuckle at the excessive cuteness of the baby picture, you'll be prompted to use the security option in Settings. It could be a pattern, a PIN, or a password. Figure 17-13 shows the options. Just tap the lock type and then select the security option.

You and you alone get to decide how carefully you protect the data. Choose wisely.

Secure Folder Settings

Secure Folder Lock Type

FIGURE 17-13: The Secure Folder Settings.

Using Knox to Make Your Phone as Secure as Fort Knox

It doesn't matter whether you bought the phone at a retail store or your company supplied it to you. The fact of the matter is that company data that resides on your phone belongs to your employer. You probably signed a document (now sitting in your HR file) that states that you agree with this arrangement.

This policy is necessary for the company because it has a financial and legal obligation to protect company data, particularly if it pertains to individual customers. Like it or not, this obligation trumps your sense of privacy over the phone you bought and (still) pay for. If this really gets under your skin, you can always carry two smartphones: one for business and one for personal use. This solves the problem, but it's a hassle.

However, there is a better way. Samsung has a highly skilled group that has developed a secure system called *Knox*. Knox logically divides your phone into two modes: one for business use and the other for your personal use. You tap an icon, and you're in business mode. You tap another icon, and you're in personal mode. Switching between the two is instant, and Knox keeps the information from each mode separate.

This is a capability that is only of interest to you if your employer offers support for the service.

TIP

When it is available, Knox comes with three capabilities for the employer:

- >> Security for the Android OS
- >> Limitations on the apps that access the business side of your phone
- >> Remote mobile-device management

This arrangement means that your employer can remotely control the business apps and potentially wipe the data on the business side at its discretion — but it has nothing to do with your personal information. The personal side remains your responsibility.

You may want to suggest to your company's IT department that it look into supporting Knox. Doing so can take a burden off your back.

TIF

Being Careful with Bluetooth

In Chapter 3, I looked at syncing your phone with Bluetooth devices. I did not mention the potential for security risk at that point. I do it now.

Some people are concerned that people with a radio scanner can listen in on their voice calls. This was possible, but not easy, in the early days of mobile phone use. Your Galaxy S21 can use only digital systems, so picking your conversation out of the air is practically impossible.

Some people are concerned that a radio scanner and a computer can pick up your data connection. It's not that simple. Maybe the NSA could get some of your data that way using complicated supercomputing algorithms, but it's much easier for thieves and pranksters to use wired communications to access the accounts of the folks who use "oooo" as their PIN and "password" or "password" as their password.

Perhaps the greatest vulnerability your phone faces is called *bluejacking*, which involves using some simple tricks to gain access to your phone via Bluetooth.

Do a test: The next time you're in a public place, such as a coffee shop, a restaurant, or a train station, turn on Bluetooth. Tap the button that makes you visible to all Bluetooth devices and then tap Scan. While your Bluetooth device is visible, you'll see all the other Bluetooth devices in your vicinity. You'll probably find lots of them. If not, try this at an airport. Wow!

If you were trying to pair with another Bluetooth device, you'd be prompted to see whether you're willing to accept connection to that device. In this case, you are not.

However, a hacker will see that you are open for pairing and take this opportunity to use the PIN 0000 to make a connection. When you're actively pairing, your Bluetooth device won't accept an unknown device's offer to pair. But if your device is both unpaired and visible, hackers can fool your Bluetooth device and force a connection.

After a connection is established, all your information is available to the hackers to use as they will. Here are the steps to protect yourself:

Don't pair your phone to another Bluetooth device in a public place.
Believe it or not, crooks go to public places to look for phones in pairing mode.
When they pair with a phone, they look for interesting data to steal. It would be nice if these people had more productive hobbies, like Parkour or

- searching for Bigfoot. However, as long as these folks are out there, it is safer to pair your Bluetooth device in a not-so-public place.
- Make sure that you know the name of the device with which you want to pair. You should pair only with that device. Decline if you are not sure or if other Bluetooth devices offer to connect.
- >> Shorten the default time-out setting. The default is that you will be visible for two minutes. However, you can go into the menu settings and change the option for Visible Time-out to whatever you want. Make this time shorter than two minutes. Don't set it to Never Time Out. This is like leaving the windows open and the keys in the ignition on your Cadillac Escalade. A shorter time of visibility means that you have to be vigilant for less time.
- >> From time to time, check the names of the devices that are paired to your device. If you don't recognize the name of a device, click the Settings icon to the right of the unfamiliar name and unpair it. Some damage may have been done by the intruder, but with any luck, you've nipped it in the bud.

Here's an important point: When handled properly, Bluetooth is as secure as can be. However, a few mistakes can open you up to human vermin with more technical knowledge than decency. Don't make those mistakes, and you can safely enjoy this capability, knowing that all the data on your phone is safe.

Protecting against Malware

One of the main reasons application developers write apps for Android is that Google doesn't have an onerous preapproval process for a new app to be placed in the Play Store. This is unlike the Apple App Store or Microsoft Windows Phone Store, where each derivation of an app must be validated.

Many developers prefer to avoid bureaucracy. At least in theory, this attracts more developers to do more stuff for Android phones.

However, this approach does expose users like you and me to the potential for malware that can, inadvertently or intentionally, do things that are not advertised. Some of these "things" may be minor annoyances, or they could really mess up your phone (for openers).

Market forces, in the form of negative feedback, are present to kill apps that are badly written or are meant to steal your private data. However, this informal safeguard works only after some poor soul has experienced problems — such as theft of personal information — and reported it.

Rather than simply avoiding new apps, you can download apps designed to protect the information on your phone. These are available from many of the firms that make antivirus software for your PC. Importantly, many of these antivirus applications are free. If you want a nicer interface and some enhanced features, you can pay a few dollars, but it isn't necessary.

Examples include NQ Mobile Security and Antivirus, Lookout Security and Antivirus, Kaspersky Mobile Security, and Norton Security Antivirus. If you have inadvertently downloaded an app that includes malicious software, these apps will stop that app.

Downloading Apps Only from Reputable Sources

Another way to avoid malware is to download mobile software only from trust-worthy websites. This book has focused exclusively on the Google Play Store. You can download Android apps for your phone from a number of other reputable sites, including Amazon Appstore and GetJar.

Keep in mind that these stores are always on the lookout to withdraw applications that include malicious software. Google uses an internally developed solution it calls Bouncer to check for malicious software and remove it from the Play Store. Other mobile software distribution companies have their own approaches to addressing this problem. The problem is that policing malicious software is a hit-or-miss proposition.

As a rule, you should hesitate to download an Android app unless you know where it has been. You are safest if you restrict your app shopping to reputable companies. Be very skeptical of any other source of an Android app.

Rescuing Your Phone When It Gets Lost

Other options allow you to be more proactive than waiting for a Good Samaritan to reach out to your home phone or email if you lose your phone.

There are apps that help you find your phone. Here are a few "lost it" scenarios and some possible solutions for your quandary:

You know that you lost your phone somewhere in your house. You would try calling your own number, but you had your phone set to Vibrate Only mode.

Solution: Remote Ring. By sending a text to your phone with the "right" code that you preprogrammed when you set up this service, your phone will ring on its loudest setting, even if you have the ringer set to Vibrate Only.

If you know that your phone is in your house, the accuracy of GPS isn't savvy enough to tell you whether it's lost between the seat cushions of your couch or in the pocket of your raincoat. That's where the Remote Ring feature comes in handy.

Solution: Map Current Location. This feature allows you to track, within the accuracy of the GPS signal, the location of your phone. You need access to the website of the company with which you arranged to provide this service, and it will show you (on a map) the rough location of your phone.

Here is where having an account with Samsung comes in handy. Hopefully, you signed up for a Samsung Account when you first got your phone. If you did, you're signed up for the Find My Mobile at http://findmymobile.samsung.com. Figure 17-14 shows the Find My Mobile PC screen.

FIGURE 17-14: The Samsung Find My Mobile PC screen. You can see from this screen that my phone is at 935 Pennsylvania Ave. NW, Washington, DC, which happens to be the headquarters for the FBI. All you need to do is get to a PC and sign in to your Samsung account (unless your phone is at the FBI). You can tell your phone to ring by clicking on Ring My Device. You can have the PC bring up a map by clicking Locate My Device.

I suggest trying these out before you lose your phone the first time.

Wiping Your Device Clean

As a last-ditch option, you can use Find My Mobile (see preceding section) to remotely disable your device or wipe it clean. Here are some of the possible scenarios:

>> You were robbed, and a thief has your phone.

Solution: Remote Lock. After your phone has been taken, this app allows you to create a four-digit PIN that, when sent to your phone from another mobile phone or a web page, locks down your phone. This capability is above and beyond the protection you get from your Screen Lock and prevents further access to applications, phone, and data.

If you know that your phone was stolen — that is, not just lost — do *not* try to track down the thief yourself. Get the police involved and let them know that you have this service on your phone — and that you know where your phone is.

You're a very important executive or international spy. You stored important plans on your phone, and you have reason to believe that the "other side" has stolen your phone to acquire your secrets.

Solution: Remote Erase. Also known as Remote Wipe, this option resets the phone to its factory settings, wiping out all the information and settings on your phone.

You can't add Remote Erase *after* you've lost your phone. You must sign up for your Samsung service beforehand. It's not possible to remotely enable this capability to your phone. You need to have your phone in hand when you download and install either a lock app or a wipe app.

- » Delivering next generation of entertainment
- » Finding you indoors
- » Improving 911 capabilities

Chapter 18

Ten Features to Look for Down the Road

ith the power of your Samsung Galaxy S21 and the flexibility offered in Android applications development, it can be difficult to imagine that even more capabilities could be in the works. In spite of this, the following are ten features that would improve the usability and value of your Galaxy S21 phone.

Your Medical Information Hub

All kinds of fitness apps track your steps. There are also medical apps that let you access the information for your doctor and access the results of medical tests. But these apps are just the tip of the iceberg.

Many companies make devices that connect to your smartphone over Bluetooth. Examples include blood pressure cuffs, continuous positive airway pressure (CPAP) machines, pulse oximeters, and glucose monitors. These devices collect the information and send it securely to an application on the Internet so you or medical professional can monitor trends.

The ultimate solution are medical sensors that you wear and alert you, your loved ones, or medical/emergency response professionals with your location and situation. This technology can be tricky, because a reading that is fine for you may signal a problem for someone else. The technology challenges include collecting data from the different kinds of sensors and having the intelligence, probably artificial, to know whether this condition is serious or urgent and who to call.

Better 911 Services

The 911 system has been keeping the United States safe for more than 45 years. But the dirty secret of this service is that the underlying technology used to communicate information on the caller's location hasn't been updated in a long time.

To put this in perspective, your smartphone is designed to work with data at up to 300 million bits per second. When you call 911, the phone that answers your call is designed to work with data at up to 120 bits per second. (Seriously. I am not making this up.)

Many states and regions are trying to address this problem. This effort is called next-generation 911, or NG911 NG911 promises to make the information you already have on your phone available to the people who are sending you help. This new technology is slowly being implemented region by region in different states and counties.

With a larger data pipeline between your smartphone and the first responders, you can send anything that's relevant, including medical history, your emergency contacts, insurance data, and whether you have any protection orders against stalkers. All this information can help you — and it's available right away because, regardless of where you happen to be, your phone is typically there with you.

The larger pipeline also allows you to send information. Let's say you're visiting a new city and you see the drapes on fire in a multistory building. You call 911, but you don't know where you are or the address of the building, and all you can do is guess the floor with the fire. This is next to worthless for the 911 operator. With NG911, you can point the camera of your phone to show the operator the fire. Now the operator knows where you are and can pinpoint the fire based on the orientation of the phone. Problem solved and lives saved.

Home Internet of Things Services to Differentiate Real Estate

Much of the discussion about home Internet of Things (IoT) services involves individuals buying new appliances, thermostats, lighting, security, and other items. That works for homeowners. It can also work for apartment dwellers and new home buyers where the landlord or builder provides these services as a way to differentiate their offerings. Typically, they offer a mobile app to access all this stuff. This makes it easier for you to adopt this capability without having to maintain it yourself.

The Internet of Things is a catchall term for when a manufacturer gives you, the customer, the ability to control a "thing" from your phone, like use your phone as a TV remote control. Unlike your TV or stereo remote that uses an infrared light beam to control your TV or stereo, the manufacturer offers you the ability to control your thermostat, lights, or doorbell through the Internet using an app on your S21. Unlike the TV remote, it doesn't matter if you're in the room. You can check in on the electronic "thing" from anywhere you happen to be.

This also works at the office (when we're all allowed back into the office, that is). If your office space is too hot or too cold, you can submit a ticket and maybe the building staff will adjust the thermostat in a few hours. In the future, your office will give you an app on your smartphone that will replace your security card, let you tell them when your office is too hot or too cold with the tap of an icon, remind you to keep safe distances, and let you reserve conference rooms.

New Delivery Concepts

Most of us over the age of 5 years old know our address. It is on our driver's license. It is where we get things delivered from Amazon.com and other e-tailers. It is customary to have stuff shipped to a real address. However, if you are homeless, a road-warrior for business, or simply social, you are not always at that physical address.

Here is the future: Your smartphone will increasingly be used as the place to arrange for delivery. You can arrange to have physical stuff delivered to where you are, rather than an address. Shippers know where you will be based upon your smartphone, and can deliver to you personally.

This delivery can be by a drone, but more likely, it will still be by truck. They can find you and get the physical whatever-it-is-that-you-want in your hands quicker than you can say Jack Robinson (i.e., impressively fast).

Smarter Customer Care for Your Phone

You may not realize this, but your cellular carrier lives on pins and needles during the first few weeks after you get your new phone. This is the period when you can return your phone, no questions asked. Once you go past that date, you cannot cancel your contract without a lot of hassle on your part.

This is why, if you bring your phone back to the store reporting a problem, your carrier will tend to swap out your old phone for a brand new one.

Usually, you'll just take the new phone and walk out with a big smile on your face. This outcome is good customer care for most products — but not necessarily good customer care for smartphones. The reason? One of the most common sources of trouble has nothing to do with the phone at all. For example, you may have left your Wi-Fi and Bluetooth on all the time, causing your battery to drain too fast. You may have left your phone on your dashboard and cooked the battery. Or, through no fault of your own, you may have downloaded two badly written apps that conflict with each other, causing the CPU in the phone to run nonstop as these two apps battle it out for resources. The problem here is that unless someone spends the time to help you with the underlying problem, you'll be back in the store with the same problem.

At that point, however, you cannot return your phone. If you're sympathetic, or very annoying, your carrier may give you a refurbished phone. You walk out of the store, but without the biggest smile on your face. Unfortunately, nobody dealt with the underlying trouble, so you'll be back, once again, with the same problem.

No surprise if you start to think that the problem is with that darn phone. In fact, the store needs to listen to you about how you're using the phone and then help you get the most out of it. This is hard to do in a retail environment where the sales force is under pressure to sell lines of service and gets no concrete reward for helping you with your problem.

This is where smarter customer care comes in. With the proper tools, you can work with a product expert to troubleshoot your phone. Some companies specialize in understanding the underlying problems and coming up with solutions for

consumers. This kind of customer care costs the carriers a little more, but it makes for fewer unnecessary returns of perfectly good phones — and for much happier customers.

Smartphone as Entertainment Hub

Today's savvy technology customer has some or all of the following:

- Intelligent Big Screen TV or Dumb TV with a set-top box for home entertainment.
- >> Home Stereo System for immersive music.
- >> Home PC/Laptop for home management and entertainment.
- >> Work or School PC/Laptop. This helps you keep home and work separate.
- Tablet for the folks who find the larger screen to complement their smartphone.
- >> Gaming Console for games.

It would be hard to argue that having all these devices in one would not have advantages except for the following realities:

- Docking your smartphone to your big-screen TV and/or stereo system is not very convenient.
- Docking your smartphone so that you can use a full size computer screen, keyboard, and mouse is also not very convenient.
- >> The tablet screen size can be easier to view.
- >> The digital music on your smartphone is great, but there are many people who still want access to their DVD, CD, and/or vinyl collections.
- Gaming Consoles still have better games than what are available on a smartphone.

There will come a day when docking becomes so convenient that all your computing and entertainment will come through your smartphone, and you'll connect to an ergonomic keyboard, a bigger screen, and/or more powerful music amplifier at your convenience. The elements are there today, but they are just not convenient enough.

Driving in Your Car

After years of tempting us in science fiction movies, driverless cars are now starting to appear on the roads. Several insurance companies offer you an app to store your auto insurance information. Some car manufacturers allow you to check the location of your car and lock/unlock your car. These are all a good start.

What about the car unlocking and adjusting the seats and mirrors when you get close without one of those bulky key fobs? What about communication between your car and phone that would more intelligently let you use certain phone features if you are in the passenger seat rather than the driver seat or, if you are in the driver seat, to give you the freedom to check some texts while the traffic is stopped?

It is generally preferable for a car to have its Intelligence built in and run off the car battery. That said, your smartphone knows more about you and your preferences. The best of both worlds is when your car and your phone can collaborate to provide the best and safest experience.

Serving You Better

The smartphone is the mechanism that companies use to find a better way to serve you. This will show up in a few ways.

The first is in much better mobile advertising. There has been talk for a long time that advertisers can tell where you are and then give you ads or coupons based upon your proximity. This is just now starting to become a reality. It's still kinda clumsy. If you have been Googling, say, televisions, you may see ads relating to sales about televisions. In the future, however, your phone may tell you about a sale going on for Samsung televisions when you walk by the Sears store in the mall. That is cool.

Even cooler is to be told that that particular model is on sale at the Wal-Mart store and that this particular sale is the best in town by over \$20. This can happen if you are doing research at the moment. It may be possible for your app to flag you if you have ever done this kind of research on the Internet.

The second way smartphones are enhancing service is by automating the ordertaking process. For example, wherever you see a video kiosk, that company can

allow you to interact with the information on the kiosk with your Samsung Galaxy S21. Some fast-food restaurants have installed kiosks so that customers can bypass the line to order from the menu. The items are totaled and paid for by credit card. The customer steps aside and waits for his or her number to be called.

This exact transaction could take place on your smartphone. You don't have to wait while the guy in front of you struggles to decide between a double cheeseburger or two single cheeseburgers . . . and hold the pickles. Instead, you can place your order on your smartphone and wait with eager anticipation to find out what toys are in your kid's meal.

Placing You Indoors

The Global Positioning System (GPS) is great. It can tell you precisely your location on the road and off the road. Chapter 14 covers how it can help you get to where you want to be.

There is a confession to be made. GPS doesn't work so well within buildings. Once you are in a building, your phone only kind of knows where you are. The satellite responsible for sending out signals so that your phone can figure out your position is no longer visible, and the GPS in your phone waits patiently until it sees another satellite. Until then, it stops trying to figure out where you are.

This is rarely a problem if you are, say, at your home. It is probably only a few thousand square feet. Things are altogether different if you are wandering around the Palazzo Casino in Las Vegas. At 6.95 million square feet, this building has the most floor area of any building in the United States.

You could be anywhere in the 160 acres of luxury resort space. It is unfortunate if the Carnevino Steakhouse sends you a mobile coupon offering a two-for-one meal to your Galaxy S21 while you are already sitting in the Delmonico Steakhouse. It can be a tragedy if you start choking on too big a bite of your porterhouse steak and emergency services cannot find you.

There are some efforts out there to come up with a better way to locate you when you are indoors. One approach has been to estimate your location based upon signal strength of known Wi-Fi access points. Companies that hire a large number of smarticles (smart people) are trying a variety of technologies to address this problem. May the best company win so that we may all get better location-based services!

289

Reducing Your Carbon Footprint

The concept of a "smart home" is gaining momentum for the consumer electronics. So, what is a smart home and what's in it for you? The basic idea is that appliances, doorbells, computers, and lighting connect to a central hub that monitors everything and allows you to control stuff from your smartphone. It sends you an alert if someone rings your doorbell and shows you who it is. You can turn lights on or off. It can turn your thermostat up or down based upon your daily routines.

The next step beyond remote control is even smarter courtesy of your S21. It will not only be able to tell when you leave the house, but also know your location and direction and how soon you'll be home. In addition, the central hub will monitor your use of electricity and be able to tell what appliance is in use. It can tell the difference between the power use for your oven, the hot water heater, and the television.

So if you forgot to turn off the iron on the ironing board as you drove away from home, no problem. The hub sends you a text. You tell the hub to turn off the iron from your Galaxy S21. When the hub sees you're gone, it adjusts the thermostat to require less power. When the hub sees that you're on your way home, your smart home readjusts the thermostat so that everything is comfortable when you walk in the door. Your smart home is no longer making its best guesses based upon what it thinks is your normal routine. Your smart home knows exactly where you are and how soon you'll be walking in the door because your trusty smartphone let the hub know. This all reduces your power consumption without any inconvenience to you.

Index

A	Android platform, 14–15
About This Game option, 168	answering phone calls, 51–53
accessing	Apple Lightning connector, 24
Camera app, 135	Apple Pay system, 231
Google Play Store, 116–118	appointments
websites, 109–111	creating, 208–211
action games, 166	deleting, 208-211
Active Matrix, 137	editing, 208-211
Adaptive Fast Charging, 22	separating, 211–213
Add a new account option (calend	dars) 206 apps
Add Contacts icon, 102	Amazon Prime Video, 193–196
adding	Android, 118-130
contacts as you dial, 99–101	Contacts, 90–99
contacts manually, 101–102	downloading, 14, 280
email accounts, 76–82	Facebook, 122–127, 143
	Google TV, 192–197
loyalty cards to Samsung Pay, 24	medical, 283–284
shortcuts to Home screen, 37	Messaging, 61, 143. See also text messages
songs as ringtones/alarms, 188-	rating 129_120
Addon T20 Bluetooth speaker (Au 177–178	scrolling, 41
Advanced Recording option (Setti	실어 보다 그는 사이 되었다. 그는 사람이 가장 가장 하지만 하는 것이 되었다. 그 그 그래요 그래요 그래요 그래요 그래요 그래요 그래요 그래요 그래요
adventure games, 166	YouTube Music, 182–190
Airplane mode, 51, 109	AR Doodle option (Mode icon), 146, 160-161
alarms, adding music as, 188–190	
album, licensing by the, 179	arcade games, 167
Albums category (YouTube Music	그는 그
Alert Settings option (calendars), 2	
Alert style option (calendars), 208	그 그 이 그는 그 그 그 그 그 그 그 그 그 그 그 그 그 그 그 그
Alternate Calendars option (calen	
Amazon Music, 183–186	assigning pictures to contacts, 92
Amazon Prime Video app,	Attach link (Mail app), 85
193–196	attachments
Android apps	receiving music as, 186
about, 118–130	sending via text messages, 68-69
curated categories, 122	audio files, data and, 180
installing, 122–127	Audio Pro's Addon T20 Bluetooth speaker,
managing, 122–127	177-178

augmented reality, 215, 216	building
Augmented Reality subcategory, 119	AR emojis, 259–261
Auto HDR option (Settings icon), 147	contacts within database, 99–102
Auto & Vehicles category, 120	events, 208-211
autocorrect, 65	Secure Folder, 274–276
AutoFocus feature, 141	videos, 153–161
automatic backup, 73	business applications, 11
Marin marin maki singk	Business category, 120
	buttons, 29
В	buttons, hardware
Back button, 41	about, 26
backgrounds, 253–255	Home button(s), 35–37
backlight, 137	Power button, 26–27
battery	Volume button(s), 27–29
backlight, 137	buying from online music stores,
managing life of, 21-26	182–186
mapping apps and, 216	
Power Savings Mode, 255–256	Control of the contro
battery charger, 23	- 프로그램의
Beauty category, 120	Calendar icon, 202
Belkin's BOOST [↑] CHARGE Wireless Charging	calendars
Stand + Speaker, 252	about, 201
Bing (Microsoft), 109	creating events, 208–213
Bing icon, 108	setting display options, 206–208
Bing Maps, 217	setting display preferences, 203–206
Bixby Vision, 148–150	
Bluetooth	syncing, 201–203 call log, 54–55
about, 10	Call option, 222
security and, 278–279	
sending pictures via, 143	calls
Bluetooth headsets, syncing, 56–58	about, 47
Bluetooth speakers	answering, 51–53
choosing, 177–178	call log, 54–55
using, 248–249	emergency, 55–56
board games, 167	headset alternatives, 59
Books category, 119	making, 47–51
Books & Reference category, 120	syncing Bluetooth headsets, 56–58
BOOST1CHARGE Wireless Charging Stand +	camera. See pictures
Speaker (Belkin), 252	Camera app, accessing, 135
browsers	Camera/Camcorder mode switch icon, 139
defined, 109	Canada, emergency calls in, 56
starting, 108–109	capacitative touchscreen, 10

car charger, 22, 23 Playlists (YouTube Music app), 187 car icon, 222 Productivity, 121 car mount, 249-251 Shopping, 121 car speakers, 249-251 Social, 121 carbon footprint, 290 Songs (YouTube Music app), 187 card games, 167 Sports, 121 case, 264-266 Stations (YouTube Music app), 188 Tools, 121 casino games, 167 Top Charts subcategory, 119 casual games, 167 Travel & Local, 121 categories Albums (YouTube Music app), 187 Video Players & Editors, 122 Weather, 122 Art & Design, 119 Artists (YouTube Music app), 187 For You, 119 Augmented Reality, 119 categories, curated, 222 Categories tab (Play Store Games category), Auto & Vehicles, 120 166-169 Beauty, 120 cellular coverage, GPS coverage and, 216 Books, 119 changing map scale, 218-220 Books & Reference, 120 charging Business, 120 about, 21-26 Comics, 120 connectors for, 24 Education, 120 charging mats, wireless, 251-252 Entertainment, 120 Cheat Sheet (website), 4 Events, 120 choosing Finance, 120 Bluetooth speakers, 177-178 Food & Drink, 120 headsets, 174-175 Games, 118 lock options, 269-271 Genres (YouTube Music app), 187 search engines, 111-114 Health & Fitness, 120 Chrome (Google), 109 House & Home, 120 Chrome icon, 108, 109 Kids, 120 cleaning touchscreens, 30 Libraries & Demo, 120 Cloud Services option, 17 Lifestyle, 120 Combined Inbox icon, 84-85 Maps & Navigation, 121 Comics category, 120 Medical, 121 Compose icon, 85 Movies & TV, 119 connecting Music & Audio, 121 for charging, 24 News & Magazines, 121 to stereos, 178-179 Parenting, 121 contact list, sending text messages Personalization, 121 from, 65 Photography, 121 Contact Manager, 10 Play Store Games, 164–169

contactless payment logo, 231

contacts	car speakers, 249–251
about, 89–90	controlling home electronics, 256-257
adding as you dial, 99-101	creating AR emojis, 259-261
adding manually, 101–102	custom screen images, 253–255
advantages of, 102–103	Galaxy S21, 13-15
Contacts app, 90–99	power savings, 255–256
creating within database, 99-102	Samsung Dex Docking Cable, 259
Favorites tab, 104	wearables, 257–258
managing, 89–104	wireless charging mats, 251-252
Contacts app	wraps, 252–253
about, 90	Cycling option, 225
linking, 96-99	
where to store, 92-96	D The Control of the Section Management and
Contacts icon, 90	"dash-cam," 153
controlling	
Android apps, 122–127	data, audio files and, 180
battery life, 21–26	database, creating contacts within, 99–102
contacts, 89-104	Date and Time option, 16
home electronics, 256-257	default time-out setting, 279 deleting
pictures, 150–151	
Samsung Pay, 240–241	events, 208–211
text history, 69-70	pictures, 152 shortcuts from Home screen, 38
conversations, via text messages, 66-68	
corporate email accounts, setting up,	delivery concepts, 285–286
82–84	Description option, 167
creating	Device Function keys about, 39
AR emojis, 259–261	Back button, 41
contacts within database, 99–102	Recent Apps button, 39–41
events, 208–213	Device Name option, 18
Secure Folder, 274–276	digital camcorder, 11
videos, 153–161	directions
cropping pictures, 151	about, 11
crosstalk, 137	
curated categories, 222	getting, 224–225
custom screen images, 253–255	Directions icon, 224
customer care, 286–287	Directions option, 222
Customization service option (calendars), 208	Director's View option (Mode icon), 146, 159
customizing	display options, for calendars,
about, 247	206–208
backlight, 137	display preferences, calendar, 203-206
Bluetooth speakers, 248–249	docking cable, 259

docking station, 249	editing, 208-211
dots, 35	separating, 211–213
dot-surrounded-by-a-circle icon, 219	Events category, 120
double tap, 33-34	external charger, 23
downloading	
applications, 14	F
apps, 280	
Facebook app, 122–127	Facebook app
games, 13	downloading, 122–127
Drafts folder, 87	sending pictures via, 143
drag, 32	Facebook icon, 126
driving, 288	facial recognition, 271–272
Driving option, 225	Fast Charging pad, 251
	Favorites tab (Contacts app), 104
Edition in the second region	features, future, 283–290
	feedback, leaving on games, 169–172
ear buds, 176	file formats
editing events, 208–211	for music, 186
Education category, 120	for video, 197
educational games, 167	Finance category, 120
email	Find My Mobile (website), 281
about, 71	finding
forwarding, 87–88	lost phones, 280–282
non-Gmail accounts, 76–82	nearby services, 221–223
reading, 84–85	fingerprint, entering, 273–274
replying to, 87–88	First day of week option (calendars), 207
sending, 85-87, 142	fitness information, 11
setting up, 71–84	Flash options icon, 139
writing, 85–87	Flashlight capability, 38
Email app. See email	flick, 32–33
Email icon, 74	font size, for text messages, 68
emergency calls, 55–56	Food & Drink category, 120
Emergency Mode option, 43	Food option (Mode icon), 145
EMV chip, 231	For You subcategory, 119
entering fingerprint, 273–274	Format and advanced option (Settings icon), 147
Entertainment category, 120	formats, file
entertainment hub, 287	for music, 186
Europe, emergency calls in, 56	for video, 197
events	forwarding email, 87-88
creating, 208–213	front-facing camera, 10
deleting, 208–211	Function keys, 35

G	Get Directions option, 225
Galaxy S21. See also specific topics	getting directions, 224–225
about, 1–2	getting started, with Samsung Pay, 232–234
basic features of, 9–10	Global Positioning System (GPS), 11, 216, 289
charging, 21–26	Gmail (Google)
customizing, 13–15	about, 71–72
managing battery life, 21–26	advantages of, 73
navigating, 26–42	preparing, 72
setting up, 15–18	sending pictures via, 143
Sleep mode, 43	setting up existing accounts, 73-74
smartphone features, 10–13	setting up new accounts, 75–76
turning off, 43	Gmail icon, 74
turning on, 19–21	Google Account Sign-up option, 16–17
uses for, 10–13	Google Chrome, 109
Gallery app. See pictures	Google Drive, 73, 143
Gallery icon, 138	Google Gmail
games	about, 71–72
about, 163	advantages of, 73
downloading, 13	preparing, 72
- CHANGES C. 1922 - 122일 : 122 - 122 - 122 - 122 - 122 - 122 - 122 - 122 - 122 - 122 - 122 - 122 - 122 - 122 -	sending pictures via, 143
genres for, 166–169	setting up existing accounts, 73-74
leaving feedback on, 169–172	setting up new accounts, 75–76
Play Store Games category, 164–169	Google icon, 108, 109
Games category, 118	Google Maps app, 217
gear, 257–258	Google Maps icon, 217
generating	Google Maps Navigation, 226
AR emojis, 259–261	Google Pay icon, 232
contacts within database, 99–102	Google Photos, 73
events, 208–213	Google Play app, for viewing videos, 197
Secure Folder, 274–276	Google Play Store
Videos, 166–169	about, 73, 115
genres, for games, 166-169	accessing, 116–118
Genres category (YouTube Music app), 187	installing Android apps, 122–127
gestures	managing Android apps, 122–127
double tap, 33–34	rating apps, 128–130
drag, 32	uninstalling apps, 128–130
flick, 32-33	Google TV app
pinch and stretch, 33	· [집시 하시스()()()()()()()()()()()()()()()()()()()
pinching, 110	about, 192–193
press and hold, 31	screens, 193–196
stretching, 110	Gorilla Glass, 30, 264
tap, 30-31	GPS (Global Positioning System), 11, 216, 289
	Grid Lines option (Settings icon), 147

hardware buttons about, 26 Home button(s), 35-37 Power button, 26-27 Volume button(s), 27-29 headphones, 174-175 headsets about, 174-175 headsets about, 174-175 headsets about, 174-175 headsets about, 174-175 headith & Fitness category, 120 Hide declined events option (calendars), 208 Highlight short events option (calendars), 207 high-resolution screen, 10 Home button(s), 35-37 home electronics, controlling, 256-257 home loT services, 285 Home screen about, 34-35 adding shortcuts, 37 moving shortcuts, 38 Play Store Games category, 120 House of Marley, 249 Hyperlapse option (Mode icon), 146, 159 hyperlink, 30 defined, 29 Directions, 224 dot-surrounded-by-a-circle, 219 Email, 74 explained, 3-4 Facebook, 126 Flash options, 139 Gallery, 138 Gmail, 74 Google Nay, 217 Google Pay, 232 Internet, 109 Lens Selection, 138 Messages, 62 Motion Photo, 139 Phone, 55 Photo Effects, 139 Play Store, 116-117 Rear facing camera to front-facing camera switch, 138 Remember, 4 Samsung Pay, 232 Scene Optimizer, 138 Settings, 57, 139, 146-148, 159-160 Shutter button, 138 Technical Stuff, 4 Timer, 139 Tip, 3 Voice Recognition, 42 Warning, 4 HeartRadio, 191 images about, 12 advanced features, 144-148 assigning to contacts, 92 cropping, 151 deleting, 152 managing, 150-151 printing, 151	H TOS Emphasis of the commercial conversa.	Contacts, 90
about, 26 Home button(s), 35-37 Power button, 26-27 Volume button(s), 27-29 headphones, 174-175 headsets about, 174-175 alternatives to, 59 Bluetooth, 56-58 choosing, 174-175 Health & Fitness category, 120 Hide declined events option (calendars), 208 Highlight short events option (calendars), 207 high-resolution screen, 10 Home button(s), 35-37 home electronics, controlling, 256-257 home loT services, 285 Home screen about, 34-35 adding shortcuts, 37 moving shortcuts, 38 Play Store Games category, 120 House of Marley, 249 Hyperlapse option (Mode icon), 146, 159 hyperlink, 30 I cons Add Contacts, 102 Aspect Ratio, 139 Bing, 108 Calendar, 202 Camera/Camcorder mode camera switch, 139 Promine loto, 84-85 Directions, 224 dot-surrounded-by-a-circle, 219 Email, 74 explained, 3-4 Facebook, 126 Flash options, 139 Gallery, 138 Gmail, 74 Google, 108, 109 Google Maps, 217 Google Pay, 232 Internet, 109 Lens Selection, 138 Messages, 62 Motion Photo, 139 Phone, 55 Photo Effects, 139 Play Store, 116-117 Rear facing camera to front-facing camera switch, 138 Remember, 4 Samsung Pay, 232 Scene Optimizer, 138 Settings, 57, 139, 146-148, 159-160 Shutter button, 138 Technical Stuff, 4 Timer, 139 Tip, 3 Voice Recognition, 42 Warning, 4 HeartRadio, 191 images about, 12 advanced features, 144-148 assigning to contacts, 92 cropping, 151 deleting, 152 managing, 150-151 printing, 151	4. 하다 하는 사람들이 되었다. 1980년 1월 1일	defined, 29
Home button(s), 35–37 Power button, 26–27 Volume button(s), 27–29 headphones, 174–175 headsets about, 174–175 alternatives to, 59 Bluetooth, 56–58 choosing, 174–175 Health & Fitness category, 120 Hide declined events option (calendars), 208 Highlight short events option (calendars), 207 high-resolution screen, 10 Home button(s), 35–37 home electronics, controlling, 256–257 home loT services, 285 Home screen about, 34–35 adding shortcuts, 38 Play Store Games category, 120 House of Marley, 249 Hyperlapse option (Mode icon), 146, 159 hyperlink, 30 Lens Selection, 138 Messages, 62 Motion Photo, 139 Phone, 55 Photo Effects, 139 Play Store, 116–117 Rear facing camera to front-facing camera switch, 138 Remember, 4 Samsung Pay, 232 Scene Optimizer, 138 Settings, 57, 139, 146–148, 159–160 Shutter button, 138 Tip, 3 Voice Recognition, 42 Warning, 4 HeartRadio, 191 images about, 12 advanced features, 144–148 assigning to contacts, 92 cropping, 151 deleting, 152 managing, 150–151 printing, 151		Directions, 224
Power button, 26-27 Volume button(s), 27-29 headphones, 174-175 headsets about, 174-175 alternatives to, 59 Bluetooth, 56-58 choosing, 174-175 Health & Fitness category, 120 Hide declined events option (calendars), 208 Highlight short events option (calendars), 207 high-resolution screen, 10 Home button(s), 35-37 home electronics, controlling, 256-257 home loT services, 285 Home screen about, 34-35 adding shortcuts, 37 moving shortcuts, 38 Play Store Games category, 165-166 removing shortcuts, 38 Hours option, 223 House & Home category, 120 House of Marley, 249 Hyperlapse option (Mode icon), 146, 159 hyperlink, 30 Lemal, 74 Facebook, 126 Flash options, 139 Google, 108, 109 Google Maps, 217 Google Pay, 232 Internet, 109 Lens Selection, 138 Messages, 62 Motion Photo, 139 Phone, 55 Photo Effects, 139 Play Store, 116-117 Rear facing camera to front-facing camera switch, 138 Remember, 4 Samsung Pay, 232 Scene Optimizer, 138 Settings, 57, 139, 146-148, 159-160 Shutter button, 138 Technical Stuff, 4 Timer, 139 Tip, 3 Voice Recognition, 42 Warning, 4 HeartRadio, 191 images about, 12 advanced features, 144-148 assigning to contacts, 92 cropping, 151 deleting, 152 managing, 150-151 printing, 151		dot-surrounded-by-a-circle, 219
volume button(s), 27-29 headphones, 174-175 headsets about, 174-175 headsets about, 174-175 healternatives to, 59 Bluetooth, 56-58 choosing, 174-175 Health & Fitness category, 120 Hide declined events option (calendars), 208 Highlight short events option (calendars), 207 high-resolution screen, 10 Home button(s), 35-37 home electronics, controlling, 256-257 home loT services, 285 Home screen about, 34-35 adding shortcuts, 37 moving shortcuts, 38 Play Store Games category, 165-166 removing shortcuts, 38 Hours option, 223 House & Home category, 120 House of Marley, 249 Hyperlapse option (Mode icon), 146, 159 hyperlink, 30 Play Store Games category, 165-166 removing shortcuts, 38 Hours option, 223 House & Home category, 120 House of Marley, 249 Hyperlapse option (Mode icon), 146, 159 hyperlink, 30 Play Store, 116-117 Rear facing camera to front-facing camera switch, 138 Remember, 4 Samsung Pay, 232 Scene Optimizer, 138 Settings, 57, 139, 146-148, 159-160 Shutter button, 138 Technical Stuff, 4 Timer, 139 Tip, 3 Voice Recognition, 42 Warning, 4 HeartRadio, 191 images about, 12 advanced features, 144-148 assigning to contacts, 92 cropping, 151 deleting, 152 managing, 150-151 printing, 151		Email, 74
headphones, 174–175 headsets about, 174–175 alternatives to, 59 Bluetooth, 56–58 choosing, 174–175 Health & Fitness category, 120 Hide declined events option (calendars), 208 Highlight short events option (calendars), 207 high-resolution screen, 10 Home button(s), 35–37 home electronics, controlling, 256–257 home loT services, 285 Home screen about, 34–35 adding shortcuts, 37 moving shortcuts, 38 Play Store Games category, 165–166 removing shortcuts, 38 Hours option, 223 House & Home category, 120 House of Marley, 249 Hyperlapse option (Mode icon), 146, 159 hyperlink, 30 Add Contacts, 102 Aspect Ratio, 139 Bing, 108 Calendar, 202 Camera/Camcorder mode camera switch, 139 Combined Inbox, 84–85 Flash options, 139 Gallery, 138 Gamil, 74 Google, 108, 109 Google Maps, 217 Google Pay, 232 Internet, 109 Lens Selection, 138 Messages, 62 Motion Photo, 139 Phone, 55 Photo Effects, 139 Play Store, 116–117 Rear facing camera to front-facing camera switch, 138 Remember, 4 Samsung Pay, 232 Scene Optimizer, 138 Settings, 57, 139, 146–148, 159–160 Shutter button, 138 Technical Stuff, 4 Timer, 139 Tip, 3 Voice Recognition, 42 Warning, 4 HearrRadio, 191 images about, 12 advanced features, 144–148 assigning to contacts, 92 cropping, 151 deleting, 152 managing, 150–151 printing, 151		explained, 3–4
headsets about, 174–175 alternatives to, 59 Bluetooth, 56–58 choosing, 174–175 Health & Fitness category, 120 Hide declined events option (calendars), 208 Highlight short events option (calendars), 207 high-resolution screen, 10 Home button(s), 35–37 home electronics, controlling, 256–257 home loT services, 285 Home screen about, 34–35 adding shortcuts, 37 moving shortcuts, 38 Play Store Games category, 165–166 removing shortcuts, 38 Hours option, 223 House & Home category, 120 House of Marley, 249 Hyperlapse option (Mode icon), 146, 159 hyperlink, 30 I icons Add Contacts, 102 Aspect Ratio, 139 Bing, 108 Calendar, 202 Camera/Camcorder mode camera switch, 139 Combined Inbox, 84–85 Rash options, 139 Gallery, 138 Galler, 109 Google Pay, 232 Internet, 109 Lens Selection, 138 Messages, 62 Motion Photo, 139 Phone, 55 Photo Effects, 139 Photo Effects, 139 Photo Effects, 139 Phone, 55 P		Facebook, 126
about, 174–175 alternatives to, 59 Bluetooth, 56–58 choosing, 174–175 Health & Fitness category, 120 Hide declined events option (calendars), 208 Highlight short events option (calendars), 207 high-resolution screen, 10 Home button(s), 35–37 home electronics, controlling, 256–257 home loT services, 285 Home screen about, 34–35 adding shortcuts, 37 moving shortcuts, 38 Play Store Games category, 165–166 removing shortcuts, 38 Hours option, 223 House & Home category, 120 House of Marley, 249 Hyperlapse option (Mode icon), 146, 159 hyperlink, 30 I icons Add Contacts, 102 Aspect Ratio, 139 Bing, 108 Calendar, 202 Camera/Camcorder mode camera switch, 139 Combined Inbox, 84–85 Gallery, 138 Gmail, 74 Google, 108, 109 Google Apy, 232 Internet, 109 Lens Selection, 138 Messages, 62 Motion Photo, 139 Photo, 55 Photo Effects, 139 Play Store, 116–117 Rear facing camera to front-facing camera switch, 138 Remember, 4 Samsung Pay, 232 Scene Optimizer, 138 Settings, 57, 139, 146–148, 159–160 Shutter button, 138 Technical Stuff, 4 Timer, 139 Tip, 3 Voice Recognition, 42 Warning, 4 IHeartRadio, 191 images about, 12 advanced features, 144–148 assigning to contacts, 92 cropping, 151 deleting, 152 managing, 150–151 printing, 151	그는 이 가장 수 있다는 그 집에 가는 이 가는 이 그는 그 생각이 없다는 것이 되는 것이 되었다. 그런 그리고 있다는 그 사람들이 되었다.	Flash options, 139
alternatives to, 59 Bluetooth, 56-58 choosing, 174-175 Health & Fitness category, 120 Hide declined events option (calendars), 208 Highlight short events option (calendars), 207 high-resolution screen, 10 Home button(s), 35-37 home electronics, controlling, 256-257 home loT services, 285 Home screen about, 34-35 adding shortcuts, 37 moving shortcuts, 38 Play Store Games category, 165-166 removing shortcuts, 38 Hours option, 223 House & Home category, 120 House of Marley, 249 Hyperlapse option (Mode icon), 146, 159 hyperlink, 30 Add Contacts, 102 Aspect Ratio, 139 Bing, 108 Calendar, 202 Camera/Camcorder mode camera switch, 139 Combined Inbox, 84-85 Google, 108, 109 Google Maps, 217 Google Pay, 232 Internet, 109 Lens Selection, 138 Messages, 62 Motion Photo, 139 Phone, 55 Photo Effects, 139 Phone, 55 Photo Effects, 139 Play Store, 116-117 Rear facing camera to front-facing camera switch, 138 Remember, 4 Samsung Pay, 232 Scene Optimizer, 138 Settings, 57, 139, 146-148, 159-160 Shutter button, 138 Technical Stuff, 4 Timer, 139 Tip, 3 Voice Recognition, 42 Warrning, 4 HeartRadio, 191 images about, 12 advanced features, 144-148 assigning to contacts, 92 cropping, 151 deleting, 152 managing, 150-151 printing, 151		Gallery, 138
Bluetooth, 56-58 choosing, 174-175 Health & Fitness category, 120 Hidd declined events option (calendars), 208 Highlight short events option (calendars), 208 Home button(s), 35-37 home electronics, controlling, 256-257 home loT services, 285 Home screen about, 34-35 adding shortcuts, 37 moving shortcuts, 38 Play Store Games category, 165-166 removing shortcuts, 38 Hours option, 223 House & Home category, 120 House of Marley, 249 Hyperlapse option (Mode icon), 146, 159 hyperlink, 30 I icons Add Contacts, 102 Aspect Ratio, 139 Bing, 108 Calendar, 202 Camera/Camcorder mode camera switch, 139 Chrome, 108, 109 Combined Inbox, 84-85 Google Maps, 217 Google Pay, 232 Internet, 109 Lens Selection, 138 Messages, 62 Motion Photo, 139 Phone, 55 Phote Effects, 139 Play Store, 116-117 Rear facing camera to front-facing camera switch, 138 Remember, 4 Samsung Pay, 232 Scene Optimizer, 138 Settings, 57, 139, 146-148, 159-160 Shutter button, 138 Technical Stuff, 4 Timer, 139 Tip, 3 Voice Recognition, 42 Warning, 4 IHeartRadio, 191 images about, 12 advanced features, 144-148 assigning to contacts, 92 cropping, 151 deleting, 152 managing, 150-151 printing, 151		Gmail, 74
choosing, 174–175 Health & Fitness category, 120 Hide declined events option (calendars), 208 Highlight short events option (calendars), 207 high-resolution screen, 10 Home button(s), 35–37 home electronics, controlling, 256–257 home loT services, 285 Home screen about, 34–35 adding shortcuts, 37 moving shortcuts, 38 Play Store Games category, 165–166 removing shortcuts, 38 Hours option, 223 House & Home category, 120 House of Marley, 249 Hyperlapse option (Mode icon), 146, 159 hyperlink, 30 I icons Add Contacts, 102 Aspect Ratio, 139 Bing, 108 Calendar, 202 Camera/Camcorder mode camera switch, 139 Chrome, 108, 109 Combined Inbox, 84–85 Google Maps, 217 Google Pay, 232 Internet, 109 Lens Selection, 138 Messages, 62 Motion Photo, 139 Hess Selection, 139 Ressages, 62 Motion Photo, 139 Phone, 55 Phote Effects, 139 Play Store, 116–117 Rear facing camera to front-facing camera switch, 138 Remember, 4 Samsung Pay, 232 Scene Optimizer, 138 Settings, 57, 139, 146–148, 159–160 Shutter button, 138 Technical Stuff, 4 Timer, 139 Tip, 3 Voice Recognition, 42 Warning, 4 IHeartRadio, 191 images about, 12 advanced features, 144–148 assigning to contacts, 92 cropping, 151 deleting, 152 managing, 150–151 printing, 151		Google, 108, 109
Health & Fitness category, 120 Hide declined events option (calendars), 208 Highlight short events option (calendars), 207 high-resolution screen, 10 Home button(s), 35–37 home electronics, controlling, 256–257 home loT services, 285 Home screen about, 34–35 adding shortcuts, 37 moving shortcuts, 38 Play Store Games category, 165–166 removing shortcuts, 38 Hours option, 223 House & Home category, 120 House of Marley, 249 Hyperlapse option (Mode icon), 146, 159 hyperlink, 30 I icons Add Contacts, 102 Aspect Ratio, 139 Bing, 108 Calendar, 202 Camera/Camcorder mode camera switch, 139 Chrome, 108, 109 Combined Inbox, 84–85 Internet, 109 Lens Selection, 138 Messages, 62 Motion Photo, 139 Hessages, 62 Motion Photo, 139 Phone, 55 Photo Effects, 139 Play Store, 116–117 Rear facing camera to front-facing camera switch, 138 Remember, 4 Samsung Pay, 232 Scene Optimizer, 138 Settings, 57, 139, 146–148, 159–160 Shutter button, 138 Technical Stuff, 4 Timer, 139 Tip, 3 Voice Recognition, 42 Warning, 4 IHeartRadio, 191 images about, 12 advanced features, 144–148 assigning to contacts, 92 cropping, 151 deleting, 152 managing, 150–151 printing, 151		Google Maps, 217
Hide declined events option (calendars), 208 Highlight short events option (calendars), 207 high-resolution screen, 10 Home button(s), 35–37 home electronics, controlling, 256–257 home loT services, 285 Home screen about, 34–35 adding shortcuts, 37 moving shortcuts, 38 Play Store Games category, 165–166 removing shortcuts, 38 Hours option, 223 House & Home category, 120 House of Marley, 249 Hyperlapse option (Mode icon), 146, 159 hyperlink, 30 I cons Add Contacts, 102 Aspect Ratio, 139 Bing, 108 Calendar, 202 Camera/Camcorder mode camera switch, 139 Chrome, 108, 109 Combined Inbox, 84–85 Internet, 109 Lens Selection, 138 Messages, 62 Motion Photo, 139 Phone, 55 Photo Effects, 139 Play Store, 116–117 Rear facing camera to front-facing camera switch, 139 Settings, 57, 139, 146–148, 159–160 Shutter button, 138 Technical Stuff, 4 Timer, 139 Tip, 3 Voice Recognition, 42 Warning, 4 HeartRadio, 191 images about, 12 advanced features, 144–148 assigning to contacts, 92 cropping, 151 deleting, 152 managing, 150–151 printing, 151	그는 그리고 맛이 그 자꾸 것을 가게 보고 있다. 그는 그렇게 그는 것이 가게 하지 않는 것이 그게 살이 그 가운데 그 그렇게 되었다.	Google Pay, 232
Highlight short events option (calendars), 207 high-resolution screen, 10 Home button(s), 35–37 home electronics, controlling, 256–257 home loT services, 285 Home screen about, 34–35 adding shortcuts, 37 moving shortcuts, 38 Play Store Games category, 165–166 removing shortcuts, 38 Hours option, 223 House & Home category, 120 House of Marley, 249 Hyperlapse option (Mode icon), 146, 159 hyperlink, 30 I cons Add Contacts, 102 Aspect Ratio, 139 Bing, 108 Calendar, 202 Camera/Camcorder mode camera switch, 139 Chrome, 108, 109 Combined Inbox, 84–85 Lens Selection, 138 Messages, 62 Motion Photo, 139 Phone, 55 Photo Effects, 139 Play Store, 116–117 Rear facing camera to front-facing camera switch, 138 Remember, 4 Samsung Pay, 232 Scene Optimizer, 138 Settings, 57, 139, 146–148, 159–160 Shutter button, 138 Technical Stuff, 4 Timer, 139 Tip, 3 Voice Recognition, 42 Warning, 4 I HeartRadio, 191 images about, 12 advanced features, 144–148 assigning to contacts, 92 cropping, 151 deleting, 152 managing, 150–151 printing, 151	이 마음이에 가게 되는 것을 하는데 하는데 그들은 그렇게요? 그리고 내내는 글 이웃 주를 되었다. 중 주목에게 하는 것이다.	Internet, 109
high-resolution screen, 10 Home button(s), 35–37 home electronics, controlling, 256–257 home loT services, 285 Home screen about, 34–35 adding shortcuts, 37 moving shortcuts, 38 Play Store Games category, 165–166 removing shortcuts, 38 Hours option, 223 House & Home category, 120 House of Marley, 249 Hyperlapse option (Mode icon), 146, 159 hyperlink, 30 I icons Add Contacts, 102 Aspect Ratio, 139 Bing, 108 Calendar, 202 Camera/Camcorder mode camera switch, 139 Chrome, 108, 109 Combined Inbox, 84–85 Motion Photo, 139 Phone, 55 Photo Effects, 139 Play Store, 116–117 Rear facing camera to front-facing camera switch, 138 Remember, 4 Samsung Pay, 232 Scene Optimizer, 138 Settings, 57, 139, 146–148, 159–160 Shutter button, 138 Technical Stuff, 4 Timer, 139 Tip, 3 Voice Recognition, 42 Warning, 4 IHeartRadio, 191 images about, 12 advanced features, 144–148 assigning to contacts, 92 cropping, 151 deleting, 152 managing, 150–151 printing, 151		Lens Selection, 138
Home button(s), 35–37 home electronics, controlling, 256–257 home loT services, 285 Home screen about, 34–35 adding shortcuts, 37 moving shortcuts, 38 Play Store Games category, 165–166 removing shortcuts, 38 Hours option, 223 House & Home category, 120 House of Marley, 249 Hyperlapse option (Mode icon), 146, 159 hyperlink, 30 I cons Add Contacts, 102 Aspect Ratio, 139 Bing, 108 Calendar, 202 Camera/Camcorder mode camera switch, 139 Chrome, 108, 109 Combined Inbox, 84–85 Motion Photo, 139 Phone, 55 Photo Effects, 139 Play Store, 116–117 Rear facing camera to front-facing camera switch, 139 Play Store, 116–117 Rear facing camera to front-facing camera switch, 139 Play Store, 116–117 Rear facing camera to front-facing camera switch, 139 Play Store, 116–117 Rear facing camera to front-facing camera switch, 139 Play Store, 116–117 Rear facing camera to front-facing camera switch, 139 Play Store, 116–117 Rear facing camera to front-facing camera switch, 139 Play Store, 116–117 Rear facing camera to front-facing camera switch, 139 Play Store, 116–117 Rear facing camera to front-facing camera switch, 139 Play Store, 116–117 Rear facing camera to front-facing camera switch, 139 Play Store, 116–117 Rear facing camera to front-facing camera switch, 139 Play Store, 116–117 Rear facing camera to front-facing camera switch, 139 Play Store, 116–117 Rear facing camera to front-facing camera switch, 139 Play Store, 116–117 Rear facing camera to front-facing camera switch, 139 Play Store, 116–117 Rear facing camera to front-facing camera switch, 139 Play Store, 116–117 Rear facing camera switch, 139 Play Store, 116–117 Rear facing camera to front-facing camera switch, 139 Play Store, 116–117 Rear facing camera to front-facing camera switch, 139 Play Store, 116–117 Rear facing camera switch, 139 Play Store, 116–117 Rear facing camera switch, 139 Play Store, 106 Play Store, 107 Play Store, 106 Play Store, 107 Play Sto	는 "사이다면 시트라니어, 사이에는 15개를 하시다고 이렇게 있는 사람들이 하고 있다면서 보다 하는 것이다면서 보다 다른 사이트를 다 하는 것이다.	Messages, 62
home electronics, controlling, 256-257 home loT services, 285 Home screen about, 34-35 adding shortcuts, 37 moving shortcuts, 38 Play Store Games category, 165-166 removing shortcuts, 38 Hours option, 223 House & Home category, 120 House of Marley, 249 Hyperlapse option (Mode icon), 146, 159 hyperlink, 30 I I I I I I I I I I I I I I I I I I I	그렇게 끊이 먹어 가는 얼마나 없었다. 그렇게 그렇게 그렇게 하는 그는 그는 그는 그를 가게 되었다면 되었다. 그는 그는 그를 다 먹었다면 없다면 그렇게 되었다. 그는 그는 그를 다 먹었다면 없다면 그렇게 되었다. 그는 그는 그를 다 먹었다면 없다면 그렇게 되었다면 그렇게 되었다.	Motion Photo, 139
home loT services, 285 Home screen about, 34–35 adding shortcuts, 37 moving shortcuts, 38 Play Store Games category, 165–166 removing shortcuts, 38 Hours option, 223 House & Home category, 120 House of Marley, 249 Hyperlapse option (Mode icon), 146, 159 hyperlink, 30 I icons Add Contacts, 102 Aspect Ratio, 139 Bing, 108 Calendar, 202 Camera/Camcorder mode camera switch, 139 Chrome, 108, 109 Combined Inbox, 84–85 Photo Effects, 139 Play Store, 116–117 Rear facing camera to front-facing camera switch, 139 Remember, 4 Samsung Pay, 232 Scene Optimizer, 138 Settings, 57, 139, 146–148, 159–160 Shutter button, 138 Technical Stuff, 4 Timer, 139 Tip, 3 Voice Recognition, 42 Warning, 4 IHeartRadio, 191 images about, 12 advanced features, 144–148 assigning to contacts, 92 cropping, 151 deleting, 152 managing, 150–151 printing, 151		Phone, 55
Home screen about, 34-35 adding shortcuts, 37 moving shortcuts, 38 Play Store Games category, 165-166 removing shortcuts, 38 Hours option, 223 House & Home category, 120 House of Marley, 249 Hyperlapse option (Mode icon), 146, 159 hyperlink, 30 I Icons Add Contacts, 102 Aspect Ratio, 139 Bing, 108 Calendar, 202 Camera/Camcorder mode camera switch, 139 Combined Inbox, 84-85 Play Store, 116-117 Rear facing camera to front-facing camera switch, 138 Remember, 4 Samsung Pay, 232 Scene Optimizer, 138 Settings, 57, 139, 146-148, 159-160 Shutter button, 138 Technical Stuff, 4 Timer, 139 Tip, 3 Voice Recognition, 42 Warning, 4 IHeartRadio, 191 images about, 12 advanced features, 144-148 assigning to contacts, 92 cropping, 151 deleting, 152 managing, 150-151 printing, 151	[2]	Photo Effects, 139
about, 34–35 adding shortcuts, 37 moving shortcuts, 38 Play Store Games category, 165–166 removing shortcuts, 38 Hours option, 223 House & Home category, 120 House of Marley, 249 Hyperlapse option (Mode icon), 146, 159 hyperlink, 30 I Icons Add Contacts, 102 Aspect Ratio, 139 Bing, 108 Calendar, 202 Camera/Camcorder mode camera switch, 139 Combined Inbox, 84–85 Rear facing camera to front-facing camera switch, 138 Remember, 4 Samsung Pay, 232 Scene Optimizer, 138 Settings, 57, 139, 146–148, 159–160 Shutter button, 138 Technical Stuff, 4 Timer, 139 Tip, 3 Voice Recognition, 42 Warning, 4 IHeartRadio, 191 images about, 12 advanced features, 144–148 assigning to contacts, 92 cropping, 151 deleting, 152 managing, 150–151 printing, 151		Play Store, 116-117
moving shortcuts, 38 Play Store Games category, 165–166 removing shortcuts, 38 Hours option, 223 House & Home category, 120 House of Marley, 249 Hyperlapse option (Mode icon), 146, 159 hyperlink, 30 I icons Add Contacts, 102 Aspect Ratio, 139 Bing, 108 Calendar, 202 Camera/Camcorder mode camera switch, 139 Combined Inbox, 84–85 Kermenble, 4 Samsung Pay, 232 Scene Optimizer, 138 Settings, 57, 139, 146–148, 159–160 Shutter button, 138 Technical Stuff, 4 Timer, 139 Tip, 3 Voice Recognition, 42 Warning, 4 IHeartRadio, 191 images about, 12 advanced features, 144–148 assigning to contacts, 92 cropping, 151 deleting, 152 managing, 150–151 printing, 151	about, 34–35	
Play Store Games category, 165–166 removing shortcuts, 38 Hours option, 223 House & Home category, 120 House of Marley, 249 Hyperlapse option (Mode icon), 146, 159 hyperlink, 30 I Iteratrandia, 191 icons Add Contacts, 102 Aspect Ratio, 139 Bing, 108 Calendar, 202 Camera/Camcorder mode camera switch, 139 Chrome, 108, 109 Combined Inbox, 84–85 Scene Optimizer, 138 Settings, 57, 139, 146–148, 159–160 Shutter button, 138 Technical Stuff, 4 Timer, 139 Tip, 3 Voice Recognition, 42 Warning, 4 IHeartRadio, 191 images about, 12 advanced features, 144–148 assigning to contacts, 92 cropping, 151 deleting, 152 managing, 150–151 printing, 151		Remember, 4
removing shortcuts, 38 Hours option, 223 House & Home category, 120 House of Marley, 249 Hyperlapse option (Mode icon), 146, 159 hyperlink, 30 IlleartRadio, 191 icons Add Contacts, 102 Aspect Ratio, 139 Bing, 108 Calendar, 202 Camera/Camcorder mode camera switch, 139 Chrome, 108, 109 Combined Inbox, 84–85 Settings, 57, 139, 146–148, 159–160 Shutter button, 138 Technical Stuff, 4 Timer, 139 Tip, 3 Voice Recognition, 42 Warning, 4 IlHeartRadio, 191 images about, 12 advanced features, 144–148 assigning to contacts, 92 cropping, 151 deleting, 152 managing, 150–151 printing, 151	는 ^^ (HERRY) : () 프로그램 (HERRY) (HERRY) : () - () - () - () - () - () - () - (Samsung Pay, 232
Hours option, 223 House & Home category, 120 House of Marley, 249 Hyperlapse option (Mode icon), 146, 159 hyperlink, 30 I I I I I I I I I I I I I I I I I I I	이 가는 것 같습니다. 하는 그 그 없는 그는 가능하는 것이 하는 사람들이 그 생물을 다 하게 되는 것이라고 있다. 그는 그를 다 하는 것이다.	Scene Optimizer, 138
House & Home category, 120 House of Marley, 249 Hyperlapse option (Mode icon), 146, 159 hyperlink, 30 Interview of Marley, 249 Hyperlapse option (Mode icon), 146, 159 hyperlink, 30 Interview of Marley, 249 Timer, 139 Tip, 3 Voice Recognition, 42 Warning, 4 IHeartRadio, 191 images Add Contacts, 102 Aspect Ratio, 139 Bing, 108 Calendar, 202 Camera/Camcorder mode camera switch, 139 Chrome, 108, 109 Combined Inbox, 84–85 Tip, 3 Voice Recognition, 42 Warning, 4 IHeartRadio, 191 images about, 12 advanced features, 144–148 assigning to contacts, 92 cropping, 151 deleting, 152 managing, 150–151 printing, 151	그는 이 보호를 열차하면 가게 되었다. 그 아이를 하는데 하는데 하는데 하는데 하는데 하는데 되었다. 그 아이를 하는데	Settings, 57, 139, 146–148, 159–160
House of Marley, 249 Hyperlapse option (Mode icon), 146, 159 hyperlink, 30 Tip, 3 Voice Recognition, 42 Warning, 4 HeartRadio, 191 icons Add Contacts, 102 Aspect Ratio, 139 Bing, 108 Calendar, 202 Camera/Camcorder mode camera switch, 139 Chrome, 108, 109 Combined Inbox, 84–85 Timer, 139 Tip, 3 Voice Recognition, 42 Warning, 4 HeartRadio, 191 images about, 12 advanced features, 144–148 assigning to contacts, 92 cropping, 151 deleting, 152 managing, 150–151 printing, 151		Shutter button, 138
Hyperlapse option (Mode icon), 146, 159 hyperlink, 30 Tip, 3 Voice Recognition, 42 Warning, 4 IHeartRadio, 191 icons Add Contacts, 102 Aspect Ratio, 139 Bing, 108 Calendar, 202 Camera/Camcorder mode camera switch, 139 Chrome, 108, 109 Combined Inbox, 84–85 Tip, 3 Voice Recognition, 42 Warning, 4 IHeartRadio, 191 images about, 12 advanced features, 144–148 assigning to contacts, 92 cropping, 151 deleting, 152 managing, 150–151 printing, 151		Technical Stuff, 4
hyperlink, 30 Voice Recognition, 42 Warning, 4 IHeartRadio, 191 icons Add Contacts, 102 Aspect Ratio, 139 Bing, 108 Calendar, 202 Camera/Camcorder mode camera switch, 139 Chrome, 108, 109 Combined Inbox, 84–85 Voice Recognition, 42 Warning, 4 IHeartRadio, 191 images about, 12 advanced features, 144–148 assigning to contacts, 92 cropping, 151 deleting, 152 managing, 150–151 printing, 151		Timer, 139
Warning, 4 IHeartRadio, 191 icons Add Contacts, 102 Aspect Ratio, 139 Bing, 108 Calendar, 202 Camera/Camcorder mode camera switch, 139 Chrome, 108, 109 Combined Inbox, 84–85 Warning, 4 IHeartRadio, 191 images about, 12 advanced features, 144–148 assigning to contacts, 92 cropping, 151 deleting, 152 managing, 150–151 printing, 151	그리고 그렇게 그렇게 하다 그 이 그래요요. 그 그리고 그리고 그리고 그리고 그리고 그리고 그리고 그리고 그리고 그	Tip, 3
Warning, 4 IHeartRadio, 191 icons images Add Contacts, 102 Aspect Ratio, 139 Bing, 108 Calendar, 202 Camera/Camcorder mode camera switch, 139 Chrome, 108, 109 Combined Inbox, 84–85 Warning, 4 IHeartRadio, 191 images about, 12 advanced features, 144–148 assigning to contacts, 92 cropping, 151 deleting, 152 managing, 150–151 printing, 151	hyperlink, 30	Voice Recognition, 42
icons images Add Contacts, 102 about, 12 Aspect Ratio, 139 advanced features, 144–148 Bing, 108 assigning to contacts, 92 Calendar, 202 cropping, 151 Camera/Camcorder mode camera switch, 139 Chrome, 108, 109 managing, 150–151 Combined Inbox, 84–85 printing, 151		Warning, 4
Add Contacts, 102 Aspect Ratio, 139 Bing, 108 Calendar, 202 Camera/Camcorder mode camera switch, 139 Chrome, 108, 109 Combined Inbox, 84–85 about, 12 advanced features, 144–148 assigning to contacts, 92 cropping, 151 deleting, 152 managing, 150–151 printing, 151		IHeartRadio, 191
Add Contacts, 102 Aspect Ratio, 139 Bing, 108 Calendar, 202 Camera/Camcorder mode camera switch, 139 Chrome, 108, 109 Combined Inbox, 84–85 about, 12 advanced features, 144–148 assigning to contacts, 92 cropping, 151 deleting, 152 managing, 150–151 printing, 151	icons	images
Aspect Ratio, 139 Bing, 108 Calendar, 202 Camera/Camcorder mode camera switch, 139 Chrome, 108, 109 Combined Inbox, 84–85 advanced features, 144–148 assigning to contacts, 92 cropping, 151 deleting, 152 managing, 150–151 printing, 151		about, 12
Bing, 108 assigning to contacts, 92 Calendar, 202 cropping, 151 Camera/Camcorder mode camera switch, 139 Chrome, 108, 109 managing, 150–151 Combined Inbox, 84–85 printing, 151	Aspect Datio 120	advanced features, 144–148
Calendar, 202 cropping, 151 Camera/Camcorder mode camera switch, 139 Chrome, 108, 109 deleting, 152 Combined Inbox, 84–85 printing, 151 cropping, 151 deleting, 152 managing, 150–151 printing, 151	그 사람들이 하면서 가는 아이들이 얼마나 나는 사람들이 되었다.	assigning to contacts, 92
Camera/Camcorder mode camera switch, 139 deleting, 152 Chrome, 108, 109 managing, 150–151 Combined Inbox, 84–85 printing, 151	a.ll000	cropping, 151
Chrome, 108, 109 managing, 150–151 Combined Inbox, 84–85 printing, 151		
Combined Inbox, 84–85 printing, 151		
	C	printing, 151
	Compose, 85	renaming, 151

images (continued)	Let even titles wrap option (calendars), 207
sharing, 133-152	Libraries & Demo category, 120
taking, 135–144	license agreements, 125
using, 151	licensing multimedia files,
using on your phone, 151	179–180
installing Android apps, 122-127	Lifestyle category, 120
Internet access	light-emitting diodes (LEDs), 137
about, 10, 11-12, 107	linking Contacts app, 96–99
accessing websites, 109–111	LiPo batteries, 23, 24
defined, 109	lithium-polymer (LiPo) batteries, 23
mobile browsing compared with mobile apps, 114	Live focus option (Mode icon), 145 locating
starting browsers, 108–109	lost phones, 280-282
terminology, 109	nearby services, 221–223
Internet icon, 109	Location Options, 17
Internet radio, 190–192	Location Tags option (Settings icon), 147
Internet resources	lock options
accessing, 109–111	about, 266-269
Cheat Sheet, 4	fingerprint, 273-274
Find My Mobile, 281	preparing for, 269
Skinit, 252	selecting, 269–271
in-the-ear headsets, 176–177	Lock time zone option (calendars), 208
	locked phone, 15
K *	lost phones, 280–282
그래, 이 경우 등에 가는 그는 것이 되었다. 그 이 가는 그는 가장이 그 생각이 들어갔다. 그는 것이 없었다.	low light conditions, 141
keyboard software, 41–42 voice recognition, 42	loyalty cards, adding to Samsung Pay, 241–244
Kids category, 120	
Knox, 277	M
	making phone calls, 47–51
교육 : 1명리 : 기능의	malware protection, 279-280
	Manage calendar colors option (calendars), 206
landscape orientation, 42, 197	managing
Language/Accessibility option, 16	Android apps, 122-127
launching browsers, 108–109	battery life, 21–26
launching Google Maps app, 217	contacts, 89–104
LCDs, 137	home electronics, 256-257
Learn About Key Features option, 17	pictures, 150–151
leaving feedback on games, 169–172	Samsung Pay, 240–241
LEDs (light-emitting diodes), 137	text history, 69-70
Lens Selection icon, 138	mapping, 11
significant	mapping apps, battery life and, 216

maps about, 215-216 changing map scale, 218-220 finding nearby services, 221-223 getting directions, 224-225 GPS (global positioning system), 216 upgrading navigation, 226-227 using, 217-223 zooming, 219 Maps & Navigation category, 121 MAQAM (website), 183 medical apps, 283-284 Medical category, 121 memory, 180-181 Menu option, 223 messages email, 71-88, 142 text, 61-70 Messages icon, 62 Messaging app. See also text messages about, 61 sending pictures via, 143 metadata, 151 Mexico, emergency calls in, 56 Microsoft Bing, 109 micro-USB connector, 24 MMS message, 69 mobile apps, compared with mobile browsing, 114 mobile browsing, compared with mobile apps, 114 mobile payments, 230-231 mobile web page, 108 Mode setting (camera), 144-146 monochrome LEDs, 137 monthly pass, 180 More Games by Developer option, 169 More link (Mail app), 86 More option, 223 Motion Photo icon, 139 Movies & TV category, 119 moving shortcuts on Home screen, 38

multimedia, 10, 13, 179-180 multimedia files, licensing, 179-180 music. See also multimedia about, 173-174 adding as ringtones/alarms, 188-190 basic multimedia capabilities, 182-197 carriers and, 179 choosing Bluetooth speakers, 177-178 choosing headsets, 174-175 connecting to stereos, 178-179 considerations for, 173-197 file formats for, 186 Internet radio, 190-192 licensing multimedia files, 179-180 memory for, 180-181 Music & Audio category, 121 music games, 167

N

Navigate option, 225 navigating about, 26 Device Function keys, 41 extended Home screen, 34-38 hardware buttons, 26-29 keyboard, 41-42 notification area/screen, 38-39 orientation, 42 screens, 31-32 touchscreen, 29-34 navigation, upgrading, 226-227 nearby services, finding, 221-223 Neuvenalife, 258 News & Magazines category, 121 nickel-cadmium (NiCad) batteries, 23 Night option (Mode icon), 145 911 calls, 55-56 911 system, 284 non-Gmail accounts, 76-82 notification area/screen, 35, 38-39

Index

0

OLEDs (organic LEDs), 137

online music stores, buying from, 182-186

on-the-ear headsets, 176-177

options

About This Game, 168

Add a new account (calendars), 206

Advanced Recording (Settings icon), 160

Alert Settings (calendars), 208

Alert style (calendars), 208

Alternate Calendars (calendars), 207

AR Doodle (Mode icon), 146, 160-161

Auto HDR (Settings icon), 147

Call, 222

Cloud Services, 17

Customization service (calendars), 208

Cycling, 225

Date and Time, 16

Description, 167

Device Name, 18

Directions, 222

Director's View (Mode icon), 146, 159

display, for calendars, 206-208

Driving, 225

Emergency Mode, 43

First day of week (calendars), 207

Food (Mode icon), 145

Format and advanced (Settings icon), 147

Get Directions, 225

Google Account Sign-up, 16–17

Grid Lines (Settings icon), 147

Hide declined events (calendars), 208

Highlight short events (calendars), 207

Hours, 223

Hyperlapse (Mode icon), 146, 159

Language/Accessibility, 16

Learn About Key Features, 17

Let even titles wrap (calendars), 207

Live focus (Mode icon), 145

Location Options, 17

Location Tags (Settings icon), 147

Lock time zone (calendars), 208

Manage calendar colors (calendars), 206

Menu, 223

More, 223

More Games by Developer, 169

Navigate, 225

Night (Mode icon), 145

Order Online, 222

Panorama (Mode icon), 145

Password, 269-271

Pattern, 269-271

Permission (Mail app), 86

Phone Ownership, 17

Photo Effects, 148

PIN, 269-271

Portrait (Mode icon), 145

Portrait Video (Mode icon), 146, 158

Power Off, 43

Price, 169

Priority (Mail app), 86

Pro (Mode icon), 145

Pro Video (Mode icon), 146, 158

Public Transportation, 225

Ratings/Comments, 168

Restart, 43

Reviews, 168, 223

Save, 222

Save in Drafts (Mail app), 86

Save Selfies as Previewed (Settings icon), 147

Scan QR Codes (Settings icon), 146

Scene Optimizer (Settings icon), 146

Security (Mail app), 86

Send email to myself (Mail app), 86

Set As, for pictures, 151

setting on viewfinder, 146-148, 159-160

Setting Up Voicemail, 17

Settings to keep (Settings icon), 147

Share Place, 222

Shooting Methods (Settings icon), 147

Shot Suggestions (Settings icon), 146

Show completed reminders (calendars), 208

Show weather forecast (calendars), 207-208

Show week numbers (calendars), 207

Shutter Sound (Settings icon), 147 custom screen images, 253-255 power savings, 255-256 Sign up for a Samsung Account, 16 Samsung Dex Docking Cable, 259 Slow Motion (Mode icon), 146, 159 Smart Color Tone (Settings icon), 147 wearables, 257-258 wireless charging mats, 251-252 Street View, 222 Super Slow-mo (Mode icon), 146, 159 wraps, 252-253 phone calls Swipe Shutter Button (Settings icon), 146 about, 47 Taxi or Ride Service, 225 Tracking AutoFocus (Settings icon), 147 answering, 51-53 call log, 54-55 Turn on Rich Text (Mail app), 86 Use Wide Angle for Group Selfies (Settings emergency, 55-56 icon), 147 headset alternatives, 59 Users Also Viewed/Users Also Installed, 169 making, 47-51 Vibration Feedback (Settings icon), 148 syncing Bluetooth headsets, 56-58 Video Stabilization (Settings icon), 160 Phone icon, 55 Walking Navigation, 225 Phone Ownership option, 17 Website, 222 Photo Effects icon, 139 What's New, 168 Photo Effects options, 148 Wi-Fi, 16 Photo mode settings, 144-146 Order Online option, 222 Photo transfer feature, 141 organic LEDs (OLEDs), 137 Photography category, 121 organization, camera and, 141 photos orientation, 42, 218 Otterbox, 265 advanced features, 144-148 over-the-ear headsets, 176-177 assigning to contacts, 92 cropping, 151 P deleting, 152 managing, 150-151 pairing phones, 278-279 printing, 151 Pandora, 191 renaming, 151 Panorama option (Mode icon), 145 sharing, 133-152 Parenting category, 121 taking, 135-144 password, 269 using, 151 Password option, 269-271 using on your phone, 151 Pattern option, 269-271 pictures Permission option (Mail app), 86 about, 12 Personalization category, 121 advanced features, 144-148 personalizing assigning to contacts, 92 about, 247 cropping, 151 Bluetooth speakers, 248-249 deleting, 152 car speakers, 249-251 managing, 150-151 controlling home electronics, 256-257 printing, 151 creating AR emojis, 259-261

pictures (continued)	R
renaming, 151	racing games, 167
sharing, 133-152	rating apps, 128–130
taking, 135–144	Ratings/Comments option, 168
using, 151	reading email, 84–85
using on your phone, 151	Rear facing camera to front-facing camera
PIN option, 269–271	switch icon, 138
pinch and stretch, 33	receiving
pinching, 110	music as attachments, 186
Play Store	text messages, 69
about, 13, 73, 115	Recent Apps button, 39-41
accessing, 116–118	Recent link, 54
installing Android apps, 122–127	Record button, 154-155
managing Android apps, 122–127	recording sounds, 186-187
rating apps, 128–130	RefDesk, 110-111
uninstalling apps, 128–130	regular web page, 108
Play Store Games category	Remember icon, 4
about, 164–165	Remote Erase, 282
Categories tab, 166–169	Remote Lock, 282
Home screen, 165–166	removing
Play Store icon, 116–117	events, 208-211
playing downloaded music, 187-190	pictures, 152
Playlists category (YouTube Music app), 187	shortcuts from Home screen, 38
portable external charger, 23	renaming pictures, 151
Portrait option (Mode icon), 145	rental videos, 180
Portrait Video option (Mode icon), 146, 158	replying to email, 87-88
Power button, 20, 26–27	resolution
Power Off option, 43	for camera, 141
Power Savings Mode, 255–256	screen, 141
preparing Google Gmail, 72	resources, Internet
press and hold, 31	accessing, 109–111
Price option, 169	Cheat Sheet, 4
primary shortcuts, 35, 47–48	Find My Mobile, 281
printing pictures, 151	Skinit, 252
Priority option (Mail app), 86	Restart option, 43
Pro option (Mode icon), 145	Reviews option, 168, 223
Pro Video option (Mode icon), 146, 158	ringtones
Productivity category, 121	about, 10
Public Transportation option, 225	adding music as, 188–190
purchase videos, 180	role playing games, 167
puzzle games, 167	

S	Play Store dames category, 165-166
safety, while driving, 227	removing shortcuts, 38
Samsung Dex Docking Cable, 259	screen cover, 264–266
Samsung Galaxy Buds, 58	screen images, 253–255
Samsung Galaxy S21	screen resolution, 141
about, 1–2	screen size, 11
basic features of, 9–10	screens
charging, 21–26	Google TV app, 193–196
customizing, 13–15	navigating, 31–32
managing battery life, 21–26	scrolling apps, 41
navigating, 26–42	search engine, 109, 111–114
setting up, 15–18	Secure Folder, 274–276
Sleep mode, 43	security
smartphone features, 10–13	about, 263–264
turning off, 43	Bluetooth, 278–279
turning on, 19–21	case, 264–266
uses for, 10–13	creating Secure Folder, 274–276
Samsung Galaxy Watch, 257	downloading apps, 280
Samsung Knox, 277	facial recognition, 271–272
Samsung Pay	Knox, 277
about, 229–230	locating your phone, 280–282
adding loyalty cards, 241–244	lock options, 266–274
getting started, 232–234	malware, 279–280
how it works, 230–231	screen cover, 264–266
managing, 240–241	wiping clean, 282
setting up, 234–238	security code, for headsets, 58
using, 238–240	Security options (Mail app), 86
Samsung Pay icon, 232	selecting
Satellite view, 219	Bluetooth speakers, 177-178
Save in Drafts option (Mail app), 86	headsets, 174–175
Save option, 222	lock options, 269–271
Save Selfies as Previewed option (Settings	Send email to myself option (Mail app), 86
icon), 147	Send link (Mail app), 85
scale, map, 218–220	sending
Scan QR Codes option (Settings icon), 146	attachments via text messages,
Scene Optimizer icon, 138	68-69
Scene Optimizer option (Settings icon), 146	email, 85–87
screen, Home	text messages, 61–65
about 24.25	separating events, 211–213
adding shortcuts, 37	service enhancements, 288–289
moving shortcuts, 38	Set As option, for pictures, 151
A 10 - 10 - 10 - 10 - 10 - 10 - 10 - 10	

setting smart home, 290 calendar display preferences, 203-206 smartphone, 19 display options for calendars, 206-208 SMS (short message service) message, 69 options on viewfinder, 146-148, 159-160 Social category, 121 Video mode, 158-159 software keyboard, 41 Setting Up Voicemail option, 17 songs. See also multimedia Settings icon, 57, 139, 146-148, 159-160 about, 173-174 Settings to keep option (Settings icon), 147 adding as ringtones/alarms, 188-190 basic multimedia capabilities, 182-197 setup about, 15-18 carriers and, 179 choosing Bluetooth speakers, corporate email accounts, 82-84 177-178 email, 71-84 choosing headsets, 174-175 existing Gmail accounts, 73-74 connecting to stereos, 178-179 new Gmail accounts, 75-76 considerations for, 173-197 Samsung Pay, 234-238 file formats for, 186 Share Place option, 222 Internet radio, 190-192 sharing pictures, 133-152 licensing multimedia files, 179-180 Shooting Methods option (Settings icon), 147 memory for, 180-181 Shopping category, 121 Songs category (YouTube Music app), 187 short message service (SMS) message, 69 sounds, recording, 186-187 shortcuts speakers adding to Home screen, 37 about, 174 moving on Home screen, 38 car, 249-251 removing from Home screen, 38 Sports category, 121 Shot Suggestions option (Settings icon), 146 sports games, 167 Show completed reminders option (calendars), 208 starting browsers, 108-109 Show weather forecast option (calendars), Stations category (YouTube Music app), 188 207-208 stereo Bluetooth headsets, 176-177 Show week numbers option (calendars), 207 stereos, connecting to, 178-179 Shutter button icon, 138 Stop button, 155 Shutter Sound option (Settings icon), 147 storing contacts, 92-96 Sign up for a Samsung Account option, 16 strategy games, 167 SIM card, 95 Street View option, 222 simulation games, 167 stretch, pinch and, 33 64MP digital camera, 9-10 stretching, 110 Skinit (website), 252 Super AMOLED (Active-Matrix Organic Light-Slacker Radio, 191 Emitting Diode) screen, 27, 137 Sleep mode, 43 Super Slow-mo option (Mode icon), 146, 159 slideshow, 151 Swipe Shutter Button option (Settings icon), 146 SlipGrip, 250 syncing Slow Motion option (Mode icon), 146, 159 Bluetooth headsets, 56-58 Smart Color Tone option (Settings icon), 147 calendars, 201-203

Ten de la constanta de la cons	Travel & Local category, 121
taking	trivia games, 167
pictures, 135–144	Turn on Rich Text option (Mail app), 86
video, 154–157	turning off, 43
tap, 30–31, 33–34	turning on, 19–21
Taxi or Ride Service option, 225	
TeacherTube, 196	H U TO THE SECOND
Technical Stuff icon, 4	uninstalling apps, 128–130
TeleNav, 217	unlock pattern, 269
telephone calls	"unlocked" GSM phone, 15
about, 47	upgrading navigation, 226–227
answering, 51–53	USB travel charger, 23
call log, 54-55	USB-A connector, 22
emergency, 55-56	USB-C connector, 21–22
headset alternatives, 59	Use Wide Angle for Group Selfies option (Settings
making, 47–51	icon), 147
syncing Bluetooth headsets, 56-58	Users Also Viewed/Users Also Installed option, 169
Terrain view, 219	
text messages	V Italian too a seed
about, 61	
conversations via, 66–68	vertical orientation, 42
receiving, 69	Video Format option 155
sending, 61-65	Video Format option, 155 Video mode settings, 158–159
sending attachments with, 68-69	Video Players & Editors category, 122
thermal runaway, 25–26	Video Stabilization option (Settings icon), 160
thumbnail, 30	Video Stabilization option (Settings Icon), 160
Timer icon, 139	videos. See also multimedia
Tip icon, 3	about, 173–174
Tools category, 121	basic multimedia capabilities, 182–197
Top Charts subcategory, 119	carriers and, 179
touchscreen	choosing Bluetooth speakers, 177–178
about, 29–30	choosing bidetooth speakers, 177–178
cleaning, 30	connecting to stereos, 178–179
double tap, 33–34	considerations for, 173–197
drag, 32	creating, 153–161
flick, 32–33	file formats for, 197
navigating screens, 31–32	licensing for, 180
pinch and stretch, 33	licensing multimedia files, 179–180
press and hold, 31	memory for, 180–181
tap, 30–31	taking, 154–157
track, licensing by the, 179	viewing, 197
Tracking AutoFocus option (Settings icon), 147	

viewfinder, 137–138, 146–148, 159–160 viewing videos, 197 voice recognition, 42 Voice Recognition icon, 42 voicemail, 53 Volume button(s), 27–29 VZ Navigator, 217

W

Walking Navigation option, 225 wallpapers, 253-255 Warning icon, 4 Waze, 217 wearables, 257-258 Weather category, 122 web browsers defined, 109 starting, 108-109 Website option, 222 websites accessing, 109-111 Cheat Sheet, 4 Find My Mobile, 281 MAQAM, 183 Skinit, 252

What's New option, 168
widgets, 14
Wi-Fi Direct, sending pictures via, 143
Wi-Fi option, 16
wiping devices clean, 282
wired headsets, 175–177
wireless charger, 23
wireless charging mats, 251–252
wireless e-mail, 10, 13
Wireless PowerShare, 26
word games, 167
wraps, 252–253
writing email, 85–87

Y

YouTube Music app about, 182 buying from online music stores, 182–186 playing downloaded music, 187–190 receiving music as attachments, 186 recording sounds, 186–187

Z

zooming maps, 219

About the Author

Bill Hughes is an experienced marketing strategy executive with over two decades of experience in sales, strategic marketing, and business development roles at several leading corporations, including Xerox, Microsoft, IBM, GE, Motorola, and US West Cellular.

Bill has worked with Microsoft to enhance its marketing to mobile applications developers. He also has led initiatives to develop new products and solutions with several high-tech organizations, including Sprint, Motorola, SBC, and Tyco Electronics as a Principal Consultant with Phlogiston, Inc.

Bill was a professor of marketing at the Kellogg School of Management at Northwestern University, where he taught Business Marketing to graduate MBA students.

Bill also has written articles on wireless technology for several wireless industry trade magazines. He also has contributed to articles in *USA Today* and *Forbes*. These articles were based upon his research reports written for In-Stat, where he was a principal analyst, covering the wireless industry, specializing in smartphones and business applications of wireless devices.

Bill graduated with honors with an MBA degree from the Kellogg School of Management at Northwestern University and earned a Bachelor of Science degree with distinction from the College of Engineering at Cornell University, where he was elected to the Tau Beta Pi Engineering Honorary.

Dedication

I would like to dedicate this book to Lindsey Hughes. Thanks for being a great daughter-in-law.

Author's Acknowledgments

I need to thank a number of people who helped make this book a reality. First, I would like thank my literary agent, Carole Jelen, of Waterside Publishing, for her support, encouragement, knowledge, and negotiation skills.

I would also like to thank the team at Wiley Publishing: Kelsey Baird, Michelle Hacker, and Elizabeth Kuball. Your expertise helped me through the creative process. Thanks for your guidance.

I would also like to thank Kristen Tatti of Otterbox, Ami Brannon of Neuvana, Cassandra Weller of Asylum Public Relations, Cassie Pineda and Jen Warren of Belkin, Alexander Stricker at CodeKonditor, Maria Tullgren of Audio Pro, Veronica Stetter at Skinit, Joseph Kawar of SlipGrips, and multiple individuals from Edelman.

Thanks go out to numerous people at Samsung who helped make this book possible.

Finally, I would like to acknowledge Ellis, Arlen, Quinlan, and Indy for constantly making me proud.

Publisher's Acknowledgments

Acquisitions Editor: Kelsey Baird Project Editor: Elizabeth Kuball Copy Editor: Elizabeth Kuball

Proofreader: Debbye Butler

Production Editor: Tamilmani Varadharaj

Cover Image: Hardware and screen images courtesy of Bill Hughes; Background image

© AureliasDreams/Gettyimages